African art in transit is an absorbing account of the commodification and circulation of African objects in the international art market today. Based on extensive field research among art traders in Côte d'Ivoire, Christopher Steiner analyzes the role of the African middleman in linking those who produce and supply works of art in Africa with those who buy and collect so-called "primitive" art in Europe and America. Moving easily from ethnographic vignette to social theory, Steiner provides a lucid interpretation which reveals not only a complex economic network with its own internal logic and rules, but also an elaborate process of transcultural valuation and exchange. By focusing directly on the intermediaries in the African art trade, he unveils a critical new perspective on how symbolic codes and economic values are produced and mediated in the context of shifting geographic and cultural domains. He calls into question conventional definitions of authenticity in African art, demonstrating how the categories "authentic" and "traditional" are continually negotiated and redefined by a plurality of market participants spread out across the globe.

African art in transit

African art in transit

Christopher B. Steiner

Natural History Museum of Los Angeles County

CAMBRIDGE
UNIVERSITY PRESS

Published by the Press Syndicate of the University of Cambridge
The Pitt Building, Trumpington Street, Cambridge CB2 1RP
40 West 20th Street, New York, NY 10011–4211, USA
10 Stamford Road, Oakleigh, Melbourne 3166, Australia

First published 1994

Printed in Great Britain at the University Press, Cambridge

A catalogue record for this book is available from the British Library

Library of Congress cataloguing in publication data

ISBN 0 521 43447 5 hardback
ISBN 0 521 45752 1 paperback

WD

For my parents and Kathy
with love and gratitude

Because no idea and no object can exist in isolation from its cultural context, it is impossible to sever mechanically an item from one culture and place it in another.　　　　　　　　　　Bronislaw Malinowski, "The Life of Culture" (1927)

A collector we know has placed his primitive art in niches with palm-tree backgrounds. This may be all right for a Lord and Taylor window, but it just doesn't work in a home.　　Matty Alperton, "Decorating with Primitive Art" (1981)

Contents

List of illustrations *page* x
Acknowledgments xiii

Introduction: The anthropology of African art in a
transnational market 1

1 Commodity outlets and the classification of goods 16

2 The division of labor and the management of capital 40

3 An economy of words: bargaining and the social production
 of value 61

4 The political economy of ethnicity in a plural market 80

5 The quest for authenticity and the invention of African art 100

6 Cultural brokerage and the mediation of knowledge 130

Conclusion: African art and the discourses of value 157

Notes 165
References 195
Index 211

Illustrations

Maps

1 Map of Côte d'Ivoire. *page* 3
2 Map of Abidjan. 22
3 Plan of Plateau market place, Abidjan. 24

Plates

1 Young boys at Plateau market place polishing Senufo masks
with paste wax. Abidjan, April 1988. 17
2 Market-place stall. Bouaké, December 1987. 20
3 Traders at their stalls in front of Le Mont Korhogo Hotel.
Korhogo, August 1988. 21
4 Partial view of the inside of an original concrete-frame stall
at the Plateau market place. Abidjan, June 1988. 23
5 Wooden-frame stall built in the 1970s at the Plateau market
place. Abidjan, June 1988. 25
6 Storehouse with proprietors. Treichville quarter, Abidjan,
November 1987. 27
7 Hausa storehouse-owners with children. Treichville quarter,
Abidjan, July 1988. 29
8 "Marchand d'Objets d'Arts Africains" art gallery and souvenir
shop outside Hotel Les Cascades. Man, June 1988. 31
9 "Galerie Bassamoise" roadside stall. Near Grand Bassam,
October 1987. 33
10 Artisanal workshop. Port de Carena, Abidjan, June 1988. 37
11 Dan doll with painted wooden face and costume made of
cotton cloth, raphia fibers, feathers, wool yarn, and fur.
Private collection. Photograph by Richard Meier. 43
12 Interior view of an art storehouse. Treichville quarter,
Abidjan, November 1987. 45
13 Market-place stallholder with his stock of merchandise.
Man, June 1988. 47

14 European tourists negotiating a sale with Wolof traders at
 Plateau market place. Abidjan, December 1987. 57
15 Hausa trader examining a Senufo statue before offering a price
 to an itinerant supplier. Aoussabougou, Korhogo, December 1987. 63
16 Hausa traders bargaining in a storehouse. Treichville quarter,
 Abidjan, June 1991. 67
17 Senufo *kpélié*-style mask. Private collection. Photograph by
 Richard Meier. 83
18 Wooden house ladders in a trader's storehouse. Treichville
 quarter, Abidjan, June 1991. 113
19 Wooden pestles in a trader's storehouse. Treichville quarter,
 Abidjan, June 1991. 115
20 Slingshots stained with potassium permanganate drying at the
 Plateau market place. Abidjan, March 1988. 116
21 A pile of slingshots displayed among other objects at the stall
 of a Plateau market-place trader. Abidjan, April 1988. 117
22 Carver finishing the detail work on a wooden slingshot.
 Abidjan, March 1988. 118
23 Broken Baule statue "transformed" into a slingshot by replacing
 the broken legs with a forked pinnacle. Abidjan, July 1988. 119
24 Employee at an African art framing gallery constructing a box
 frame for a display of Akan goldweights. Abidjan, July 1991. 121
25 A framed Dan mask and brass bracelet and goldweights on
 display at an African art framing gallery. Abidjan, July 1988. 123
26 American gallery-owner buying trade beads from a Hausa
 merchant in the Treichville market place. Abidjan, December
 1987. 126
27 Young Hausa trader with a display of trade beads at his market-
 place stall. Treichville quarter, Abidjan, July 1988. 127
28 Hausa trader at his stall in the front of the Plateau market place.
 Abidjan, November 1988. 134
29 Hausa trader with wooden trunk in the back section of the
 Plateau market place. Abidjan, May 1988. 135
30 Hausa trader unloading a shipment of Asante stools at Kennedy
 airport. New York, June 1989. 137
31 A carver repairing the arm on an Asante female figure. Plateau
 market place, Abidjan, January 1988. 141
32 Storehouse assistant embellishing Dan masks with padded
 cowrie-covered headdresses. Treichville quarter, Abidjan,
 November 1987. 142
33 Small Akan brass boxes stained with potassium permanganate to
 dull the surface finish. Plateau market place, Abidjan, July 1988. 143

34 Dan wooden face masks covered with kola nut compound to
 imitate the surface texture of a mask that had received
 "traditional "sacrifices. Man, June 1988. 144
35 Asante combs splattered with a kola nut residue. Plateau
 market place, Abidjan, March 1988. 145
36 Baule figure with beaded waistband and necklace. Reproduced
 by permission of the Peabody Museum, Harvard University.
 Photograph by Hillel Burger. 146
37 Baule figure with cotton loin-cloth affixed around its waist.
 Reproduced by permission of the Musée de l'Homme, Paris.
 Photograph by Charles Lemzaouda. 147
38 Baule figure showing partially removed wooden "loin-cloth."
 Private collection. Photograph by Hillel Burger. 149
39 Baule "colonial" figure wearing Western-style cap, shirt,
 shorts, sandals, and wristwatch. Private collection. Photograph
 by C. B. Steiner. 150
40 Guinean workshop artist with "colonial" figures. Port de
 Carena, Abidjan, June 1988. 151
41 Workshop apprentice painting "colonial" figures. Bouaké,
 December 1988. 152
42 Dioula trader sanding down the paint from a lot of newly arrived
 "colonial" figures. Plateau market place, Abidjan, June 1988. 153

Unless indicated otherwise, all photographs are by the author.

Acknowledgments

The research for this book was undertaken in several phases: a preliminary trip to Côte d'Ivoire in the summer of 1986 funded by a travel grant from the Department of Anthropology at Harvard University; an extended period of field research from October 1987 to October 1988 funded jointly by a Fulbright Fellowship from the Institute of International Education and a Sinclair Kennedy Travelling Fellowship from Harvard; a return visit in the summer of 1991; and a short period of library and museum research in France during the summer of 1992 funded by the American Council of Learned Societies. The original dissertation upon which this book is based was rewritten for publication from 1990–91 under the auspices of a Kalbfleisch Postdoctoral Fellowship at the American Museum of Natural History in New York. The Natural History Museum of Los Angeles County provided a conducive environment from which to make the final revisions to the manuscript. It is with great pleasure that I acknowledge all of the institutions and funding agencies that have helped to make this book better or, indeed, even possible.

I wish to thank the government of the République de Côte d'Ivoire for permitting me to conduct my field research. My affiliation in 1987–88 with the Université Nationale de Côte d'Ivoire was granted by Touré Bakary. Joachim Bony authorized and oversaw my position as Research Associate at the Institut d'Histoire, d'Art et d'Archéologie Africain in Abidjan. A. D. Hauhouot Asseypo and The Honorable J. J. Bechio wrote letters of introduction that were worth their weight in gold. I thank them all for their assistance and for the seriousness with which they took my project.

During my years of training at Harvard, I benefited immensely from the example of Sally Falk Moore, who provided generous advice and offered critical insight into the theoretical possibilities of my work. Her friendship and guidance have motivated me throughout the course of my studies and the beginning of my career. Jane Guyer, Charles Lindholm, David Maybury-Lewis, Pauline Peters, Parker Shipton, Stanley Tambiah, and Nur Yalman have helped me situate my research within the broader context of anthropological history and thought. I have profited tremendously from listening to them all. Monni Adams has shared with enthusiasm her extensive knowledge of West

African art and culture. Her stream of constructive commentary on my work has been indispensable. I owe thanks to Kalman Applbaum, Paul Brodwin, Bart Dean, Paul Gelles, Richard Grinker, Bapa Jhala, Ingrid Jordt, Mike Lambert, Jay Levi, Terry O'Nell, Norbert Peabody, and Anna Simons – who were always there at the right time. Without their camaraderie, the early stages of writing this book would have been a much lonelier task.

Preliminary bibliographic research was undertaken at the National Museum of African Art, Smithsonian Institution, where Janet Stanley offered invaluable assistance. My work at Harvard was immeasurably aided by the exceptional collections and knowledgeable staff at the Tozzer and Widener Libraries, as well as at the Peabody Museum. The Musée de l'Homme and Bibliothèque Nationale in Paris provided generous access to their collections. The American Cultural Center in Abidjan administered the Fulbright Fellowship, and contributed logistical support. While in Abidjan, Christopher Fitzgerald, George Hegarty, Nancy Nolan, Stephan Ruiz, Ray Silverman, and Ellen Suthers offered some much-needed motivation and direction at difficult junctures in the research.

My formative thoughts on the subjects of transcultural trade, the anthropology of art, and the political economy of taste were developed as an undergraduate at The Johns Hopkins University. For their help in forming my initial ideas, and for their sustaining interest in my work, I am indebted particularly to David William Cohen, Richard Price, and Sally Price, as well as to Philip Curtin, Sidney Mintz, John Murra, William Sturtevant, and Katherine Verdery. My specific ideas about the research and writing of this book were refined and improved upon through my conversations with Paula Ben-Amos, Gillian Feeley-Harnick, Christraud Geary, Stephen Gudeman, Margaret Hardin, Jean Hay, Ivan Karp, Bennetta Jules-Rosette, Sidney Kasfir, Simon Ottenberg, Philip Ravenhill, Enid Schildkrout, Susan Vogel, Richard Werbner, and Savané Yaya. Revisions to the final draft benefited from a careful reading by Michael Herzfeld, and from the suggestions made by the anonymous reviewers chosen by the press. Some of the direct quotations from African art traders that appear in the book were recorded on video in the course of my collaboration with Ilisa Barbash and Lucien Taylor on the making of *In and Out of Africa*, an ethnographic documentary about the trade in African art distributed by the University of California Extension Center for Media and Independent Learning, 2176 Shattuck Ave., Berkeley, CA 94704.

All the maps in this book were expertly drawn by Lee Nathaniel Saffel, who somehow managed to transform my sloppy sketch of an Abidjan market place into a professional illustration. My color field photographs were printed in black-and-white by John De Leon, Richard Meier, and Donald Meyer. I am grateful for all of their hard work.

To my parents, Nancy and Erwin Steiner, I owe special thanks for their

unflagging encouragement, their generous support, and their persistence in trying to understand what it is I actually study. To Kathy Skelly, I am grateful for the clarity of her editorial assistance and for the inspiration she has provided throughout the course of researching and writing this book.

Finally, to those who contributed most centrally to this book, I owe the art traders in Côte d'Ivoire a tremendous debt of gratitude which I can never repay – the kind of debt with which many of them are unfortunately all too familiar. The traders welcomed me into the fold of their professional brotherhood, allowed me to observe the inner workings of their business, extended their hospitality and trust, and unselfishly shared with me the vast riches of their knowledge. Without their collaboration this book could never have been realized.

Introduction
The anthropology of African art in a transnational market

In the first decades of this century, the discipline of social anthropology defined its subject matter as the study of the inner workings of closed social systems which were isolated supposedly both from the external world and from one another. The choice for this unit of study was developed in part as a reaction against the conjectures of cultural diffusionism – a then current theory which stressed how cultural traits and material culture diffused around the world. Rather than look at the movement of peoples and things from one socio-economic context to the next, social anthropology – whose theories were to become grounded in its methods of localized and intensive ethnographic field-work – claimed as its focus of analysis the single tribe, the isolated community, and the remote village. "[E]ach society with its characteristic culture," writes Eric Wolf, "[was] conceived as an integrated and bounded system, set off against other equally bounded systems" (1982: 4).

In the past twenty-five years or so, anthropology has reacted strongly against the fiction of "primitive" isolates – deconstructing the internal architecture of putatively autonomous and self-regulating systems. The critique has taken essentially two paths. First, at the local level, the definition of the "system" itself has been revised to include "process" (i.e., history, competition, and social change). Key words associated with the earlier model of society – homeostasis, cohesion, and balance – have been replaced by new concepts such as pluralism, heterogeneity, crisis, conflict, and transformation. Second, at the supra-local level, the model of "bounded systems" has been challenged by those who see the world itself as a transformative force defined by historical processes and, in particular, shaped by the conflicts and contradictions of a capitalist world economy. In this formulation, the vision of the world has returned, in a curious fashion, to one espoused by the early diffusionists – that is to say, the world as global matrix, with transnational contacts and macro-scale linkages.[1]

Drawing inspiration both from Immanuel Wallerstein's research on the sociology of the modern world system (1974, 1979) and from Fernand Braudel's research on the social history of global commerce (1973, 1982), anthropologists engaged in the formulation of this second revisionist model

1

have been turning their attention increasingly to the migration of persons and things in the transnational world economy. Expanding the focal range in the ethnographic lens, the subject of social anthropology has been pushed beyond the conventional community setting. Attention to global interdependence and cross-cultural exchange has revealed, as George Marcus and Michael Fischer have recently stated, an array of political and economic processes which "are registered in the activities of dispersed groups or individuals whose actions have mutual, often unintended, consequences for each other, as they are connected by markets and other major institutions that make the world a system" (1986: 91).

One way of constructing a "multilocale" ethnography within the boundaries of a single text is to trace the movement of particular commodities through space and time. Sidney Mintz, in *Sweetness and Power* (1985), tracks the history of sugar as a vehicle for analyzing the development of Afro-Caribbean slavery, the rise of Western capitalism, and the emergence of a transatlantic diaspora of mercantile accumulation. Eric Wolf, in *Europe and the People Without History* (1982), deals with the mobility of several commodities – reconstructing the major political and economic patterns of world history in order to shed light on the relationship among far-separated populations whose lives were entangled in a swirl of transglobal trade. And in *The Social Life of Things* (1986), a volume of collected essays edited by Arjun Appadurai, the contributors follow the circulation of objects (or groups of objects) as they move through specific cultural and historical milieus. Because a commodity does not always stay in the context for which it was intended, nor does it necessarily remain in the region within which it was produced, a commodity is said to have a "social life," whose value, spirit, and meaning changes through time.

This book is about the trade in African art in Côte d'Ivoire, West Africa (Map 1).[2] It is about the circulation of art objects through local, national, and transnational economies, and it is about those whose lives are caught up in its supply, distribution, and exchange. The book takes as its unit of study a group of both itinerant and settled merchants who specialize in the commerce of African art – middlemen who link either village-level object-owners, or contemporary artists and artisans, to Western collectors, dealers, and tourists. The "community" of traders is made up of members from many different ethnic groups, and represents individuals from a whole range of social backgrounds and from various levels of economic success. Because the merchandise that the traders buy and sell is defined, classified, and evaluated largely in terms of Western concepts such as "art" and "authenticity," the traders are not only moving a set of objects through the world economic system, they are also exchanging information – mediating, modifying, and commenting on a broad spectrum of cultural knowledge.

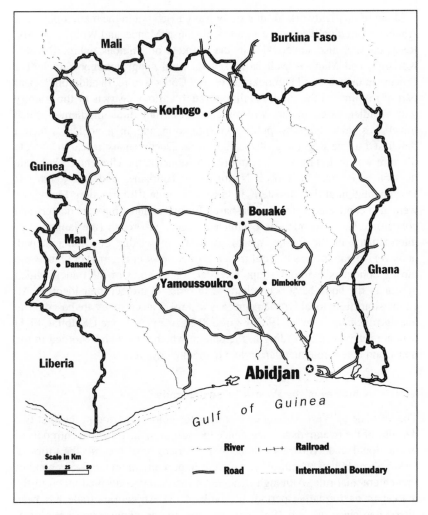

Map 1 Côte d'Ivoire.

Much of the fieldwork for this study was carried out in the market places of Abidjan – principally among art traders of Hausa, Mande, and Wolof ethnicity. Research was also undertaken in the markets of Yamoussoukro, Bouaké, Korhogo, and Man, as well as in several rural supply entrepôts including Danané in the west and Dimbokro in central Côte d'Ivoire. In addition, I spent part of my time in the field traveling through various districts of the country with Abidjan-based traders who purchase art from rural middlemen. Such travel was done both by public transportation and in a vehicle which I purchased at the beginning of the fieldwork. Documentary research in Côte d'Ivoire was undertaken in the Archives Nationales, the Université Nationale de Côte d'Ivoire, the Office National du Tourisme, and the Centre de Documentation at the Ministère de la Culture et de l'Information. Interviews were also conducted with Abidjan-based European and American dealers and collectors. The research was conducted largely in French (the language of intermediacy in the market place). A basic knowledge of Dioula helped, however, to gain access to rural traders.[3] Interviews in the market place were mostly conducted without a tape recorder.[4] The names of the traders which appear in the book have been changed in order to protect their identity. All conversions from local Ivoirian currency to American currency are based on an average exchange rate for 1987–88 of 300 CFA francs to one US dollar. Field data are referenced according to the date in which they were recorded in my notes, and dates are American style, i.e. month, day, year.

A history of the West African art trade

The art trade in West Africa began during the colonial period in the first two decades of the twentieth century. Since its inception, the principal entrepôts of international trade (in francophone West Africa) have been in the cities of Dakar and Abidjan – both of which were important administrative centers of French colonial rule. Although Senegalese merchants controlled much of the market in its formative period, the bulk of the African art trade has been distributed since the late 1950s among three major ethnic groups: Wolof of Senegal, Hausa of Niger and Nigeria, and Mande of Mali, Burkina Faso, Guinea, and Côte d'Ivoire. All of these ethnic groups have historical links to the spread of mercantile capitalism in West Africa and, in particular, all of them have been responsible for the formation of cross-cultural trading diasporas throughout the region.

Two developments, which occurred at roughly the same time but in different parts of the world, are in large measure responsible for the formation of the art trade in West Africa. The first development was the "discovery" of African art at the turn of the century by European artists and intellectuals, such as Matisse, Picasso, Braque, Vlaminck, and Apollinaire. Their interest in

African forms and aesthetics stimulated a slowly rising demand for African art objects in Europe. At first, the demand was limited largely to the Cubists and their immediate entourage. But by the 1910–20s, the demand for African art in Europe had already spread to other sectors of the society. In particular, the end of the First World War brought about an atmosphere in France which was conducive to engaging the interest of a wider public in the appreciation and collection of African art (cf. W. Cohen 1980: 284–85). The disdain in which Africans had previously been held by the great majority of France's population was replaced after the war "by a certain curiosity about the customs of these [African] people who had fought fiercely [against the Germans] and were now joyful partners in the victory celebrations" (Paudrat 1984: 157). The success of the African pavilion at the Exposition Coloniale de Vincennes in 1931 fueled even further the demand for African objects in France (Laude 1971: 20). Even after the Cubist movement had ended, and many of the artists themselves had lost all interest in African art, the *market* for African art, which they had inspired and helped organize, had already developed its own commercial structure and economic force – enabling it to continue and flourish without their support.[5]

While interest in African art was slowly emerging in Europe – spreading further and further outside the inner circle of modern primitivists – European presence in Africa was growing at a curious pace, as the scramble for the continent unfolded. By the 1920s, after most parts of West Africa had been conquered by and divided among the major European powers, colonial administrations were set into place, thereby securing commercial access to West Africa by metropole-based trading companies and expatriate firms.[6] The colonial administration in Afrique Occidentale Française (AOF) granted special rights and privileges to some of their most "loyal" subjects. The Senegalese, in particular, who among other things were associated with the *tirailleurs sénégalais* (i.e., a group of armed forces who fought for France to conquer vast territories of West Africa) were protected by colonial rule and granted access to virtually all the territories in West Africa which were administered by the French (Manning 1988: 63–64).

This new form of transnational socio-political hierarchy, which emerged during the colonial period in West Africa, allowed for members of certain ethnic groups (such as the Wolof of Senegal) to displace themselves with increased security and greater facility (Challenor 1979; Echenberg 1991). Under protection of European colonial rule, these groups were able to travel across what had once been hostile and dangerous geo-political and ethnic frontiers. Increased access for commercial pursuits by both European and African entrepreneurs meant not only that Europeans had found new potential markets for the sale of their goods in the colonies (Steiner 1985), but it meant also that the colonies had found a new source of demand for their goods in

Europe. Although most of the exports which were made by colonial trading firms were of raw materials forged on the back of cheap labor, somewhere in the shadows of these vast commercial ventures one finds the small, tentative beginnings of an African art trade.

The career of one of the first professional African art dealers in Europe, Paul Guillaume, was launched accidentally by a curious intersection of these two historical developments.[7] Guillaume's initial interest in African art was sparked in 1911 by the unanticipated visit of artist Joseph Brummer. "Informed by Apollinaire of the presence of an African object of quality in the window of an automobile appliance store," writes Jean-Louis Paudrat, "Brummer negotiated its purchase from the young clerk [Guillaume] and induced him to show him regularly the 'fetishes' received by the clerk's firm through its colonial rubber supplies" (Paudrat 1984: 152; cf. Donne 1978: 107). Within a year of Brummer's visit, Guillaume had quit his job at the automobile supply shop, and had begun actively to seek his own supply of African art. From 1912 to 1920, Guillaume continuously increased his shipments of art from rubber contractors in West Africa, and began to place advertisements in the colonial press for the purpose of extending the range of his stock (Paudrat 1984: 153). By the 1920s, Guillaume had opened his first gallery on rue La Boétie in Paris. He continued to search for new suppliers of African art by developing a network of contacts with colonial officials from AOF. At Le Bréhant, a Parisian café frequented by officials on leave from the colonies, Guillaume posted a sign which read: "Paul Guillaume pays high prices for all pieces and collections of African origin" (Paudrat 1984: 160).[8]

Although the historical record is decidedly silent about the role of the African middleman in supplying colonial agents with the artworks which were being exported to the metropole, it would not be imprudent to infer that the commercial exporters who were shipping African objects to European dealers, such as Paul Guillaume (as well as Carl Einstein, Charles Vignier, Pierre Verité, Charles Ratton, and others), were not collecting the art themselves from the remote rural villages from which the objects were being extracted. As in so many other modes of extraction which, at different moments in the African past, have supplied a variety of export commodities for shipment to the West – the most obvious case being the Atlantic slave trade – it was the African intermediary who provided the first and most vital link in the commercial chain.

From the 1920–30s onward, the trade in African art became increasingly structured and organized on the side of supply. By this time, African artists had already started reproducing objects expressly for the export market. Some of these pieces were being commissioned by local colonial administrators, either for their own collections or as gifts for their friends and family in the metropole. Others were already being marketed from stalls and storehouses owned

by African traders in French colonial capitals, such as Dakar and Abidjan. By the 1950s, African art traders from AOF were regularly making the journey to France to sell objects directly to European-based dealers.[9] As the supply diminished of what the Western collector defines as the "classic" genres of African art – ideally, wooden face masks and ritual statuary (see Rubin 1984: 15–17) – traders expanded their inventory to include other categories of "art," such as household or utilitarian items, furniture, textiles, etc.

From very early on in the trade, newly carved objects were being artificially aged – their patina, coloration, and surface wear being carefully altered – so that the objects could be marketed in the West as antique or "authentic" art. During the decades of the 1960–70s, the art market in West Africa had probably reached its boom. Not only had an extensive demand been created in Europe, but also by this time demand had reached the shores of America. "The Peace Corps, the civil-rights movement, African nationalism, and the beginning of mass tourism to West Africa," writes Nicholas Lemann, "all increased American interest in African art" (1987: 26). In the late 1970s, most analysts would probably agree, the art market in West Africa had started to take a downward turn. Economic recessions in the West and diminishing supplies in Africa both contributed to a sluggish market and a deflationary spiral. While the market for the resale of African art from private collections was ignited by the economic bonfire of the 1980s – with record prices being set at one auction after another – the West African side of the trade smoldered, never returning to where it had been during the 1960–70s. Part of the reason for this is that many buyers had become convinced that all examples of "genuine" African art had already been taken out of the continent. The economic competition in the African art market had thus shifted from the site of original supply in Africa to the locus of the recirculation of previously owned objects in the West. While the market, in Côte d'Ivoire alone, still currently supports several hundred full-time African traders and middlemen, its scale has been significantly reduced by the combined negative forces of diminishing supply and dwindling demand. Although new traders keep entering the market each year, their economic returns keep going down and their future grows increasingly uncertain.

African art through the lens of commerce

The study of African art has tended to concentrate on the function or aesthetics of various forms of art within the context of a single, highly localized ethnographic setting.[10] In order to describe a given art form in what is supposedly its most pristine or "authentic" state, scholars specializing in the study of African art have often isolated the unit of analysis without taking into account the effects of outside influence.[11] Such a mode of investigation is inevitably

artificial since it is arguable that at no time has African art existed in total cultural isolation. In recent years, studies of African art have begun to take more seriously the impact of outside forces on local artistic expression. Some recent works, for example, have taken into account: (1) the complexity of ethnic attribution in African arts (e.g., the movement of objects for ritual use across ethnic boundaries); (2) the impact of the world economic system on local artistic production (e.g., the manufacturing of so-called "tourist" or "airport" arts); (3) the articulation of Islam and other world religions with indigenous African beliefs in the creation of syncretic sacred arts; and (4) the incorporation of Western manufactured products (plastic dolls, factory-made cloth, industrial hardware, etc.) into so-called "traditional" contexts.

Although the field of vision has widened greatly in the past few years, one area of research which remains largely unexplored is the commercial aspect of African art and, in particular, the analysis of the specialized trading diasporas which are used to circulate art objects throughout the African continent and the rest of the world. There are several reasons, I believe, which account for the lack of interest among scholars in the African art trade. First, like the study of markets in general, the study of art markets may appear initially to be a daunting task – requiring the understanding of a complex system characterized by extensive verbal bargaining, complicated credit relations, and a nearly untraceable network of circulating goods and capital. The study of the African art trade by a *Westerner* is made even more problematic by the very fact that the investigator belongs by definition to the consumer class and, as a result, is often considered to be a potential buyer of art rather than simply a patron of ideas.[12]

Second, the study of the African art market poses many of the same problems as the study of an African secret society – with the added obstacle that most traders do not want the investigator to become an initiate. Trade secrets cover a broad spectrum of activities. Traders, for example, are reluctant to talk about their earnings (for fear that kin, friends, or other traders will want to borrow money); they will not speak readily of their commercial success (almost all traders returning to Africa from Europe or America will try to discourage others from going abroad by saying that business is generally bad); they will not display or reveal their entire stock (for they know that the fewer times an object is seen, the higher its potential value will remain);[13] they will not easily reveal either the sources of their goods or their network of clients (for one of the key functions of traders is to maintain their status as middlemen, by keeping apart both village object-owners and producers from Western consumers); and, lastly, they will not divulge freely their techniques of artificial aging or mechanical patination (so as, understandably, to keep the buyers somewhat mystified).

Third, because the study of African art has developed largely in conjunction

with the collection of African art in the West, I would argue that those who study African art (especially those trained as art historians) have been disinclined to write about a system which makes of aesthetic objects temporary commodities in the "middle passage" from African village to Western vitrine. In the collection of African art by Westerners, the aesthetic value of an object is usually given more overt attention than its economic value.[14] Moreover, since the collection of African art is often associated with an idealized Western vision of static "primitive" culture, most collectors, I believe, would prefer to read about the uses of African art in a putatively unchanging pre-colonial milieu than about the commoditization of African art in a post-colonial trans-national economy.[15]

Finally, there has been a tendency among Western scholars and collectors alike to dismiss African art traders as "misinformed" or "ignorant," and unable, therefore, to truly appreciate or recognize the aesthetic merit and ethnographic provenance of what they sell.[16] Traders are often treated by Westerners with disrespect, and sometimes even with unbecoming disdain. Most of the traders who travel with their merchandise to Europe and America are described by Westerners as "runners," while their Western counterparts who travel to Africa to purchase large volumes of art for export to the West are referred to by the far more genteel and prestigious term "dealers." The implication of this semantic discrimination, I would argue, is closely related to a distinction which is commonly drawn between the African artist and the Western connoisseur. While the latter is said to be capable of judging aesthetic qualities and of ranking the relative "importance" of different works of African art, the former, it is said, simply produces his work spontaneously – oblivious somehow to the "genius" which guides his own hand (Price 1989: 87–89). The African art trader, in a similar tone, is often described as one who handles "masterpieces" without knowledge or care; he is portrayed as a blind supplier of raw materials (hence the word "runner") whose goods are "transformed" by the Western dealer who, contrary to his African counterpart, is entirely capable of appreci-ating what he sells (cf. Taylor and Brooke 1969). When collectors of African art buy from Western dealers, they expect to be guided by the seller's good taste and judgment. In general, they neither expect to be cheated by the dealer, nor to cheat the dealer themselves. When these same individuals buy the same sort of objects from an African "runner," they expect only to encounter deceit – either to be misguided by the seller into buying a "fake," or, conversely, to misguide the seller by buying something from him which is actually worth far more than the price at which he agrees to sell. As Lemann puts it, those who "patronize the runners [are] convinced that these people – usually illiterate and speaking only broken English – can't possibly know what the stuff they're selling is really worth" (1987: 28). The wife of a collector in New York told me once that her husband saw nearly every African "runner" that called him at his

Manhattan office. "He keeps hoping to find that one masterpiece, like a real Fang reliquary figure or something, buried somewhere in the junk that the runners usually sell" (12/20/89).

Hence, on the one hand, the economic quality of a trader's merchandise is ignored in order to draw attention away from the monetary value of the category "art." And, on the other hand, the artistic/cultural elements which make up the trader's craft are dismissed since it is believed that only the Western buyer or dealer is really capable of appreciating aesthetic worth. For all the reasons listed above, then, the African art trader has been relegated by silence to an invisible cog in the wheels of a complex transnational market – a market which functions because of, *not* in spite of, the African middleman.

Analysis of the African art trade not only sheds light on a "forgotten" people, it also illuminates an important facet of African art which has generally been neglected in the literature. By broadening the parameters of discernible influence, the study of the art trade integrates areas hitherto treated in relative isolation. Because traders move continually back-and-forth from local to global economy, a study of the art market sheds light on the impact of Western consumption on African art and aesthetics. Exogenous demand has not only encouraged traders to drain villages of their artistic wealth, but it has also led to the creation of new forms of material culture (hybrid styles, invented genres, replicas, and fakes) constructed, in James Clifford's apposite phrase, from the "debris of colonial culture contact" (1985: 166). Hence, the study of the African art trade uncovers not only a complex economic system with its own internal structure, logic, and rules, it reveals also an elaborate process of cross-cultural exchange in which the image of Africa and its arts are continually being negotiated and redefined by a plurality of market participants spread out across the world.

Paradigms in the study of African art

This book draws upon and contributes to several different bodies of literature, including those on the sociology of the market place, the linguistics of verbal bargaining, the structuring of ethnicity in cross-cultural trade, the political economy of commoditization, and the dynamics of cultural brokerage or the mediation of knowledge. Most components of these diverse bodies of literature are referenced and discussed in the places of the book where they are most relevant. In this section, therefore, I have chosen to restrict my discussion to the literature on African art, and, in particular, to locate this work within the history of scholarship on African art and material culture.

The study of African art developed largely in conjunction with the discipline of anthropology at the beginning of this century. Some of the earliest works on African art were written in order to further particular claims within a broader

debate between diffusionist and evolutionist schools of thought. African art was used either as visual evidence for the spread of cultural traits from innovative centers to imitative peripheries, or as evidence for the social evolution of cultures – from groups which were supposedly capable of only naturalistic representation to those which had presumably graduated to the mastery of geometric stylization and abstract forms (Silver 1979a: 270–71; Gerbrands 1990: 15–17).

As the field of anthropology altered its emphasis from diffusion to context, and from evolution to function, the study of African art followed in its path. Drawing upon the new discourse of anthropology, and in particular taking a lead from Malinowski and Radcliffe-Brown, the focus in the study of African art was to become the indigenous context – which would reveal the place of art within a balanced holistic system of social and cultural functions. In this sense, art was understood simply as yet another vital organ in the proper maintenance and functioning of a stable social organism. Eventually, the term "ethno-aesthetics" came to be used as a label for this type of approach. Faced with an abundance of non-Western art in the repositories of Western museums, ethno-aesthetics was conceived as an analytic method to resituate these objects within the environment of their original use. Philip Dark wrote in 1967:

At this time, when so many art forms from non-western cultures are being sold in our cities in increasing numbers, one might say en-masse, while the buyers remain, to a large extent, ignorant of the context in which they were made, we have need of anthro-pologists who can help bring understanding of art in context to those who have some of its results *hors de contexte*. (1967: 133)

By the early 1970s, anthropologists had begun to question the privileged place of "context" within the study and analysis of African art. Increasingly aware of the permeability of the boundaries which surrounded the area of study, scholars began to peer through some of the cracks in the imagined borders which putatively encased the art in its indigenous milieu. "There is no *a priori* guarantee that a particular linguistic or other group or sub-group identified in advance by the researcher, no matter how ingeniously characterized," wrote Whitney Davis recently, "is, in fact, the full and real context of and for a particular history of representations" (1989: 26).

In challenging what was perceived to be an overemphasis on local context, research on African art took two directions. First, the local context itself was broadened and redefined to include inter-group relations and contacts. In so doing, it was discovered that art objects were not only created for local use, but were also borrowed and traded among ethnic groups within a wide geographic terrain – both art and artists moving from place to place, crosscutting and penetrating an array of so-called ethnic "boundaries" (Bravmann 1973; Frank 1987). "Interaction, not isolation," summarizes Monica Visonà, "seems to

characterize much of the production and distribution of traditional art forms. Yet African art is still presented to the general public as if there were a representative style for each ethnic group and as if each piece were either a typical or atypical example of a single population's oeuvre" (1987: 38).

Second, the unit of analysis was expanded not only to include contacts within and among a wide range of proximate ethnic groups, but also to include the impact of international tourism on local art production. This literature, which is gathered generally under the heading of "tourist art" studies, has tended to be of two sorts. On the one hand, there have been works which have described and analyzed the production and manufacture of art objects for sale to tourists (e.g., see Ben-Amos 1971, 1976; Silver 1976, 1979b, 1981a, 1981b; Richter 1980; Ross and Reichert 1983; Wolff 1985). These studies have dealt with such issues as the social relations of production in communities of petty craft manufacturers, the organization of apprenticeship and the incorporation of workers in a local artisanal economy, and the impact of new artistic forms on the social system of artistic production. The focus has been primarily on the local level. How have artists and artisan groups reacted or adapted to outside demand? How have styles of art been changed or modified for foreign consumption? How has production for internal use been articulated with production for external use?

On the other hand, there have been a number of works which have attempted to place tourist art within the semiotic domain of a system of signs. Using a linguistic model, these studies have analyzed tourist art as a "process of communication involving image creators who attempt to represent aspects of their own cultures to meet the expectations of image consumers who treat art as an example of the exotic" (Jules-Rosette 1984: 1). One of the earliest and most conceptually imaginative studies of this genre is Paula Ben-Amos's seminal paper on "Pidgin Languages and Tourist Arts" (1977), in which tourist arts are compared to secondary trade languages and analyzed as a special-purpose, restricted, and standardized code used expressly for cross-cultural communication. Whether they are examining the production of objects or the production of meanings, the level of analysis in both types of tourist art studies has tended to be the local artistic community – i.e., restricting themselves to the production end in a transnational market of cross-cultural exchange.

In the past few years, the study of African tourist art production has been complemented by a series of works on the consumption of African art (or, more usually, of "primitive" art in general) in the West (e.g., Clifford 1985, 1988; Jamin 1982, 1985; Manning 1985; MacClancy 1988; Errington 1989; Price 1989; Torgovnick 1990). These works have sought to unpack the symbolic load with which African art objects are charged when they are displayed out of context. Rather than use the study of decontextualized objects as a stepping

stone to an analysis which seeks to resituate the objects in their "indigenous" context, the displacement of the object itself is taken as the problematic and focus of research. Reflecting upon the very same collections of non-Western art that prompted a previous generation of anthropologists to want to know more about the meaning of these objects in the places from which they came, some anthropologists are now wondering how these objects came to be wrenched from the places in which they were made and what they mean now in the places where they have come to rest. Studies of this sort pose some of the following type of questions. Why have these objects been moved to where they are? What are the political and economic forces which have allowed cultural property to be removed from their original owners? And what do they mean now that they are situated in this new milieu?

Because the symbols of African art are silent outside their original community of spokespersons, the objects are themselves tabula rasa – virgin icons upon which observers imprint their own significance and interpretation. "Stripped of its original authorship and, more generally, of conceptual footnotes," writes Sally Price, "the object stands nakedly before the gaze of the Western viewer" (1989: 106). And, writing in a similar language, Georges Balandier once remarked, "objects under glass [are] as helpless in the presence of sightseers as the dead in the presence of the crowds on All Saints' Day. Both are 'defenseless', so that we have unlimited freedom to consider and treat them as we please" (1967: 100). Symbols that make no reference to sexuality in their original context are charged by the Western viewer with raw sexual connotations. Portraits of living spirits are mistaken for representations of the dead or, more generally, they are glossed as idols in a cult of ancestor worship. Emblems of beauty and peace are misinterpreted as signs of fear and terror.

By studying the mechanisms of exchange which move art objects from Africa to the rest of the world, this book bridges the distance between the field of production and the field of consumption. It provides, so to say, the "missing link(s)" in a long commercial chain which stretches from the smallest rural villages in West Africa to the largest urban centers in the Western world.[17] In particular, the study of the exchange of African art throws light on two distinct processes which occur at the intermediate level of the art market. First, the study documents the process of commoditization. It explores the way in which objects are moved from one system of value to another, and describes the mechanisms by which values are assigned to objects at each stage in the network of trade. In so doing, it analyzes a distinct moment in the "life history" of African art – i.e., a commodity phase which separates an object both from its "traditional" sphere of value as ritual or sacred icon, and its "modernist" sphere of value as *objet d'art*. Second, it illustrates an elaborate process of cross-cultural information exchange or, what I will refer to more generally as, the mediation of knowledge. The study suggests that in their commercial pursuits

art traders are not mindlessly moving goods from one place to another, they are also mediating between art producers and art consumers – adding economic value to what they sell by interpreting and capitalizing on the cultural values and desires from two different worlds. This book, therefore, is as much about the *transit* of African objects in the commercial space of the modern world system as it is about the *transition* of African objects at a distinct moment and critical time in the history of Africa and its arts.

The book is divided into six chapters. Approximately the first half of the book is devoted to a study of the economic structure of the trade. The second half is largely about the trade in cultural information and the mediation of knowledge. In Chapter 1, I describe the basic structure of the Ivoirian art market – providing a description of the different commodity outlets and a classification of the type of goods that are sold at different levels of the trade. In Chapter 2, I describe the division of labor in the market and examine the management of capital, in particular the systems of credit and commission payments both within the market place and a trader's personal network of clients.

In Chapter 3, I analyze the production of value in the market economy, and present an analysis of four different modes of bargaining or verbal price negotiation. It is demonstrated, in this chapter, that each level in the bargaining process is associated with a different structuring of value. The bargaining process, it is suggested, is aimed largely at gauging the worth of an object in the transactor's value system.

Chapter 4 opens with an extended case study recounting an episode during my fieldwork in which an art trader from one ethnic group cut across the market hierarchy to buy directly from a supplier from a different ethnic group. The conflict which ensues from his action is described in detail and then analyzed in order to throw light on the nature of ethnic relations within the market context. The chapter goes on to look more broadly at the role of ethnicity in the art market – from a discussion of cross-cultural trade to an analysis of the commoditization of ethnicity itself.

In Chapter 5, I discuss the concept of authenticity as it applies to the art market. It begins with an overview of some of the definitions of authenticity in African art which are most widely held both by Western scholars and art collectors. It then goes on to examine the notion of authenticity from the perspective of the African art traders. Analysis of two cases – one on the commoditization of slingshots, and the other on the symbolic transformation of trade beads – serves to illustrate some of the points that are made at the beginning of the chapter. It is argued throughout that the authenticity of African art is a Western construction that is based on powerful economic and culturally hegemonic motives.

In Chapter 6, I bring together much of the preceding material by analyzing

the role of art traders as cultural brokers or mediators of knowledge. While traders relate to artists some of the preferences and desires of the Western clientele, they also communicate to the clientele a particular image of African art and culture. I demonstrate in this chapter the means by which art traders manipulate both the meaning and value of objects through contextualized presentation, verbal description, and physical alteration.

Finally, in the conclusion, I present the material from the book in light of competing discourses on value. Drawing especially on Pierre Bourdieu's sociological analysis of the "mis-recognition" of cultural capital, I demonstrate how the Western (e)valuation of African art builds itself in direct opposition to both use value and exchange value.

1 Commodity outlets and the classification of goods

> To walk into a market place . . . is to wonder how one can really go about studying it. The market place itself is often large and amorphous; buyers and seller look alike; the products are probably mostly unfamiliar, and the measures of quantity and the means for calculating value unusual; the process of exchange may either be so rapid as to be almost incomprehensible, or very slow, but with little to clarify the rationale of negotiation. There is a strong temptation to view much of the activity as erratic and pointless, particularly if one is unfamiliar with the premises of value which underlie local trade.
>
> Sidney W. Mintz, *Peasant Market Places and Economic Development in Latin America* (1964)

Entering any one of the large art market places[1] in Côte d'Ivoire is very much like penetrating the confused and dizzying world which Sidney Mintz once described for the market places of rural Latin America. As one walks amidst rows of carefully displayed objects of art in the crowded aisles of the market place, it seems almost unfathomable to understand the logic behind the division of space, the organization of the marketing arena, or the structure of the trade itself. Beside the scores of neatly aligned objects which fill the dense market space, one encounters dozens, or more often hundreds, of people wandering among the stalls, busily bargaining to make a deal, or simply sitting in small groups talking among themselves.

One of Abidjan's largest market places which specializes in the sale of art objects is situated in the heart of a public garden built by the French administration during the colonial era. From a central vantage point, somewhere in the middle of this large, labyrinthine market place, one can observe a virtual stream of human activity. A woman passes by carrying on her head a massive aluminum pot which drips with condensation from the iced water which it contains. A young man, wearing a brightly colored woolen cap, files through the market place carrying on his head an enamelware platter stacked to the edge with slabs of dried beef. Two boys, who normally earn their livelihood on the fringe of the Ivoirian economy as ambulant shoe-shiners, are crouched on the ground arduously polishing wooden masks with Johnson's paste wax (Plate 1). A tall, stately man wearing an elegant flowing damask robe and an

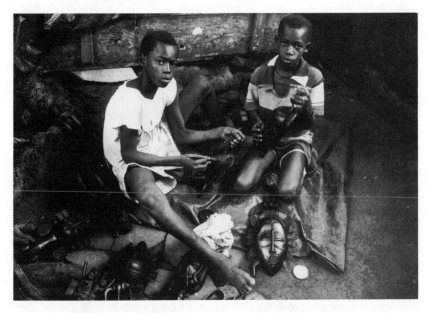

1 Young boys at Plateau market place polishing Senufo masks with paste wax. Abidjan, April 1988.

embroidered Muslim skullcap sits quietly on a wooden crate in front of a pile of statuettes, masks, brass castings, and bead necklaces. Some of the traders are scrutinizing the man's merchandise, haggling over a price, throwing objects down in disgust, walking away, coming back. A group of merchants saunter between stalls dragging in their hands burlap sacs pregnant with amorphous outlines of the wooden artifacts that are stuffed inside. Seated low to the ground on small wooden stools, a half-dozen men sit in a circle around a tin bowl filled to the rim with rice, vegetables, and steamed fish. As they eat, they discuss with passion such diverse topics as the upcoming soccer finals, the intrigues of national politics, and the troubled world economy.

Among this bustling and diverse crowd of people, one wonders, as an anthropologist, who are the art traders that are supposed to be selling in the market place? Who are the suppliers bringing goods from afar? Which of these people are merely idlers and curious bystanders? Where are the customers? Who owns which space in the market place? To whom do all these wondrous objects belong? And how, in essence, as Clifford Geertz once eloquently put it, can one ever hope to "reduce the surface tumult of the bazaar [economy] to the deep calm of social theory?" (1979: 197).

After several seemingly endless weeks of dutifully watching, wandering, and talking to people in the market place, a sense of order eventually begins to

emerge. Far from the initial feeling of hopeless disorder and chaos which appeared to exist on the surface, one discovers that the market place is in fact a scrupulously structured social space in which every object has its rightful owner and in which every person has a specific status and a recognized set of social and economic roles. The principal art market place in Abidjan (known as the *marché artisanale du Plateau*), for example, is divided among traders representing six different francophone West African nations. Within these sections, stalls are individually maintained and rented from the Abidjan City Hall (*mairie*). Each trader who rents a stall has his own stock of merchandise which he buys and sells. Every day (except Sunday)[2] traders arrive in the market place around seven or eight in the morning to unpack their merchandise from locked metal trunks which are stored beneath the wooden tables at their stalls. After sipping a strong cup of "Senegalese" roasted coffee or (for the more wealthy traders) an espresso from the Café Kona, a Lebanese operated snackbar on the edge of the Plateau market place, the traders neatly align their wares according to object types on rows of vinyl-covered concrete or wooden shelves. Some objects are dusted or polished with a rag; each is placed where it had been just the day before. Every evening, as the sun begins to set around six o'clock, the traders pack their merchandise once again into their aluminum trunks. Since no paper or padding is ever used to protect the packed objects, items are occasionally damaged in the course of this daily routine.

At night, the market place and the trunks are looked after by a group of squatters, pickpockets, and prostitutes who make their home under the market's concrete canopies, cook their meals on small charcoal braziers, and sleep on the vinyl-covered shelves. Occasionally, the traders reward the men and women who "guard" the market at night by giving them small amounts of change. The traders note that none of their merchandise has ever been stolen. The thieves, they say, are too afraid of the spiritual power represented by the statues and masks. For good measure, however, most of the Muslim traders place paper or cloth packages of protective amulets inside their storage trunks and in the rafters above their stalls – charms, prepared by the *malamai*, that work to protect their merchandise from damage or theft.[3]

Commodity outlets

In Abidjan, the largest city and principal port of trade in Côte d'Ivoire,[4] there are several outlets for the sale of art. Art is sold from both open-air and indoor market places where traders display their goods on wooden or concrete shelves in covered stalls. Art is sold from warehouse-like shops, where merchants conduct their business from rooms jammed full with their stock-in-trade. Art is sold out of merchants' private homes and compounds, where objects are stored in cabinets, dresser drawers, and under beds. Art is sold from roadside stands

along the route to seashore beaches and resorts, as well as on the beaches themselves by ambulant peddlers. Finally, art is sold in up-scale galleries (both independent stores and hotel gift shops), where objects are individually priced, carefully lighted, and displayed in climate controlled surroundings. The following is a synopsis of the different outlets where art is sold in Abidjan. I have chosen to describe in greatest detail the sale outlets in Abidjan (rather than some other urban center in Côte d'Ivoire), because Abidjan is the hub of the internal exchange system and provides the greatest quantity and variety of sale outlets.[5] The discussion is organized by order of relative importance in the local economy of the art trade.

Market places

Within Côte d'Ivoire there are four major art market centers (Abidjan, Bouaké, Korhogo, and Man). At Man, near the Liberian border in western Côte d'Ivoire, about half of the second floor of a two-story concrete structure is devoted to the sale of art. Mixed in among the textile, hardware, and produce vendors, a group of art traders proffer their goods from wooden tables and stacked shelves. A few of the traders also have small rooms with locking doors in which they can store and exhibit their art objects. In Bouaké, in the central part of the country, there are two venues for the sale of art. Outside the principal tourist hotel, Le Ran, there are about ten wooden stalls in which traders display their art. Within the main market place,[6] there is a section where a dozen or so art traders ply their ware (Plate 2). In this market place, the art objects are sold side-by-side with both traditional medicines and cotton fabrics. Although no art traders sell in the main commercial market place of Korhogo, in northern Côte d'Ivoire, there is an art market place of sorts which is set up outside the most popular tourist hotel, Le Mont Korhogo (Plate 3). Objects here are displayed on wooden tables which line both sides of the street outside the main entrance gate of the hotel.

In Abidjan there are three market places where art is sold to foreign and local buyers. The oldest and largest one is located in the heart of Abidjan's commercial district, known as the Plateau quarter. The second largest art market place is in an elite residential neighborhood called Cocody quarter. And the third is in an African residential neighborhood known as Treichville quarter (see Map 2).[7]

The smallest concentration of art is sold in what is one of the largest permanent market places in all of West Africa, which is located in Treichville quarter, one of several working-class residential neighborhoods in greater Abidjan. The market place as a whole caters to a local African clientele. It consists of a two-story, open frame concrete structure built around a huge central quadrangle. The building which houses the Treichville market place

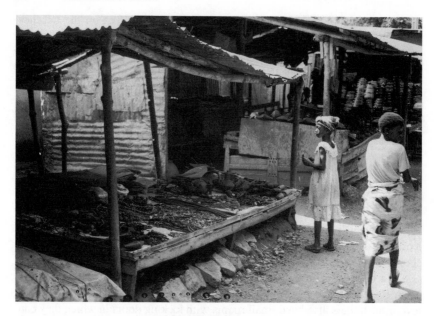

2 Market-place stall. Bouaké, December 1987.

was constructed in the late 1960s by the newly independent Ivoirian govern-
ment. Spices, fruits, and vegetables are sold by marketwomen in the open
courtyard (for an insightful ethnography of the marketwomen of Treichville,
see Lewis 1976).[8] Meat and fish, hardware, cooking implements, household
products, cosmetics, and jewelry are sold on the inside ground floor of the
building. Textiles, shoes, clothes, and some works of art are sold from
the second floor of the building. The stairs which lead to the second floor of the
market are lined with sellers of various crafts. Among Westerners visiting Côte
d'Ivoire, the market place is known principally for its European trade beads.
Vast quantities of glass beads are sold by a dozen or so traders who specialize
in bead commerce (see Chapter 5 for a discussion of the significance of the
bead trade). Furthermore, tourists often visit the market in order to experience
the vibrancy of an "authentic" African market place, with the bustle and
commotion which Western visitors have come to expect from such places.[9]
"After lunch," says the itinerary for a West African tour group, "sightseeing
includes the Treichville market" (Anon. 1987a). Thus, the market experience
in Treichville becomes as much of a tourist commodity as the souvenirs which
the traders sell (see Chapter 3 on marketing and bargaining as tourist
performances).[10]

 The second largest art market, which was built in the 1970s by the post-
colonial Ivoirian government, is situated on the Boulevard de France in the

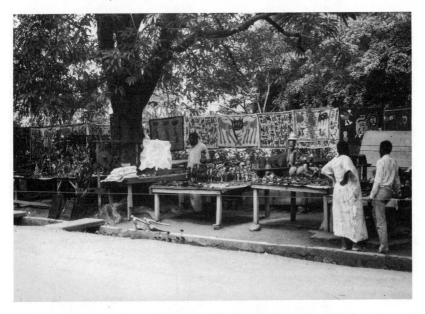

3 Traders at their stalls in front of Le Mont Korhogo Hotel. Korhogo, August
1988.

elite residential neighborhood of Cocody quarter. The art section of this
market caters especially to a vast expatriate clientele who reside largely in
this part of the city. Like the market place in Treichville, the Cocody market
place is housed in a two-story concrete structure. Vegetables, fruits, and other
foods are sold on the ground floor of the market. Art objects, crafts, and
souvenirs are sold on the second floor. Sellers of leather sandals, handbags,
and belts, as well as beaded bracelets and other jewelry, line the two front
staircases which give public access to the second floor of the market. The
Cocody market place differs from those in Treichville and Plateau quarters in
that it contains large individual rooms which can be locked at night. Unlike the
Plateau where objects must be packed and unpacked on a daily basis, and
unlike the Treichville market place where goods are secured under tightly
roped plastic covers, the Cocody market place provides permanent stores
where goods can be easily secured and stored.[11] One of the results of this
facility is that larger items (e.g., stools, chairs, oversized masks and statues)
tend to be sold out of these stores in the Cocody market place.

 The oldest permanent market place in Côte d'Ivoire where art is offered for
sale is the Plateau market place. The market place was constructed by the
French in the early 1920s at the center of an elegant public garden (*jardin
public*),[12] at the intersection of two busy streets in the Plateau quarter

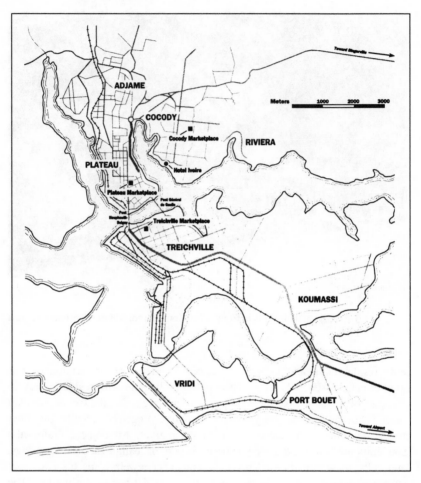

Map 2 Abidjan.

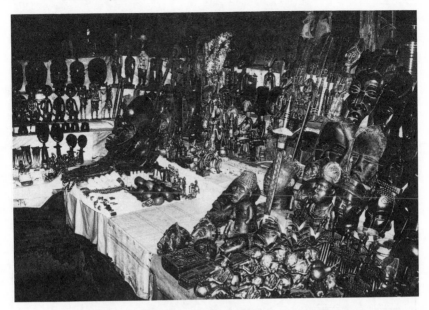

4 Partial view of the inside of an original concrete-frame stall at the Plateau market place. The empty section in the center of the display area represents the allotted space for a trader who did not come to the market place that day to exhibit his merchandise. Abidjan, June 1988.

(Boulevard de la République and Avenue Chardy) and opposite the first tourist/expatriate hotel built in Abidjan, L'Hôtel du Parc, which opened about the same time (Nedelec 1974: 98). The Hotel du Parc shut down in the mid-1970s.[13] Traders recall that when the hotel was in its prime during the 1940–50s, the hotel's bar, called Le Bardon (which was the hotel's original name), was a lively place for meeting many clients and selling vast quantities of African art. Collectors would sit on the terrace of the outdoor café across from the market place, while traders streamed through with bags full of art. This period, according to traders, was the heyday of the Plateau market place.[14]

The original market place consisted of five large concrete canopies under which traders displayed their goods on concrete ledges and shelves (Plate 4). From about 1920 to 1970, the market was dominated largely by Wolof merchants who had migrated from Senegal (and, for this reason, the market place is still often referred to as the *marché sénégalais*).[15] During the 1970s, the government of Côte d'Ivoire became concerned with the high concentration of Senegalese traders in the art market. As part of a broader state policy to encourage the "Ivoirianization" of the economy, the government sought to

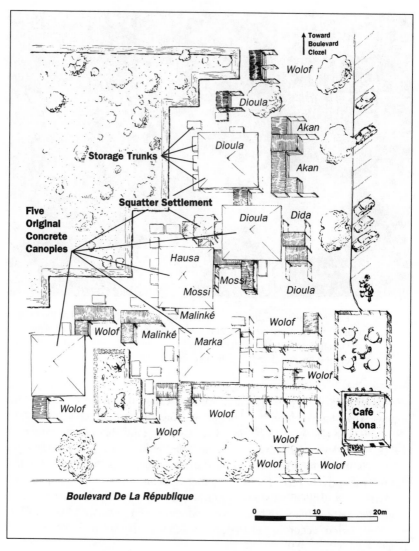

Map 3 Plan of Plateau market place, Abidjan.

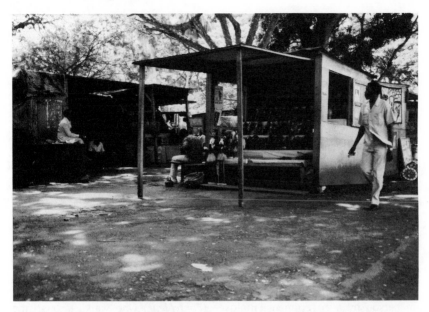

5 Wooden-frame stall built in the 1970s at the Plateau market place. Abidjan,
June 1988.

break the Wolof monopoly in the art trade.[16] The Plateau market place was
officially divided among traders representing a coalition of six francophone
African nations – Côte d'Ivoire, Burkina Faso, Mali, Guinea, Niger, and
Senegal (see Map 3). Added to the original concrete canopies were wooden
frame structures with wooden display shelves covered with vinyl fabric
(Plate 5). Like many post-colonial African cities, the market place accommo-
dated its new arrivals by expanding around the rubble of a decaying colonial
structure.

 The division of the market place resulted in the creation of a government-
sanctioned syndicate, the Syndicat des Antiquaires, which officially authorizes
its members to buy and sell African art in Côte d'Ivoire.[17] The syndicate is
managed largely by Ivoirian traders, however, non-Ivoirians are accepted as
members, and some hold title positions. Each member of the syndicate receives
an identification card, and pays annual dues. The syndicate is supposed to help
its members with legal problems.[18] It is also responsible for paying part of the
funeral expenses of its members.[19]

 Beyond these pragmatic expectations, one of the syndicate's principal roles
is to maintain the economic viability of the middleman by restricting the
direct participation of local carvers in the sale of art to Western buyers. Hans
Himmelheber elucidates this point when he notes, "The Syndicat des

Antiquaires hinders the artists from marketing their own works. They can sell something to tourists who find them by chance, but a carver cannot travel with a bag full of masks and peddle them from a streetcorner" (1975: 25, translated from the German).[20] The state control of ethnic diversification is most strongly felt in the Plateau market place. Since the other Abidjan market places are of more recent construction (1960–70s), there was a greater degree of ethnic diversity among the traders from the very beginning.

The Plateau market place is known among collectors for selling many of the finer, more expensive pieces of African art. It is also a place where collectors can make contact with traders who will then take them to their homes or shops where even more expensive or important objects are often kept. The market place is designed in a roughly semi-circular form. Stalls along the market periphery are still run exclusively by the Wolofs who founded the market site.[21] In the center of the market place, however, stalls are divided among traders from various ethnic and national origins – including Malinké from Guinea, Hausa from Niger, Mossi and Dioula from Burkina Faso and Mali, and Baule, Guéré, and Dida from Côte d'Ivoire. A weekly fee for the usage of market space is paid by traders to the Abidjan *mairie*. The stall fee or right is collected in person by a government employee (*contrôleur*) who walks through the market place collecting money and tickets (with stall numbers printed on them) which stallholders must tear off from a booklet which they receive at the time when they rent the stall.[22] Unlike other markets, where the price of the stall right is calculated according to the type of merchandise which is being sold (Babb 1989: 104), the fee in these market places is based on the size and quality of the stall area (i.e., covered stall, open stall, fraction of a larger stall, etc.).[23]

In the early 1980s, several traders in the Plateau market place decided to expand their marketing space by selling art from wooden trunks located roughly in the center of the market. The trunks allowed these traders to divide their stock among the more commonplace tourist crafts which were displayed on shelves in the front of the market place and some of the more expensive pieces (sometimes older pieces) which were "hidden" in locked trunks. When these boxes were installed, traders say that they had enough "old" objects to fill nearly the entire trunk. Nowadays, however, they say that such objects are so hard to find that the trunk serves mainly to keep separate the good tourist copies from the poorer ones. When selling art to collectors and tourists, the location of objects in trunks makes them seem more special. Traders are very conscious of presentation; the more valuable an object is thought to be, the more layers of wrapping are used to cover it – the object is first wrapped in paper, stored in a zipped travel bag, and locked in the trunk (for more detail on the role of presentation in the marketing techniques used by traders, see Chapter 6).

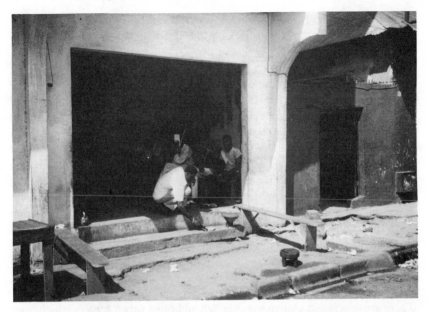

6 Storehouse with proprietors. Treichville quarter, Abidjan, November 1987.

Storehouses

Hidden from the average tourist or collector in the major urban centers of Côte d'Ivoire are storehouses or warehouses in which vast quantities of objects are stockpiled (Plate 6). In Korhogo, the storehouses are located in a Hausa residential neighborhood, called Aoussabougou (see Chapter 4). In Man, there are Hausa-operated storehouses scattered in different parts of the town. In Abidjan, most of the storehouses are located in Treichville quarter. Many of these facilities are operated by Hausa traders (Plate 7).[24] Some of the store-houses face the street (with large garage-like entrances); others are built in compounds off the main street; and yet others are located in rooms within the family dwelling itself. The storehouses serve several functions. First, they are used as a kind of "dumping ground" for itinerant suppliers. Whatever a supplier is unable to sell to the market place stallholders or other local traders, he will wholesale to, or even leave on credit with, the storehouse owners. As a result of this practice, many of the storehouses are filled with piles of mediocre and inferior quality art which has been rejected by a majority of local buyers. The storehouses also serve as marketing venues for African traders who ship objects abroad, and for wholesale Western dealers who buy in Côte d'Ivoire. These buyers purchase both the low quality items which have accumulated over time, and the better quality items which are stored in smaller quantities.

Objects are packed in wooden crates or cardboard boxes, and driven directly from Treichville to the cargo docks at the international airport or to one of several shipping ports.

Another function of the art storehouses is to provide a selling space for itinerant traders. While some of the suppliers sell from the compounds they share in Abobo Gare (on the outskirts of metropolitan Abidjan), and a few sell directly in the three Abidjan market places, a number of the suppliers sell their wares out of the Treichville storehouses. One of the storehouse owners, Alhadji Salka, for instance, lent out his space to Jibrim Taroare, a Hausa supplier based in the town of Bobo-Dioulasso in Burkina Faso. Taroare would visit Abidjan roughly every six weeks. He would store his bags and boxes of objects in Salka's storehouse, and would sell to local traders from this space. Salka was given a commission based on Taroare's profits. Since Salka was elderly and partially disabled, the "rental" of his storehouse provided him with one of his few sources of regular income.[25]

Galleries

There are several art galleries in Abidjan and other urban centers which cater both to foreign African art collectors and souvenir buyers. At Yamoussoukro, there is a small gallery in the main tourist hotel, Le President. And at Man, there is a "gallery" built outside Hotel Les Cascades (Plate 8). Most of the galleries, however, that are designed according to Western criteria (i.e., with posted price tags and boutique lighting) are located in or around the major tourist hotels in Abidjan – Hotel Ivoire, Novotel, Hilton Hotel, and Hotel du Golfe. The largest, oldest, and best known gallery in Côte d'Ivoire is the Rose d'Ivoire situated in the basement of the Hotel Ivoire in the Cocody quarter of Abidjan.[26] The Rose d'Ivoire was established in the 1960s and originally run by an East Indian family.[27] It is now owned and operated by an expatriate French dealer. The gallery contains most of the same items which are available in the market places. Unlike the market place, however, a price tag is affixed to each item. A staff of about four African salesmen, each robed in identical blue smocks, are always available to answer a buyer's questions. The salesmen never push a client toward making a purchase, they are simply there to respond to inquiries, remove objects that are exhibited in locked cases, and ring up an occasional sale at the register. I would argue that this unobtrusive, non-aggressive form of behavior is in fact a calculated sales tactic; the whole idea of the gallery is to provide the buyer with an alternative to the bustle and confusion of the outdoor market place.

Although it tries to differentiate itself from the market place, the gallery bears certain structural similarities to those observed in outdoor vending arenas. Like the Plateau market place, for example, the Rose d'Ivoire is

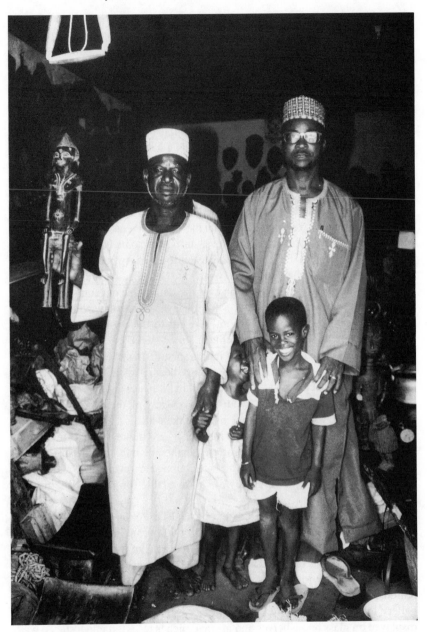

7 Hausa storehouse-owners with children. Treichville quarter, Abidjan, July
1988.

organized and structured around thresholds of secrecy that are meant to attest
to different levels of authenticity, various ranges of price, and different claims
about investment value. The main room of the gallery is stocked with replicas
or copies which are intended largely for hotel guests, tourists, business
travelers, and other casual buyers. An alcove at the back corner of the main
gallery is filled with better quality, more expensive, and more carefully crafted
replicas. It also contains a small selection of older, used objects (mainly
furniture, musical instruments, and household items). Across from this
recessed area in the main basement gallery is a locked room containing what
are presented to the buyer as fine, rare, and "authentic" objects. Two tiny,
plexi-covered windows cut into walls at opposite ends of the room allow
prospective buyers to peer rather uncomfortably into the locked chamber.
Those wishing to enter the room, however, need to get a salesman to unlock the
door; the salesman is required to wait inside while the customer looks around.
Masks, statues, decorated heddle pulleys, staffs, and some traditional weapons
set out on the surface of a huge wooden Senufo funerary bed are displayed in
this room. These are the three areas which are designed for public consump-
tion. Access to each level requires an ever greater degree of inquisitiveness on
the part of the consumer. Finally, a fourth level of secrecy with cautiously
restricted access is located in a room adjacent to the owner's private office
which is one floor above the basement store.[28] One evening, two French
collectors and I were ushered into the inner sanctum. In a cramped room, where
a tiny air conditioning duct battled the intense heat of track lighting, the owner
and his prospective clients sat in leather armchairs analyzing the aesthetic merit
of various *objets d'art* which lined the four walls of the room. In a secret
compartment hidden behind a panel in one of the walls is a locked combination
safe. Within the safe, the owner told his guests, are the real "treasures" of the
Rose d'Ivoire, some of which are protected in their own felt bag. Many of these
objects are from the owner's private collection. However, he was quick to
inform the prospective buyers, they are all available for sale – if the price is
right.

A second private gallery in Abidjan is the Galerie Pokou which is owned and
operated by a Lebanese dealer who has spent a lifetime in Côte d'Ivoire. The
gallery requires a brief mention here simply because of its unique approach to
the presentation of its objects. Unlike the Rose d'Ivoire, the Galerie Pokou does
not generally cater to tourists or casual buyers. It is located in Marcory, a
remote part of suburban Abidjan, on a side street which is difficult to find. The
gallery is housed in a room of the owner's estate. About twenty objects are
displayed on glass bookshelves and in small niches recessed into a stucco wall.
This "semi-public" room of the gallery was only opened in 1987.[29] This part of
the gallery is intended, according to the owner, to attract some mid-level
collectors to his store. The main focus of the business, however, are the

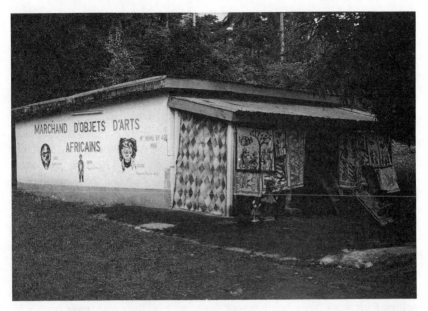

8 "Marchand d'Objets d'Arts Africains" art gallery and souvenir shop out-
side Hotel Les Cascades. Man, June 1988.

up-scale objects which are sold from the owner's sitting room. Like the levels
of secrecy built into the Rose d'Ivoire, the Galerie Pokou constructs a level of
secrecy by allowing the buyer to gain access to the owner's "private" quarters.
Six pedestals (each with its own spot light and rotating platform) are arranged
in different corners of the living room. Sipping an aromatic blend of Lebanese
coffee, the owner tries to ascertain the buyer's preferences with regard to style,
genre, object type, price range, etc. He then goes to a backroom – which is
strictly off limits to outsiders *and* anthropologists – and emerges with several
samples of the type of art in which the client has expressed interest, displaying
each object on its own stand. Unlike the Rose d'Ivoire, there are no prices
posted on these objects. Prices are stated verbally. Some bargaining or price
negotiation occurs, however, it does not follow the same pattern as bargaining
in the market places (see Chapter 3).[30]

Roadside stalls

Along the side of the road leading beyond the Abidjan airport at Port Bouët and
toward the ex-colonial capital of Grand Bassam is about a half-mile stretch of
covered roadside stalls (Plate 9). The stalls cater primarily to expatriates and
tourists driving east from Abidjan toward the resort beaches and hotels located

along the Atlantic coast. Most of the stalls are owned by Senegalese merchants; some, however, are run by Ivoirians. Many of the same contemporary objects which are available in the Abidjan market places are sold from the roadside stalls. In addition, however, the stalls sell a few items which are manufactured on site and, for the most part, are not available anywhere else. Among these items are the works of Anoh Acou, a Baule artist who creates wooden carvings of Western household items (shoes, suits, radios, telephones, etc.).[31] Because he sells his carvings directly from one of the roadside stalls, Anoh Acou is able to avoid the middlemen in the urban market places. Another art form, which is manufactured and sold at the roadside stalls outside Grand Bassam, are cotton textile belts and sashes. These items are created by a group of weavers who work on narrow-band horizontal looms in the back area of the stalls. They are woven in brightly colored threads and displayed on large wooden racks along the side of the road. A small group of artists from Ghana, headed by a man named Ringo, sell wooden airplanes, helicopters, buses, cars, and boats fabricated from scrap lumber and colored with brilliant enamel paints. Most of these artists are highly independent entrepreneurs who have no interest in dealing with the market-place middlemen. They have been very successful in selling their work from their roadside stalls, and, on their own, have been able to market their goods to a number of art and craft galleries in New York City. Finally, a number of the roadside stalls sell bamboo and rattan furniture (chairs, couches, tables, lamps, etc.) which are made on site by local craftsmen. Most of these items are purchased by expatriates for furnishing their Abidjan homes.

Beach vendors

Although it makes up a relatively small portion of the overall art market in Côte d'Ivoire, some art is sold by ambulant vendors who walk up and down the beach hawking their wares to sunbathing expatriates and tourists. Some of these vendors are small-scale Wolof traders, many of whom are young boys who are not able to sell on their own in Abidjan. They deal largely in small wooden drums (*tam tam*), roughly hewn Akan fertility dolls (*akuaba*), various styles of bracelets and necklaces, and carved wooden penises. Curiously, the beach is one of the few places where this last item is sold. They are usually kept hidden inside the vendor's robe pocket or in a plastic bag; when they are proffered to the Western buyer, they are revealed with a great show of mock secrecy.

The largest group of itinerant beach vendors are migrant Tuaregs from Mali and Niger. Dressed in their customary blue robes and headwraps, they walk up and down the beaches selling leather-covered boxes or trunks and leather sheathed swords and knives. Most of the boxes are made by the vendors themselves in Abidjan. A recent innovation is the manufacturing of boxes which

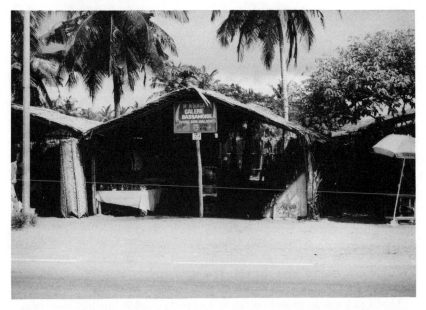

9 "Galerie Bassamoise" roadside stall. Near Grand Bassam, October 1987.

have been designed with individual partitions to accommodate either audio or video cassettes. Because of the strict regulation of trade in the urban market places, the beach is one of the few areas where the Tuareg craftsmen are allowed to sell directly to Western buyers.

Classification of goods

At this point, it may be helpful to classify the range of goods which traders sell in the market places. The typology which I propose combines the trader's own classification of object types with the prevalent social scientific typology of commoditized forms of art (Graburn 1976, 1984; Richter 1980).[32]

Antiquités

Objects which the traders classify as *antiquités* include items which were made for indigenous use but have become commodities and found their way into the art market. This is the category of goods which interests serious (i.e., investment-oriented) African art collectors and dealers. When sold in Abidjan, these type of items are generally found in the wooden trunks at the back of the market place, in the storehouses and homes in Treichville quarter, as well as in permanent galleries.

Antiquités enter the market at a slow place and on a piecemeal basis. First, an *antiquité* can be brought directly to the market place by the owner or another villager.[33] Objects (that are either stolen or bought in a community) sometimes arrive in the hands of high school or university students returning to Abidjan from school vacations spent in their village. Sellers such as these have very little idea what an object is actually worth, and when the piece is brought into the market place traders will usually criticize it saying that it is neither good nor really old. After extended haggling and verbal humiliation the object is usually purchased by a trader for the lowest possible price.[34] Second, an object can be obtained in a village by a local carver. Aware of the economic value of an old mask or statue, artists sometimes offer to substitute a replica in exchange for the original. These pieces are sold to traders in the larger towns who then transport them to Abidjan. Finally, the bulk of the *antiquités* that enter the market are collected by professional traders who wander on foot or bicycle from village to village searching for art. Objects collected in this manner are obtained largely through barter – exchanged for imported enamelware basins, machetes, pressure lamps, sugar, and cloth.

Although it would be difficult to inventory a complete stock of such items, it is nonetheless possible to identify a certain range of object types. Items in this category include: wooden face masks (a majority of which are from Côte d'Ivoire, Burkina Faso, Mali, Liberia, Guinea, and a smaller number from Sierra Leone, Nigeria, Cameroon, Zaire); metal masks (Senufo brass and aluminum *kpélié*); fiber masks (Senufo and Dogon); miniature masks (Dan and Mano); wooden statues and statuettes (a very large portion of which are Lobi, Baule, Senufo, but also Agni, Attié, Koulango, Bété, Dan from Côte d'Ivoire and others from Burkina Faso, Mali, Liberia, Ghana, Togo, Nigeria, Cameroon, Zaire); musical instruments (flutes, whistles, rattles, iron gongs with wooden clappers, anklets and bracelets with bells, drums, xylophones, blowing horns, string kora); weaving implements (beater bars, shuttles, pulleys, heddles, weaving swords, spindle whorls); household items (spoons, ladles, pestles, clay and wooden pipes, medical equipment, canes and walking sticks, flywhisks, slingshots, whips, gameboards, iron currencies, iron lamps, ladders, fishing gaffs, animal traps and nets, granary doorlocks, storage baskets, bowls, containers, bags); furniture (chairs, stools, beds); personal adornment (combs, hairpins, bracelets, necklaces, rings, earrings, hats, head-dresses, shoes and sandals, pubic aprons); goldweighing equipment (brass weights, scales, measuring spoons, sieves, storage boxes); ironsmithing instruments (pliers, bellows, anvils); weapons (bows and arrows, quivers, knives, swords, axes, spears, clubs, antique European and Arab-made rifles and hand guns); ritual objects (divination boards, oracle boxes, funerary vessels, pendants, amulets, circumcision knives); regalia items (staffs, finials,

ceremonial flywhisks, crowns); textiles (tie-and-dye fabrics, narrow-band cloths, hunter's tunics).

Copies

Copies, sometimes known in the literature as "commercial fine arts," "replicas" or "pseudo-traditional" arts, are defined here as art-forms which imitate traditional forms of art but are produced expressly for sale to outsiders. These types of objects are made for eventual sale although they adhere to culturally embedded aesthetic and formal standards. *Copies* are sold both in the front and in the back of urban market places, from storehouses, galleries, roadside stalls, and beaches. They are sometimes marketed as replicas, but also have the potential of being sold as *antiquités* – depending on the seller's assessment of the buyer's knowledge of African art. Included in this category are: wooden face masks (primarily carved in the style of the four major art producing ethnic groups in Côte d'Ivoire – Baule, Guro, Senufo, Dan – as well as in the styles of some other groups within Côte d'Ivoire and from other West and Central African nations); miniature masks (Dan, but also Guéré, Senufo, Baule); statues and statuettes (Baule, Senufo, Asante, Fante, and Lobi among others); goldweights (geometric and figurative) and measuring spoons; gameboards; musical instruments (drums, xylophones, string kora with brass or cowrie decorations); bronze casts of royal portrait heads from Benin and Ife; wooden display combs (Asante); Tuareg leather boxes and embroidered saddle bags, as well as leather handled and sheathed swords and daggers; Tuareg silver and silver-alloy jewelry (bracelets, *croix d'Agadez* pendants, earrings); leather-covered Fulani herding hats.

Nyama-nyama

"When the profit motive or the economic competition of poverty override aesthetic standards," writes Nelson Graburn, "satisfying the consumer becomes more important than pleasing the artist. These are often called 'tourist' arts or 'airport' arts and may bear little relation to traditional arts of the creator culture or to those of any other groups" (1976: 6). Many of these items are visual fictions bearing only minor resemblance to anything known in either the culture of production or consumption. This category of art sometimes glossed by traders as "*nyama-nyama*"[35] is marketed almost exclusively to foreign tourists, business travelers, and expatriates. Serious collectors of African art hold these objects in disdain, viewing them, as Price puts it "as a ruse perpetrated by wily natives" (1989: 79). Included in this category are: a number of "invented" sculptural genres (among the most popular are the so-called "skeleton" figures carved in Senufo style); masks (the most

noteworthy are the circular Luba/Songye-inspired masks which are inlaid with brass, beads, and shells);[36] small brass figurative statues (lost-wax casts in the form of musicians, women carrying head loads, farmers with hoes, etc., as well as figures representing enlarged goldweight motifs and so-called "porno-graphic" weights, known in the local trade as *bétisses*); ivory bracelets and necklaces (both pure white ones which are marketed as new, and those which are stained dark with tea or henna and marketed as "antiques"); ivory figures (animals, female busts, carved horns); malachite jewelry (necklaces, bracelets, earrings); malachite carvings (mainly animals, small lidded boxes, and carved chess pieces and boards); both ebony and "fake" ebony (i.e., a light wood stained with dark dyes) figures carved in the form of wild animals (elephant, antelope, giraffe, bird) or humans (generally a profile bust of a female with elaborate coiffure); cowrie-covered belts and bracelets; beaded bracelets from Mali; painted mud cloths from Korhogo; ice buckets and small "cocktail" dishes made from carved coconut shells; cups with painted floral designs made from shafts of bamboo; throw pillow covers embroidered with designs of animals and masks; shoes, handbags, wallets, and belts made from alligator, snake, and other reptilian skins; dyed leather sandals from Mali and Niger; woven straw hats.

Western-derived art forms

Western-derived art forms are defined here as items which are conceived within "European traditions, but in content express feelings totally different [and] appropriate to the new cultures" (Graburn 1976: 7). This is the smallest category of objects sold in the market. In the Plateau market place, there were a handful of oil paintings on canvas representing village and pastoral scenes; some "sand paintings" made by pouring different colors of sand over patches of white glue; and some repoussé copper plaque designs. In all my time in the market place, I never saw a single one of these objects sold (for a sensitive discussion of the difficulties of marketing this category of art, see Jules-Rosette 1990).

Supply and distribution

Objects sold in the various Côte d'Ivoire art markets are obtained from a number of different sources. Some items are acquired from itinerant traders or carriers who hunt through rural villages for anything that can be resold into the art market. A small percentage of objects are acquired directly from villagers who bring art objects to market vendors. Some items are purchased from agents who, acting as representatives of artists (or groups of artists), transport recently manufactured objects from rural or suburban artisanal workshops to urban

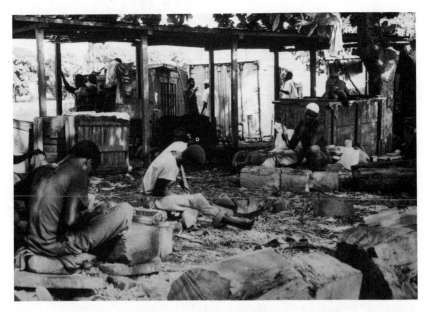

10 Artisanal workshop. Port de Carena, Abidjan, June 1988.

market places (Plate 10). Finally, some objects are purchased directly by
market vendors who themselves travel to rural towns and villages purchasing
from local traders and local artists.

Although they often claim to buyers (especially tourists) that they them-
selves purchased an object from a village owner, in no case was I able to find
an urban market trader who himself travels through rural areas buying artifacts
from village sources. The persistence and energy necessary to establish village-
level contacts and supply networks is incompatible with the time which is
required for selling merchandise in the market places. Since they cannot afford
to wait for the highest price, those who supply art from village sources must
sell their merchandise with only a small margin of profit. And since they
cannot afford the time to search through villages for art, those who sell art in
the market places must rely on professional intermediaries for their supply of
goods.

Intermediate mobile traders (many of whom are of Hausa, Djerma, or Dioula
ethnicity) travel from village to village in search of whatever they think
they can sell to merchants of art in any of the larger towns of Côte d'Ivoire,
as well as in Abidjan itself. Itinerant traders are organized in informal
groups that specialize in particular geographic regions. Among the Baule, for
example, Hausa traders are centered around the towns of Bouaké and
Dimbokro; among the Senufo, traders congregate in and around the town of

Korhogo; among the Dan, traders work both out of the towns of Man and Danané.

When they are ready to go out on their searches for art, the traders radiate from a central town to the surrounding villages. Most of the traders return again and again to the same villages, and to many of the same individuals within these villages, in order to inquire about the status of particular objects which they may be in the process of negotiating.[37] Some itinerant merchants communicate in the local language. Many of those who work in central-west Ghana, for instance, speak Asante. Traders who do not speak a local language must communicate in a lingua franca, which in most regions of Côte d'Ivoire is Dioula. Many of the traders, however, who are not competent in a local language, or those who are unfamiliar with a certain village, will use villagers as "guides" to local sources of art. In some cases these guides are village youths who have secret knowledge of where objects are stored in the village community.[38] In other cases, these local-level guides are village carvers who know the location of older objects – e.g., those which either they or another artist they know carved in the past. By negotiating through a local artist, traders are sometimes able to acquire an old figure or mask with the understanding that the carver will provide a replica for local use.[39]

Itinerant suppliers arrive in Abidjan alone or in small groups of two or three. Many of the Hausa/Djerma traders stay in Abobo quarter, a residential neighborhood to the north of Abidjan proper. Once they have arrived with their goods, informal networks of communication inform some of the merchants at the Plateau market place that the itinerant suppliers are in town. Being informed of this arrival is extremely important for the trader since supplies are limited and they must be quick in seeking out the objects. As one trader told me, after having an argument with a customer, "I would much rather lose a customer than a supplier. New customers can always be found, but regular suppliers are very hard to find" (1/29/88). Even though most suppliers, in the particular network which I studied, were Hausa, they showed very little preference in their trading practices to other Hausa merchants. Money, in this case, speaks louder than ethnicity. When they would arrive in Abidjan, for example, the Hausa suppliers would not inform the Hausa traders in preference to the non-Hausa. In fact, one of the most successful buyers from the Hausa suppliers was Asan Diop, a Wolof trader from Senegal. Because he was a good client who "paid well," he was among the first that the Hausa suppliers would notify when they arrived in town. And, furthermore, since he was one of the few market-place traders who drove a motorcycle, one of the fastest means of transportation through the crowded streets of Abidjan, he was usually able to arrive in Abobo quarter before anyone else.

In some rural-urban West African market systems, such as the cattle market in Nigeria which was studied in the 1960s by Abner Cohen, itinerant suppliers

have a personal relationship with an urban "landlord"[40] who lodges, feeds, and entertains the suppliers when they arrive in the city. The landlord uses his own distribution networks to sell the cattle which the suppliers have brought, and after a few weeks, the landlord pays the suppliers the price which had been negotiated for the cattle (Cohen 1965; Hill 1966).

No such arrangement exists between the art traders and art suppliers. The suppliers reside with kin involved in other commercial pursuits, or if they have no such contacts they simply stay at inexpensive hotels. When Abdurrahman Madu, for example, a stallholder in the Plateau market place in Abidjan, travels to other urban centers in Côte d'Ivoire, he does not stay in the homes of the local traders from whom he buys. He prefers to stay in hotels. "They invite me to stay with them, but if you accept then it becomes too complicated. What if you can't agree on a price. If he has put you up in his home, it is much more difficult to bargain. Maybe he has nothing I even want to buy. I don't want to feel obliged to buy something" (12/1/87).

The difference between the arrangements which exist for the cattle market versus those for the art market can be explained largely by the difference in the nature of the merchandise which is being exchanged. Although there may be some variability in the quality of cattle within a single herd, the difference in quality is rather negligible.[41] In the art market, however, especially where *antiquités* are concerned, there is a huge difference in quality and value among the various items which are bought and sold. Since the quality of goods is so unpredictable, contractual agreements and trading partnerships are more risky and therefore less profitable.

2 The division of labor and the management of capital

If the division of labor produces solidarity, it is not only because it makes each individual an *exchangist*, as the economists say; it is because it creates among men an entire system of rights and duties which link them together in a durable way.

Emile Durkheim, *The Division of Labor in Society* (1933) [1893]

The type of traders who sell art in the Côte d'Ivoire art market range from large-scale owners of supply storehouses with a high-investment inventory of several thousand objects, to the petty street vendors who own virtually no stock at all.[1] The different types of traders cater to a whole range of foreign consumers, ranging from wholesale purchasers who ship entire sea freight containers of African art from Côte d'Ivoire to European or American ports of trade, to the vacationing tourists or business travelers interested in acquiring only one or two souvenirs.

Unlike other sectors of the West African market economy which are largely dominated by women traders (e.g., the cloth, vegetable, and prepared food trades), the art market is almost exclusively a male domain (cf. Mintz 1971: 257). The predominance of men can be attributed to several different factors. First, many of the supply networks for the art trade have grown out of traditional commercial routes, especially those controlled by Hausa merchants (see Amselle 1977; Lovejoy 1980; Grégoire 1992). Since these older trades (e.g., the kola nut trade) were largely male-oriented forms of commerce (except see Gnobo 1976), the art trade has remained in the hands of male traders. Second, and perhaps of greater significance, is the fact that many of the arts which the traders handle are considered to be the property of men. In the village context, for instance, most masks and figural statues are carved by men, owned by men, and in some cases are even forbidden to be seen by women and children. Although many of the arts which traders sell are not considered sacred (but rather contemporary copies made exclusively for the trade) the male-centered perspective which characterizes the "traditional" arts still predominates. Finally, the Syndicat des Antiquaires, which licenses all legitimate art trade in Côte d'Ivoire, does not permit women to join in their

40

membership. This, however, is more the result of this gendered division of labor than its cause.

The role of women

The only cases of female participation in the art trade with which I am familiar, involve long-distance suppliers of art from parts of Côte d'Ivoire and other West African nations. Like most exceptions, these few cases involving women's participation in the commerce of art are particularly illuminating, and throw light on some profound assumptions about the division of labor by gender in the African art market.

Bembe Aminata is a supplier of Dan dolls (*poupées Dan*) from the region of Man in western Côte d'Ivoire (Plate 11).[2] About once a month, she travels by public transportation with a supply of Dan dolls (approximately 200 stuffed into burlap sacs) from Man to Abidjan. She obtains the dolls on credit from the craftsmen who make them at various workshops in and around the towns of Man and Danané (see Bouabré 1987a: 11). In Abidjan, she sells the dolls on short-term credit to the market-place traders. After distributing the dolls to traders at both the Plateau and Cocody market places,[3] Aminata waits for up to thirty days to collect her money. Although no trader could sell all the dolls he had obtained within the thirty-day period of credit, he is usually able to raise the necessary cash from the sale of other objects in his stock.

While in Abidjan, Aminata visits the market places almost every day – socializing with the traders and subtly reminding them, through her presence, that she is still waiting to be paid. She is housed on the outskirts of Abidjan with her husband's family. I never witnessed a case where Aminata took back the dolls from a trader who had defaulted on his credit by not paying for the goods within the thirty-day period. Often, I saw her stay longer than thirty days in order to collect. In one instance, I noted that she left Abidjan without having collected from a particular trader (who was unable to raise enough money, but promised to pay her the moment she got back).

Another woman who was involved at the supply end of the market was Kwasi Adja, an English-speaking Asante woman from Ghana who transported carvings from a craft workshop in the Asante capital of Kumase in west-central Ghana. Her brother is one of the carvers from the Kumase workshop.[4] Unlike Aminata, Adja did not stay in Abidjan for a month at a time. She required payment from her buyers within three or four days. She took back objects from those who did not pay.

Women who have no formal ties to the art trade are sometimes used as couriers on an informal basis by traders from other parts of West Africa. A trader from Bamako, for example, sent two women – who were on their way to Abidjan to visit relatives – with a shipment of Bamana antelope figures (*chi*

wara). The women traveled by public bus with the objects packed in sacs. The figures were delivered to a Plateau market-place trader who had ordered the pieces from his "brother" in Mali. When asked why women were involved in the supply of workshop artifacts to Abidjan markets, all the traders (including the women suppliers themselves) responded that women could cross border patrols with greater ease than men and, therefore, were less likely to get "taxed," harassed, or have their goods confiscated.[5]

Recently, a number of Guinean women have been arriving in New York City with cargo loads of African art. They come to the United States to buy video recorders, televisions, and radios for resale in Africa. Their goal in selling the art is not to turn a direct profit, but rather to finance the purchase of electronic equipment through a short-term credit arrangement. That is to say, they take the art in Guinea on credit from workshop artists, they sell the art at (or near) cost, and then use the cash to buy electronics in New York. Their profit, therefore, is turned in Africa on the sale of Western goods rather than in the West on the sale of African goods.

Some of the New York based male art traders blame these women for the sluggish African art market which currently exists in the United States.[6] "Women, unlike men, will sell their merchandise at any price," said Malam Yaaro. "They don't have what it takes to wait for a reasonable amount of money. It's because of them that things are not working anymore in New York" (3/14/92). Since the veteran New York traders know that the women have to return to Africa as quickly as possible (to turn their profit on the electronics and to pay their debt to the art producers), they will negotiate to buy a woman's entire shipment of art for substantially below market value.[7] The traders who buy from the women can then pass on the savings to their American clients, thereby squeezing out their competition who cannot afford to sell at such low prices, and ultimately driving down the market value of certain object types. This process, according to some of the New York based traders, has resulted in a deflationary trend in the American market for African art, so that objects which once sold easily for $80 or $100, now sell for as little as $30 or $40.

Hierarchy of traders

The men who sell art in the African market system can be classified according to criteria of wealth, power, and reputation. Far from being a homogenous group of entrepreneurs, art traders draw either obvious or subtle distinctions of class and status among themselves. Although it may not always be clear to the outside observer where a particular person fits into the hierarchy of African art traders, the men themselves are acutely aware of their social position – each aspiring through prayer and action for upward mobility and greater respect.

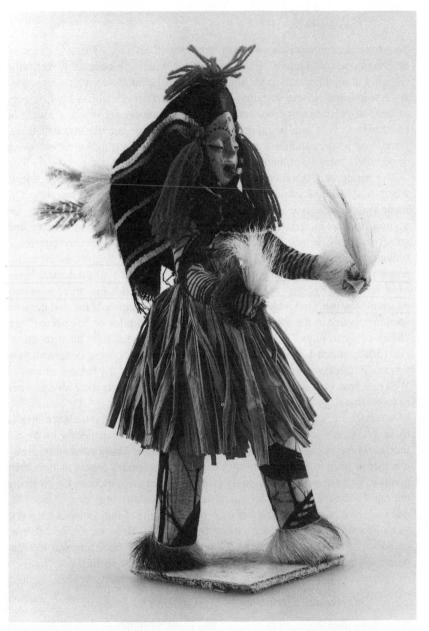

11 Dan doll with painted wooden face and costume made of cotton cloth, raphia fibers, feathers, wool yarn, and fur. Height 29 cm. Private collection. Photograph by Richard Meier.

Storehouse owners

The main storehouses in Abidjan are located in the African residential neighborhood of Treichville quarter. Two avenue blocks of Treichville (roughly at the intersection of Avenues 11 and 12) are lined with warehouse-style storefronts whose interiors are often overflowing with a huge variety of heaped or stacked objects of art. Sitting outdoors on wooden chairs or squatting on goat-skin mats, drinking tonic water or heavily sweetened tea, storehouse owners and their assistants spend the day waiting for either buyers or suppliers to arrive at their stores.

The inside of a storehouse usually consists of a jumbled array of objects which have been accumulated over a period of many years (Plate 12). The scene is not unlike one which Geertz described for the Moroccan bazaar: "an accumulation of material objects [which] God himself could not inventory, and some of which He could probably not even identify . . . sensory confusion brought to a majestic pitch" (1979: 197). The sense of disarray in the store-house is, at least in part, the result of abandon, but it is also a calculated way in which a trader creates the impression that buried inside his storehouse may be a real treasure. One Abidjan-based American collector told me that he liked spending hours in the storehouses, digging through piles of "neglected" art. "Most of these guys," he said, "don't even know what they have in there" (11/15/87). When I related this idea to the traders, they were delighted. "Do you really think we would leave a good piece buried at the bottom of a pile? We know that what is there is no good, but if someone thinks there are treasures in there, that is good for our business" (12/2/87).[8]

Although the storehouses contain largely objects which the traders consider to be of inferior quality,[9] they provide one of the few instances in the art market where storage and accumulation are possible. Many African traders – whether in art or in other commodities – lack the necessary capital to store their goods in order to wait for seasonal or unanticipated price increases.[10] Noticing the rapid increase in prices for so-called "colonial" carvings (see Chapter 6), one trader told me that he knew if he held on to some of these statues for a few years he could probably make a much higher profit. However, he said that he could not afford the luxury of not selling. He needed a quick turnover to recuperate his invested capital with only a modest margin of profit.[11]

Market-place stallholders

In all three market places in Abidjan, the rights to stalls are strictly controlled by the municipal government. Stalls (or smaller spaces within a stall) must be rented from the Abidjan City Hall. The fee, which is collected on a weekly basis, ranges from 200 CFA (50 cents) to 1,500 CFA ($5). In exchange for this

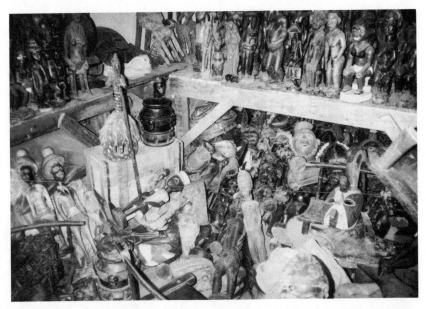

12 Interior view of an art storehouse. Treichville quarter, Abidjan, November 1987.

fee, the City Hall provides a small amount of security (occasional guard patrols at night) and cleans the market space on a more-or-less regular basis.[12]

Most stallholders begin their careers as assistants or apprentices. Some are sent as young boys from their natal village or home country to work for a relative in Abidjan. By selling to tourists and foreign buyers, the young men begin to learn the routines of the market place – the networks of supply, the range and quality of art forms, the tactics of successful bargaining, and the tastes and preferences of the consumers. Eventually they may be left in charge of the stall, while the owner conducts business out of his home or storehouse. And, later they may be given complete responsibility for the stall – buying stock-in-trade, paying stall fees, etc. (Plate 13).

Within the market place there is a constant tension between competition and cooperation. Because of the way the market place is laid out (with stalls grouped closely together along adjoining paths), and because of the high degree of similarity among the merchandise which is being bought and sold, traders are always in economic rivalry with one another.[13] In the tourist trade – where there is a limited range of variability in product type and quality – most merchants are selling roughly the same sort of goods which they have purchased at about the same price. In other sectors of the African market economy (e.g., fruits and vegetables), traders handle daily competition by

relying on the business of regular customers. Traders create their own body of repeat-customers by extending credit (Mintz 1961, 1964a; Lewis 1976). Because traders in the art market cater largely to tourists and other transients, the art traders (at the level of the tourist trade at least) can neither rely on the business of a return clientele nor on the patronage of indebted buyers.

Competition in the art market comes not only from external rivals but also from within a business enterprise itself. Most multi-trader stalls (where a stall-holder hires one or more assistants or apprentices) tend toward fragmentation as employees turn into entrepreneurs who run their own affairs within the framework of their employer's business (cf. Fanselow 1990: 258). In the Plateau market place, for example, Barane M'Bol was employed by his uncle to sell at one of the market-place stalls. M'Bol, however, was also active surreptitiously in seeking out his own clients in the street, he was engaged in credit and commission sales with other traders, and he bought objects on his own from itinerant suppliers. Although he did not pay for the stall right and was not responsible for the management of a large stock-in-trade, he used his position to his own advantage, in such a way that he was inevitably under-cutting his employer's earnings.

Door-to-door vendors

Many of the storehouse owners have what one trader called, "a small army of young men," who sell art door-to-door to a large Abidjan expatriate clientele. These ambulant traders or, what are sometimes called in the literature, circuit-traders, take goods on credit (see below) from the storehouse owners and ply their wares both at the homes of expatriate clients and, less frequently, to some of the stallholders in the market places.[14] Depending on a customer's generosity and tendency to buy, foreigners who have become integrated into the urban network are visited by at least three or four salesmen a month.[15] Working alone or in groups of two to three, traders generally arrive at a customer's home with several bags of art. Some of the traders have their own cars, most of them, however, travel by taxi, while some of the less prosperous must carry their heavy loads on foot or by public transportation. Occasionally, traders phone their clients ahead to set up appointments, often, however, they simply show up at the client's doorstep – and must sometimes wait up to half a day before they are even received in the person's home.[16] Some clients invite the traders into their homes, others receive traders on the veranda, driveway, or lawn. At an orientation meeting organized by the American Embassy in Abidjan, a speaker told the new arrivals that for security reasons art traders should not be invited inside their homes. Some non-diplomatic collectors, who do not consider the traders to be a security risk, do not allow merchants to enter their homes for different reasons. First, collectors often do not want the

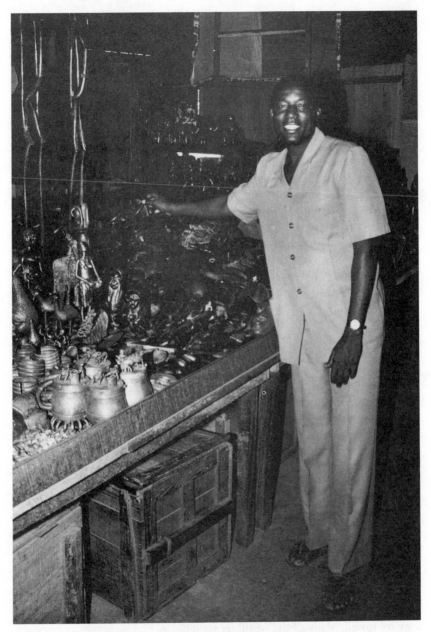

13 Market-place stallholder with his stock of merchandise. Man, June 1988.

vendors to see their collections, for they might have objects in their possession which were bought from rival traders.[17] Second, a collector might not let a door-to-door vendor into his home for fear that the trader might spread the word that the collector has a certain object in his possession. If a collector sells to other collectors (via the intermediary of an African trader) he would not want the people to whom he sells to know that he owns certain objects which he may eventually want to put on the market.

One example of this tactic is illustrated by François Dupont, an account executive for a French-owned bank in Abidjan. Several years after having been assigned to the Abidjan branch of the bank for which he worked in Paris, Dupont began collecting Akan goldweights. At first, when traders brought him newly arrived lots of weights, he would carefully choose what he felt were the best pieces. He would negotiate a price for the objects he had selected, and the trader would then sell the rest of the lot to other collectors or African traders. Eventually, Dupont says, he realized that because he was picking out what (both he and the trader felt) were the best pieces in the lot, he was essentially paying for the entire lot. Whatever the trader sold after he left Dupont's house was above and beyond what he thought he could get for the whole lot. Therefore, rather than select choice objects, Dupont began purchasing entire lots of goldweights. He would retain the pieces he wanted and would place the rest of the weights on the market. Since he was European, however, it would have been awkward (or, in his words, "demeaning") to go door-to-door to his collector friends and sell the weights. Therefore, he entered into an agreement with a single African trader who acted as his agent in the resale of goldweights which he did not want for his collection. The trader was given a price, and he made his profit from whatever he could get above that price. Dupont sold a number of his weights to a well-established Lebanese dealer in Abidjan. According to Dupont, if the Lebanese dealer knew that the weights were coming from his collection he would probably never buy them.[18] To prevent him, and any other collectors or dealers, from gaining access to knowledge regarding his stock, Dupont only allowed a select group of traders into his home, and, furthermore, he never displayed his entire collection.

Street hawkers and stall assistants

At least half the people who are involved in the exchange of art in the Plateau market place are neither stallholders nor even the actual owners of the objects they try to sell. Many of the wealthier stallholders hire assistants to carry out the daily business of selling art to tourists and other foreign buyers. Some of the more prosperous stallholders who carry both souvenir and up-scale art often do not get involved directly selling to tourists. Although they are present

nearly every day at their stall in the market place, they usually do not deal with customers unless someone is looking for *antiquités* or serious collectible art. They are also present in the event that a supplier should happen to bring a shipment of goods into the market place.

In order to avoid bargaining with tourists, large-scale stallholders hire one or more apprentices who are paid a modest weekly salary, an occasional commission on a sale, and sometimes given a lunchtime meal. Many of these apprentices are members of the stallholder's extended family – relatives who have been sent to the city by family members, or relatives who have lost their jobs in the city (construction, transportation, etc.) and are looking for temporary employment until they can find another position in the urban labor force. If a stallholder's assistant happens not to be a direct relative, in every instance that I know he is at least a member of the same ethnic group. Wolofs will always hire other Wolofs, Hausas will hire other Hausas, Dioulas will hire other Dioulas, etc. Stall assistants do not always become professional traders. If they have the opportunity, many of them would favor moving on to other sectors of urban employment.

Although they do not purchase objects themselves, stall assistants are familiar with the appropriate retail price for the type of objects stocked in the stalls where they work. Their knowledge, however, of the symbolism, meaning, and history of African art is generally minimal. Successful assistants increase their number of sales by picking up from other traders the stories which are told about different types of objects (cf. Chapter 6). The measure of an assistant's accomplishment depends on his aggressiveness in the market place and in his ability to "catch" tourists. When buyers visit the market place there is an unwritten rule which prevents other vendors from intruding and starting competitive bargaining or trying to distract the buyer (cf. Malinowski and de la Fuente 1985: 63). In F. G. Bailey's language (1969), however, one might say that like players engaged in a game with agreed upon rules, traders modify and contest the boundaries of cooperative behavior.

During the rainy season the Plateau market place floods quickly after a storm. Pathé Diop's stall, which is on the outer perimeter of the market place, has a tendency to get completely surrounded by a huge puddle of rainwater. Diop decided to place a wooden plank across the flooded area so that his customers could walk up to his stall. Because the plank was very narrow, however, customers could not turn around and leave if Diop was standing behind them. "This is good for my business," said Diop, "because the tourists can't walk away from my stall" (7/14/88). Some of the traders complained that the plank was an unfair means by which to monopolize a group of buyers. "When they come in [to the market place] they get stuck in that one area, and then we don't get a chance to show them our things" (7/14/88). Eventually, Diop agreed to lay down more planks so that others could simultaneously

gain access to the area – without the tourists or the traders getting their feet wet.

Another means of pushing the rules of market-place competition, is to go outside the market with a handful of goods and approach tourists directly on the street before they enter the market arena. Wolof traders refer to this practice as *poroh-poroh*.[19] Using this technique, traders either sell directly on the street, or lure tourists back to their stalls in the market place.

Internal market peddlers

In the Plateau market place, a small number of marginal actors in the art market economy earn a meager livelihood as internal market peddlers. Their role consists of selling objects from the stock of one stallholder to another stallholder in the market place. If a stallholder needs to raise a small amount of cash in a hurry – e.g., to pay the rental fee on his stall to the stall-right collector from the *mairie*, to buy a desirable object from an itinerant supplier, to repay an overdue loan which may have come to term through sudden social pressure, or simply to buy himself a midday meal – he may choose to liquidate one or more objects from his stock. Usually he selects an object which has been in his inventory for some time. Often, the seller may not even remember how much he originally paid for the item.

In order to liquidate an object or small portion of stock, the stallholder gives the item(s) to one of the internal market peddlers with whom he usually deals.[20] The trader sets a price (which is always low and often well below the normal price range for a particular type of object). The internal market peddler walks through the market place calling out the type of object he has to sell. He tries to get anything above the owner's asking price.[21] Because all the other stall-holders know that the object is being sold inexpensively and fast, the peddler's profit tends to be very low. Stallholders call peddlers from one end of the market to the next. "Hey, let's see what treasures you have for us today," one trader said as he motioned with his hand for the peddler to come nearer (12/2/87). The stallholders treat the internal market peddlers with calculated disrespect – reminding them that they are merely hawkers as opposed to real merchants of art.

The internal market peddlers allow stallholders to acquire quickly small amounts of cash without "lowering" their status to the level of a petty hawker.[22] Even after persistent questioning by rival stallholders, a peddler will not reveal the source of the objects he sells. A stallholder's temporary financial problems are thus kept secret from other traders. In every instance of intra-market peddling which I have witnessed, the object was eventually sold. The peddler's charge, that is to say, was never returned unsold to its owner. The system, therefore, provides a proven means of raising a small amount of cash in a hurry.

On becoming an art trader

Some of the traders have a childhood background in Qur'anic education (undertaken in their native country under the tutelage of a *marabout*) which enables them to read and write in Arabic script. Many can also read and write Roman numerals. Market-place traders who have frequent interaction with foreign buyers have a basic knowledge of spoken French. Some traders also speak a little English (which comes either from their interaction with tourists or from time spent in anglophone countries, such as Ghana or Nigeria). Unlike some other West African trade industries (e.g., the Hausa cattle market in Nigeria), none of the traders keep regular written accounts of their purchases, sales, or inventory (cf. Cohen 1965). Art merchants with a large stock-in-trade have an uncanny capacity to recall the price which they paid for nearly every object purchased within at least the last month, and often the past several years. They also have a keen memory for the objects which they themselves have handled – i.e., bought, sold, or simply seen. When a trader visits an expatriate collector's home, for instance, he can usually point out every object in the person's collection which has passed through his hands or which was offered to him for sale; he can recall from whom it was bought and for how much it was sold. When I showed some of the market-place traders a photographic book of carved West African slingshots, *Potomo Waka*, which had been published by a local Abidjan-based African art collector, many of them were able to recognize the slingshots which they (or one of their agents) had sold to the author of the book (see Chapter 5).

The success of an art trader depends on a combination of hard work, commercial acumen (which may include anything from knowing how to manage capital to developing a trained eye for quality art objects), prayer, and good fortune. This last variable, which accounts for the success of an art trader, is the one which is most talked about by the traders themselves. Good fortune is usually spoken of as a combination of luck and the will of God. If a trader makes a big sale, he will often kiss the money he receives (e.g., a 5,000 CFA note) and place the folded bill to his forehead. "Money brings money," they say. No matter how bad their business may be, traders find reassurance in the phrase *Dieu est grand* [God is great]. Lack of money, poor investments, and financial ruin are only considered temporary conditions in the life career of a trader. There is always the hope that the next day an itinerant supplier will bring a masterpiece (*une pièce "top"*)[23] to the market and sell it inexpensively. Or, there is the expectation that a foreign tourist or collector will buy something for far more money than it is usually worth. This is the faith which keeps a struggling trader in business – the glimmer of hope which enables him to open and close his market-place stall even if he has no more money in his pockets.

As Abdurrahman Madu put it, "It's like fishing . . . in the market you never know what you will catch" (1/29/88).

Many of the traders in the market place began as apprentices to their fathers, uncles, or some other male relative. Most of the stallholders seem to conceptualize art trading as a lifelong, full-time, permanent career. Many of the other merchants in the market place, however, simply consider trading as a temporary form of employment which provides a small amount of income until some more stable form of wage labor comes along.

A number of traders with whom I am acquainted entered the market through other forms of commerce. Bakayoko Ibrahim, for example, drives a truck with supplies of dried fish. He loads the dried fish from the ports in Abidjan and transports them to towns and villages in southern Burkina Faso and northern Ghana. Most of the regions where he sells fish are inhabited by members of the Lobi ethnic group. Because Lobi religion relies heavily on personal shrines made up of wooden sculptures and divination through carved figures, the Lobi people produce vast quantities of figural art (Meyer 1981). One of Ibrahim's cousins, who was himself an art trader in Ouagadougou, Burkina Faso, suggested that instead of returning from his fish-supplying trips with an empty truck, he should fill the truck with carvings which could then be sold in Abidjan. Ibrahim took his cousin's advice and began bringing back truck loads of Lobi sculpture. At first, he says, he bought anything he could find. Eventually, however, he developed an eye for quality in Lobi art and began buying pieces of greater value. He has been buying and selling Lobi art for the past ten years.[24]

When I met Ibrahim for the first time, he was sitting under the shade of a boabab tree in his family compound. Two of the six rooms in the compound are used for the storage of art. Ibrahim does not have a stall in any of the Abidjan market places. He sells to the stallholders, as well as to Western dealers who make their way to his compound (usually escorted by one of the market-place hawkers who is familiar with Ibrahim's "store"). It is unusual for traders to specialize – as Bakayoko Ibrahim has done – in the art of a single ethnic group, however, because of the circumstance under which Ibrahim collects the art, he is restricted to collecting in a single area among a single ethnic group. Thus, he is one of the few traders in the Côte d'Ivoire art market to have a genuine area specialty.[25]

Another trader who entered the market in a similar way as Bakayoko Ibrahim is Mulinde Robert. His transition to the art market, however, was sketched on a broader international scale. In 1976, Robert began coming to the United States from his native Nigeria to buy televisions, radios, and (eventually) video recorders. He shipped these objects to Nigeria where his brother sold them on the local market in Lagos. One of Robert's acquaintances in Nigeria, who was an art trader in one of the local tourist market places,

suggested that since he already knew so much about international shipping, and already had so many useful contacts in the Nigerian customs service, that he begin shipping art from Nigeria to the United States. In the past several years, Robert has begun the importation of art. So far, his operation is of limited scale – i.e., transporting objects in his personal luggage on every trip he makes from Nigeria to the United States. Because he is not tied into the network of full-time African art traders in the United States, he does not have many clients and is, therefore, having trouble finding outlets for the objects which he transports.

After graduating from Qur'anic school, Malam Yaaro began his career as an Islamic religious specialist or *malam*. The *malamai* are a powerful group of mystical diviners and interpreters of Islam who draw upon Qur'anic scriptures and formulae with the goal of securing individual prosperity and good fortune for their clients (Cohen 1969: 165–70). A *malam* can help a person to get rich, to prosper in their trade, and to positively control their future. The *malamai*, however, do not get paid directly for their services, they must instead rely on the generosity of those they help. Not long after starting his career as a *malam*, Yaaro realized that those he helped were quickly getting rich while he remained poor. "Why should I keep praying for someone else to get rich?" Yaaro asked rhetorically, "It just didn't make any sense" (3/14/92). He chose, therefore, to leave the mystical world in order to reap directly the fruits of the material world. Through business connections he had made as a *malam*, he was able to enter the diamond industry in northern Côte d'Ivoire. Basing himself in the town of Korhogo, Yaaro would travel through remote villages buying mined diamonds from local diggers or organizing digs himself. His business expanded to the diamond mines of Ghana, where he would buy the precious minerals in order to export them to Liberia. In the late 1970s, however, Yaaro fell on hard times in the diamond market. Scrambling for a new profession, he was able to use his extant village connections in Côte d'Ivoire and Ghana to begin trading in art. The transition from diamonds to art was not an easy one for Malam Yaaro. Although the Hausa take pride in their business acumen and their monopoly over many different forms of commerce, the trade in African art objects represented a radical departure for Yaaro – an excursion into a world of "idols" and "fetishes" from which his intensive Qur'anic education had steered him away.[26] As he put it in one of our conversations:

I had left home to earn money, but I had no more job. I saw people making good money selling art. I knew God didn't approve of this kind of work, but in order to make money I got involved in the trade . . . When you have nothing and you need to eat you sometimes have to do things that God doesn't like. That's why I sell art even though I know God doesn't approve. (6/22/91)

Yaaro started to buy and sell in the regions of Korhogo and Accra. Within the last few years, he has expanded his business to the United States, where he now

travels with a truck load of objects, selling art from New York to Los Angeles and most nearly everywhere in between. Before his first trip to America, Yaaro himself consulted a *malam* to insure a prosperous and successful journey. In discussing this consultation, Yaaro is quick to add, however, "I knew that when I would make money thanks to the blessings of the *malam*, I would repay him well for what he had done" (3/14/92).

There are a number of barriers that prevent people from becoming full-time traders (especially market-place traders). First, one must be admitted to the Syndicat des Antiquaires. Second, one must raise enough capital to purchase a market-place stall. Third, one must develop an eye for quality and a capacity for judging value and resale potential. One example of an unsuccessful bid to become a full-time trader in the market for *antiquités* is offered through the life history of Yusufu Tijjani, a thirty-two-year-old Hausa trader who now resides in the town of Korhogo. Tijjani has been selling African art since he was in his early twenties. He works for his father's brother, who is a well-established African art trader in northern Côte d'Ivoire. Tijjani recounted that when he first came to Korhogo, from his natal village in Niger, to work for his uncle, he tried to learn as much as he could about the trade and about the different types of artworks that his uncle bought and sold. When he himself had accumulated a little capital (from savings on commissions paid by his uncle) he began buying art directly from the itinerant suppliers. He displayed his goods alongside the objects he was selling for his uncle.

One day, he says, he purchased a Senufo rhythm pounder (*deble*) from one of the Dioula merchants who had just returned from the villages. "I really thought it was *top*," he said in an interview. He bargained for the piece, and agreed to pay the owner 40,000 CFA (about $130 in 1988). He left a deposit of 10,000 CFA and brought the piece to show his uncle. His uncle looked at the object and told him he had made a big error, that the piece was a recent copy, and that it was not worth anywhere near the price he had agreed to pay.[27] Tijjani tried to return the object to the supplier, but the merchant was not willing to give him back his deposit. So, Tijjani said, he returned the statue and forfeited the 10,000 CFA. "It was worth taking the loss in order to get rid of the thing," he said (6/6/88). Since this unfortunate incident, Tijjani has never bought anything on his own. He works strictly for his uncle, and sells mostly tourist pieces in front of the Mont Korhogo Hotel.

Credit, commissions, and capital

Unlike many other market systems in West Africa, the African art market is not structured around formal credit organizations or marketing cooperatives. One does not find, for instance, the rotating credit associations which are characteristic of many agricultural, produce, and textile markets. Nor does one find the

large-scale money-lending institutions which, for instance, finance the cattle markets in various parts of West Africa. In the West African art market, credit is hard to come by, and capital is even harder to find. Most traders enter the African art business through kin relations – i.e., as helpers or assistants. From these relations, the traders gain the knowledge (e.g., the capacity to recognize quality objects and the ability to estimate appropriate object value) which is necessary to participate in the art trade. They also acquire enough stock-in-trade and capital to eventually branch off on their own.

One reason, I believe, that the art market does not follow a typical West African market strategy of money lending or credit relations (i.e., supplier-landlord-client associations) has to do with the nature of the commodities which the art traders buy and sell. In the *antiquités* trade, especially, the quality of objects varies so greatly, and the supply of first-rate items is so limited, that suppliers have no idea what they will find when they go into rural areas in search of resaleable goods. In the cattle markets, by contrast, the supply is known to both itinerant buyers and the landlords or intermediary brokers. If a supplier is given money on credit to bring cattle back to the city for a sponsoring landlord, both he and the landlord know pretty well what will be brought back. That is to say, from the broker's perspective, the investment is relatively secure. However, if a stallholder, gallery owner, or storehouse trader lent money to an itinerant supplier in the art market, he would have no way of knowing what the supplier will find – if anything at all. The cost of the trip, and the supply of manufactured goods with which to barter, would all be absorbed by the middleman who would have no guarantee on his investment.

The main problem, however, is also one of confidence. According to most of the traders whom I interviewed, the reluctance to finance suppliers or to form partnerships with specific suppliers is attributed to lack of trust.[28] Some traders say that the few times when they have given suppliers advances to purchase art, they discovered that the suppliers returned to Abidjan and sold *to other traders* whatever quality items they had found in the rural areas. After they had sold all they could, the suppliers would then go to their backers and report that they had not found very much. What accounts for this practice, according to the traders who have experimented with financing itinerant suppliers, is that the suppliers can make a larger profit by selling to traders with whom they have no financial or social debt. That is to say, if they brought all their goods to their backers, they would have to sell at a rate which took into account a monetary obligation. By selling to those who have not backed their trip, the suppliers can maximize their profit on the objects they have brought back, and at the same time capitalize on the defrayal of their purchase and travel costs.

Financial partnerships can be disadvantageous from both the backer's and the supplier's point of view. According to suppliers, they prefer to remain

independent since there is always a chance that they will be able to buy a valuable item for very little money. If they were in a partnership, they would be obliged (at least in theory) to resell that item for less profit than they might otherwise be able to get. From the financier's perspective, fixed partnerships can also be detrimental. Again, because of the high degree of variability in the quality of items, traders prefer not to be obliged to buy from a set group of suppliers. They would rather have a wide field of suppliers with whom they do not have contractual obligations, and from whom they can purchase carefully selected items. Although credit is not common between suppliers and middle-men, credit relations do exist among traders within the resale market itself. At this level, the market system operates on several types of credit relations and systems of commission payment.

Market-place commissions

Traders who do not own either their own stall in the market place or their own stock of merchandise, can still participate in the trade as sellers or agents for other market-place traders. The profit they can derive from this type of participation is in the form of commissions or what traders refer to as *lèk*.[29] Market *lèk* is a kind of sales commission which allows traders who do not have enough capital with which to buy stock to still earn some money from the African art trade. As a tourist or group of tourists wanders through the market place, browsing at art objects in various stalls, there is usually at least one trader following the buyers from stall to stall, from one section of the market to another (Plate 14). Without knowing it, the tourists are crossing, at a brisk pace, scores of different lines of ownership. The trader accompanying the tourists through the market place becomes a sort of self-appointed "salesman," or as they are sometimes called in the literature "itinerant commission seller," who functions to bridge the different lines of ownership – creating an illusion that the market place is just like one big department store where you can pay for any item at any register. Rather than bargain with a number of different traders, the tourists deal only with "their" salesman. Traders say that this system is less confusing for the tourists, and, therefore, in the end, better for business.[30]

If a prospective buyer picks up an object which is the property of a given stall owner, the commission seller (rather than the owner of the stall) will conduct the bargaining. He usually knows the approximate value of an object, and so he will therefore conduct the bargaining without the help of the owner until the very last moment before the sale is finalized. If a successful sale appears to be imminent, then the commission seller will confirm the last price with the owner – speaking either in Dioula, Wolof, Hausa, or some other language which is presumably unintelligible to the tourist. After the customer is gone, the

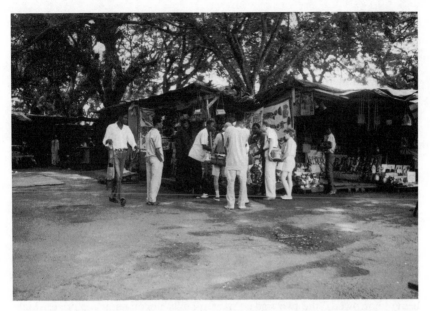

14 European tourists negotiating a sale with Wolof traders at Plateau market place. Abidjan, December 1987.

commission seller must give to the owner the entire amount of cash earned from the sale. He will then demand his commission or *lèk*. The amount of the *lèk* which is paid is generally very small (100 to 1,000 CFA depending on the profit from the sale). The amount of the *lèk* is never fixed in relation to particular objects or to a particular sale price. For this reason, it is a value which is almost always vigorously contested.

Arguments erupt frequently in the market place about the payment of *lèk*. Stallholders may claim that their margin of profit was too small to give any significant amount of *lèk*. They may pay more or less *lèk* depending on their relationship to the commission seller (e.g., ethnic affiliation, friendship, etc.). I have witnessed several instances where a trader tried to hold back a seller's *lèk* altogether. These instances sometimes erupt into market-wide debates about stallholders and their relation to commission sellers. The stallholders claim that they do not need the commission sellers, that they represent a drain on their margin of profit, and that they clutter and crowd the atmosphere of the market place. The commission sellers, in their turn, claim that they are an invaluable asset to the marketing system, that they help tourists find their way through a maze of merchandise in the market place, and that they entice tourists to buy when they might not otherwise do so. Although the *lèk* system allows

those without stock-in-trade to still participate at some level in the market, profits from *lèk* are always small. The merchandise credit system, on the other hand, can be a much more lucrative form of trade in which those without stock-in-trade are also able to participate. For the purposes of clarity in presentation, I will divide merchandise credit arrangements into two different categories: market-place credit and client credit.

Market-place credit

Watching from a distance the transactions of a market-place buyer, a trader might notice that a customer is particularly interested in a certain type of merchandise (e.g., bronze figurines, Dan face masks, figural goldweights, ivory jewelry, etc.). Having observed the buyer's tastes and preferences, the trader may try to pursue the client with whatever it is s/he seems most to want. If the trader does not have in his stock the type of item which the buyer seeks or, as is more commonly the case, if he is not himself a stallholder and thus by extension not an owner of resale goods, the trader would attempt to obtain the object from another merchant in the market place. At the time that the piece is being "borrowed," the two traders must quickly negotiate a sale price which is offered on extremely short-term credit. Whatever the outcome of this rapid bargaining or price negotiation, the trader who pursues the client draws his profit by getting whatever he can above the owner's asking price. When a trader borrows an object in such a manner it is referred to as taking the object on *ràngu*.[31]

Prices set in this manner tend to be relatively high. Since the stallholder knows that the middleman has a potential buyer who is interested in a specific type of item, he sets the price higher than he might otherwise under different circumstances – e.g., if a customer just happened to pick up the item at his stall. Another reason for which the object-owner may wish to set a high price on the item is to discourage the trader from taking it. For reasons of social and commercial etiquette, a stallholder cannot refuse openly to give an object to another salesman (especially one of his own ethnic group). Yet, traders often have interpersonal conflicts which come between them and other market-place vendors. Although the trader cannot refuse to "lend" the object to another trader, he does have a right to set the price wherever he wishes – thus, the price can be so unreasonably high that the trader asking to take the object on *ràngu* could not possibly sell it for any sort of a profit. The result, of course, is the same as not giving the trader the item at all, yet the object-owner does not deviate from the ideal of proper commercial behavior which mandates inter-trader cooperation.

Client credit

In addition to merchandise credit which is set in the market place, traders also establish credit in the broader arena of urban clientship. Many stallholders, storehouse owners, and even some of the smaller scale vendors have a set of regular clients in Abidjan and other Ivoirian urban centers. Some of their clients are African art collectors or dealers, others are expatriates (embassy personnel, visiting university lecturers, school teachers, journalists, corporate representatives, lawyers, entrepreneurs, etc.) who purchase art on an occasional basis. Because the knowledge of customer location and buying preferences are carefully guarded by traders, most African art sellers have only a limited network of potential buyers.[32] The *ràngu* system allows a trader to broaden his pool of customers; while, at the same time, it allows the middlemen to retain control over the whereabouts and preferences of their specific clientele.

If a trader sees an object in the possession of another trader which he believes one of his clients may want to buy, he will approach the owner of the object and request to borrow it in order to show it to a prospective buyer. Commercial etiquette prohibits a trader from refusing to lend an object to a fellow trader. Often times, however, traders will have their reasons not to lend an object to a particular person. These reasons might include the middleman's reputation for not promptly returning unsold merchandise; his reputation for not having much success at selling merchandise; or his reputation for not promptly paying the owner for the merchandise which has been sold.[33] Since in the *ràngu* system of merchandise credit the risks are not shared between the contracting parties but are borne wholly by the supplier of the goods, the object-owner must be careful with the disbursement of his stock (cf. Geertz 1979: 134). Those who are reluctant to lend out their objects through the *ràngu* system resort to various strategies which are designed not to break the unwritten market rule that one must never turn down another trader's request for the temporary loan of an object. One such strategy is simply not to allow other traders to view certain items in one's stock. Some objects may be kept at home, others may be stored in sealed bags under the trader's stall, or locked in a wooden trunk at the back of the market place. When a trader shows an object to a customer in the market place, he may draw the customer aside to show the object in an area which is out of view from other traders. Although, to be sure, this technique is partly intended to convey to prospective buyers the impression that they are being shown something which is unusual and secret (and, therefore, presumably very valuable), the practice is also intended to prevent other traders from later requesting to borrow the object on *ràngu*. Another strategy which is used by traders in order to turn down politely a request for an object

loan, is to set the price of the desired item so high that it would be impossible to resell it at a profit or even to sell it at all. This is the same strategy which is used to turn down a request for market-place credit (discussed above), however, in the case of client credit it is considered to be an even more effective technique. In the market place, since they are usually reselling to tourists with whom they have no long-term or repeated exchange, traders may elect to borrow an object even if the asking price is exceedingly high. Because they have no relationship at stake with the prospective buyer, it costs the trader nothing to try. With client *ràngu*, however, a trader is asking to borrow an object in order to show it to one of his regular customers. If the asking price is much too high, the trader may actually end up vexing his customer. The cost of this insult would usually outweigh the benefits of an unlikely sale.

One of the results of this complex interplay of credit and commissions is that when an item is sold the benefits are distributed among so many individuals that if the buyer tries to return the object it would be nearly impossible to recuperate the money from all the profit-takers and beneficiaries. One case from my fieldnotes may serve to illustrate the point. A French expatriate client bought a Dan wooden face mask from Kyauta Salihu, a Hausa trader at the Plateau market place in Abidjan. The buyer paid 70,000 CFA ($230). Later in the afternoon, on the same day of his purchase, the buyer asked for the return of his money in exchange for the mask. He explained to the merchant that he decided it was not worth the amount which he had paid, and that he had some doubts about the mask's quality and authenticity. Although he was one of Salihu's regular clients, the merchant was unable to return the money. Salihu explained to the buyer that the money had already been distributed among several people associated in various ways with the transaction. Some of those involved in the exchange had already left Abidjan. The buyer did not believe the trader's explanation, and as he marched off he told the trader that he would never conduct business with him ever again. As it turns out, however, the trader was being perfectly honest. The bulk of the money (wholesale cost) had been given to the two itinerant traders who had brought the mask, that very morning, to the Plateau market place. Another portion of the sum (*ràngu*) went to the stallholder whom the itinerant traders had first approached. Finally, a small percentage of the money (*lèk*) went to Salihu who had arranged, on behalf of the other stallholder, the sale of the item to his regular customer.[34]

3 An economy of words: bargaining and the social production of value

> The chief factor [Ogotemmêli] explained, in an exchange or sale is the spoken word, the words exchanged between the two parties, the discussion of the price. It is as if the cloth and the cowries were speaking. The goods come to an agreement with one another through the mouths of men.
>
> Marcel Griaule, *Conversations with Ogotemmêli* (1965) [1948]

> Value does not have its description branded on its forehead; it rather transforms every product of labour into a social hieroglyphic. Later on, men try to decipher the hieroglyphic, to get behind the secret of their own social product: for the characteristics which objects . . . have of being values is as much men's social product as their language. Karl Marx, *Capital* (1867)

According to the literature in economic anthropology, bargaining is generally found in economies which are characterized by such features as a flexible price policy, the non-standardization of weights and measures, and the lack of a large-scale information network which serves to inform buyers and sellers about the current trends in a supply-and-demand situation. The bargaining process in the art market follows many of the same patterns as bargaining in other sectors of the West African market economy, and also shows many similarities to bargaining strategies found in market economies in other parts of the world (see Uchendu 1967; Cassady 1968; Khuri 1968; Geertz 1979; Alexander and Alexander 1987).[1]

The value of individual art objects is established in the African art market through intensive verbal bargaining or haggling over price. Bargaining is used by traders as a price-setting mechanism both for *buying* objects from itinerant suppliers or workshop artists and for *selling* objects to other traders, Western collectors and dealers, tourists or other buyers. The object's price depends on such variable factors as the source of the object, the prevalent market conditions, the trader's current financial situation, the time of day during which the sale takes place (or the week or month during which the transaction occurs), and the trader's personal relationship to the buyer. From the middleman's perspective, bargaining occurs at least twice in the "life history" of an object. The object is first purchased from the supplier through bargaining (Plate 15), and it is then sold to the collector or tourist through a similar bargaining

process. More often than not, the price of an object is negotiated even more than twice – i.e., if it is lent out on credit or if it takes a circuitous path through the multiple networks of the market system (see Chapter 2).

In this chapter, I will examine the bargaining process which serves to establish the value of an African art object. I will draw a distinction between four types of bargaining mechanisms, which I will call extractive, wholesale, retail, and performative. Extractive bargaining is associated with the negotiation of *antiquités* (i.e., "antique" objects) directly from village-level owners.[2] Rather than determine economic value, I will argue that this type of bargaining aims primarily at coaxing the object away from its owner – luring an artifact from its indigenous milieu into the realm of the market economy, and thereby transferring an item from a non-commodity phase to that of a commodity. Wholesale bargaining is associated with the resale of these same items among the community of art traders themselves.[3] Here, economic worth is negotiated within the sphere of an African system of value. This type of bargaining also refers to the sale of newly carved objects – *copies* (replicas) and *nyama-nyama* (souvenirs) – from artisanal workshops to market-place or storehouse traders. Retail bargaining refers to the sale of objects by African traders to Western collectors or dealers. In this type of bargaining there is a tension between two different systems of value: an object's worth in the African trade relative to its worth in the Western market. Both parties in the bargaining transaction may be aware that two different systems of value are at play, and indeed both may be attempting to push the valuation process into the other person's domain. Performative bargaining refers to the sale of art objects by African traders to foreign tourists. This type of bargaining, I will argue, is at least in part a "staged" performance which fulfills certain expectations held by tourists concerning the experience of an "authentic" West African market place.

The four modes of bargaining exist simultaneously in an economic system which moves objects from one realm of value to the next. In the course of each transaction during the economic life history of an object which circulates in the African art market the value of an individual object doubles (at the very least) in price. Indeed, from the price paid in a village to the price at which it is sold in a New York or Paris gallery, the cost of an African object increases by a factor of ten or more (cf. Price 1989: 3). Thus, for example, a Dan mask acquired in a village in western Côte d'Ivoire by a mobile supplier may cost him $20 (in cash or barter equivalent). This value may increase to $40–60 when the item is sold to a stallholder or storehouse-owner in a nearby urban center (e.g., in Danané or Man). The price could then easily jump to $80–120 when the mask is sold to an African trader from the urban capital. From there, the object may be sold to an African dealer who intends to take the mask to Europe or America – he might pay anywhere from $200 to $400. The object would then

"EXTRACTIVE BARGAINING"

"WHOLESALE BARGAINING"

"RETAIL BARGAINING"

"PERFORMATIVE BARGAINING"

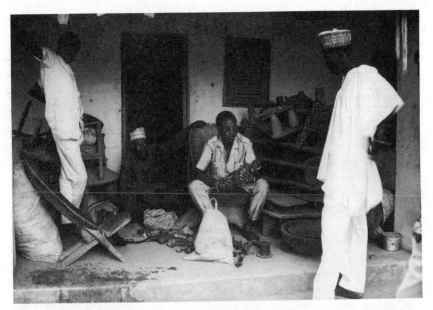

15 Hausa trader examining a Senufo statue before offering a price to an itinerant supplier. Aoussabougou, Korhogo, December 1987.

reach its penultimate destination in the hands of an American or European gallery owner who might pay somewhere between $800 and $1,000. Finally, it would be sold from the gallery to a private collector for about $1,600–2,000 (cf. Hersey 1982). As Abdurrahman Madu reflected:

A work of African art has no fixed price. I can buy a mask for 200,000 [CFA] and sell it to my friend Bernard for 300,000; Bernard could then sell it to Samir for 400,000; Samir could sell it to [the American dealer] David for 1 million, and David could sell it to someone in his gallery for 2 million, and so on. That's what happens; the price just keeps going up. (6/25/91)

The perceived value of an item is thus wholly dependent on where one is situated in the chain of economic transactions, and each transaction is characterized by the logic of its own system of value and mode of bargaining.

Extractive bargaining

In an edited volume entitled *The Social Life of Things*, Arjun Appadurai underscores the fluidity of economic commodities by demonstrating that certain items can move in and out of a commodity phase. "The commodity *candidacy* of things," writes Appadurai, "is less a temporal than a conceptual feature, and

it refers to the standards and criteria (symbolic, classificatory, and moral) that define the exchangeability of things in any particular social and historical context" (1986: 13–14, original emphasis). In the West African art market, the commodity potential of *antiquités* is tapped by itinerant traders who travel from village to village looking for objects which can be transferred to the global economy of the art market. The fact that migrant or diaspora traders are largely responsible for the first step in the commoditization of African art agrees with Appadurai's general contention that foreigners are often responsible for major shifts in the definition of object value. "Dealings with strangers," he notes in the same essay, "might provide contexts for the commoditization of things that are otherwise protected from commoditization" (1986: 15). A Senegalese trader in the Plateau market place confirmed this hypothesis when he explained that prior to the Wolof commoditization of African art, Ivoirians had no idea that their artworks were worth any money. "It was only when we arrived," said Barane M'Bol, "that we showed them how much money their art was really worth. Now that we taught them this, however, they want to control the market and push us out" (10/26/87).

At the village level of the art trade, bargaining serves less as a means for extracting goods from the local context. The price (which is usually represented by the bartering of both cash *and* manufactured goods)[4] does not represent the "real" value of the object as perceived by either side in the transaction. To the seller, the price is a recompense for parting with a personal object. In the language of economics, one would say that the seller evaluates the object according to its use-value, while the buyer judges its worth according to its exchange-value.[5] Thus, in this sense, bargaining is aimed less at determining a universal price as it is at striking a compromise between two different evaluatory systems. Since much art is obtained during times of personal or regional crisis, objects are often sold as a last, desperate resort to obtain cash or its equivalent in bartered goods.[6] Some things which may be highly prized at the village level, may have no worth on the international art market; and, by the same token, other items which may be held in low esteem by village-level owners, may, in fact, be highly valued by foreign buyers. At this level of the trade, the bargaining has nothing to do either with what the seller paid *or* with what the seller knows about the "true" value of the object in the world market. Bargaining here is less concerned with price as it is with the negotiation of a sale – i.e., convincing someone to sell something. As Sekou Yaka once explained to me:

When buying in villages, you have to be very careful about what you say. You have to be gentle and polite. You have to explain to the elders that these objects are things which people want to learn about. "Your children," you must tell them, "won't be able to appreciate or understand these things unless we take them and preserve them in museums and in books."[7] (2/15/88)

Although the encroachment of Western demand allows for the possibility that all African art objects *could* become commodities, some items are never transferred to the economic realm. African art traders recount, with a tinge of bitterness, that villagers are sometimes unwilling to part with certain of their possessions. Malam Abubakar, for instance, a Hausa trader whom I interviewed on several occasions, told me about the time he spent traveling among the Lobi people in the region of Bouna in north-eastern Côte d'Ivoire and across the border into southern Burkina Faso. "I saw women there wearing ivory lip plugs and huge bracelets," he said. "But they wouldn't sell them for any price. It just makes you want to grab them right off their body . . . They didn't even understand what it was they were wearing" (2/23/88). To the women who wore them, these ornaments drew their meaning from the cultural world to which they belonged. They were, so to say, literally priceless. To the trader, who knew the value of these ornaments in the art market, the objects were meaningful only within the context of an economic world into which he hoped the objects could be drawn.[8] I asked another art trader, Abdurrahman Madu, how he felt about villagers who were reluctant to part with certain objects:

I think it's just crazy because they say they can't see themselves accepting money in exchange for something they inherited . . . That's the mentality of the villagers. Even if they're not doing anything with it, they would rather let the termites eat it up [*le bouffer*] rather than sell it. Even though it would be better for them to accept even just 1000 CFA with which they could buy some soap for washing their children's clothes, they would prefer to watch these things turn into dust. That's their mentality. (6/25/91)

Wholesale bargaining

Wholesale bargaining occurs among African suppliers and traders. It is a system of bargaining where prices are negotiated within a relatively closed universe of value (Plate 16). At this level, in the commerce of *antiquités*, the bargaining process does not take into account the value of the object in the village context, nor does it consider directly the ultimate value of the object in the West. Wholesale bargaining is rather a means by which price is established within the parameters of local standards and regional fluctuations of supply and demand. Although urban buyers may be more aware than their rural suppliers of what an object may be worth in the Western market,[9] they do not allow this knowledge to permeate the negotiation of price. The process of verbal bargaining is aimed strictly at determining a value which enables the seller to draw a reasonable margin of profit above his cost. This type of intra-trade bargaining is what comes closest to typical patterns of market-place bargaining in other sectors of the West African economy.

In contrast to the trade in *antiquités* – where bargaining is intended to assign

a specific economic value to an art object – in the *copies* and *nyama-nyama* trades, wholesale bargaining serves principally as a means of product allocation.[10] Because many trade pieces are relatively standardized and substitutable, quality is more-or-less predictable and prices are generally well known. Whatever variations exist in prices are due to the relative merit of one artist's work over another's, or to the higher standards of one workshop's output over any other's. Since the prices of standardized goods are relatively fixed, whatever bargaining occurs at this level is achieved within a narrow price range. Traders are familiar with the "going rate" on any particular type of item. Therefore, any increase in price is a result of competition among traders to secure a desired lot of goods or a result of sudden increase in demand; conversely any decrease in price is a result of the middleman's need for immediate cash or the result of a sudden drop in demand.[11] By contrast, in the buying and selling of *antiquités*, quality is always highly heterogeneous, unstandardized, and unpredictable. Buyers can never be sure whether or not an object is "real" or "fake" (see Chapter 5). There is always a suspicion that the seller is trying to misrepresent the objects which he is selling. Thus in the transaction of *antiquités* there is always an information asymmetry between the seller, who passes on something uncertain (objects) in return for something certain (money), and the buyer, who does the reverse. Hence, in this context, to borrow Geertz's language (1979), the person who is passing on goods in return for money is far more certain of what he receives than the person who is passing on money in return for goods.

Retail bargaining

The negotiation of price which occurs between African traders and Western dealers or collectors is referred to here as retail bargaining. I distinguish this type of bargaining from the intra-trade negotiations which occur among African merchants themselves. Unlike most forms of wholesale bargaining, retail bargaining begins to take into account the value of the object in the West – i.e., a completely different system of valuation from that which characterizes both village-market and market-market transactions. While wholesale bargaining constructs value from local criteria of supply and demand, retail bargaining constructs value on the basis of Western taste and preferences. Dan face masks and Baule female figures, to choose two well-known examples, have historically been more valued in the Western art market than, say, Lobi statues (which have only been growing in popularity during the past several years).[12] Although the costs of extraction (by which I mean collection, transportation, etc.) may be the same for all of these objects, or may perhaps even be greater for the latter set of items, the Western market does not determine value according to supply-side criteria. As one gallery owner in New York told me,

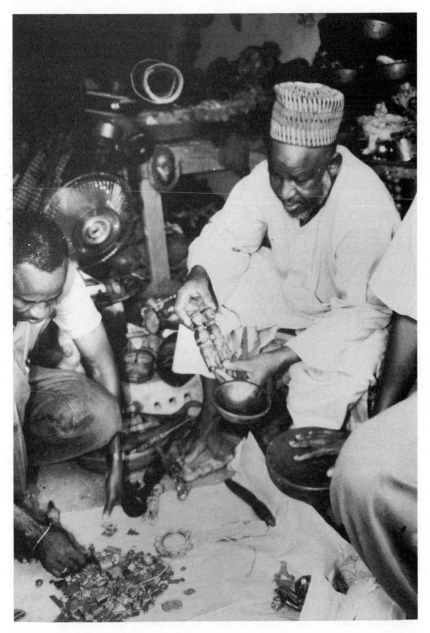

16 Hausa traders bargaining in a storehouse. Treichville quarter, Abidjan, June 1991.

"What you pay over there, has nothing to do with how you price it in the gallery" (8/5/89). Thus in retail bargaining there is always a tension between two different systems of value. On the one hand, there is the African trade value (which is based on local supply and only a fragmentary or elliptical knowledge of Western demand). And, on the other hand, there is the Western trade value (which is based on gallery prices, auction records, and taste-setting trends). In retail bargaining, where there is a bilateral asymmetry between the urban African trader and the foreign buyer, the transaction is aimed at gauging the worth of an object in terms of the "opponent's" value system: i.e., how much can the seller get away with asking, and how little can the buyer pay. The use of bargaining as a method to overcome indeterminacy in a transcultural economic exchange was clearly explained in the early years of this century to a British traveler in Cairo, who reported a trader's response to his inquiry regarding how a trader could sell an object for two pounds for which he had begun by asking over a hundred:

These things [he said] are worth to us – nothing. To you they are worth various sums of money. How are we to know what they are worth to you? The price you will pay seems to us to depend, not on the things, but on the persons who buy them. You say this thing is worth two pounds to you. It might be worth two hundred to someone else. How are we to tell what it will fetch except by trying? (Conway 1914: 64)

One way in which an African trader can attempt to catch a glimpse of an object's value in the Western market is to insist that the Western collector or dealer open the bargaining process by proposing an initial price. I have witnessed several instances in which the seller was so uncertain of an object's value that he refused to bargain unless the buyer stated an initial price. When the buyer is not willing to initiate the negotiation (which happens quite often), the sale can be aborted by the trader, who would rather lose an opportunity to sell than agree on a price which he later finds out was too low. The same British traveler in Cairo reports another incident which neatly captures a situation where the sale of an artifact was thwarted simply because the buyer was unwilling to state an initial price. Because the passage demonstrates so clearly the interaction between buyer and seller in a situation where the market value of an object is unknown to both parties in the transaction, I quote the passage at length.

Someone must have quickly marked me down as a greedy collector . . . for late in one of the first evenings after our arrival, I was told that two natives were enquiring for me. They entered my room like conspirators, bringing an air of mystery with them. After seeming to assure themselves that they were not overlooked, one of them drew a small packet from his bosom and placed in my hands a most beautiful little manuscript of the Koran. It was fifteenth-century work, still in its original binding, and I think they intended me to believe that it had been stolen, as was probably the fact. It was the first time I had had dealings with an Oriental. Would that that lost opportunity might return!

But such a chance will never again be mine. "What will you give us for this?" they demanded. "We must sell it quickly, and you can have it cheap." I bade them name their price, but they hung back. "Tell us what you will pay; it is worth much more money than we can wait to get. Buy it from us, and you shall have it cheap." "No!" I replied. "I can't be buyer and seller too. Name your price, and if I can afford it I will buy. But I am sure this thing is too expensive for me." "A price, a price!" they cried. "Name a price that you will pay, and let us see." But I would not, thinking that they would only laugh if I did; so at last they suggested eighty pounds. "That is truly very cheap," I said, "and the book is worth much more; but I have not eighty pounds to spare, as I want to buy ancient Egyptian things, so you must find another purchaser." "We will take less. Tell us what you will pay. Name any sum." But I foolishly would not. Five pounds was in the back of my mind, and I was ashamed to utter the words. I refused to deal, and sent them away still urging, and finally whining out the words, "Name a price; name a price, however small." If I had said five pounds, I now know that they would have jumped at the money, and that wonderful book would have been mine; but through shamefacedness at a first contact with these new folk I lost a golden opportunity. (Conway 1914: 62–64)

Although, in retail bargaining the Western buyer is generally at an advantage in knowing the potential resale value of an object in the Western market, there are certain conditions under which the trader can manipulate buyer–seller asymmetry to his advantage: (1) when dealing with absolute one-of-a-kind objects; and (2) when providing a client with a regular supply of hard-to-find goods. If a work of art is viewed as aesthetically unique, with no substitutes, the seller has a great deal of control over the price. That is to say, since there are no other sellers of that particular type of good, the seller is not limited in any way by values established by his competition. As Constance Bates concluded in a study of the international art market in the West, the "amount of seller control is inversely related to the consumer's perceived alternatives" (1979: 170). Under these conditions, the seller can orchestrate the bargaining process so as to push the buyer(s) in a direction which may lead them to reveal what they genuinely believe the object to be worth – e.g., the seller can stick to a very high price in order to judge (perhaps from the buyer's facial expression or from the pace of bargaining itself) how high the buyer is really willing to go.[13]

In situations where a trader has a regular relationship with a buyer, he can often regulate his prices within a narrow inflationary scale. One case from my fieldnotes may serve to illustrate the way in which price fluctuations occur even within the marketing of almost identical items. Alhadji Amadou, a stall-holder at the Plateau market place, has a regular client who purchases Akan brass or silver spoons (saawa) which were used in the past for measuring and dispensing golddust. Although these spoons are not especially rare, there is a limited supply of the finest quality, oldest spoons. Since most itinerant suppliers knew that Amadou purchased these type of spoons, they would usually reserve their supply for him. Thus, within the Abidjan market, one

could say that Amadou controlled a considerable monopoly on a limited supply of *saawa* spoons. His client would buy these spoons in small wholesale quantities of about five to twenty at a time. Amadou brought spoons to her home about twice a month. The client would select the best spoons from the lot. And with these, she would create box frames with displays of one or two spoons in each (see the discussion of frames and framing in Chapter 5). The gallery owner purchased the spoons for about 1,500 CFA ($5) each. In turn, she sold the frames (*encadrements*) in her gallery for about 30,000–120,000 CFA ($100–400) each.

Although Amadou had established an average price for the spoons (during the two years or so since he had been selling them to her), when times were especially hard he would sometimes try to get more money by telling the customer that a particular lot of spoons did not belong to him, but that they had been taken on credit (*ràngu*) from another trader who was asking for a higher price. Or, employing a slightly different tactic, he would say that the supply of spoons had been getting scarcer, and that the village-level suppliers were asking for more money. Or, taking yet another approach, he would insist that *these* spoons were not exactly the same as the ones she had bought before (*c'est pas la même chose*). In all three instances, the trader used these explanations as a means of pushing the client to pay a slightly higher amount each time he went to deliver a supply of spoons.[14] Sometimes the buyer would give in to the inflation in price, other times she would argue with the trader in order to have the price remain the same. Amadou was careful not to annoy the buyer. He would always try to push the price just to the point where he felt she would not argue too much. Indeed, the capacity to judge the consumer's spending limit is perhaps one of the most important elements in a seller's successful bargaining strategy.

On one occasion, while I was present in the gallery, the buyer grew irritated with the trader's insistence on a higher price. Amadou had a number of debts to repay, business had been bad of late, and he was trying to push the buyer beyond the point where he might normally have stopped. Rankled by Amadou's pressure, the gallery owner barked, "Why do you want more money for these things anyway? I know you all find these things for free in the gutters [*égouts*] of Treichville" (5/2/88). The buyer's comment raises an interesting assumption, which I believe is rather prevalent among Western purchasers, namely that the middlemen pay nothing or next to nothing for the items they sell. Although it is true that the cost of the object at this level of the trade is minimal in contrast to the prices which are paid on the final consumption side of the market, it is certainly not true that the middlemen get the objects for free. Indeed, the African merchant's margin of profit is far lower than the European gallery owner's margin. And the sum spent to acquire objects is far higher – when viewed as relative to annual income and capital

endowment – on the African side of the trade than it is on the European side.

Bargaining as performance

In their ethnography of rural market places in Mexico, Bronislaw Malinowski and Julio de la Fuente tried to correct a prevalent view that market places in the non-Western world functioned principally as arenas for social gathering where people congregated for fun and carried out irrational economic behavior (i.e., bargaining). "We soon discovered," they wrote in 1957, "that the Indians or peasants never go [to the market place] to amuse themselves or for any other collateral reason. They go to the market to transact business" (1985 ed.: 68). Commenting further on the bargaining process itself, they concluded, "people do not bargain . . . for the pleasure of verbal interchange or any other psychological reason, but because throughout a market day the price of maize rises and falls . . . in a manner which is definitely determined by the need of the consumer and the financial requirements of the producer" (1985 ed.: 138).[15]

Bargaining in the tourist art market goes against what Malinowski and de la Fuente observed in the Mexican market place. Unlike other areas of the art market which do indeed follow a pattern of serious economic negotiation, the bargaining process between Western tourists and African traders is constructed in such a way so as to satisfy the image of amusement which characterizes the Western stereotype of market-place transacting. As one Western observer put it in a brochure distributed to American Embassy personnel in Abidjan, "Disputing prices and quality are part of the fun . . . and disappointed is the merchant who receives his initial, most often outrageously high, asking price" (Anon. n.d.b: 8). Or, as another Western buyer put it, "Most fun was shopping at the huts along the road . . . I always think ethnic jewelry and bags are very valid for spring . . . and I love to bargain; it's a real challenge" (Anon. 1984: 4). Commenting more critically on the issue, Daniel Boorstin once observed: "Shopping, like tipping, is one of the few activities remaining for the tourist. It is a chink in the wall of prearrangements which separates him from the country he visits. No wonder he finds it exciting. When he shops he actually encounters natives, negotiates in their strange language, and discovers the local business etiquette" (1962: 92).

Acutely aware of this type of expectation, African traders manipulate the bargaining process in order to satisfy what they perceive as the Western image of market-place bargaining. In so doing, they will exaggerate their response to an offered price, extend the bargaining time beyond its practical length, and in general use the bargaining process as an arena for entertaining the client with outlandish claims and humorous remarks – thereby blurring, as it were, the

usual distinction between acting and *trans*acting. As Asan Diop, a Wolof trader in the Plateau market place, put it, "White people like to discuss the price for a long time. They like to be grabbed and pulled here and there. I know that's why they come here" (11/15/87). When bargaining with tourists, traders discuss not only the price of an object but also "sell" the object by introducing into the discourse of bargaining a kind of on-going product advertisement. The advertisement (by which I mean any type of discourse which increases the likelihood of sale) may include information about the object's putative collection history, as well as the symbolic meaning or traditional use of the object in its indigenous setting. It may also consist of statements about other types of people who buy similar items, or it may attempt to flatter the buyers by complimenting them on their good taste and aesthetic judgment.[16]

Hence, although on the surface it would appear that wholesale bargaining among traders and retail bargaining between African traders and Western dealers or collectors is the same as the bargaining which occurs between market-place traders and foreign tourists, the latter, I would argue, is a totally unique form of bargaining which bears only surface resemblances to the other forms of price negotiation.[17] Bargaining with tourists differs from retail bargaining not only in the sense that it is performative, but also in so far as the asymmetry between buyer and seller is *reversed*. While in retail bargaining the buyer has more knowledge of an object's ultimate value than does the seller (i.e., the Western buyer has greater access than does the trader to information concerning Western-appraised value), in bargaining with a tourist the seller has the advantage of knowing better what an object is "really" worth.[18] On the whole, tourists are also at a disadvantage in the sense that they are not familiar with the conventions of market-place bargaining. They may, for example, be unaware that bids must alternate in fairly rapid succession, that backward moves are forbidden, that accepted bids must be honored, that one ought not to break off an interchange that is moving actively ahead, and so on.[19]

One example from my field data, which is typical of many similar instances, may serve to illustrate a pattern of miscommunication between tourist and trader. A European tourist walking through the Plateau market place stopped at a covered stall and picked up an item from one of the shelves. She examined the object and asked the trader how much he wanted for it. Rather than simply state a price (as the tourist probably expected the trader to do), the trader began with a lengthy explanation of what the item was; he then looked around at other items surrounding the one which the tourist had selected and then scrutinized the object itself. All of these activities are means by which the trader postpones his answer about the price of the object, in order to give himself enough time to calculate his initial asking price – a calculation which is based on such diverse factors as cost, inventory status, time of day, month in the year, perception of customer taste, and the appearance of the client (i.e., as in the

French expression, *donner le prix à la tête du client*). After being told a price, the tourist put down the item. She then immediately picked up another object, and again asked the trader how much it was. Rather than state another price, the trader grabbed the first object and handed it to the reluctant buyer. She tried to put the object down but her efforts were blocked by the trader who now stood between her and the stall. He asked her how much she was willing to pay. The tourist insisted that she was only "curious" about the price; she really did not want to buy that particular item. As if ignoring the buyer's last statement, the trader offered a lower price. The tourist protested again that it was not a matter of money or cost but simply that she did not want to buy that particular item. "Alright," said the trader, "how much will you give?" (2/29/88).

The miscommunication between buyer and seller is based on the clash of two different understandings of the bargaining process. A knowledgeable African buyer would never pick something up simply to request for a price to be quoted in the abstract. The buyer would only select an item if s/he was interested in engaging in a serious bout of price negotiation. From the trader's perspective, the tourist, in this case, is attempting to gain market information without committing herself to buying an object. She is trying to overcome the indeterminacy of a market context where prices are not fixed or posted. An American expatriate once complained to me that she thought the traders did not understand the fact that people sometimes just want to "look at things." The traders, I would argue, are profoundly aware that not everything a person touches is necessarily something they want to buy; however, because of the way the market is organized the trader cannot know if the next item the tourist will "look at" will be from his stock or from the stock of one of his competitors (possibly located only a few inches away on the same shelf of the stall). Thus, it is to the trader's advantage to insist on selling the first thing that the tourist selects. I would postulate further that a trader's experience proves that with enough insistence a person may well be persuaded to buy something they do not initially want.[20]

Bargaining as social process

Beyond its obvious pragmatic function in establishing price, bargaining also plays a critical social role in the structuring of inter-personal relations within the market place. It provides a language through which buyer and seller create new bonds of solidarity where none may have existed before. When buying from itinerant suppliers, urban merchants interweave into the banter of their price-setting dialogue a socio-cultural discourse which draws on the language of kinship, religion, ethnicity, and personal history. Buyers and sellers often refer to one another as "brothers." If one is younger than the other, one may be referred to as "my son" and the other as "father." Fictive-kinship terms such as

these are invoked either by the buyer in order to heighten his claim that the purchase price should be lowered, or by the seller to achieve the same goal with regard to raising the selling price. Islam is also often invoked as a common ground between buyers and sellers. This sort of appeal to shared religious belief was most noticeably used by a Lebanese dealer who bought from African suppliers. When a supplier entered the front gate of his estate, the Lebanese dealer would welcome the trader with the Arabic greeting *asàlaam àlaikùm*. Even though nothing else united the buyer and seller – neither ethnicity, nationality, class, nor economic status – the Arabic salutation was a subtle (yet, I would argue, calculated) way of communicating to the African trader that they had some shared beliefs and interests. Finally, traders will appeal to commerce itself as a "fraternal" link between buyer and seller. While making an argument to a European dealer for increasing his offering price, an African trader said, "Between us there is no difference. We are both the same" (12/7/87). The similarity to which the trader was referring was the fact that both he and the foreign buyer were professional merchants. By heightening the buyer's sensitivity to this shared ethos or occupational solidarity, the seller hoped to obtain a higher price (cf. Curtin 1984: 46–47).

A trader's initial asking price will vary depending on the type of customer with whom he is dealing. If the initial asking price is too low, the trader will risk having to go too near or even below his minimal selling price. By the same token, however, if his initial asking price is too high he may discourage not only the sale which is currently at hand but also all future sales as well (cf. Cassady 1968: 58). Thus, the seller's initial asking price must be carefully chosen in order to insure a reasonable margin of profit but not discourage or scare away the customer.[21]

An initial price is usually stated only after a protracted set of apologies and explanations. The trader's discourse is intended, at least in part, to stall his answer long enough to calculate his desired margin of profit (which represents the difference between his cost and his opening price – which usually must be at least double of what he actually hopes to receive). During the course of negotiation, a trader can also insert statements which (although seemingly superfluous to the price negotiation itself) are aimed at pushing the buyer toward making a higher offer. In order to deflect attention from himself and attempt to fix the selling price at a higher level than might otherwise be possible, I once heard a trader tell a buyer the following account: "The object which you have picked out does not belong to me. I am selling it for my brother[22] who wants 20,000 CFA for it. If it were up to me, of course, I would give you a better price. But since it is not mine, I have to sell it to you at the price he told me" (5/19/88). As the bargaining unfolds, the price will inevitably go lower than the fictive "owner's" asking price – this, after all, is in the very nature of the bargaining process itself. The seller, however, can stay faithful

to the original script of his verbal drama by telling the buyer that he himself realizes that the owner's price is too high, and that he will tell the owner that he accepted a lower price because it was the only reasonable amount he could get for the object.

Another device which a trader can use as a bargaining strategy is to quote the price which he himself paid for a particular object. As a means of underscoring the veracity of what he is saying, when revealing the putative wholesale cost of an item, the trader will often accompany his statement by an invocation of Allah: i.e., "*Wàllahì* [in the name of God], I myself paid more than that for this object." The trader then follows by stating his putative cost. This step in the bargaining process has at least two effects. First, it makes it seem as though the trader is being completely honest with the prospective buyer; that he is breaking an unwritten rule of commercial competition by taking the buyer into his confidence and unmasking the seller's buying price – one of the most guarded secrets of the trade. Second, the statement exposes what would appear to be the trader's final price – that is to say, the lowest he is willing to go in this particular bout of price negotiation. Revealing cost (even if the amount is untrue)[23] is a radical move in the bargaining strategy. For, after a trader establishes that he has paid a certain price for an object, it is difficult for him to go below that price without jeopardizing his credibility. In order to make a sale, however, traders must often go below their stated "cost." In so doing, they will claim that it is worth taking a short-term loss in order to forge a long-term relationship with a client. They are thus able to turn a situation which potentially discredits their integrity into one which creates the illusion that they are willing to make a sacrifice for the sake of forging a union of commerce and a bond of friendship.

A different sort of price "ultimatum" which a trader can insert into the bargaining process is to say that a second buyer has offered more than what the present buyer is willing to pay, or simply that another buyer has offered a specific sum of money which is higher than what the present buyer has offered.[24] If a seller uses this tactic, but then agrees to sell the object for less than the "other buyer's" price, he can save himself from embarrassment by saying that although he could have made more money elsewhere he values his relationship to the customer more than he values money. By insinuating that someone else was willing to pay more, this type of bargaining tactic also lets the buyer believe that s/he is getting some sort of preferential price.[25] Since prices are not posted in the market place, there is no other way of suggesting to the buyer that s/he is getting a special discount off the "normal" selling price. However, by introducing a second (imaginary) buyer into the banter of bargaining, the trader creates the illusion that there is already an established price for the object, and that the buyer is purchasing the object for a price which is somewhere below that agreed upon value.[26]

Market information and bargaining

Knowledge or information is one of the most valuable commodities in the African art market. The importance of market knowledge was plainly underscored by K. E. Boulding when he remarked, "As it is exchange or potentiality of exchange or relevance to exchange that makes things commodities, one would think that economists would be interested in knowledge itself as a commodity. It is certainly something which is bought and sold" (1971: 22–23). With market knowledge, traders are able to have a better understanding of the buying and selling price of the objects they trade; they have a greater sense of supply and demand; they are more capable of recognizing quality and authenticity, as well as the fungibility and grading of object types; and they are better suited to predict future market trends – thereby being able to buy objects before their value increases and to sell before it declines.[27]

If market information were perfectly distributed, then there would be no need for bargaining – prices for all qualities of objects would be known to all participants in the trade. Knowledge, however, is not equally distributed in the market system. As Cassady notes in his article on bargaining in Mexico, "In traditional markets the vendor is not likely to have access to the type of market information that is routinely available through the newspaper or radio to those operating in markets in more advanced economies" (Cassady 1968: 59). And, as Geertz says in his essay on the Sefrou bazaar, information on the market place is

generally poor, scarce, maldistributed, inefficiently communicated, and intensely valued . . . The level of ignorance about everything from product quality and going prices to market possibilities and production costs is very high, and a great deal of the way in which the bazaar is organized and functions . . . can be interpreted as either an attempt to reduce such ignorance for someone, increase it for someone, or defend someone against it. (1979: 124–25)

Addressing himself to the case of the art trade in particular, one African art merchant, Abdurraham Madu, offered the following thoughts on the disparity of market knowledge:

You know that if everyone in the world were equally sophisticated, the world would chew itself up. We can't all have the same amount of intelligence . . . There will always be a certain number of ignorant people. There are those with their eyes open and those with their eyes closed. If we all had our eyes open – if you knew everything that I knew – things just wouldn't work. It's like a scale; as one end goes up, the other end necessarily must go back down . . . If everyone knew the same thing, then there would be no market. (6/25/91)

One of the key functions of bargaining, then, is to overcome indeterminacy in situations where only limited market information is available. Among the

information which traders guard most closely there are three, in particular, which stand out as being among the most valued type of market knowledge: (1) price (both purchase and sale); (2) source (both village and intra-market); and (3) quality (whether an object is "real" or "fake").

No trader wants other market-place traders to know how much he has paid for any item in his stock, nor does he want anyone to know for how much he sold an item to either another trader or to a foreign buyer. When traders sell art objects to Western collectors or tourists in the market place, they often take the person aside so that other traders cannot overhear the prices which are being discussed. If it is not possible to move away from a group of traders, the seller might whisper prices into the buyer's ear (especially as the price negotiation reaches its conclusion). There are at least three explanations for why a merchant would want to tell the client his price in confidence. First, it is a dramatic technique which is calculated to let the client believe that s/he is getting such a good price that the trader would be embarrassed to have his rivals know that he was selling something so inexpensively. In fact, traders will even tell the buyer not to repeat the price to anyone else for fear that others will want to buy a similar item for the same low price ("This price is *only for you*"). A second motivation for stating the price in confidence, is in point of fact to discourage the consumer from repeating the purchase price – not, however, in fear of embarrassment for having underpriced an item, but in order for a trader to keep his financial affairs secret. If the seller owed money to another market-place trader, for example, he would not want that trader to find out that he had just earned enough cash to be able to pay him back. Finally, a third reason why a trader would try to keep his prices concealed is so that others cannot gain ("free") market information about the current rate on a certain type of item. Say, for example, that a trader sells a particular style of Senufo mask to a Western dealer for a considerable profit. The trader also knows that another stallholder in the market place has a very similar type of mask in his stock. The trader intends to get that object from the stallholder, and offer it for sale to the same dealer at his hotel later that day. If the other trader found out how much the foreign buyer had paid, he would either demand to receive that amount from the trader who took it on credit (*ràngu*), or he would attempt to find the buyer himself in order to sell the mask directly to him. If he is not aware of how much was paid, however, then the trader can try to get the mask for a lower credit price and make another worthwhile profit (from the same buyer) on the sale of the other mask.

A second area of market information which is highly guarded by African art traders is knowledge relating to the source of one's goods. No village-level supplier would want to let others know exactly where he was getting his art. Secrecy in these matters is the best way of minimizing competition. Once an object reaches an urban market place, traders continue to guard information

concerning the source of an object – not from which village it comes but from which supplier or market-place trader is was taken on credit (*ràngu*). As part of the verbal exchange in bargaining, buyers will try to sense whether an object "belongs" to the seller, or whether it has been taken from someone else on credit. If the object is believed to have been taken on credit, then the prospective buyer may attempt to find the source. He may say, for instance, that he is not interested in the piece, and will then try to follow the merchant back to his supplier – even if this takes several days of research and inquiry. If the supplier is located, then the trader may try to buy the object directly from the source (thereby avoiding paying whatever profit would have gone to the additional middleman). If the object were purchased from the source, both buyer and seller would want to conduct the transaction in secrecy – insuring that the now-defunct middleman was not aware that he had been traced to his source, by-passed in the circuit of exchange, and shut out of his financial reward.

A third area of knowledge which is closely guarded by traders concerns the "authenticity" or "genuineness" of art objects. When buying and selling *antiquités* in the art market, there is always an element of suspicion as to whether the piece is "real" or "fake." Sometimes the seller knows if an object has been "faked,"[28] often, however, the seller himself is not really sure. Thus, the buyer must first ask himself, has the object been faked (by either an artist or a trader somewhere along the market network). And, second, he must ask himself, does the seller know whether or not the object has indeed been faked. What ensues in the bargaining process is a language game of discreet inquiries – in which the buyer tries not only to discover the "authenticity" of the object by examining its physical properties, but tries also to uncover something about an object's "genuine" worth by deciphering subtle cues (encoded in shifts in price and the pace of bargaining itself) which may communicate the seller's sincere convictions about the value of the object. If he felt that an object was fake, for instance, the seller might drop his price much more rapidly than if he had strong convictions that an object was real.

Discrepancy in market knowledge directly affects the price of exchanged goods. Those with a greater capacity to judge authenticity will tend to pay more for objects they believe to be of high quality (and, therefore, will have access to more goods). Those with a lesser ability to distinguish "real" from "fake," will tend to pay less (and, therefore, will have only limited access to goods). A useful model which may help to better explain this process can be inferred from George Akerlof's influential essay (1970) on market mechanisms in situations where there exists a high degree of quality uncertainty and frequent product misrepresentation. The example on which he chooses to build his model is the second-hand automobile market in the United States. In this type of market situation, there is a wide spectrum of commodities divided at either extreme between good cars and bad cars (which are commonly referred to as "lemons").

If the used car market became flooded with lemons, the result, Akerlof predicts, is that the price of *all* second-hand cars would be driven down. Because the purchaser cannot evaluate (with any degree of certainty) the"true" condition of a used car at the time of purchase (i.e., engine problems might not become apparent until some time after the sale was finalized), the reasonable buyer would offer the value of a lemon regardless of whether the car appeared to be in good condition or not. Hence, the seller of an average or above-average car is either faced with having to accept less than fair market value for the product he sells or not selling the car at all (Akerlof 1970: 489–92).

If one applies Akerlof's model to the African art market in Côte d'Ivoire, several parallels emerge. First, if one equates the category "good cars" with that of "genuine art," and "bad cars" with "fakes," one could postulate that if the African art market became flooded with fakes (as some might argue it already has), the price of *all* artworks (which are classified as *antiquités*) would go down. On the whole, this statement is true; however, for the African art market Akerlof's model becomes more enlightening if we append another dimension. Unlike the used car market where *nobody* can spot a lemon before making a purchase,[29] in the African art market some people do have the capacity to better recognize object authenticity. Therefore, rather than consisting of a homogenous class of buyers, the art market has a hierarchy of different buyers who can be ranked according to their expertise or their ability to distinguish "real" art from "fake" art. In expanding the applicability of Akerlof's model, I would suggest that if the art market became flooded with fakes, one portion of the buying population (in this case, I am especially referring to the population of African middlemen) would flourish while another would suffer. Merchants with less information or those with less experience in evaluating the quality of an object, would always offer the seller the price of a below-average piece (i.e., a fake or a *copie*). Thus a high quality object – which in resale to the Western art market would be judged authentic – would be purchased by the middleman for the price of a low quality item so as to minimize the risk of mistakenly overpaying for a portion of his stock. However, those with greater knowledge of object quality, would be willing to take bigger (informed) risks on the objects which they buy. This second group of buyers would come to monopolize the trade in *antiquités* – pushing out all those who did not possess a keen capacity to judge authenticity in an accurate manner. Competition, in this regard, is thus regulated by market information and differential access to specialized knowledge.

4 The political economy of ethnicity in a plural market

At the beginning of January 1988, after having been in the field for several months, I traveled with a Hausa trader to the town of Korhogo, located near the borders of Burkina Faso and Mali in northern Côte d'Ivoire. Korhogo is the largest town in that part of Côte d'Ivoire, and serves as a regional government center (*préfecture*), as well as the urban capital of the Senufo and Dioula, the two largest ethnic groups in the area.

One of the residential neighborhoods of Korhogo, called Aoussabougou, is inhabited largely by Hausa migrants.[1] Many of these migrants are traders or shopkeepers in and around Korhogo; some of them are merchants specializing in the art trade. In Aoussabougou, there are approximately six major art storehouses owned by heavily invested traders. Within the town of Korhogo as a whole, art is also sold from the street in front of the main tourist hotel, Le Mont Korhogo, and from a small stand on the veranda of the Motel Agip. Lining the hill in front of Le Mont Korhogo are twenty or so wooden tables with shelves upon which traders display their goods for sale to tourists. Although some of the items they sell are from the Senufo region, many of the objects are carved in styles which are representative of other parts of Côte d'Ivoire and West Africa as a whole. A number of the traders who sell in front of the hotel are Wolofs, a few of whom also own storehouses which are located in different areas of Korhogo.[2] Art is also sold in Korhogo by Senufo and Kulebele carvers from a cluster of family-operated workshops in what is known as Koko quarter.[3]

The trader with whom I traveled north from Abidjan, Abdurrahman Madu, is a thirty-year-old man whose father, about twenty-five years ago, made the transition from the transportation and marketing of kola nuts to the commerce in African art. After completing his Qur'anic education, Madu migrated to Abidjan in 1972 from his natal village in Niger in order to begin a career as a professional art trader. He started out by selling new ivory carvings, as well as ivory and malachite jewelry, at the Plateau market place in central Abidjan. At first, he was employed by his father as a helper and stall apprentice. Now, however, he runs his own stall, and largely supports both his ailing father, who still resides in Abidjan, and the rest of his family who live in Niger. Because

Madu is one of the most economically successful members of his family, his relatives (both near and distant) are often imposing on him to lend them money. On several occasions, he said, his penniless cousins from Niger have arrived by bus in Abidjan and brought the bus driver right up to Madu's home in order to collect the fare.

In 1981, Madu realized for the first time that there was more money to be made in the trade in *antiquités* than there was in the ivory and malachite crafts and other "tourist" carvings which he was then selling from his father's stall. While maintaining the stall in the front of the market place – where identical *copies* and *nyama-nyama* are lined side-by-side – Madu built himself a wooden trunk in the back of the market from which he hoped to sell older works of art (see Chapter 6).[4] He began buying stock from the various suppliers who sent art objects from the villages. Since he had already been working in the market for about nine years, he knew many of the merchants who supplied artifacts to the traders in Abidjan. From his earnings in the front of the market, Madu was able to finance the growth of his stock-in-trade for the trunk in the back of the market.[5] Over a period of about seven years, he has developed a small network of clients in Abidjan, and, at any given time, his trunk is usually filled to capacity with various kinds of works of art.

Before this trip to Korhogo, Madu had never been to the northern part of Côte d'Ivoire. However, he knew most of the Korhogo-based dealers from their visits to Abidjan. In fact, one of the most prosperous art dealers in Korhogo, Alhadji Usuman, is Madu's father's brother. While traveling to Korhogo, Madu said that he was not at all concerned with the fact that he had never been to the area to which we were going. "They are all Hausas," he said with confidence, "so there will be no problem" (1/20/88).

When we arrived in the town of Korhogo, we went directly to Aoussabougou, the largest Hausa residential neighborhood (*zango*) in Korhogo. We went first to greet Madu's uncle, Alhadji Usuman. He was sitting under the shade of a small storefront outside his family compound. His tall stature and broad frame filled the elegant scarlet robe that he wore. Madu and I spoke with Usuman for about half an hour.[6] The purpose of Madu's visit was never stated directly, but it must surely have been understood that he traveled to Korhogo in order to purchase works of art.[7] After visiting Usuman, we moved on to five more dealers all located within a short walking distance from Usuman's family compound and storehouse. All the dealers told Madu that they were pleased that he had finally made it to Korhogo. They welcomed him and hoped he would find something he would want to buy and take back to his market-place stall in Abidjan.

Alhadji Usuman is a wealthy man by any standard. His compound is the largest of all the compounds owned by art dealers in Aoussabougou. I was told that he owned not only his own extended family compound, but was also

landlord of at least ten other compounds in the neighborhood. Usuman owns two cars, and employs a full-time driver. He has taken all five of his wives on the pilgrimage (hadj) to Mecca. He has borne the expense of several very costly cataract eye operations – a problem which now seriously impairs his vision. When breaking the fast at the end of the holy month of Ramadan, Usuman is known to sacrifice at least a dozen sheep. When he goes to Abidjan he does not travel the long and arduous eleven-hour drive – he flies Air Ivoire. Three rooms of his compound are used for the storage of art objects. Some of his more precious goods are also stored under his bed within the main family residence. Usuman has two full-time assistants who maintain the storehouse, purchase art from the Koko quarter workshops,[8] buy from itinerant suppliers, and sell to visiting African traders or art dealers from the West.

After several hours of making the appropriate rounds to greet all the major art dealers in Korhogo, we were approached cautiously by an old Hausa trader named Bagari Tanko. Madu had never before met this man. Tanko was an elderly trader who went by foot or, more usually, by motorbike through Senufo villages searching and bartering for objects of art. He had never been to Abidjan. Normally he would have no contact with Westerners, and, as a rule, he would have no business speaking directly with a trader from Abidjan (such as Madu). His normal network of contacts consisted rather of the established Korhogo-based dealers, such as Alhadji Usuman, to whom he would bring the goods that he found in the villages. Usuman, or one of his colleagues in Aoussabougou, would buy Tanko's goods and then transport them to Abidjan or else sell them to a trader like Madu who had made the journey to Korhogo. The fact that I was traveling with Madu was something of an anomaly to the traders. It is for this reason, I believe, that Tanko broke the normal hierarchy of the commercial circuit and approached Madu directly.

Tanko asked if Madu would be interested in looking at some old masks that a Senufo carver had just brought back from a village that very morning. Without hesitation, Madu agreed, and we followed Tanko to the home of Ngolo Coulibaly. Unlike our visits to the compounds of the Hausa traders, here our business was announced as soon as we entered the door. Tanko informed Coulibaly that Madu was an art trader from Abidjan who had come to Korhogo to buy works of art. He asked Coulibaly to show him the objects he had just brought back from the "bush" (la brousse). At first, the Senufo carver was reluctant to do so. He said he was tired, that he had just come back from a one-week trip through the villages, and that he would prefer to show the masks some other day.[9] After some extensive coaxing from Tanko, Coulibaly finally produced, from a vinyl travel bag, two small kpélié-style Senufo face masks (Plate 17).

Madu examined the masks closely – taking them out of the dimly lit room, and scrutinizing them in the scorching light of the midday sun. After carefully

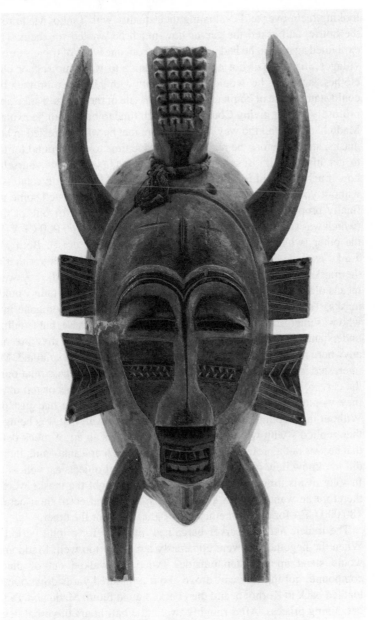

17 Senufo *kpélié*-style mask. Wood with fiber attachment. Height 32 cm.
Private collection. Photograph by Richard Meier.

looking them over and evaluating their quality with Tanko, Madu returned to the house, and asked the carver how much he wanted for them. The carver explained again that he had just returned from one week of travels through rural villages, that he had not even had a chance to wash himself or change his clothes, and that he would have consult with his older brother before he could state a price or begin to negotiate the sale of the masks. Tanko apologized profusely for not giving Coulibaly enough time to bathe, but he explained that Madu had come all the way from Abidjan, that he was interested in buying the masks, and, therefore, he really did not have time to wait around for Coulibaly to get his brother. Besides, Madu interjected, "you know yourself exactly how much you paid for the masks, so you should be able to establish a price without your brother's help" (1/21/88). The carver protested some more, but finally proposed that Madu pay 200,000 CFA ($650) for one of the masks (which was surmounted with a small carved bird) and 160,000 CFA ($525) for the other (which was surmounted with a geometric crest). Both Madu and Tanko exploded with laughter and then explained to the carver that although the masks he had found were very pretty and well carved, they were by no means old (ancien) nor, as the traders say, were they top. Madu would buy the masks, Tanko told the Senufo carver, because he knew someone in Abidjan who was interested in purchasing nice copies such as these, but Coulibaly must understand that these masks are not authentic, and that they are not worth anywhere near the price he quoted. Furthermore, Tanko explained, Madu was interested in buying the masks in order to establish a business relationship with the carver. Next time, if the carver found some antiquités or top masks, then they would be willing to discuss prices like the one he had just proposed. Without interrupting, Coulibaly listened politely to all that was being said. He then replied – with what can only be described as an air of mock deference – that he was not a professional art trader like Madu or Tanko, and, therefore, he did not know how to recognize the quality of art objects as well as they did. In spite of his limitations, however, he still thought the masks were old and therefore he wanted to get a price which he felt reflected their actual value: 180,000 CFA for one of them, and 140,000 CFA for the other.

The traders and the carver bargained intensely for a long period of time. When the negotiations were apparently not going too well, Madu and Tanko would stand up and step outside. Twice we walked out of the carver's compound, got into my car, drove about a hundred yards down the dirt road that led back to Korhogo, and then backed up to return Madu and Tanko to the bargaining process. After roughly two and a half hours of verbal negotiation, only 10,000 CFA separated Madu's offering price (25,000 CFA for each mask) from the carver's proposed selling price (35,000 CFA each). It seemed, for a moment, that neither would move on their "last" price, until Tanko, who had not said a word for some time, intervened in the price negotiation to suggest

that the two parties compromise. "You both have made such great effort in nearly reaching an agreement," he said to Madu and Coulibaly, "it would be foolish to walk away now that so little money separates you. Why don't you each put in 5,000 CFA and be done with this affair." After much grumbling by Coulibaly, and yet another "staged" departure in my car, Madu finally bought the two masks for 30,000 CFA ($100) each. While driving away from the carver's compound, Tanko was thanked by Madu for his help, and promptly paid a percentage (1,000 CFA).

We returned with the masks to Aoussabougou. Almost immediately, Madu was approached by a number of Hausa traders – who, apparently, already knew what had happened at the carver's home – and was reprimanded in very strong terms for having bought directly from Ngolo Coulibaly. Alhadji Usuman, in particular, was outraged by Madu's actions. Usuman (who, as it turns out, was regularly supplied by Coulibaly) had not only been denied the opportunity to buy the kpélié masks, he had moreover missed the chance to resell them to Madu at a profit. Usuman said that the incident was especially insulting to him since it had been committed by his own brother's son.

Not long after the neighborhood was set in motion by our return, the Senufo carver, Ngolo Coulibaly, arrived on his motorbike followed by his older brother. The traders immediately stopped arguing and turned their attention in unison toward the two Senufo men. Coulibaly's brother approached the crowd of Hausa traders and explained to them that his little brother had done a very foolish thing. He was upset that Coulibaly had not consulted with him before selling the masks, since he felt that the masks were worth far more than Madu had paid. He requested that the masks be returned, and stretched out a bundle of bills in a gesture suggesting that he would give Madu his money back. All of a sudden, the community of traders who had just been quarreling so thunderously with Madu and Tanko, shifted their tone dramatically and began arguing with the carver and his older brother. Rallying their alliance with Madu, one of the art traders, Mamman Yayaji, explained in patronizing terms to the Senufo carvers, "A deal is a deal. If Coulibaly were a child then perhaps we would consider exchanging the masks for the money. But Coulibaly is hardly a child, he is, in fact, the head of a large family and a responsible husband and father. Therefore, there is no way we will return the masks." Usuman interjected, "This is not a serious way to conduct business. We are all here, after all, for the sake of commerce" (1/21/88). The discussion heated quickly into a verbal and physical dispute – Senufo and Hausa yelling at one another and pushing each other around. At this point the older brother said he was going to get the police in order to help settle the matter. The moment it was mentioned that the police might be brought in to resolve the altercation, Tanko interrupted to say that the real owner of the masks was the American. He pointed to me. Madu was only an agent that had negotiated the sale, Tanko explained

to the Senufo brothers, so if they wanted to get the police it was with the American that they would have to present their claim. The masks were then abruptly shoved in my hands, at which point the Senufo brothers got back on their motorbikes and left Aoussabougou, saying that it was all an unfortunate misunderstanding but that they were willing to let the whole thing drop.[10]

As the community slowly calmed down after the event, two explanations were given as to why Coulibaly had come to make his claim, and, in particular, why his older brother had become involved. In their first explanation, some of the Hausa traders thought Coulibaly himself might have believed in earnest that he had made a mistake and sold the masks for too little money. He would have brought his brother along to add strength to his argument and to legitimate his claim. The second explanation which was given by other Hausa traders, which both Madu and Tanko thought was the more likely of the two, is that Coulibaly was expected to split the profit from the sale of the masks with his older brother, who was his business partner. Since the older brother had not been present during the transaction – because Madu and Tanko had been so insistent that the deal take place without the delay of getting the brother – he may indeed have suspected that Coulibaly was not telling the truth about the amount for which the masks had been sold. That is to say, he was questioning his rightful share of the profit. By contesting the sale in public, in the presence of the buyers and the other traders, Coulibaly's older brother was able to verify that the masks had indeed been sold for 30,000 CFA each (a figure that was mentioned several times in the argument, and which was the amount of money he held in his hand when he offered to return the sum to Madu). Thus, according to the second explanation, the Senufo brothers never had any intention of returning the money, taking back the masks, or even getting the police. Coulibaly's brother was simply verifying within the context of a public forum the details of a private transaction from which he felt he had been unfairly excluded.

The drama of the *kpélié* mask purchase in Korhogo provides a small window onto at least one aspect of the role of ethnicity in structuring the social organization of trade. The incident is not only a good example of an obvious shifting structural opposition – what Evans-Pritchard (1940) referred to in his classic formulation of the problem as the "fission and fusion" of political segmentary opposition[11] – but it is also a striking demonstration of the intensity of ethnic loyalty, which is (as we shall see below) a crucial element in the commercial success of migrant ethnic minorities.

Ethnicity and cross-cultural trade

Throughout the world it is common to find ethnic minorities playing prominent roles in, or even monopolizing, trade and other commercial activities. The

Chinese in Southeast Asia, the Asians in East Africa, the Syrians and Lebanese
in North and West Africa, and the Jews in Medieval Europe provide some of
the best documented examples (Cohen 1971; Foster 1974; Curtin 1984).
African ethnic groups who have migrated to West Africa from other parts of
the continent also play a crucial role in all aspects of trade and marketing.
Among the best-known West African ethnic groups specializing in cross-
cultural commerce are the Wolofs of Senegal, the Hausa of northern Nigeria
and southern Niger, and the Dioula or Malinké of the western Sudan.[12] These
groups have migrated throughout the globe, conducting their business – as
ethnic minorities – in all parts of Africa, Europe, North America, and (more
recently) Southeast Asia and Japan. All of these groups, not surprisingly,
control major shares of the contemporary African art market.[13]

One of the reasons ethnic minorities play such a prominent role in trans-
national commerce is that their alien status dismisses them from many of the
social obligations or constraints which could potentially hinder the successful
operation of economic exchange. If, for example, a trader were fully part of
a village society and subject to the controls and moral obligations of the
community, he would be expected to be generous in the "traditional way" to
those in need. It would be difficult for him to refuse credit, for example, and it
would not always be possible to collect debts. In short, it would be hard to reap
a profit from the very network of kin, neighbors, and friends on whom a
trader's life was dependent and with whom he was socially and culturally
intermeshed (Bonacich 1973: 585; Foster 1974: 441).

Although ethnic minorities are involved, for different reasons, in a huge
variety of commercial enterprises, a trader's status as an outsider is almost
a necessary precondition for participating in the African art trade. If members
of the local population attempted openly to buy and sell art objects on their
own, they would inevitably face the scorn of the community. In many cases,
they would probably be punished severely if they were found selling sacred
objects.

As a means of diverting local outrage, village elders who are forced, by
economic need, to sell sacred goods to traders often report to their community
that the pieces were stolen by the traders. Traders say that as a result of this
practice some itinerant merchants have even been killed by local populations.
In one exceptional case with which I am familiar, a village community reported
the theft of a mask to the local police. The matter was brought to authorities in
Abidjan who were able to trace the mask to a Wolof trader who had already left
for France with the object. The trader's associates in Abidjan were able to
contact him in Paris before the mask had been sold, and the object was shipped
back to Abidjan and returned to the village. The Wolof trader was never
reimbursed for the cost of the mask, but he avoided a serious legal confron-
tation (which he would almost surely have lost). This is the only widely

reported instance of its kind. In this case, extensive media coverage and the Ivoirian government's recent campaign for nationalism through the preservation of local artistic traditions (see below) were largely responsible for the return of the sacred icon.

Outsiders in inter-ethnic commerce have the advantage of being able to leave an area quickly if they are caught in illicit or sacrilegious activities. Furthermore, they have the advantage of not being enmeshed in the moral or religious fabric of the local community with whom they trade. As Georg Simmel once put it, the itinerant trader, whose status in a community is defined as that of outsider or stranger, "is not tied down in his action by habit, piety, and precedent" (1950: 405; cf. Levine 1979). Abdurrahman Madu said:

In the past, most Ivoirians who came to the market place were afraid to touch the masks. They thought that they would die if they came in contact with them. To these people the masks were fetishes. For those of us who sell masks, however, we can touch them all we want. We don't give a damn. Even if they tell me that there's a certain kind of mask that prevents you from sleeping at night, I could take it home with me and use it as a pillow. Because I don't believe in these things. You have to believe in something in order for it to be effective. If you don't believe in it, then nothing will ever happen to you. (6/25/91)

Since a disproportionate number of art traders – whether they be Wolof, Hausa, or Mande – are Muslim in faith, their commercial activities are not hindered by conflicting ethical interests or religious beliefs. Immersed solely in the economics of the trade, Muslim traders are completely detached from the spiritual aspect of the objects they sell. As Alhadji Kabiru stated when discussing a Baule monkey figure (*asri kofi*) that was displayed in his stall: "To me this thing represents money. To the Baule it's a god. A Baule could die if he touched this. Yet to me it means absolutely nothing. It's simply a piece of wood – no different from this countertop [in my stall]. It means nothing to me . . . To me this is just money, it's not a fetish" (6/19/91).

Muslim traders have no interest in collecting the African art they sell. Most traders decorate their home with Western products – images of urban prosperity clipped from newspapers and magazines, wall calendars with glossy pin-ups, colorful posters, or banners supporting African and European sports teams. As Malam Yaaro stressed in one of our conversations, "If you see a Muslim selling [African] art, you can be sure there is a non-Muslim somewhere who is buying it. I would never spend money on art just to display it on a table . . . I wouldn't want my children to see it or to know anything about it" (6/22/91).

Indeed, many of the art traders are critical of the populations from whom they buy art – viewing them variously as pagan, idolatrous, animistic, and superstitious.[14] As Yaaro went on to say:

These people speak to their [art] objects but they never speak back. If you leave the object somewhere for a year or so, and then return, you'll find that it hasn't moved, it hasn't eaten, it hasn't drunk, it hasn't spoken. But if the object really were a god then it would speak back when spoken to! Only the people who don't yet know God worship things in this way. We Muslims have never done that. (6/22/91)

Both the Qur'an and the hadith[15] take a decidedly aniconic stance – a negative view toward representational art – and, in particular, both strongly condemn the creation of idols and their use in religious practice. "The hadith literature," René Bravmann notes, "is uncompromising on the subject of representational art, and its judgments are leveled not only at all types of image-makers – that is, painters and sculptors – but also at all types of artistic creativity in which representational forms are possible" (1974: 16). Since Islam strongly condemns the fashioning of representational art and the worship of figural forms, the activities of art traders should not only be seen as non-conflicting with their own religious beliefs, but indeed the decontextualization of sacred materials could actually be looked upon favorably by the religion of the traders.[16]

Situational ethnic identity

In his classic monograph *Political Systems of Highland Burma* (1954), Edmund Leach argued that ethnicity is based on subjective claims of categorical ascription that have no necessary relationship to an observer's perception of cultural discontinuities (cf. Bentley 1987). His argument can be interpreted as a direct challenge to socio-geographic models of "culture areas" – e.g., see Melville Herskovits (1930) on the mapping of ethnic groups in Africa – in which complexes of cultural traits that are identified by observers are used to map cultural or ethnic divisions within a prescribed geographic region. Subsequent to Leach's work on ethnicity and ethnic group identity, the culture area approach has largely fallen into disfavor among anthropologists. As Fredrik Barth concluded in his work among the Swat Pathan, "the concept of 'culture areas' . . . becomes inapplicable. Different ethnic groups and culture types will have overlapping distributions and disconforming borders" (1956: 1088).

The insight that ethnicity is claimed rather than predetermined (in some primordial way) has been widely adopted in social scientific studies of ethnic identity (Wallerstein 1960; Barth, ed. 1969; Skinner 1975; Schildkrout 1978; Van Binsbergen 1981; Maybury-Lewis 1984; Comaroff 1987; Moore 1989). Such studies view ethnicity variously as a conscious expression of short-term economic interest, as a fiction constructed by leaders and sold to their followers, or as the by-product of a dynamic process of interest aggregation. The departure from fixed ethnic attributes allows for the possibility of

shifting ethnic identity according to situational circumstance. In the art trade, merchants manipulate their ethnic identity according to what they perceive as shifting economic advantage. Although, as noted earlier, many of the traders in the Plateau market place in Abidjan are Wolofs from Senegal they will often tell tourists that they are from Côte d'Ivoire and usually, more precisely, that they are Baule. Wolof traders claim to be from Côte d'Ivoire in order to satisfy the tourist's quest for authenticity. Traders say that tourists prefer to buy souvenirs from Ivoirian merchants – the authenticity of the experience being heightened if they buy from "local" or "native" sellers (cf. MacCannell 1976: 149–60). The reason many Wolofs claim specifically to be members of the Baule ethnic group is twofold. First, since much of the art that tourists buy is carved in the Baule style (e.g., wooden Baule face masks and statues), a trader's claim to Baule ethnicity makes him a more legitimate spokesman for the objects he sells. Second, since it is a well-known fact that the President of the Republic of Côte d'Ivoire, Félix Houphouët-Boigny, is of Baule heritage, by claiming Baule identity the trader is also drawing a symbolic connection between himself, the President, and the state. When making a sale, traders will sometimes make direct reference to the President. If they are trying to sell a Baule mask, for example, they might say, "This is a mask from the President's village." Or, when selling a Dan doll, I once overheard a trader telling a group of tourists, "These are [like] the dancers that came out to entertain the President. I saw them on television" (10/11/87). The practice of "ethnic prevarication" is so widespread in the market place, that even a popular Côte d'Ivoire guide book finds reason to warn tourists about the manipulation of national and ethnic identities: "[M]any of the Senegalese try to pass themselves off as Ivoirians in order to lend authority to their pittance of knowledge about Ivoirian art" (Rémy 1976: 89, my translation from the French).[17]

Traders who do not try to hide their Senegalese identity – i.e., those who admit openly to being Wolof – emphasize instead in the banter of bargaining their "pan-African" identity. Remarks of this nature include: "We are all Africans in the marketplace"; "We are all brothers"; "All Africans are the same." When I interviewed Mulinde Robert, a Nigerian merchant who now sells in the United States, I asked him why he became involved in the African art trade. He answered, succinctly, "Well first of all, I am African" (9/12/89).

The fabrics of identity

Because the authenticity of an African art object is often measured not only by the quality of the object itself but also by the characteristics (credibility, reputation, knowledge, appearance) of the person selling the object, African art dealers who have extensive contact with Western buyers sometimes choose their attire carefully in order to heighten or underscore their status as "authentic"

African traders.[18] Thus, many of the traders have taken to wearing long flowing robes made of cotton damask and finely embroidered silk which have come to symbolize the traditional style of Muslims in Africa (cf. Mazrui 1970).[19] The fact that Islam is (theoretically) incompatible with the representational art which the traders sell, does not seem to undermine the effectiveness of their clothes in communicating to tourists their role as legitimate *Africans*.

In subtle ways, traders also use personal adornment to differentiate themselves from other Africans in the market place. Many of the more successful traders, for instance, especially in the Plateau market place, have attached small Akan brass pendants to the key rings that hold their car keys and/or the keys to the padlocks on their storage trunks. The traders explain that by continually handling the pendants which hang from their key rings, they give the brass a shiny patina which imitates indigenous handling and age. After several months, the traders say, they can saw off the loop on the pendant and sell the object as though it were a fine old Akan goldweight. During the period of field research, however, I never witnessed a trader removing a pendant from his key ring, let alone sawing off a pendant's loop. In fact, many traders could point to the various pendants on their ring and recount when they purchased them and for how long they had been there (usually several years). Rather than a mechanism for artificial patination, I would postulate, the pendants ought more correctly to be regarded as symbolic markers which differentiate the stallholders and prosperous market-place traders from the suppliers and other Africans who frequent the market place. Many of the traders displayed their key rings rather ostentatiously by allowing the pendants to hang from their trouser or robe pocket.

Traders returning from Europe or America symbolize their high status as international dealers by wearing expensive European-tailored clothes, fine leather shoes or trendy imported "high-back" sneakers, expensive watches, designer sunglasses, and heavy gold chains. When the traders walk through the market places, looking to buy supplies for their next trip abroad, their status as successful international merchants is clearly signaled by their fancy Western attire. It is these same dealers, ironically, who sometimes switch to wearing traditional Muslim robes when they are in Europe or America selling to Western buyers.

The construction of ethnic artifacts

At the demand end of the African art market, ethnicity functions as a form of commodity – which can be packaged, marketed, and sold to foreign buyers. Many of the art objects traded in the market places are classified according to their ethnic style: *Dan* masks, *Senufo* figures, *Baule* combs, etc. In most cases, it is ethnicity alone which is the most intrinsic element in the definition and

classification of art objects. When tourists buy art in the market place, one of the first questions they ask the trader is, "What tribe is this from?" Some traders are able to recognize, with great accuracy, the ethnic attribution of an art object. Others, however, have not the slightest clue where an object may be from. Whether or not a trader knows in which ethnic style an object is carved, he will *always* provide the buyer with an ethnic attribution – i.e., failure to do so might jeopardize the sale.

For those who are unable to recognize ethnic attributions, the tendency is to identify *everything* as Baule: "It's Baule, just like the President" (11/20/87). Objects which are asymmetrical or unusual in form are often identified as Lobi (since most Lobi art is of distorted or unequal proportions). I once asked a stall apprentice to identify a very poorly executed Dan mask (it was clearly an attempt to copy the form of a Dan mask, but was probably carved by a novice workshop-artist from another part of West Africa). The trader examined the mask and said that it was "Dan-Lobi." Clearly, he recognized the artist's attempt at capturing a Dan aesthetic, but, at the same time, he attributed the mask's lopsidedness to the work of a Lobi. When I asked him how the Dan and the Lobi could come together, since they were separated by so much geographic distance,[20] the trader said, without skipping a beat, "No, this is from before-before [*avant-avant*] when the two groups were really one" (2/10/88).

I would argue that the importance of ethnicity in the classification of art objects in the market is largely a result of the dissemination of Western scholarship and its particular vision of African art. Until fairly recently, most publications on African art were organized around the theme of "style regions" which divided the arts of Africa into discrete and easily identifiable ethnic zones. In her critique of this system of organization, Sidney Kasfir summarizes what is sometimes called the "one tribe, one style" paradigm by noting that according to this view "every tribe is a universe unto itself and . . . furthermore, the art of one tribe is quite meaningless to the members of another tribe" (1984: 171). Historian Jan Vansina offers a similar critique: "The identification by 'tribe' rested on the ingrained European belief that each then-catalogued ethnic group differed from all others in its customs and especially, apparently, in its visual arts, while all members of the 'tribe', on the other hand, wrought art objects in the same style" (1984: 29; see also Ravenhill 1988). The idea that there exists a direct relationship between ethnic identity and aesthetic style grows out of a Durkheimian assumption that "primitive" art is the creation of a collective mind instead of an individual artist.

In many publications on African art, writers have tended to use a core group of objects (from Western museums and private collections) which have come to symbolize, through repeated use in different publications, the quintessential aesthetic forms of individual ethnic groups.[21] Anything which deviates from

these "accepted" archetypes are judged in the art market as either inauthentic or unsaleable (see Chapter 5).

Hence, within the narrow parameters of minimal aesthetic deviation, an object is made to stand for the art of an entire ethnic group or culture. The result of this type of classification, Clifford has observed in a slightly different context, is to "create the illusion of adequate representation of a world by first cutting objects out of specific contexts (whether cultural, historical, or inter-subjective) and making them 'stand for' abstract wholes – a 'Bambara' mask, for example, becoming an ethnographic metonym for Bambara culture" (1988: 220; see also Stewart 1984: 162–65). Thus when a buyer purchases an object from a particular ethnic group, s/he is carrying away a slice of an entire cultural system.

The stereotypical view of ethnic attributions, which underlies the classification of art in both the tourist and collectible markets, constitutes a process which Dean MacCannell (1984) has termed "reconstructed ethnicity" and one which Nelson Graburn (1984) has called "secondary ethnicity." In this type of ethnic identity formation, the principal goal is for "the maintenance and preservation of ethnic forms for the entertainment of ethnically different others" (MacCannell 1984: 385). Ethnic attributes become commodities which can be bought and sold on the global market – ethnicity being reduced to a kind of typology of bare essences. In a famous essay in *Mythologies*, Roland Barthes linked this type of ontological reductionism to the demands of the tourist industry itself – a special brand of cultural knowledge which is produced and reproduced in tour books and brochures. "For the *Blue Guide*," writes Barthes, "men exist only as 'types'. In Spain, for instance, the Basque is an adventurous sailor, the Levantine a light-hearted gardener, the Catalan a clever tradesman and the Cantabrian a sentimental highlander. We find again here this disease of thinking in essences, which is at the bottom of every bourgeois mythology of man" (1982: 75). Ethnic groups, like their arts, can be colorfully mapped out on a poster from the Ministry of Tourism.

Masks, ethnicity, and the state

The Ivoirian government has had very little involvement in the African art market. In 1982, the Ministry of Tourism opened a branch, called the Direction de la Promotion de l'Artisanat d'Art (DPAA), which specializes in the promotion of Ivoirian art. The office published an eighty-page booklet, *Artisanat d'art de Côte d'Ivoire* which contains a wide selection of indigenous arts and crafts – everything from carved wooden masks to woven rattan floor lamps. The office was intended to facilitate access for foreign buyers to Ivoirian souvenirs and arts. As the booklet explains, "The National Office of Arts and Crafts exports its products to the whole world and may be consulted

at any time about the authenticity of Ivoirian Handicrafts" (Anon. n.d.a: 9–10). The DPAA was expected to increase the profits of Ivoirian artists by cutting directly into the earnings of professional art traders. This too is made clear in the introduction to the booklet: "We inform you that the National Office of Arts and Craftsmen [sic] is a promotion office which initiates and coordinates the different commercial and technical actions between craftsmen and customers. Thus, due to Government subsidies the Office profits are low and reduced as compared to the profit margins of private dealers" (Anon. n.d.a: 10).

On the whole, the DPAA has been completely ineffectual in achieving its goals. Foreign buyers have not chosen to place their orders through the government agency, but have continued to rely on their contacts in the market places. One of the unintended consequences of the publication of the DPAA booklet was that traders in the market place have used the booklet as a means of authenticating the objects they sell. Rather than cut into their profits, there-fore, the DPAA has actually helped traders in their work: "See," said a Wolof merchant to a French tourist while pointing to the government publication, "it's just like the one they published in this book" (3/3/88).

The Ivoirian government has made a second unsuccessful foray into the African art world through its planning and organization of large-scale masked festivals. These public "masquerades" were intended to fulfil the government's dual projects of (1) promoting international tourism in light of the country's most severe economic recession,[22] and (2) fostering national unity in the face of growing ethnic factionalism and tension. Although, as I shall argue, the ideological frameworks underlying these two goals are in many ways diametrically opposed to one another, the use of masks and masked dancing is an attempt on the part of the Ivoirian state to bridge the differences between these two nation-stabilizing strategies and mute their potential contradictions.

Masks and masking in Côte d'Ivoire are found in different forms in a variety of coastal and inland communities. Many of the estimated sixty ethnic groups in the country have their own style of mask carving and their own repertoire of masked dancing and performances. Although some aspects of masking are shrouded under a veil of secrecy and used only in the context of secret society activities, many forms consist largely of public displays intended purely for general entertainment. While these secular forms of masking are often carried out at the local level, they are sometimes incor-porated into public events organized by members of both regional and national government. A meeting of town mayors, a visit to a village by a district (préfecture) administrator, or a national tour by a high-ranking minister or diplomat are all events that would call for the performance of a masked festival. Although certain forms of secular masking probably found expression at the village level in pre-colonial times, I would argue that most public displays of masking became associated with political and bureaucratic events

during colonial rule. Huge masked festivals, for example, were organized each summer by the French to celebrate Bastille Day, while smaller masked festivals were often held at the ground-breaking reception for the construction of administrative buildings, at official ceremonies for the naming of city streets, or at the unveiling of colonial monuments (see Gorer 1935: 322–28).

Together with their function in national politics, masks and masking in post-colonial Côte d'Ivoire have, in recent years at least, played a critical role in the promotion of international tourism and the marketing of African art. Within the last decade, the mask has been appropriated by the Ivoirian state as a symbol of national identity or character.[23] As Duon Sadia, the Ivoirian Minister of Tourism, noted in a 1987 interview: "Because Côte d'Ivoire does not possess pyramids or grand ancient monuments like Egypt or Mexico, and because it does not have an abundance of wildlife like some of the countries in East Africa, Côte d'Ivoire has chosen to promote itself through its only indigenous product, Ivoirian man himself – with his culture and his traditions, of which masks and masking are an integral part" (Bouabré 1987b: 8). In another interview, the Minister of Tourism further clarified the specific function of masks in the development of the modern Ivoirian polity by noting that:

We now declare that the trademark [of Côte d'Ivoire] will be the mask, for it is representative of this country, rather pleasing to the eye, and enshrouded with an air of mystery. The mask could arouse the curiosity of foreign tourists and lead them to visit our country. We have [therefore] chosen the mask for we believe that it integrates several aspects of our culture and civilization. The mask encapsulates the traditional arts of Côte d'Ivoire, and represents the strength and history of our nation. (Philmon 1982: 13)

The promotion of tourism through the marketing of the image of the mask represents, in point of fact, a radical departure in the rhetoric of the Ivoirian state. Less than a decade before this recent campaign, for example, Félix Houphouët-Boigny, President of the Republic and founder of independent Côte d'Ivoire, declared to a congress of the National Democratic Party: "We are fed up with having Africa relegated, through the futile gaze of the observer, to a land of sunshine, rhythms, and innocuous folklore" (quoted in Boutillier, Fiéloux, and Ormières 1978: 5). For Houphouët-Boigny, in his first years of power after independence, both national integration and international economic success were to be found in the promotion of modern industrial technologies rather than in a return to traditionalism or the recreation of a "primitivist" aesthetic.[24]

Hence, in light of this philosophy, how can one explain the state's sudden shift toward traditional cultural resources and, in particular, its appropriation of the mask as a symbol of national, multiethnic pride? I would argue that this return to traditionalism is a direct result of the nation's financial collapse following the failure of its cash-crop export economy – beginning sometime in

(1980 (Brooke 1988). That is to say, as long as Côte d'Ivoire enjoyed economic prosperity through its production and export of cacao and coffee, the state used its success in the international economy as a device for rallying nationalist sentiment. It needed nothing else. Following the dramatic collapse of the price of cacao and coffee in the world market, however, politicians scrambled to find not only a new source of foreign income but also a new gathering point for nationalist sentiment. The mask was thought by some to be capable of achieving both. On the one hand, it fueled the Western imagination through its mystery and exotic appeal. On the other hand, it reconciled growing ethnic divisions by elevating the symbolism of the mask – with its plethora of ethnic styles and interpretations – to a single, national icon.

The first attempt by the government of Côte d'Ivoire to promote tourism and national solidarity through the use of African art was the festival of masks in the town of Man which was held on April 14–15, 1979. The festival was organized by Bernard Dadié, the Minister of Cultural Affairs. On the whole, the festival was poorly attended, and it received very little coverage from the Ivoirian press (only three short articles in the semi-official daily newspaper *Fraternité Matin*).

The second masked festival was organized by the Minister of Tourism, Duon Sadia. It too was held in the town of Man from February 11–15, 1983. In the second festival at Man, there was a more overt effort on behalf of the government organizers to use African art as a symbol of Côte d'Ivoire and as a mechanism for attracting the financial benefits of tourism. The masked festival at Man, Duon Sadia noted at a press conference held at the luxurious Hotel Ivoire in Abidjan, "will be the equivalent of Carnival in Rio, with an added element of the profound soul and mystery of 'non-commercialized' Africa" (Anon. 1983: 19).[25] The 1983 festival of the masks at Man was again reported by the press to be an overall failure. Very few tourists went to the festival. And the mask-bearers, who felt they were being treated without sufficient respect, refused to appear on stage. A delegation, consisting of three national ministers and a district representative, had to plead in public with the masked dancers to come out and perform for the small gathered crowd (Djidji 1983: 11).

The Ivoirian state's appropriation of the mask reached its epitome in the summer of 1987, when the Ministries of Tourism and Culture jointly organized a national masked festival. Promoted under the name "Festimask," the festival was funded by the state at an estimated cost of $500,000. Unlike previous state-sponsored masked festivals which were organized by district administrators with the exclusive participation of local ethnic groups, the Festimask attempted to bring all the ethnic groups of Côte d'Ivoire into a single event which, not surprisingly, was held in the President's home town of Yamoussoukro, in the center of the country.[26] The location of the festival was moved from Man to Yamoussoukro for several purposes.[27] The official reason reported in the

national newspaper for holding the festival in Yamoussoukro was because of its proximity to the economic capital and port city of Abidjan – thereby, the argument went, encouraging more expatriates and more tourists to attend the festival of masks. However, the unstated reason for the site of the event, I would argue, was to link the festival of masks and, more generally, the symbolism of masks and masking to the national government through its association with Houphouët-Boigny's natal village and place of retreat.

When the masked festival was moved to Yamoussoukro in 1987, it became not only a vehicle for promoting international tourism, it was also used as a means of stressing national unity. Since the end of the colonial period, many burgeoning African nations have had to push for national unity in the face of internal ethnic factionalism. Although cultural pluralism may be profitable within the realm of the international art market, it is often perceived as a major obstacle in the domain of centralized state politics. As Immanuel Wallerstein noted in 1960, "The dysfunctional aspects of ethnicity for national integration are obvious. The first is that ethnic groups are still particularistic in their orientation and diffuse in their obligations . . . The second problem, and one which worries African political leaders more, is separatism, which in various guises is a pervasive tendency in West Africa today" (1960: 137–38).

Until recently, post-colonial Côte d'Ivoire had a history of successful national integration. In a country made up of approximately sixty different ethnic groups, this record of success is an impressive triumph. One of the reasons which accounts for successful integration of ethnic groups in Côte d'Ivoire is the rapid growth and expansion of the Ivoirian economy – the so-called Ivoirian "miracle" which took place from 1960 to 1980.[28]

Because a majority of Ivoirian nationals were reaping the benefits of favorable transnational trade, it was to their (economic) advantage to remain united under a national economic cause (Dozon 1985: 53–54). Since the economy has weakened, however, in the past several years, it could be argued that ethnic factionalism has become an increasing concern to the representatives of the centralized Ivoirian state. Viewed in this context, then, the masked festival at Yamoussoukro was yet another way of promoting nationalist sentiment in the face of growing ethnic factionalism. The Festimask respected ethnic heterogeneity, i.e., each masked performance was associated with a different and unique ethnic style, while, at the same time, it brought disparate ethnic groups together into a single, united cause.

The Festimask stresses national unity in at least two ways. First, it aims to bring the ethnic distinctions embedded in styles of art into a single "folkloric" category. All masks, said the organizers of the festival, are to be thought of as members of the PDCI (Partie Démocratique de Côte d'Ivoire). And, all masks are to be considered Ivoirian patriots struggling for the good of the modern nation-state (Gnangnan 1987). Secondly, the festival of masks strives to bring

the concerns of the older generation (the so-called *mentalitées traditionelles* of the rural population) into step with national concerns, such as the promotion of international tourism and the President's long-standing campaign for West African regional peace. In the context of Festimask, the mask is a tool of the modern nation-state that serves "rational" political goals while being presented to both nationals and foreigners as a kind of "traditionalizing instrument" (Moore and Myerhoff 1977: 8–9; see also Ranger 1983). At a press conference held to clarify the role of the mask in the nationalist party, the Ivoirian Minister of Tourism, Duon Sadia, said:

When we say that the mask must become militant, we mean to signal that the mask must no longer transmit the knowledge of the ancestors in a mechanical way without any explanations. The mask must become a spokesman – communicating in the common language of our culture – for the message of peace. The performance [of Festimask] is not intended to caricature our traditional values, but rather it is aimed to preserve these traditions by adapting them to the exigencies of the modern world. (Bouabré 1987b: 8)

The Festimask was thus intended to collapse divisions in *both* space (i.e., ethnic geography) and time (i.e., generational differences).

According to Ernest Gellner, there are at least three pre-conditions for the flourishment of state nationalism: (1) that a population be culturally homogenous without internal ethnic sub-groupings; (2) that a population be literate and capable of authoring and propagating its own history; and (3) that a population be anonymous, fluid, mobile, and unmediated in its loyalty to the state (1983: 138; see also Handler 1988). International tourism in most of the developing world hinges on the exact opposite criteria from those which underlie the foundation of state nationalism. First, international tourism demands that a population be as culturally and ethnically diverse as possible. In Côte d'Ivoire, for example, the tourist art market is driven by the production of a large variety of supposedly autochthonous and stereotyped ethnic arts.[29] Second, international tourism seeks to discover a population that is *il*literate, and without a sense of historical knowledge or a proper understanding of its geographic place within the world system. And third, international tourism calls for the existence of small-scale populations in which there is no anonymity, in which whole societies recognize each and every one of their members, and in which long-distance communication is not possible among putatively isolated groups. In essence, therefore, the demands of state nationalism and the demands of international tourism are situated at opposite poles in the realm of possibilities concerning the individual's relationship to society.

The organization of Festimask was an attempt by the Ivoirian government to satisfy *simultaneously* both the monolithic requirements of effective state nationalism and the polymorphic demands of successful international tourism.

By elevating the mask to a national icon, the state was attempting (1) to subvert ethnic differences; (2) to emphasize an indigenous form of national literacy and ethnohistorical consciousness; and (3) to create a national category of aesthetic identity through the hidden and anonymous face of the mask. At the same time, however, the state was also trying to encourage international tourism by stressing both the visual diversity in ethnic material productions and the exoticism of the masked dance itself.

Although the aims of the Festimask were both complex and diverse, its results were unambiguous. Tourists, art traders, and nationals all judged the event as a complete failure. Tourists stayed away from the Festimask because, I was told by one, they anticipated a large, staged, "tourist" event. The art traders who had attended the festival in order to ply their wares to tourists were very disappointed by the poor turn out. And nationals were disgusted with the Festimask because they felt they had been treated without respect – like pawns in a commercial venture. As one of the elders who attended the Festimask put it to a representative from the Ministry of Information:

My son, we went to Yamoussoukro, and we were happy for we had been invited to the village of our President . . . But you should know that nobody took care of us; nobody even provided us with food, and that just isn't normal. Not only were we not greeted by the organizers of the festival, as is the custom, but when we [finally did get some food] it was their leftovers that we were sent to eat. (Anon. 1987b)

I would argue, in sum, that the masked festival failed in the eyes of both Ivoirian nationals and foreign tourists for the same reason. In both instances, the Festimask was viewed as an inauthentic event because it had been, as it were, too "modern" in its tactics and too insensitive to the demands of "custom." The appropriation of the hidden face by the hidden hand resulted in a particular form of the commoditization of ethnicity, in which neither the producers nor the consumers were willing to strike a bargain.

5 The quest for authenticity and the invention of African art

The concept of "authenticity" is among the most problematic and most difficult issues in the study of African art. Yet, despite its central relevance, and the frequent use in the literature of such terms as "real," "genuine," and "authentic," the subject of authenticity has received surprisingly little attention by scholars in either the fields of anthropology or art history.[1] The definition of authenticity in African art draws upon connections among such disparate issues as cultural or ethnic "purity," historical timing or periodicity, and artistic or commercial intentionality. In this chapter, I will review the definitions of authenticity in the literature on African art which have been set out by Western academics, dealers, and collectors. I will then consider the way in which African art merchants have interpreted the Western notion of authenticity, and how, in particular, they have tailored the concept to fit their own under-standing of African art. In addition, I will discuss the fascination with age in the Western appreciation of African art, and the artificial reproduction of antiques which results from this fascination. I will examine both the classifi-cation of aesthetics and the construction of the category "art," and their relevance to the contemporary African art trade. I will analyze the recirculation of "trade beads" as an example of how the familiar gets transformed into the exotic. And, I will end with some brief thoughts on, what I call, the "crisis of mis-representation" in modern transnational exchange.

The authenticity of African art

The definition of authenticity in African art that is most current among academics and dealers alike combines elements concerning an object's condition and history of use, intended audience, aesthetic merit, rarity, and estimated age. Thus, an authentic piece of African art, dealer Henri Kamer tells us, "is by definition a sculpture executed by an artist of a primitive tribe and destined for the use of this tribe in a ritual or functional way" (1974: 19). In

100

defining authentic African art, it is commonly asserted that there should be no intention of economic gain on the part of the artist. "The sculptor who creates these fetishes and masks," Kamer goes on to say, "does so without any thought of profit, in the same spirit that an inhabitant of the Cyclades executed an idol in marble 5,000 years ago" (1974: 19). Or, using a slightly more veiled language, African art connoisseur Raoul Lehuard has said that, "In order for a sculpture to be authentic, it must not only be derived from a formal truth, but its language must also be derived from a sacred truth" (1976: 73). The age of an object generally conditions its commercial viability. "In judging authenticity," writes American collector/dealer Herbert Baker, "except for a few recently discovered tribes or areas, pre World War II seems to have validity inasmuch as there was little or no commercial market" (1973: 7).

Drawing on similar themes, but using a rather more "technical" form of discourse, African art scholar Malcolm McLeod defines an "authentic" African art object as "any piece made from traditional materials by a native craftsman for acquisition and use by members of local society (though not necessarily members of his own group) that is made and used with no thought that it ultimately may be disposed of for gain to Europeans or other aliens" (1976: 31). And, in a similar vein, African art appraiser Carl Provost is of the opinion that:

An authentic piece must be produced for group use by an artist belonging to it or to a related group; the basic materials (with the exception of materials from outside sources incorporated into the object for specific purposes of decoration, protection, or magic) utilized in the creation of the piece must be indigenous to the region, and the object must function within the group in accordance with its traditions. (1980: 141)

Regardless of whether an object dates from this century or the last, it is always judged inauthentic by Western evaluators if it has not been used in a "traditional" manner. "The most obviously authentic works on which all would agree," writes art historian Frank Willett, "are those made by an African for use by his own people and so used" (1971: 216). From an anthropological perspective, William Bascom reaches the same conclusion when he notes that: "A piece may have been carved many years ago but if it was never used, perhaps because the customer who commissioned it died unexpectedly, it is not 'authentic'" (1976: 316).

African art traders understand very well the parameters of "authentic" African art as defined by Western collectors and appraisers. The language they use when speaking about objects is influenced heavily by their comprehension of Western taste, and its associated perception of authenticity. Almost nothing in the market is ever sold as "new." If pushed by a disbelieving customer, a trader might eventually concede that something he is trying to sell is only "a little old" or that "It's not ancient, but it wasn't made today." He would never

state outright, however, that an object is brand new. If age is in doubt, then the condition and usage of an object would be stressed: "The mask has danced," or "It's been around," or "It's been used until it's been tired out [*fatigué*]". If all else fails, then the uniqueness or rarity of an object is played up in the course of a sale: "I don't see why you didn't take this [object]. It's very important. You mustn't leave it" or "There isn't another one like this anywhere in the market place. If you find one like this, I'll give you this one as a gift."[2]

Although African art traders have incorporated into the vocabulary of their discourse the Western-oriented themes of age and antiquity, condition and usage, and uniqueness and rarity, I never heard a trader actually use the word "authentic" (in French, *authentique*). Most of the traders divide the objects they sell into two broad categories: old (*ancien*) and copy (*copie*). If asked to analyze the terms further, most traders with whom I spoke said that all the objects in the market should in fact be referred to as copies. A more accurate way of classifying the types of art objects they sell is to draw a distinction between an older copy and a more recent one. Dramane Kabba explained:

At the beginning, there was only one of everything that you now see in the market place. When the Europeans came, they took these things with them and put them in the museums and in the books. After that time, everything became a copy [of what was in the books]. A copy can be a hundred years old or it can only be a few years old, but everything is a copy of those first objects which are now in the museums and in the books. (3/2/88)

The trader's statement reveals an understanding of authenticity that is, at its core, significantly different from the concept of authenticity which is held widely in the West. First, according to Kabba's remarks, the original (i.e., the "authentic") objects of African art are all in Europe – they have been removed from circulation and they are, therefore, unattainable.[3] This aspect of the trader's concept of authenticity reverses the spatial/temporal chrono-geography of the Western concept. While the Western version of authenticity focuses on pre-colonial Africa as the locus of "genuine" African art (i.e., a vision that is oriented toward distance in time), the trader's version of authen-ticity focuses instead on contemporary Europe (i.e., a vision that is oriented toward distance in space). For the Westerner, authentic African art only existed in the past, *before* European contact. For the trader, authentic African art only exists in the present, *after* European contact, when the objects were taken out of Africa and declared by the Western authorities to be authentic. The trader's formulation of authenticity thus depends upon contact with Europe to discover the inherent value of an African art object.[4]

A second reversal of the Western concept of authenticity occurs at yet another level of the trader's statement. Unlike the Western collector or dealer who focuses on the object itself as the source of authenticity, the trader views

authenticity as something which emanates directly from the pages of a book. This point turns on its head Walter Benjamin's celebrated notion of the "aura" of an authentic work of art. "The presence of the original," wrote Benjamin:

is the prerequisite to the concept of authenticity . . . Confronted with its manual reproduction, which was usually branded as a forgery, the original preserved all its authenticity; not so *vis à vis* technical reproduction . . . [T]hat which withers in the age of mechanical reproduction is the aura of the work of art . . . By making many reproductions it substitutes a plurality of copies for a unique existence. (1969: 220–21)

For Kabba, in contrast to Benjamin, it is the book itself which holds the "aura" of truth about an object. It is the book which provides an original with which to measure or gauge the quality and accuracy of all subsequent "copies."[5]

The authority of the text, and the distance which is felt between the trader and that which is represented in the book, is plainly illustrated by the miscommunication in the following encounter. The owner of an African art gallery in Abidjan published a catalogue of a collection of masks and statues that were to be sold from her gallery. An American collector of my acquaintance purchased a mask from her gallery, and displayed it in his Abidjan home. Abdurrahman Madu was at the collector's house one day trying to sell him some art. The collector pointed out to him the mask that hung on the wall, and showed him the photograph of the same mask that was reproduced in the book. Madu compared the photograph with the object and told the collector that he had really done well: "The mask looks exactly like the one in the book." When the collector explained that the mask was the *actual* piece that was in the book, the trader replied, "Yes, I see what you mean, the resemblance is almost perfect. It's an excellent copy" (2/18/88).

The death of culture and the birth of fakes

A fascination for antiquity and things from the past runs deep in Western culture. An *objet d'art*, like a fine bottle of wine, is said to improve with the passage of time. Visible signs of age are demonstrated by the outward effects of decay – scratches, tears, chips, cracks, bruises, corrosion, and patina. These marks of wear, writes historian David Lowenthal, "are prized as personal links with the past, like the arms of an old rocking-chair whose lacquer and staining had succumbed to long and constant rubbing" (1985: 152; cf. Shils 1981: 63–77). As the supply of antiques dwindles, however, some artists and forgers are tempted by economic motivation to simulate the effects of natural age. Roman fondness for original Greek art, for example, is said to have led to the production of "weathered" copies. In the Renaissance, the young Michelangelo was persuaded to age artificially the surface of a marble sculpture of Cupid

by burying it for a time in the dirt. "When it was done," Vasari writes, "Baldassare de Milanese caused it to be shown to Pierfrancesco, who said 'If you buried it, I feel sure that it would pass for an antique at Rome if made to appear old, and you would get much more than by selling it here'" (1927 ed.: 4: 113). And, in a similar fashion, Giovanni Baglione reported in 1642 that after darkening a painting with smoke, Terenzio da Urbino added variegated layers of varnish and dressed a decrepit frame with shabby gilt "so that his work eventually looked as though it were really old and of some value" (quoted in Arnau 1961: 43).

One aspect of the Western image of Africa which resonates throughout the African art collecting world is the notion that authentic Africans, and by extension authentic objects of African art, no longer exist. Like the societies themselves, contemporary art objects produced in Africa are considered inauthentic approximations of traditional forms, sullied, as it were, by the degenerative impact of Western influence. Real African art, the argument goes, consists of old objects which were manufactured in the pre-contact or pre-colonial era for indigenous use. "The problem begins," art historian William Rubin explains, "when and if a question can be raised – because of the alteration of tribal life under the pressure of modern technology or Western social, political, and religious forms – as to the continuing integrity of the tradition itself" (1984: 76). Commenting on this passion for appropriating "genuine" cultural products, James Clifford has suggested correctly that "authenticity in culture or art exists just prior to the present, but not so distant or eroded as to make collection or salvage impossible" (1987: 122; see also Handler 1986).

Both the museum and the art market thrive on this particular vision of an African world, whose rapid spin into decay is set immediately in motion by the contagion of Western contact. In the context of a Western museum, one notices a reverence for the past which is expressed both in the language of explanatory text and in the symbolism of display. Even when referring to living popu-lations, for example, museum label copy is often written in past tense (Clifford 1985: 171). Like objects suspended mysteriously in space on mounts of translucent Plexi, cultures are suspended enigmatically in time within the vacuum of preteritive language. Objects that show signs of Western influence are judged impure and unworthy of either serious scholarly research or art collection with an eye toward investment. Ladislas Segy, a once prominent dealer in African art, illustrates the collector's negative attitude toward Western influence when he writes: "[W]hen actual European penetration undermined the ideological background for carving[,] the artwork [of Africa] degenerated" (1958: 23). And, in a similar vein, art critics Paul Guillaume and Thomas Munro noted as early as 1926 that, "the coming of the white man has meant the passing of the negro artist; behind remains only an occasional

uninspired craftsman dully imitating the art of his ancestors, chipping wood or ivory into a stiff, characterless image for the foreign trade" (1926: 13).

The concept of the "death of culture" was used by early anthropology as a means of legitimating its burgeoning status as a science of preservation, where artifacts stood as visible symbols salvaged from the ravages of a decaying modern world. The same concept, however, was also necessary to twentieth-century European artists who could only "discover" African art in a context freed from the encumbrance of a living African artistic counterpart with an alternative voice, and a different evaluative language. For artists like Picasso and Braque, the producers of African art were silent not only because they lived in lands that were oceans away, nor simply because they communicated in unfamiliar tongues, but more profoundly because their world view was stifled, quite conveniently, by the West's summary dismissal of whatever constituted "authentic" African culture. Finally, the "death of culture" concept reappears once again in the context of the contemporary art market. Here, it functions to inflate price by creating an artificially limited supply. Commenting on this process in both the "modern" and "primitive" art markets, Joseph Alsop has written:

On the most superficial level, it is a truism of the art market that the works of a dead but still-admired master are more valued than the works of a master still alive and currently productive. Death limits the supply; the law of supply and demand begins to operate; and so $2,000,000 comes to be paid for a Jackson Pollock, significantly described as one of the last of Pollock's major works to be available. In the same fashion, collectors', museums' and the market's interest in American Indian artifacts has been growing rapidly for a good many decades. Yet it seems most unlikely that this would be the case if the West were still dotted with trading posts where [one could cheaply obtain] admirable examples of quill work and beadwork, featherwork, blankets, pottery, wood carvings, and the like. While that was the situation, no one was interested in Indian artifacts except for a tiny number of ethnologically minded persons.[6] (1982: 21–22)

Emphasis on age not only creates a limited supply which is beneficial to those who have a stake in controlling the African art market, but it also denies artistic capacity to those who could benefit by producing for the contemporary trade. Modern work, including so-called tourist or "airport" art, is considered a demon in the cult of antiquity. In a widely circulated book on African art, Elsy Leuzinger commented: "If tourists want masks and sculptures, then they shall have them, as many as they wish! But what is produced is of most questionable value: works without any cultural roots or artistic content" (1960: 209). It is only in recent years, in fact, that tourist art has been the subject of any serious anthropological inquiry (e.g., Ben-Amos 1971; Graburn, ed. 1976; Jules-Rosette 1984). And, with few exceptions, it is still considered an inappropriate subject for art history (see Adams 1989; Kasfir 1992).

If the "death of culture" increases art market profits by limiting the supply

of authentic art, it also creates in its own wake the birth of its worst enemy – an industry of fakes, forgeries, and frauds (Allison, *et al*. 1976; Maurer 1981; Schoffel 1989). Devised to deceive the consumer, the fake object of African art is far more troublesome to the collector than the petty production of tourist crafts. African art historian William Fagg once referred to a fake as, "a work of the devil and a sin against art" (quoted in Sieber 1976: 22). And, in another instance, fakery was even placed on an equal footing with a parasitic tropical disease: "Mr. Kahan [a New York City art dealer] goes to the African continent two or three times a year, where he must fend off both new strains of dysentery and a profusion of art fakes (two out of every three pieces)" (Anon. 1982: 15).

Those who fake – both European and non-European art merchants and artists – capitalize on the "death of culture" by creating objects that imitate signs of age, ritual wear, and indigenous use. Armed with a highly sophisticated technology of *re*-production, the faker can simulate a thick accretion of soil and soot which would result from object storage in the rafters of a village cooking hut, the "sweat marks" on the inside of a mask which testify to its extensive use and wear (i.e. suggesting that the mask, as they say, has actually been "danced"), layers of feather and blood encrustation which build up after years of sacrificial libations, and a gleaming surface patina which results from decades of extensive object handling. Even an object's collection history can be forged by the faker's art. Inagaki, a Japanese mount maker who died in Paris shortly after the Second World War, was known for the exquisitely crafted mounts which he made during the early decades of this century for dealers and collectors of African art. Art forgers have imitated Inagaki stands in order to underscore an object's aura of authenticity, thereby falsely dating to the prewar period the sculpture which the mount supports (S. Vogel, ed. 1988: 4).[7]

Taxonomy and hegemony

In his review of the MoMA exhibition, *"Primitivism" in 20th-Century Art*, Clifford concluded that whatever else it may have represented the event stood as a document of a *"taxonomic* moment" in the history of art; a moment when African art and modern art were brought together on an "equal" footing; a moment when the status of so-called "primitive" objects was profoundly elevated and redefined (1985: 170). However, like any moment in a system of classification, the order and division among types is not permanent. Like the ephemeral power of a "big man" in the New Guinea Highlands, African art's moment of glory can be wiped easily away and replaced by another art form which is raised by its fall.

Taxonomies are always constructed by interested individuals to tell a particular story. They are never objective, neutral, or without intentionality. "[I]n nation-states," Shelly Errington observes, "objects associated with the

past require an interpretation to place them within the historical narrative that tells what they are and what their relation is to the present" (1989: 53). A contemporary example is the display of Aztec, Maya, and Olmec objects in the National Museum of Mexico, where artifacts are pressed into service as evidence of the state's glorious past (ibid.: 53; cf. Anderson 1983: 178–85; Wallis 1991).

African art has been the subject of numerous, often radically different, systems of classification. Cultural critic and philosopher V. Y. Mudimbe has noted that what "is called savage or primitive art covers a wide range of objects introduced by the contact between Africans and Europeans during the intensified slave trade into the classifying frame of the eighteenth century" (1988: 10). Though appearing fixed, and thereby natural, the frames of classification are constantly being negotiated and reconstructed (see Blier 1988–89). Dividing the world roughly in half, nineteenth-century evolutionists viewed the arts of one portion of humanity as a yardstick with which to measure the arts of the other. Their classification was intended to tell a story of human progress and the triumph of Western civilization. Twentieth-century artists reclassified African art in order to validate, and even heighten, their own modernist enterprise. Theirs is a story of discovery, affinity, and the generous reconciliation of two disparate artistic traditions. Today, African art dealers in Europe and America rank the arts using economic criteria. They confer value on certain objects and withhold it from others. Their system of classification establishes the boundaries of the market, and prevents those on the fringe from participating in the trade.

Whatever the intent of a particular taxonomy of African art, the point is that objects are stripped of their original meanings and manipulated to fit the agenda of the moment. Power differentials are always at play. As Clifford says: "The relations of power whereby one portion of humanity can select, value, and collect the pure products of others need to be criticized and transformed" (1985: 176). The shift of African objects from artifact into art has little to do with an objective change in the quality of the objects themselves but is a direct result of what several authors have characterized as a peculiar form of Western generosity which presents itself in a guise of cultural relativism. Sally Price writes: "The 'equality' accorded to non-Westerners (and their art), the implication goes, is not a natural reflection of human equivalence, but rather the result of Western benevolence" (1989: 25). And later, she goes on to add, the "Western observer's discriminating eye is often treated as if it were the only means by which an ethnographic object could be elevated to the status of a work of art" (1989: 68). In a similar tone, Clifford notes: "Turning up in the flea markets and museums of late nineteenth-century Europe, these objects are destined to be aesthetically redeemed, given new value in the object system of a generous modernism" (1985: 172).

The classification of African art has had a direct impact both on the market for old objects and on the current production of art for international trade. Taxonomies fix African art in stereotypical forms so that the market does not reward the production of artistic novelty. "[I]ndividual creativity beyond bounds set by Westerners," explains Jeremy MacClancy, "is generally unwanted. An object difficult to categorize can be difficult to sell" (1988: 172). Raoul Lehuard, a noted African art collector in France, confirmed MacClancy's observation when he declared: "An object is a fake when its forms are extraneous to the statuary repertoire of a given ethnic group" (1976: 74).[8] The art of Anoh Acou, a Baule woodcarver working in the West African beach resort of Grand Bassam, offers a case in point. Rather than imitate other tourist arts, which either copy "traditional" masks and statues or depict images of wildlife that stand as Western symbols of idyllic Africa, Anoh Acou carves wooden suits, formal shoes, baseball caps, crushed aluminum cans, "boom box" radios, and telephones. The market, however, does not reward his artistic talent and inventiveness. Images of progress and change do not have a place in the West's vision of Africa; they cannot be situated easily in the taxonomy of non-Western art (Jules-Rosette 1990: 29–30).

Constructing the category art

African art entered the West with a certain degree of trepidation. Unsure of its proper place in the hierarchy of the world of goods, Westerners first assigned African art to the category of curiosity, where objects were worthy neither of scientific investigation nor aesthetic appreciation. Natural and artificial objects gathered from the conquest and exploration of foreign lands were arranged together in the "cabinets of curiosities" belonging to Europe's elite. Throughout this early period, ethnographic specimens were collected haphazardly and displayed in a cluttered mass. "Because there was no *Systema Naturae* . . . by which to arrange them and precise terminology with which to discuss them" writes Adrienne Kaeppler, "few [collectors] took them seriously" (1978: 37). The objects were valued principally as trophies – icons of conquest attesting to unbridled Western power in the Age of Discovery (see Steiner 1986a).

In the second half of the nineteenth century, when the field of anthropology began to evolve from amateur avocation to scientific enterprise, the status of African art was elevated from artificial curiosity to ethnographic artifact. Random and unordered collections were given new meaning as they were subsumed within a then burgeoning museological branch of anthropological science. Pitt-Rivers, for example, who was among the first to promote the systematic collection, storage, and display of ethnographic artifacts, wrote in 1875 that the "products of human industry, are capable of classification into genera, species and varieties, in the same manner as the products of the

vegetal and animal kingdom" (1875: 307). Artificial curiosities were thus admitted to the kingdom of science – having been assigned their own version of a *Systema Naturae*.

The conceptual reclassification of material culture was followed quickly by a physical relocation of the objects themselves. In 1884, for example, the artifacts collected by Pitt-Rivers were placed in a museum which had been built especially for them at Oxford (Gerbrands 1990: 17). African art was thus moved from private display to public domain – from the wonder cabinets of the leisured class to the popular halls of ethnographic museums and world expositions. In their new context, African art objects were perceived as visual windows through which one could catch a fleeting glimpse of "primitive man." Though making a pivotal transition from personal prize to public specimen, the objects of anthropology were still intertwined with those of what were then considered to be associated scientific disciplines – e.g., paleontology, entomology, gemology, and geology. Commenting, for example, on the status of American Indian art at the American Museum of Natural History, Edmund Carpenter has written: "On public display was an incredible wealth of Northwest Coast art. Yet every piece was classified and labeled as scientific specimen. Tribal carvings were housed with seashells and minerals as objects of natural history" (1975: 11). While developing their plans for the opening of the Musée d'ethnographie du Trocadéro, Paul Rivet and Georges-Henri Rivière emphasized in 1929 that "primitive" artifacts were to be understood as "objects of knowledge" that were meant to inform instead of please (Jamin 1985: 60–63). As such, it was argued, the artifacts were privileged in their capacity for revealing dispassionate ethnographic truths. According to Marcel Griaule, in a manual he prepared for his team of researchers on the 1931–33 Dakar–Djibouti expedition, ethnographic objects were to be collected and stored systematically since they provide "an archive more precise and more revealing than the written word itself" (quoted in Jamin 1982: 90).

African art made a second fundamental category shift sometime in the early years of the twentieth century when a group of Parisian artists first discovered the art that was embedded in the category primitive. "We owe to the voyagers, colonials, and ethnologists," writes Rubin, "the arrival of these [African] objects in the West. But we owe primarily to the convictions of the pioneer modern artists their promotion from the rank of curiosities and artifacts to that of major art, indeed, to the status of art at all" (1984: 7). For these twentieth-century artists, objects of African art did not derive their meaning from an ethnographic context but were of interest only when *dépaysé* – stripped of all contextual references and indigenous symbolic meanings (Jamin 1982: 89).

This second shift in the conceptualization of African art was, however, less encompassing than the first. That is to say, while the early anthropologists were democratic in promoting *all* artificial curiosities to scientific specimens,

artists and (later) art historians were more discriminating in their selection of which objects would be permitted to pass from artifact into art. Items that were thought to speak across cultural barriers were judged as works of art, whereas those considered impervious to cross-cultural interpretation remained locked in the artifact class. Currently, one of the most articulate proponents of the art/artifact distinction is Susan Vogel, founder and director of The Center for African Art in New York City. She takes the view that a

pedestrian bundle of sticks communicates only within its own culture where understanding may depend, for example, on the knowledge that it contains branches from specific medicinal plants with particular powers ... [A carved] figure, on the other hand, has an expressive dimension and, if it is good, I venture that it will communicate something of its import even when we do not know what its intended content is. (1981b: 76)

Vogel is well aware that her proposition becomes problematic the moment we are called to judge for ourselves whether or not the figure is "good." If we do not understand the intended content of the work, how are we to know on which scale to weigh its symbolic load?

Although there are some noteworthy exceptions, participation in the art/artifact distinction tends to be divided along academic disciplinary lines. Art historians, on the one hand, generally legitimate their scholarly interests (and negotiate their research funds) by insisting that the formal aesthetic character of African art is entirely capable of being analyzed and taught through the lens of Western art historical discourse. Most anthropologists, on the other hand, justify their *raison d' être* by arguing that objects can be understood only within an appropriate ethnographic context. Those favoring a universal category of art, disparage anthropologists for their attention to ethnographic detail which, they say, suffocates the object's aesthetic below a mass of academic dogmatism. Furthermore, they suggest that emphasis on cultural context diminishes an object's capacity to *stand alone* as a genuine aesthetic creation. "The motives for this insistence [on context]," writes James Faris, "while perhaps honorable (and of paramount importance to the discipline [of anthropology]), could be argued to deny objects of the Other any potential on their own – any freedom from the security of context – almost as if in their emancipation they might be revealed as, well, primitive" (1988: 778–79).

Capitalizing on the category art

The debate over definitions of art and artifact has implications which stretch beyond the geo-politics of academic disciplinary frontiers. Indeed, the dichotomy is of central concern to participants in the African art market – where the distinction between an artifact and a work of art can mean a significant difference in an object's price tag. "The continuum from ethnographic

artifact to *objet d'art* is clearly associated in people's minds," writes Price, "with a scale of increasing monetary value and a shift from function (broadly defined) to aesthetics as an evaluatory basis" (1989: 84). Western dealers of African art drench the objects they sell in the radiance of the category art – displaying objects in pristine, context-free conditions and often criticizing the pedestrian craft of anthropology.

Drawing on a metaphor implied in the philosophical writings of Arthur Danto (1981), Errington has proposed that the category art be envisioned as a container (such as a bag) into which objects are stuffed until there exists such tremendous diversity and quantity that the container threatens to burst. No participant in the art world would want to destroy the bag (since, after all, the category art is meaningful only if it can be juxtaposed to whatever else is *not* art), yet because the category takes on greater significance and value the more limited it is in scope, all the participants in the art world want *their* class of objects to be the last one dropped into the bag – after which it would be sealed shut. Errington writes:

Curators of Renaissance paintings may shut the Art bag long before African masks can be dropped into it; curators of African masks and Benin bronzes, for their part, might insist that the items they care for should be inside the bag, but that nineteenth-century American Indian baskets and beaded shoes should be outside; dealers in "quality" "non-Western art" may insist that Navaho rugs and old Pueblo pottery should be dropped into the bag but draw the line at mere "curios" like post-World War II Zuni "fetishes," Alaskan stone carvings, and Southwestern silver jewelry made explicitly for the tourist market. (Errington forthcoming)

Research on the contemporary African art market reveals an ever-broadening expansion of the category African "art." As the supply dwindles on the African continent of what dealers and collectors classify as "authentic" African art – ideally masks and figural statues created for indigenous use before the advent of colonialism – the definition of collectible art grows in Europe and America to encompass what previously had not been appraised as legitimate art commodities.[9] Thus, more and more objects are dropped into the imagined bag. Once considered products of recent "culture contact" (and therefore as inauthentic works of art), so-called "colonial" figures – mostly polychrome statues representing either Africans in Western attire or Westerners in colonial garb – are now making the transition to the category art (see Chapter 6).

One former "artifact" which recently crossed the proverbial threshold into the world of "art" is the African metal currency. At an East Side Manhattan gallery, a recent exhibition, "Symbols of Value: Abstractions in African Metalwork," featured various forms of indigenous African iron wealth. Although previously dealing in medieval and ancient art, the gallery owner ventured into the world of African art by presenting metal currency "not as

ethnic materials, but as abstract sculpture" (Reif 1988: 37) with "its strong silhouettes, powerful shapes, and subtle textures" (Ward 1988: [1]). The abstract qualities of the objects were underscored in the gallery by intense boutique lighting and dramatic framing of single pieces each on its own pedestal. The material's transition to the category art was further signaled by the *new* economic values assigned to the currencies: from $400 for an X-shaped item to $12,000 for one in accordion-fold form. The headline of a *New York Times* review of the exhibition, "It May Look Like a Hoe, But It's Really Money," would perhaps have been more enlightening to African readers had it read "It May Look Like Money, But It's Really Art."

African stepped house ladders, used in village contexts to access the upper opening of a granary or the roof of a home, have been making their way onto the international market in the last few years. A handful of galleries in Europe and America began featuring these forked ladders in their catalogues and advertisements sometime in 1987. In contrast to the typical dirt-encrusted wooden surface of house ladders found in villages, the ladders in the galleries were cleaned, highly polished, and tastefully mounted on unobtrusive black metal bases. They were indeed well on their way to making it into the category art. Spurred by this new demand, African traders in Côte d'Ivoire began collecting vast quantities of house ladders, especially where they are most commonly found in villages throughout the region of Korhogo (Plate 18). Although the "authenticity" of ladders is not yet universally acknowledged, a number of Abidjan-based traders report having made several important wholesale transactions with Western gallery owners.

Recently, one Hausa storehouse owner of my acquaintance had acquired approximately 200 common wooden pestles – objects used by women in villages to pound rice, yams, manioc, etc. (Plate 19). Although the pestles had not yet been "discovered" by Western art collectors or dealers, Alhadji Moussa was hoping to corner the demand if it should ever arise. Some of the other traders in his storehouse that day were teasing Moussa. "Whites are crazy [*fou*] but this is really too much. These things are just ugly Alhadji!" (6/27/91). The jury is still out on the admittance of pestles to the category art.

A good example of an object's successful transition to the category art is perhaps best illustrated when one follows the commoditization of the Baule slingshot – a process which has occurred during the last few years in the Côte d'Ivoire art market. In November 1987, an illustrated coffee-table size book entitled *Potomo Waka* appeared in the window displays and shelves of many Abidjan bookstores. The book contains over one hundred glossy color photographs of sculpted slingshots from the private collection of one of the book's coauthors, Giovanni Franco Scanzi.[10] Each slingshot which is reproduced in the book is depicted on its own full color page, and each is framed in

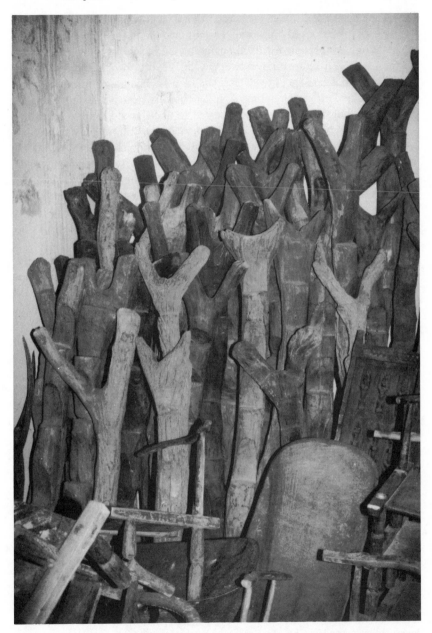

18 Wooden house ladders in a trader's storehouse. Treichville quarter, Abidjan, June 1991.

the vibrant hues of a different backdrop. An Italian entrepreneur specializing in the sale of overstocked European promotional items (ashtrays, pens, and cigarette lighters blazoned with company logos), Scanzi has been conducting business in Côte d'Ivoire for over twenty years. He only began collecting sling-shots about six years ago, however, when he was encouraged to do so by his friend Antoine Ferrari, a longtime Abidjan-based African art dealer/collector.

Because slingshots had rarely appealed to Western collectors, not many were available on the market when Scanzi began forming his collection. Market-place traders confirm that before his interest in slingshots, few of the itinerant suppliers who collect art in rural areas regularly brought back such items for sale in Abidjan.[11] Over a period of approximately three years, Scanzi collected more than a thousand slingshots purchased from about twenty different suppliers. Any trader who arrived in Abidjan knew that he could either sell his slingshots directly to the Italian collector or to a middleman who would take them to his home.

In the preface to *Potomo Waka*, the authors carefully construct a case for the "authenticity" and "artistic" value of the objects in their book. The first point they make, is meant to underscore the aesthetic quality of slingshots. They do so, largely by disparaging any interest in the ethnographic context from which the objects were removed:

The Baule catapult is a typical example of an object about which ethnography has almost nothing to reveal . . . If the ethnographer can throw some extra light on the under-standing of works of art from the Third World, this is and should remain a minor detail. Does Western art really need explanations from ethnographers to be understood? Of what importance is it to know that Rembrandt came from a patrilineal type of family or know the method of cultivating soil in "quatrocento" Italy![12] (Delcourt and Scanzi 1987: 10–11).

Here, the intended message of the text is clear: slingshots belong to the universal category art and, as such, can be sold at prices which befit their aesthetic character. The second point, which the authors emphasize in the preface, is the "authenticity" of the objects in their book. In so doing, they take great pains to emphasize that wooden slingshots are not products of the colonial era, but rather pre-date the advent of any European contact:

Some people refuse to accept Baule catapults [i.e., slingshots] as authentic African works of art because they incorporate rubber strips of European manufacture. Even though it is not possible to be certain that Africans used local rubber for the catapults they made in West Africa at the beginning of the 20th century, before the advent of the motor car and its rubber inner tube, it is more or less certain – according to an investigation carried out by Mr. Scanzi – that the Dogon tribe used large catapults powered by animal gut in pre-colonial times. The theory that catapults have only made their appearance since the use of rubber from European sources is [therefore] difficult to sustain. (1987: 9)

19 Wooden pestles in a trader's storehouse. Treichville quarter, Abidjan,
June 1991.

The reason the authors are so concerned with providing "scientific" proof
that slingshots originated in the pre-colonial era is, of course, that they are
trying to create a market for the objects within the accepted Western
definition of "authenticity" in African art – i.e., which demands that the style
has been conceived in an environment untainted by European influence. Not
only does Scanzi carefully attempt to construct a pre-colonial past for the
African slingshots which he now sells, but when he started his collection
he refused to purchase slingshots that had been painted.[13] As a result, sling-
shots with paint were sanded down and restained with potassium
permanganate[14] before being presented for sale at his home (Plate 20). At
present, Scanzi's entire collection is up for sale at art galleries in Europe and
West Africa.

 With the appearance of *Potomo Waka* in Abidjan stores and hotel gift shops,
tourists and local buyers have been eager to purchase slingshots as part of their
African art collections. In the market places, the price of an average slingshot
jumped from a range of about 1,000–6,000 CFA ($5–20) in early 1987 to
3,000–45,000 CFA ($15–150) in late 1988 (Plate 21). Because the value of
slingshots increased so dramatically, traders responded quickly and in several
ways. First, traders in Abidjan commissioned slingshots from local carvers
(Plate 22). Most were purchased unfinished from the artists and either stained

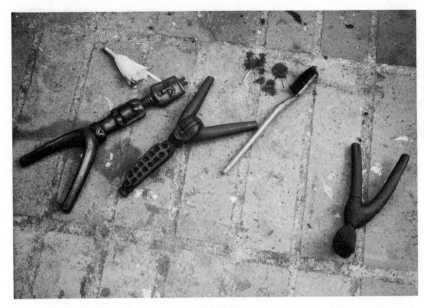

20 Slingshots stained with potassium permanganate drying at the Plateau market place. Abidjan, March 1988.

or painted by the traders themselves. Second, because they generally follow the shape of a branch and – at least some of the simpler varieties – are relatively easy to carve, traders with entrepreneurship and some basic artistic skills began to sculpt their own slingshots as they sat during the day in the market place waiting for clients to arrive. Third, traders learned to convert broken wooden artifacts into slingshots. A small Baule statue with broken legs, for example, was transformed into a slingshot by substituting a forked pinnacle for the absent legs (Plate 23). The creator of the object explained to me that, "These days there is a better chance of selling a slingshot than a broken statue" (4/12/88).[15]

When I showed *Potomo Waka* to some of the traders in the Plateau market place, they made two sorts of remarks. On the one hand, many were able to identify specific slingshots which either they or one of their intermediaries had sold to the Italian collector. On the other hand, a number of traders remarked that they had sold Scanzi other slingshots – much higher quality and much finer – none of which, they said, were reproduced in the book. "I don't understand why he would not put those [slingshots] in the book. The whole idea of writing a book like this," said Sheriff Ousman, "is to show the best pieces in the collection so that other people will know what you have" (12/8/87). When I showed *Potomo Waka* to an African art bookseller in New York, I asked her

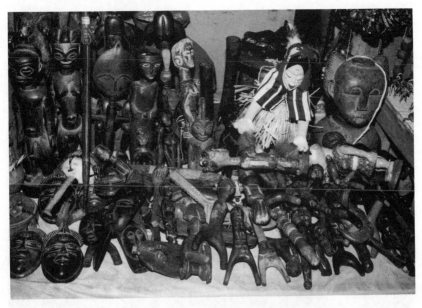

21 A pile of slingshots displayed among other objects at the stall of a Plateau
market-place trader. Abidjan, April 1988.

what she thought of the remarks made by the traders about the author not
having put in the best pieces from his collection. She told me that their
observations were not only plausible but indeed predictable. That is to say, the
author probably selected inferior pieces on purpose. There are two economi-
cally motivated reasons for which one would publish a book with inferior
examples from a large collection of objects which were eventually going to be
sold. First, she explained, by having the objects reproduced in a catalogue, the
seller adds value to some of the lesser quality pieces in his collection. In other
words, he can capitalize on the objects in the book simply because they are the
objects in the book. Second, after he has sold most of the objects which are
reproduced in the book, he can slowly begin to bring out some of the better
quality pieces from his larger collection. These pieces are now valuable
precisely because they are not in the book. The seller can point to the objects
in the catalogue and tell his client: "See this piece here, it's even better than
anything in my book." For the same reasons, the bookseller added, "Most
African art dealers love books that illustrate inferior pieces. They can turn to
any object in the book and say that what they have for sale in their gallery is of
much finer quality" (12/22/88).

A second example of the manipulation of the category art can be found in the
African art framing (*encadrement*) business which has been carving out its

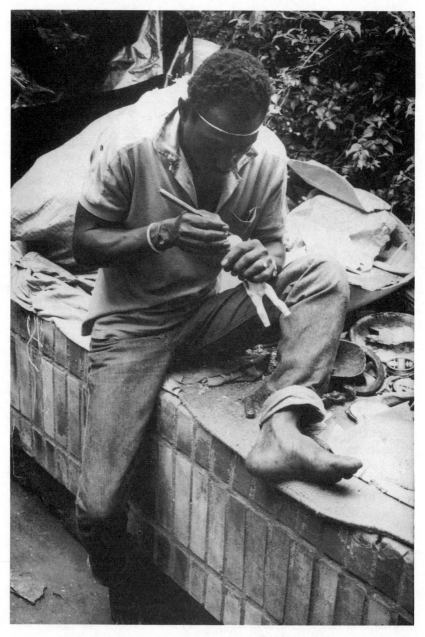

22 Carver finishing the detail work on a wooden slingshot. Abidjan, March
1988.

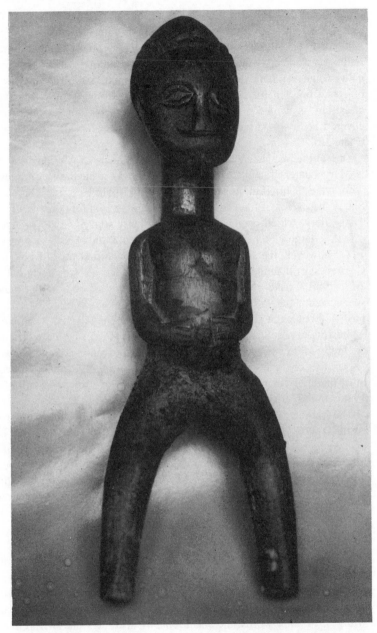

23 Broken Baule statue "transformed" into a slingshot by replacing the broken legs with a forked pinnacle. Abidjan, July 1988.

niche in the Côte d'Ivoire art market during the past several years. Within a relatively short span of time, at least four framing galleries have opened in Abidjan (Plate 24). The work they sell consists essentially of three-dimensional African art objects which are encased in wooden box frames (*coffrets*). The gallery owners (all of whom, it is interesting to note, are European) buy African objects from the market-place traders. Most of what they buy would be classified as *copies* or *nyama-nyama*. The objects are mounted on fabric covered boards, and enclosed in box frames, usually with a decorated trim (Plate 25).

One of the original, and most prominent, framers of African art in Abidjan is Mary-Laure Grange Césaréo. Approximately a hundred examples of her work were featured in an exhibition at the Abidjan Hilton in February 1988. She is the owner of the Galerie Equateur in the Marcory quarter of Abidjan. The gallery, which opened in 1982, originally sold a variety of African art objects – largely contemporary replicas aimed at the popular export trade. In 1987, however, the focus of the gallery was shifted toward box frames.[16] Césaréo says that she is "neither an expert in African art, nor a collector of African art. I have not put together an exhibit of art objects, but rather have specialized in the valorization [*mise en valeur*] of works of art" (*Guido* 1988a: 66). Although she does not market her merchandise as "antique," it is interesting to note that she ages artificially the surface of the wooden frames – thereby following a Western convention for the framing of antique paintings. "A number of the frames were aged artificially [by my staff] with kaolin and other materials, using techniques with which I myself am not familiar" (*Guido* 1988a: 66; my translation from the French).

The framing of African art illustrates, almost *ad absurdum*, the "process of aesthetization" (Baudrillard 1972) which occurs when African art is transplanted to the West. The process of framing goes one step beyond the art historical tradition of exhibiting isolated African objects in the putatively "neutral" context of a gallery or art museum – allowing the well-lit object to speak for itself without the support of interpretive ethnographic text. The frame around the object functions to invent a whole new context, or literally a constructed *cadre*, for the object in which the piece is insulated both from its original milieu and from the potential aesthetic ambiguities which might result from allowing it to speak for itself.[17] As one of the African art framers suggested in an interview: "We try to create something of value out of these African objects. By putting an object in a frame, we provide it with an *environment* that is better suited [for display] in an apartment" (7/6/91). In other words, the *encadrement* substitutes the interpretive framework of an ethnographic discourse with a physical frame which encodes its appropriated content by unequivocally announcing to its viewers that "this is art."

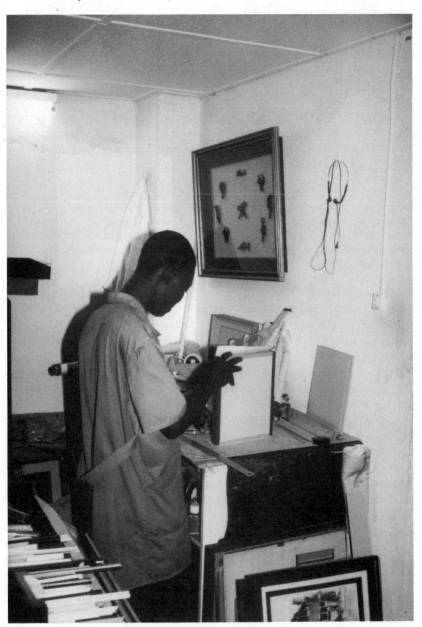

24 Employee at an African art framing gallery constructing a box frame for a display of Akan goldweights. Abidjan, July 1991.

The domestication of African art

Collections of African art tend to efface the social history of their own production. As if muted by the prophylactic glass of a display case, objects in galleries are silent as to how they got to where they are. With varying amounts of detail, accompanying explanatory text informs the viewer of an object's meaning and use in its original cultural context. Yet, it says nothing about how or why the object was collected, from whom or for how much it was purchased, or even by whom it was made. Writing about an exhibit of Sepik River art at New York's IBM Gallery, Clifford remarked:

The history of collecting was not included in the presentation. While the names of individual collectors were sometimes provided, the circumstances, priorities, funding, institutional and political contexts for the objects' physical move from New Guinea to Switzerland to New York were deemed irrelevant to their presentation as "tribal art". In their salvaged, aesthetic-ethnographic status they exist outside such mundane historical dimensions. (1987: 123–24)

In her research on the history of the African Hall at the American Museum of Natural History, Donna Haraway has pointed out a similar process in which Africans, who were involved in supplying museum expeditions with the wild animals which were shipped overseas, were conveniently overlooked in the historical record – their guidance, contribution, and sacrifice having been written out of authorship. "Behind every mounted animal, bronze sculpture, or photograph," she writes, "lies a profusion of objects and social interactions among people and other animals, which in the end can be recomposed to tell a biography embracing major themes for 20th-century United States. But the recomposition produces a story that is reticent, even mute, about Africa" (1984/85: 21; also see Simpson 1975; Coquery-Vidrovitch and Lovejoy 1985).

Although African art is silent on the subject of its collection, appropriation, and ultimate passage to the West, objects are never tacit about their subsequent excursions through Western hands. "An African figure that was once owned by Henri Matisse or Charles Ratton or Nelson Rockefeller is unrelated," writes Price, "to a sculpture by the same artist that was not" (1989: 102). An object's list of previous owners constitutes what is called its pedigree. The longer the pedigree, and the more illustrious the caretakers in the line of descent, the more prestigious (and more valuable) the object. Commenting on a Cameroonian Bangwa sculpture (known in the West as the "Bangwa Queen") which was recently sold at auction in New York, the head of Sotheby's Tribal Art Department, Bernard de Grunne, noted that "[p]art of the value of this carving is its pedigree" (Reif 1990: 32). The figure was collected at the turn of the century in Cameroon by a German explorer (not surprisingly described as "the first white man to reach the African Bangwa kingdoms"). It was deposited in

25 A framed Dan mask (right) and brass bracelet and goldweights (left) on display at an African art framing gallery. Abidjan, July 1988.

1898 at the Museum für Völkerkunde in Berlin, where it remained until it was acquired in 1926 by a German collector who then sold it a few years later to Charles Ratton, a Paris dealer. The Princess Gourielli (Helena Rubinstein) bought the queen figure from Ratton in the 1930s, at which time it was exhibited at the Museum of Modern Art's first African art show in 1935 (Northern 1986: 20). Around the same period, the figure was photographed by Man Ray, who posed a nude model at its feet. The sculpture is now in the possession of an unnamed collector who bid recently at auction $3.4 million, the highest recorded price for an object of African art.

Drawn from the semantic domain of bred animals – where authenticity is also judged by purity of descent – the term pedigree neatly captures what might be called the domestication of African art. In its wild, undiscovered state African art is raw, meaningless, and without value to the Western collector. Tamed, through appropriation and the controlled reproduction of ownership, African art becomes assimilated to the broader category art. Another term which is related to the judgment of authenticity and also drawn from the domain of animal life is vetting. Literally meaning to submit an animal to medical examination, the word vetting is used by art dealers to refer to the scrutinization of objects for the purpose of detecting post-production alteration or fakes. Recently, in the antique trade, the term was found to be indecorous. "The majority opinion is that, while vetting is no doubt appropriate for horses and cattle – the noun, after all, is derived from that beastly word 'veterinarian' – it has no place in the civilized society to which antique dealers cater and sometimes belong" (Swan 1989: 96). In the African art trade, where the canons of civilized society perhaps do not always apply, the term and practice have not been met with the same opposition.

Trade beads and the recreation of exotica

Colored glass beads of European manufacture were introduced in West Africa by seafaring traders as early as the fifteenth century. In the coastal enclaves of European trade, beads functioned as a medium of exchange through which Europeans could acquire African palm oil, ivory, gold, and slaves. Along with their economic role, imported beads also functioned in the realm of inter-national diplomacy – currying favor of chiefs along vital links in political and commercial networks. The systematic production in Europe of glass beads for foreign consumption began in Venice during the thirteenth century. Production and export increased steadily throughout the Age of Discovery. As a result of growing demand, competition to Venetian manufacturers eventually came from bead makers in Holland, as well as Bohemia and Moravia (provinces of modern-day Czechoslovakia). With the invention of new technologies and the rapid expansion of global markets, European bead production reached its

peak in the middle of the nineteenth century (Francis 1979; Dubin 1987: 107–14).

European trade beads were incorporated into the social, political, and economic symbolism of many West African cultures. They have served as emblems of social rank, indicating the power and wealth of the individual wearer. On ceremonial occasions they were worn by elders and other dignitaries to symbolize status and prestige. Young women who had completed initiation could wear strands of imported glass beads or beaded aprons during dances performed in celebration of their coming of age. Along with other forms of personal adornment, such as clothing, tattooing, and scarification, beads functioned as signs of group membership (Steiner 1990). They were integrated into all aspects of the aesthetic of dress, and were appendaged to the visual arts as decorations on masks and statues.

Some beads, especially the large Venetian chevrons, were more valued than others and were reserved for members of the ruling class. Reporting on the use of foreign beads in the kingdom of Swazi, Hilda Kuper notes that when "trade goods – particularly factory manufactured fabrics and china beads – were incorporated [into the aesthetics of local politics], the king and in some districts the chiefs established connections with individual traders, some of whom were instructed not to sell the same designs to the families of others" (1973: 355).

Since the introduction of monetary currencies during the colonial period, the use of European trade beads as a medium of exchange has essentially ended – save perhaps as a form of ritualized bridewealth payment in certain communities. Especially among urban women, trade beads have lost much of their visual appeal as a source of adornment. In present-day Côte d'Ivoire, for example, where Western fashion is promoted by the sale of French magazines and weekly broadcasts of American television serials, most African women have little interest in adorning themselves with beads dating to the era of the slave trade. Instead, young women wear modern European-style gold, silver, metal, and plastic jewelry, as well as locally manufactured ornaments of gold-plaited filigree. African women who still buy European trade beads in the local markets are either medicinal or ritual specialists who continue to value the beads for their spiritual potency (Cole 1975).

The market price of trade beads is established by African merchants through economic calculation which takes account of both scarcity in local supply and demand by foreign buyers. One exception – which throws further light on continued African demand in specialized sectors – is a particular type of tabular bead, with a blue and white "face" design on a black background, which is disproportionately expensive in comparison to similar beads. The unusually high price of this bead is a result of intense local demand by women of the Akan ethnic group who prize the bead for its symbolic and curative powers (Picard 1986). Since they know that only a select group of local patrons would

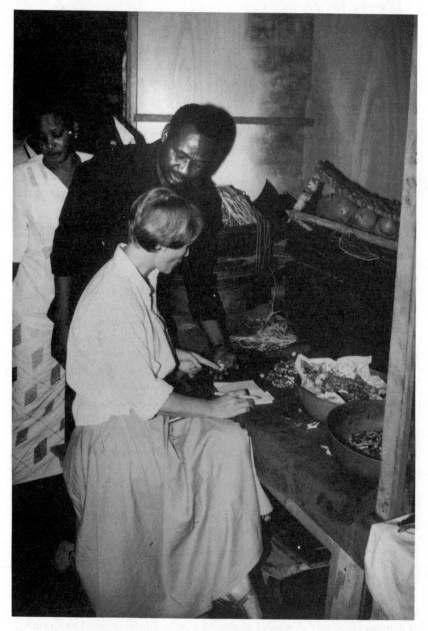

26 American gallery owner buying trade beads from a Hausa merchant in the Treichville market place. Abidjan, December 1987.

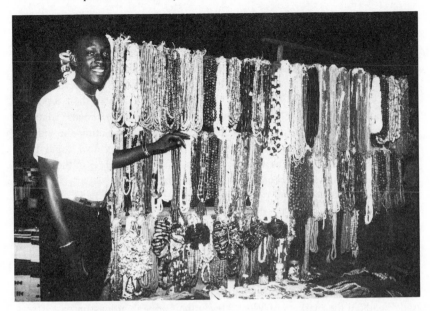

27 Young Hausa trader with a display of trade beads at his market-place stall.
Treichville quarter, Abidjan, July 1988.

be willing to pay the inflated price, traders in the various market places usually
keep these type of beads separate and hidden below their stalls.

With the exception noted above, *African* demand for trade beads has, in the
past several decades, been replaced largely by *European* demand. Hence,
although the consumption of European beads has diminished among Africans,
trade beads continue to circulate along specialized routes of transnational
commerce (Plate 26).[18] The same beads which for centuries were prized by
Africans are now sought by those inhabiting the very shores from which the
beads originated. While the beads themselves have not really changed – some
perhaps are smoother or more rounded from use, others may be slightly
chipped – the meaning of the beads has been drastically altered.

Today, in the market places of Abidjan (especially in Treichville) beads of
European origin are displayed in vast quantities for sale to foreign tourists,
dealers, and collectors (Plate 27). Traders depend on the sale of beads to
tourists and other visitors. One of the techniques the traders use to successfully
market the beads in this arena is to establish that other foreigners (just like the
present buyer) have also purchased and worn this type of "exotic" jewelry. In
the center of one stall in the Cocody market place in Abidjan, for instance, a
trader had framed a cover from *Elle* magazine (April 20, 1987) which shows a
glamorous European model covered in African trade beads and beaded

bracelets. The message to the buyer is clear: if it is fashionable enough for her, then, surely, it must be fashionable enough for *you*.[19]

Most traders also have a regular clientele of dealers and private collectors. A number of bead enthusiasts who reside as expatriates in Abidjan have developed close links to some of the major bead suppliers. In return for a slightly higher price or an occasional loan, bead collectors urge their suppliers to guarantee them first selection from a newly arrived lot of beads. Like the Swazi sumptuary decrees which Kuper described as regulating the sale of beads to Africans by European suppliers, Europeans are now regulating, through economic incentives, the distribution among themselves of these same beads by, what have now become, African suppliers.

In both their original and present markets, the beads have been valued for their "exotic" qualities. To the Africans who acquired imported beads in exchange for the riches of their land, the beads were desired because they came from far away, they were unavailable locally, and they were produced in colors and patterns which were not feasible in the repertoire of local technology. They were loaded with symbolic prestige because they represented contact and rapport with a powerful outsider. To the travelers who now buy old trade beads in the markets of West Africa, their appeal, at least in part, stems from the fact that their long presence in Africa has *again* made them exotic. Once more, they have been packed with a symbolic charge. This time, however, their symbolism communicates encounter with a romanticized vision of traditional, pristine Africa. Hence, at one time trade beads were popular because they were foreign and European, now they are again fashionable because they are considered "ethnic" – and, therefore, by definition, *still foreign*.

The assimilation or, what might be called, the "naturalization" of foreign imports is not unique to the history of beads. It is a process that has occurred in various contexts and at different times. In his tours of Great Britain during the reign of William and Mary, Daniel Defoe observed that the wearing of fine East Indian calicoes and the furnishing of homes with delicate China ware had become so integral to English taste that they came to represent "Englishness" more than they did "otherness" (Bunn 1980: 306). A similar process has also occurred in Africa where women traders give indigenous names to the imported European factory cloths which they sell in local markets. The names establish group-specific meanings and metaphors which transform a foreign commodity into an item of local "production" (Touré 1985).

Epilogue: fake masks and faux modernity

In the Plateau market place, I once witnessed the following exchange between an African art trader and a young European tourist. The tourist wanted to buy a Dan face mask which he had selected from the trader's wooden trunk in the

back of the market place. He had little money, he said, and was trying to barter for the mask by exchanging his Seiko wrist watch. In his dialogue with the trader, he often expressed his concern about whether or not the mask was "real." Several times during the bargaining, for example, the buyer asked the seller, "Is it really old?" and "Has it been worn?" While the tourist questioned the trader about the authenticity of the mask, the trader, in turn, questioned the tourist about the authenticity of his watch. "Is this the real kind of Seiko," he asked, "or is it a copy?" As the tourist examined the mask – turning it over and over again looking for the worn and weathered effects of time – the trader scrutinized the watch, passing it to other traders to get their opinion on its authenticity.

Although, on one level, the dialogue between tourist and trader may seem a bit absurd, it points to a deeper problem in modern transnational commerce: an anxiety over authenticity and a crisis of *mis*representation. While the shelves in one section of the Plateau market place are lined with replicas of so-called "traditional" artistic forms, the shelves in another part of the market place – just on the other side of the street – are stocked with imperfect imitations of modernity: counterfeit Levi jeans, fake Christian Dior belts, and pirated recordings of Michael Jackson and Madonna. Just as the Western buyer looks to Africa for authentic symbols of a "primitive" lifestyle, the African buyer looks to the West for authentic symbols of a modern lifestyle. In both of their searches for the "genuine" in each other's culture, the African trader and the Western tourist often find only mere approximations of "the real thing" – tropes of authenticity which stand for the riches of an imagined reality.

"We in Africa prefer things that were made by Europeans than things made by ourselves," Abdurrahman Madu explained. "When a European comes to Africa he buys African things – boubous, textiles, masks, and so on. He likes these things because they are African, they are not from where he comes. The same holds true for us. We want what the Europeans have . . . If I had more money I would collect European art, and the European would continue to collect our art. That's just how it is" (6/25/91). Viewed in the context of a global dialectic, the international consumer's search for authenticity under- scores the idea that far-away collectors reinvent their objects of desire. While Western notions about the authenticity of African art are constructed by privileging aesthetic forms imagined to have existed in the past – worlds that never were but might have been – African beliefs about Western authenticity are projected into the future – worlds that aren't yet but someday could be.

6 Cultural brokerage and the mediation of knowledge

> ... the men who become dealers are not, as a class, quite fools.
>
> Desmond Coke, *Confessions of an Incurable Collector* (1928)

> As performers we are merchants of morality. Our day is given over to intimate contact with the goods we display and our minds are filled with intimate understandings of them; but it may well be that the more attention we give to these goods, then the more distance we feel from them and from those who are believing enough to buy them.
>
> Erving Goffman, *The Presentation of Self in Everyday Life* (1959)

In a recent issue of a glossy coffee-table French art magazine there appears a full-page advertisement for Jean-François Gobbi's Galerie d'Art. A black-and-white photograph shows Monsieur Gobbi, in his Paris gallery, dressed in a dark suit, sporting an oversized cigar, and surrounded by his *objets d'art*. The text, below the photograph, reads as follows:

The world's largest museums and collectors await your valuable paintings. The problem, however, is that you don't know where they are – these museums and collectors who are ready to pay good money for your works of art. Jean-François Gobbi, *he*, knows where they are: they are all his clients. Today, the demand for masterpieces is so great that museums and collectors don't even discuss price . . . Now if you think you will some day come in contact with a big museum or an important collector willing to pay top dollar for your masterpiece, don't call Jean-François Gobbi. Otherwise dial 266-50-80. (*Galerie des arts*, 1985, my translation from the French)

In the art market, as in any other large-scale business enterprise, the success of the middleman demands the separation of buyers from sellers. Social, legal, and bureaucratic barriers are erected to maintain the distance between the primary suppliers of art and their ultimate consumers.[1] "The producers and consumers of the art," Bennetta Jules-Rosette has written, "live in quite different cultural worlds that achieve a rapprochement only through the immediacy of the artistic exchange" (1984: 8). It is the art trader who provides the linkages at crucial points in a series of cross-cultural exchanges. The art trader, in this sense, fits Eric Wolf's classic definition of the middleman, i.e.,

as a person "who stand[s] guard over the critical junctures or synapses of relationships" (1956: 1075). The middleman is a mediator, whose principal role can be seen as one of "limiting the access of local persons to the larger society" (S. Silverman 1965: 188). The role of the middleman comes into existence so as to bridge a gap in communication.[2] The "bridge," however, must be well guarded for, as F. G. Bailey puts it, "perfect communication will mean that the middleman is out of a job" (1969: 167–68).[3] Art dealers, in general, earn their livelihood as middlemen – moving objects across the institutional obstacles which, in some cases, they themselves have constructed in order to restrict direct exchange. The art market in Côte d'Ivoire is characterized by precisely this sort of network of relations, in which a host of African and non-African middlemen forge temporary links in a transnational chain of supply and demand.

Supplies of art objects from villages are tapped by professional African traders who travel through rural communities in search of whatever they believe can be resold (see Chapter 2). Almost all the suppliers, and even most of the wayfaring traders, have little or no idea where these objects are destined, why they are sought after, and for what price they will ultimately be bought.[4] After being collected in villages, objects are moved from town to town until they are eventually sold to a trader who has direct contact with Western clients. These traders are based in the larger towns and capital of Côte d'Ivoire. Because their primary network of relations extend outward into the world of Western buyers (rather than inward into the world of local village suppliers), they are dependent on village-level traders for their supply of goods. They themselves never buy art directly in villages.

Through their relations with Western buyers, urban traders have partial understanding of the world into which African art objects are being moved. Their experience enables them to discern certain criteria underlying Western definitions of authenticity. They know, through trial and error, which items are easiest to sell, and they can predict which objects will fetch the highest market price. Using this refractured knowledge of Western taste, traders manipulate objects in order to meet perceived demand. In this chapter, I will illustrate three ways in which African art objects are manipulated by African traders: (1) presentation of objects; (2) description of objects; and (3) alteration of objects.

Presentation of objects

The presentation of an art object for sale is not something which is carried out in a haphazard way. Careful preparations are made before an object is shown to a prospective buyer. The context in which an object is placed, and the circumstances surrounding its putative "discovery," weigh heavily in the

buyer's assessment of quality, value, and authenticity. The presentation is thus a key element in the success of a sale. If an object is uncovered in its original or "natural" setting, it is believed to be closer to the context of its creation or use and, therefore, it is less likely to be judged as a fake.[5] The very process and act of discovery confirms the collector's sense of good taste. In a travelogue narration of a voyage to Côte d'Ivoire in the 1970s, one African art collector described his visit to the Hausa quarter in Korhogo in the following way: "While my travel companions were all taking naps, I *ventured* into the *obscurity* of a hut, which was *lost* somewhere in the heart of a labyrinth of identical alleys, where I saw a magnificent Senufo hunter's tunic covered with talismans: fetish horns, leather pouches, feline teeth, and small bones; but no figural sculptures worthy of my attention" (Lehuard 1977: 28, my translation from the French, emphasis added). As the narration moves on to western Côte d'Ivoire, the same collector comes across a Muslim trader who says he has masks for sale but that they are at his home which is a one hour walk away from town. "That is no obstacle," the collector tells the trader, and the two set off on foot. "In the [trader's] home," writes the collector, "where the *light of day scarcely shines*, the masks and statues are aligned in front of me. But nothing is really old. A Bété statue is frankly new. I bargain for two Dan masks (they cost me 400 FF) and I regain the path" (Lehuard 1977: 32, emphasis added). Finally, in another article describing his travels through Burkina Faso, the author provides his readers with the following advice: "For those who collect antiques, but cannot afford the cost, or do not possess the training to '*hunt*' for objects in the bush, it is always possible to *excavate* through the stock of the urban traders who are set up alongside the Hotel Ran in Ouagadougou. Although there is a preponderance of modern sculptures, it is sometimes possible to ferret out a rare gem" (1979: 19, emphasis added).[6] Throughout these travel narratives, the author's repeated allusions to the themes of discovery and concealment cater to a peculiar vision of the African continent – the West's unending search for the elusive beat in the heart of darkness.

The manipulation of context through the calculated emplacement of objects is a widespread practice among art dealers around the world. One of the classic tricks of the French antique market, for example, was to plant reproduction furniture in old homes. In the autobiography of André Mailfert, one of the most successful makers of reproduction French antique furniture, who worked in Orléans between 1908 and 1930, the author unveils the following scheme. A dresser was made to fit the specifications of a dealer who knew he could sell such a piece to a client who was soon scheduled to arrive from abroad. Once completed, the dresser was taken to the home of an elderly woman who lived on the outskirts of Paris. A wall in the front hall was thoroughly cleaned, the dresser was placed in front of it, and with the help of an air compressor, dust was sprayed on the wall so as to leave a noticeable mark

around the edge of where the dresser now stood. The dresser was scratched in appropriate places, the drawers were filled with odds and ends taken from the woman's closet, the accumulation of decades of floor wax was quickly applied to the brass rim of the dresser legs, and a yellowed envelope, which dated from thirty years earlier, was casually tucked under the marble top to support a corner which had been made to warp. The customer was told that an old woman needed to sell an antique dresser in order to pay her taxes. He was brought to the woman's home, whereupon, after scrupulous inspection, he bought the dresser for 12,000 FF. For the use of her home the woman received 1,000 francs, the cabinet maker was paid for the price of the reproduction dresser, and the dealer kept the rest (Mailfert 1968: 54–57).[7]

In Africa, as in Europe and America, one of the key factors in the presentation of an art object is to create an illusion of discovery. Because of the barriers, which I noted earlier, that separate art consumers from art suppliers, the buyer almost never has the opportunity to uncover an object by chance or recognize its potential value *before* it enters the market, or *before* it becomes a commodity. However, part of the collector's quest, I would argue, is to discover what had previously gone unremarked.[8] As one European art critic put it, "the charm [of an art object] is bound up with the accident of its discovery" (Rheims 1961: 212). From the perspective of the Western collector, African art traders are perceived as mere suppliers of raw materials. It is the gifted connoisseur, not the African middleman, who first "sees" the aesthetic quality of a piece and thereby "transforms" a neglected artifact into an object of art (Price 1989: 7–22).[9]

African art dealers are well aware of the discovery element in Western taste. Depending on the circumstance, traders will sometimes pretend not to know much about the goods they sell in order to let the buyer believe that s/he is getting something about which the seller does not recognize the true value.[10] The principal art market place in Abidjan, located in the Plateau quarter, is constructed in such a way as to facilitate the illusion of discovery. The front of the market place consists of a series of adjoining stalls, with layered shelves, upon which are displayed quantities of identical items (Plate 28). These items are marketed largely as contemporary souvenirs made for the tourist trade. In the back of the market place, which is accessed by only three narrow paths, there are a number of large wooden trunks in which some of the traders store their goods (Plate 29). Many of the objects kept in the back of the market place are similar to those displayed in the front. The difference, however, is that they are *presented* to the buyer as unique items.[11]

Drawing on the dramaturgical idiom in the sociology of Erving Goffman, Dean MacCannell, in his book *The Tourist: A New Theory of the Leisure Class* has noted the interplay between front and back regions in the construction of authenticity at tourist sites. "Just having a back region," writes MacCannell,

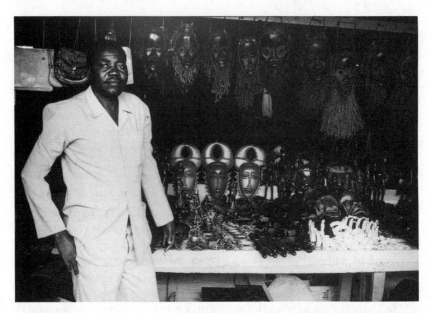

28 Hausa trader at his stall in the front of the Plateau market place. Abidjan,
 November 1988.

"generates the belief that there is something more than meets the eye; even
where no secrets are actually kept, back regions are still the places where it is
popularly believed the secrets are" (1976: 93). "[E]ntry into this space," he
concludes further on in the text, "allows adults to recapture virginal sensations
of discovery" (1976: 99). By permitting the buyer to penetrate the back region
of the market place, the African art trader thus underscores the value and
authenticity of the object he is showing.

 Like antique dealers in France, African traders also plant objects in
appropriate settings. Hamadou Diawara, an elderly Malian art trader, recounted
an instance in which he tried to sell a mask to an American buyer. The buyer
carefully examined the mask, but refused to purchase it, telling Diawara that he
doubted it was "real." Several months later, the buyer returned to Abidjan.
Diawara planted the very same mask (which had not yet been sold) in a village
located not far from the capital. The buyer was brought to the village and taken
with great circumstance into the house where the mask had been placed. The
object was examined, as best it could, in the dim light of the house. This time,
the customer bought the piece and, in Diawara's words, was "very happy with
what he had found" (11/7/87).

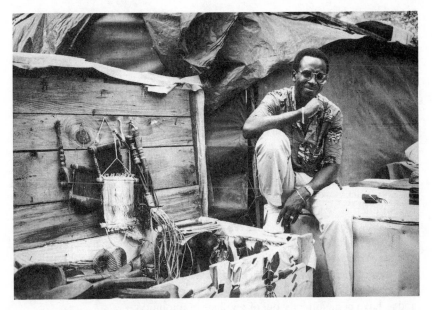

29 Hausa trader with wooden trunk in the back section of the Plateau market place. Abidjan, May 1988.

Description of objects.

Verbal cues affect judgment of authenticity and success of sale in ways similar to object emplacement. In other words, what we are told about a work of art conditions what we see (cf. Berger 1972). In Europe, for example, the title of a painting is sometimes changed to fit the current taste of collectors. In the 1950s, when macabre themes in art were more difficult to sell than light-hearted and amusing works, the title of Van Gogh's painting described in earlier catalogues as *The Cemetery* was changed in an auction catalogue to *Church under Snow* (Rheims 1961: 209). Another example of verbal embellishment comes to us from fifteenth-century Europe, where obsolete foreign coins were transformed (with a thin gold or silver overlay) into religious icons. "If these 'improved' coins failed to tempt a purchaser," reports Frank Arnau, "he was informed that they were the pieces of silver which Judas received for his betrayal of Our Lord. Countryfolk proved to be particularly interested in this type of relic" (1961: 27).

In Africa, traders communicate through verbal means two types of information about the objects they sell. To Western collectors and dealers, traders communicate information relating to the object's market history (how it was

acquired, where it comes from, etc.). To tourists, traders provide information regarding the object's cultural meaning and traditional use. Both types of information are constructed to satisfy perceived Western taste, and are intended to increase the likelihood of sale.[12] In the language of mediation studies, one might say that the trader's description of an object is phrased at the level of metacommunication or "communication about communication." The sender's messages, to borrow Gregory Bateson's phrase, are "tailored to fit" according to his ideas about the receiver, and they include instructions on how the receiver should interpret their content (1951: 210).

African art objects in the West are sometimes sold with a documented "pedigree" which consists of a list of previous owners. A quick glimpse at auction prices would indicate that a mask once owned by Vlaminck or Rockefeller is worth far more than a similar mask owned by an unknown collector.[13] Before an object leaves the African continent, however, its true pedigree is carefully hidden from prospective buyers. African traders are aware that the Western collector is concerned with neither the identity of the artist nor a history of local ownership and exchange. In fact, an object is worth far more if it is perceived by the buyer to have been created by a long-departed artist, and to have come directly out of a village community.

As a result of the economic structure of the art market in Côte d'Ivoire, however, most purchasers of African art are not the first Westerners to have seen a particular object. Since an art object does not have a fixed monetary worth, traders sometimes test an object's value by bargaining with different potential clients. In some instances, "important" pieces are even tested in the markets of Europe and America before they are returned to Africa, where ultimately they are sold to local collectors. In an attempt to hide the true channels of trade through which art objects are moved, traders will always tell the client that s/he is the *first* Westerner to have an opportunity to buy a given piece.[14] Even though (as I noted above) most traders who have direct contact with Westerners are not the ones collecting art at the village level, they will either indicate that they themselves have just arrived from purchasing an object in a village, or that a villager has just brought an object directly to them.[15]

Malam Yaaro, a Hausa dealer specializing in the art of Ghana, recently shipped to New York City twenty-six Asante stools (Plate 30). Upon arrival, an African colleague asked to select six stools from the lot in order to show them to one of his clients. After the six stools were picked out, Yaaro contacted a New York gallery owner who purchased all twenty of the remaining stools. A few days later, the trader who had taken the six stools returned with the merchandise, informing Yaaro that his client did not want to buy the stools. Yaaro immediately contacted the gallery-owner who had bought the original lot, and told him that a smaller shipment of six very fine stools had just been

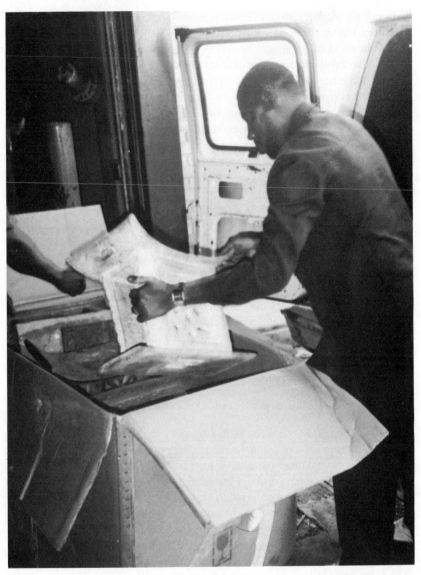

30 Hausa trader unloading a shipment of Asante stools at Kennedy airport. New York, June 1989.

sent to New York by an old Dioula woman. The true itinerary of the objects was kept hidden from the prospective buyer for several reasons. First, the seller did not want to anger the gallery owner by revealing that six of what might have been the finest stools had been removed from the original lot. Second, the seller did not want the buyer to know that the six stools had already been rejected (for whatever reason) by another Western buyer. And third, the seller wanted to create the illusion that the goods were freshly brought from Africa and had not yet even been seen by other Western eyes. In fact, by saying that an old woman transported the objects, the seller was further communicating to the buyer that not even another African trader had yet seen the stools.

While collectors are interested in learning the path of objects from village to market, tourists in Africa are concerned with learning the traditional meanings and functions of African art. Traders provide tourists not only with objects to take back home, but also with the knowledge of what the objects mean in their traditional contexts (cf. Spooner 1986: 198).[16] Indeed, it could be argued that for many tourists their experience in the market place would not be complete unless the traders told them something "interesting" about the objects they wanted to buy.[17] Jonathan Culler's remarks about tourist *sights* could easily be applied to an analysis of tourist *arts*. He writes:

To be fully satisfying the sight needs to be certified as authentic. It must have markers of authenticity attached to it. Without those markers, it could not be experienced as authentic . . . The paradox, the dilemma of authenticity, is that to be experienced as authentic it must be marked as authentic, but when it is marked as authentic it is mediated, a sign of itself, and hence not authentic in the sense of unspoiled. (1981: 137)

Traders are caught in the webs of this "paradox of authenticity." On the one hand, by offering authenticity markers, traders provide an invaluable service to tourists. Yet, on the other hand, their role as middlemen and economic intermediaries denies the tourist direct access to a wellspring of "genuine" cultural encounters with the actual art producers and users themselves.

Most of the descriptions which traders use to embellish the objects they sell are derived from market-place lore – stories which are passed from one trader to another, or which are simply overheard in the banter of market-place discourse. Most of the explanations revolve around specific "key symbols" or stereotypes of African art, which include (1) the religious/ritual nature of the art; (2) the association of the art with kingship and royalty; and (3) the antiquity and traditional foundation of the art.[18] Some of the objects sold in the market are described as religious icons or sacred symbols: "This is the most sacred object" of a given ethnic group; or that the object is "carved from the most sacred piece of wood." Some objects in the market are also described as being associated with royalty or leadership: "This is the chair of the king" or

"this is the mask of the big chief."[19] On this particular point, one Western observer has remarked wryly, "What pieces lacked in authenticity is compensated for by tall tales of their origins and use. Were these stories true, one would have to believe that Africa has as many chiefs as France has counts and marquis" (Imperato 1976: 73).

Some objects in the market are also described variously as "old," "an antique," "not from today," or from "before before." I once witnessed a Wolof trader selling a contemporary carving of an African hunter to a skeptical tourist who kept insisting that the object was not really old. In response to the buyer's incredulity, the trader was forced to revise his definition of age. Rather than concede to the buyer that the piece was, in fact, new, he simply shifted the locus of "antiquity" from one semiotic domain to the next. The result was that he never appeared to be *directly* contradicting himself. The trader began the bargaining by telling the client that the sculpture itself was old: "This is a very old piece" (*C'est une pièce très ancienne*). When pushed by the tourist to revise his claim, the trader explained that what he meant to say was that the workmanship was old (*ancien travail*) – in other words, he said, it was a replica of the type of work that was done in the past. Finally, when pushed even further to admit that it did not even represent a "traditional" style, the trader said, in exasperation, that at least the carving represented an old man (*c'est un vieux*).

Some of the market lore which is circulated among traders has nothing to do with "traditional" usage – they are stories which are invented purely to entertain the buyer. Among the items to which such stories are attached are small wooden masks which reproduce on a miniature scale the style of larger ones. Though most of these masks are attributed to the Dan of western Côte d'Ivoire, there also exist on the market miniature masks carved in the styles of several other ethnic groups. In their original context, miniature masks were integrated into a system of belief in which they functioned as spiritual guides and personal protectors (Fischer and Himmelheber 1984: 107; Steiner 1986b). In the market, however, they are known by the name "passport" masks. Asan Diop, a Wolof trader in one of the art markets of Abidjan, explains the function of "passport" masks to a group of European tourists: "Before the whiteman brought paper and pen to Africa, these small masks were the only form of identification that we Africans could carry with us. Each person owned a carving of himself and each tribe had its own kind of masks. This is the only way people could cross the frontier between tribal groups." The tourists were all amused by the trader's story, and one asked rhetorically "but where did they put the rubber stamp?" Collapsing the conventional categories of tradition and bureaucracy, the trader's explanation of the mask is phrased in terms which tourists can easily assimilate. It mocks the true meaning of the masks, reaffirms the tourist's sense of technical and cultural superiority, and provides an entertaining tale with which to return home.

Alteration of objects

Together with presentation and description, traders also satisfy Western demand through the material alteration of objects.[20] These activities include the removal of parts, the restoration of fractures and erosions (Plate 31), the addition of decorative elements (Plate 32), and the artificial transformation of surface material and patina (Plate 33). The simplest kind of material alteration consists of removing an object from its base. Objects from local private collections and galleries are sometimes put back on the market in the hands of African traders. Gallery owners, who are having trouble selling certain pieces in their Abidjan showrooms, may choose to liquidate a portion of their stock by consigning objects to an African trader. The moment the trader receives the art, he removes and discards any base on which the dealer may have mounted the object. I questioned a trader as to why he should remove the base from a piece which was so unbalanced that it could not otherwise stand. He told me that his clients would never buy something from him which had been mounted. The presence of the mount indicated that the object had already been "discovered" by another collector. Its removal reaffirmed the image that traders collect art directly from village sources.[21]

To satisfy the demand among certain Western clients for strong evidence of age and ritual use, traders replicate the shiny, worn patina which results from years of object handling. They reproduce surface accumulation of smoke, soot, soil, and dust. And, they imitate the encrustation of blood, feathers, and kola nuts which results from repeated sacrificial offerings. Because it is inexpensive and easy, traders tend to spew chewed kola nuts on a variety of objects. The process is undertaken on pieces that might normally receive such a treatment in its original context, such as masks and statues (Plate 34), but the principle is also extended to objects which would never receive kola sacrifice – such as wooden hair combs (Plate 35).

When collectors of African art began judging the quality of masks by the amount of wear on the inside surface of the mask (i.e., the so-called "sweat marks" or "grease marks" which form on the surface of the wood where the dancer's forehead, nose, and cheeks would rub), traders responded by rubbing oil (sometimes the residues which ooze from the "sea bean")[22] into the inside of a mask. More recently, many tourists have been alerted (by tour books and tour guides) to look at the inside of a mask for the tell-tale signs of use which testify that it is indeed a "real" African dance mask. Unlike the collectors, however, most tourists are not experienced enough to know that the marks are often evidenced by subtle discolorations and delicate variations in surface patination which might only be visible under certain light conditions or when viewed at particular angles. To ensure that the tourists do not overlook the presence of these marks, traders (or

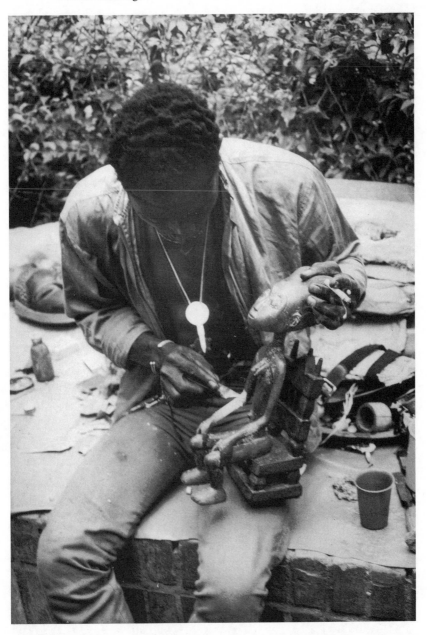

31 A carver repairing the arm on an Asante female figure which was damaged during shipment from the Kumase workshop where it was produced. Plateau market place, Abidjan, January 1988.

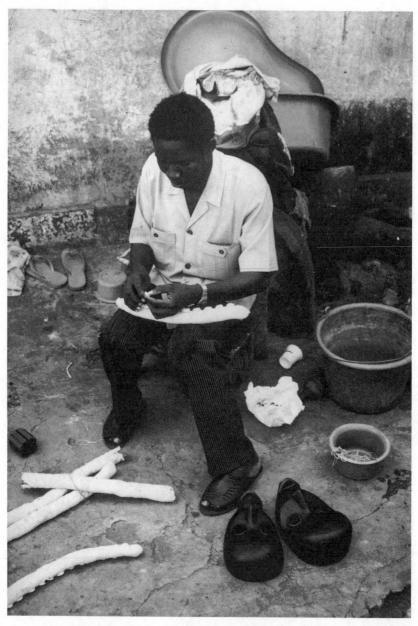

32 Storehouse assistant embellishing Dan masks with padded cowrie-
covered headdresses. Treichville quarter, Abidjan, November 1987.

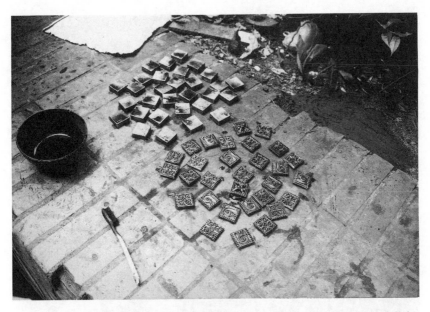

33 Small Akan brass boxes stained with potassium permanganate to dull the surface finish. Plateau market place, Abidjan, July 1988.

commissioned artists) use sandpaper to boldly inscribe the stamps of authenticity.[23]

During the early eighteenth century in Paris, French collectors of Oriental art were offended by the nakedness of certain Chinese *celadon* porcelain figures. In the hope of fetching higher prices, Parisian dealers responded by dressing up the figures in French clothes (Rheims 1961: 167). In a parallel (but inverted) case, African art traders involved directly with European buyers have remarked that their clients are more likely to buy naked Baule statues than those whose waist has been covered by a carved wooden loin cloth or *kodjo*. Collectors prefer to buy Baule statues that have no loin covering (Plate 36), or those with loin protectors made of actual cotton fabric which is affixed to the surface of the wooden sculpture (Plate 37). These type of Baule figures are thought by collectors to pre-date those that have loin cloths carved into the sculptural form itself (cf. S. Vogel 1981a).[24] Traders have responded to this preference among collectors by systematically removing, with the use of a chisel or knife, the wooden loin cloths which cover the Baule figures (Plate 38). The unstained wood which is left as a result of this process is restained with an appropriate dye, and an old piece of fabric is tied around the figure's waist to cover the damage. I have witnessed some collectors, who are now aware of this practice, peeking under a statue's loin cloth,

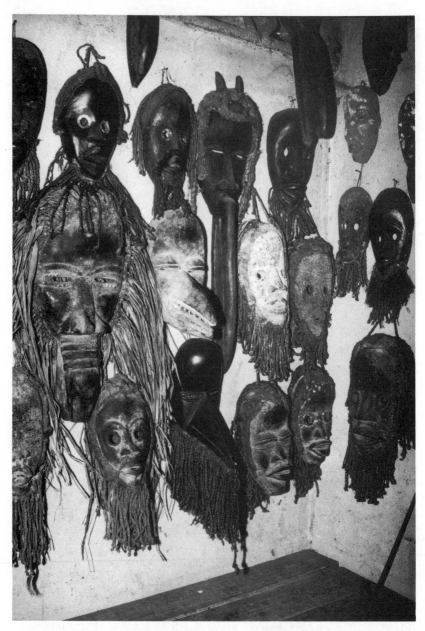

34 Dan wooden face masks covered with kola nut compound to imitate the surface texture of a mask that had received "traditional" sacrifices. Man, June 1988.

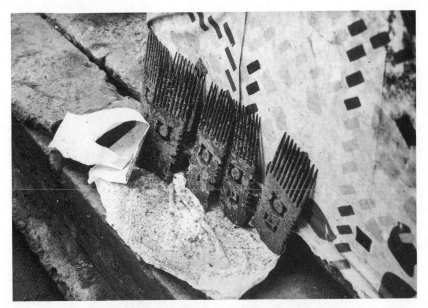

35 Asante combs splattered with a kola nut residue. Plateau market place, Abidjan, March 1988.

before buying it, to see whether its sculptural nakedness was genuine or spurious.

Traders also commission artists and craftsmen to convert, modify, beautify, improve, and repair a whole variety of objects. Utilitarian items with no obvious aesthetic motif are embellished with figural or geometric patterns. The handle of a well-worn wooden spoon, for example, can be decorated at one end with a carved representation of a human face. A comb with no adornment is embellished with a geometric motif on its handle. A beater bar (or heddle comb) with no decoration has a mask carved on its large wooden base. Old wooden bowls are "transformed" into circular face masks by gouging eye holes, carving a nose and mouth, and affixing cowrie-laden leather thongs across the chin. In so doing, an undecorated (and potentially unsaleable) bowl becomes a sculptural form which – because of the wear on the bowl – looks like it is old and used.

Objects which have decayed because of exposure to insects or harsh elements are reworked to satisfy demand.[25] A Lobi figure with a heavily eroded head and body has the features of its face recarved so that it is once again recognizable as a human being with a facial expression. The rest of the body is left untouched – showing the age and wear on the figure.[26] Combs with broken teeth are repaired. Chairs with broken legs or backs are

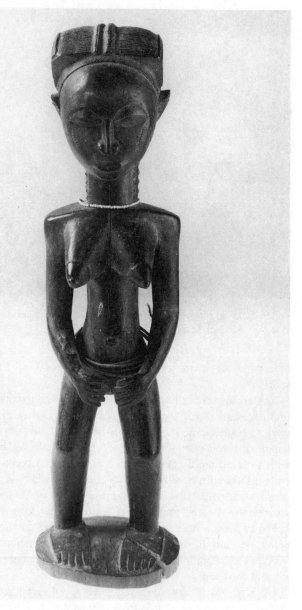

36 Baule figure with beaded waistband and necklace. Height 29 cm. Photograph by Hillel Burger.

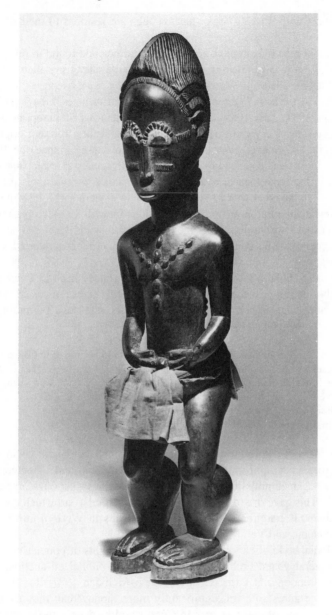

37 Baule figure with cotton loin-cloth affixed around its waist.
Height 32 cm. Photograph by Charles Lemzaouda.

fixed. Statues with missing arms, feet, or legs are restored to their original form.

Finally, a poignant example of object alteration can be found in one of the recent trends in the Ivoirian art market, namely in the sale of so-called *colon* or "colonial" statues (Plate 39). Wooden carvings of *colon* figures (representing either Europeans or Africans in Western attire) are found in societies throughout West Africa (Lips 1937; Jahn 1983). Though bearing elements of European design (clothing, posture, and various accoutrements) these statues were not originally conceived for the market, but rather for indigenous use. Among the Baule, according to research conducted by Philip Ravenhill, statues in fashionable dress were used in the same manner as other wooden statues to represent a person's "spirit lover" in the other world. "A Baule statue in modern garb," he writes, "is neither a replica of a European nor the expression of a wish for a European other-world lover, but rather a desire that the 'Baule' other-world lover exhibit those signs of success or status that characterize a White-oriented or -dominated world" (1980b: 10).

During the colonial period, modern polychrome statues, such as Baule spirit mates clothed in European dress, were not generally sold in the African art market. A Wolof trader, who has been selling African art in central Côte d'Ivoire for over forty years, recounts the following:

My father began as an art dealer in Senegal in 1940. In 1945 we moved to Côte d'Ivoire and set ourselves up in the town of Bouaké. At the time, *colon* statues had no value whatsoever in the art market. In the region of Bouaké, where there were many such carvings, we called them "painted wood" and would give them as gifts to customers who purchased large quantities of other merchandise . . . But some clients even refused to take them for free.[27] (Quoted in Werewere-Liking 1987: 15)

During the late 1950s, toward the end of French colonial rule in Côte d'Ivoire, foreign administrators, civil servants, soldiers, and other colonial expatriates began commissioning portraits of themselves – as souvenirs to take back home. This gave rise to a whole new genre of "tourist" art which grew out of an indigenous tradition of representing Africans in Western attitudes or attire (cf. Gaudio and Van Roekeghem 1984).

The colonial style of carving has reached new heights of popularity during the past several years. Following a series of well-publicized auctions held recently in London and Paris (Chauvin 1987; Melikian 1987; Roy 1987) – where *colon* figures sold for significantly more money than they ever had before – the value of *colon* statues in Côte d'Ivoire (mainly those carved in Baule and Guro styles) has been inflated dramatically and the production of replicas has swelled (Plate 40).[28] In addition, the publication of an illustrated book, *Statues colons*, by an Abidjan-based writer and gallery owner, as well as two articles on the subject of *colon* figures in the weekly Abidjan entertainment

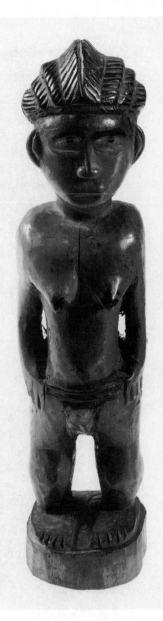

38 Baule figure showing partially removed wooden "loin-cloth." Height 17 cm. Private collection. Photograph by Hillel Burger.

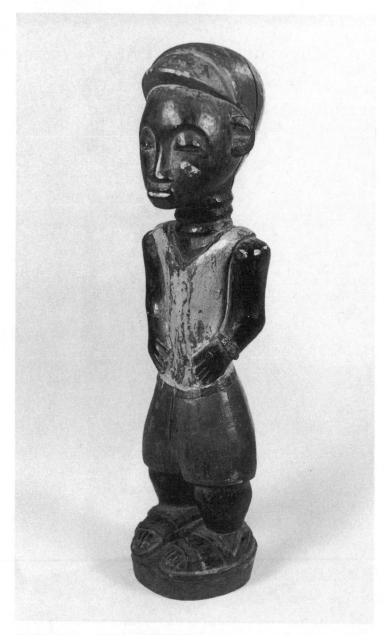

39 Baule "colonial" figure wearing Western-style cap, shirt, shorts, sandals, and wristwatch. Height 24 cm. Private collection. Photograph by C. B. Steiner.

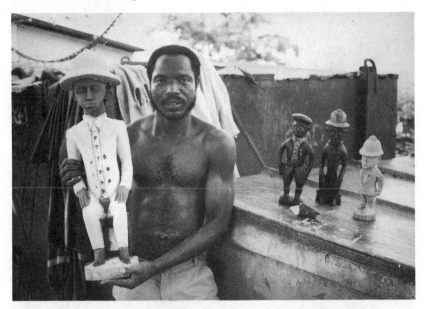

40 Guinean workshop artist with "colonial" figures. Port de Carena, Abidjan,
 June 1988.

guide (*Guido* 1987: 42–46; 1988b: 74–75), has further increased the demand
for such carvings by European expatriates and tourists alike.

When traders commission *colon* statues from workshops they sometimes
specify the style they want. One trader in the Plateau market place, for
example, sold an equestrian colonial-style figure for a considerable margin of
profit. A few days later, he sent word to a workshop in Bouaké that he wanted
to order six *colon* figures on horseback with riders wearing military helmets.
When they do not specify a particular style, artists offer a whole range of
different statues – figures carrying bibles and rifles, soccer balls and tennis
rackets. When carvings such as these are purchased from the artists, they are
always painted in lustrous enamel colors (Plate 41). Traders have found, how-
ever, that brightly painted objects do not sell as well as faded, older-looking
ones – i.e., buyers like to believe that the statues were made during the colonial
era, and that the paint has eroded naturally through time. Thus, when a trader
purchases a *colon* figure from a workshop, he will remove (or pay someone
else to remove) a layer of paint with sandpaper (Plate 42). The object will then
be stained with potassium permanganate. This treatment of the object produces
a darkened surface, with flaked paint, which can often be marketed as
antique.[29] The process of artificial aging underscores the separation of art
suppliers from art buyers. Most of the artists producing *colon* statues for the

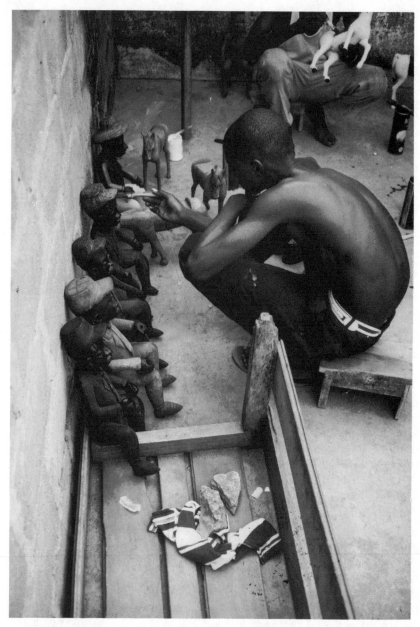

41 Workshop apprentice painting "colonial" figures. Bouaké, December 1988.

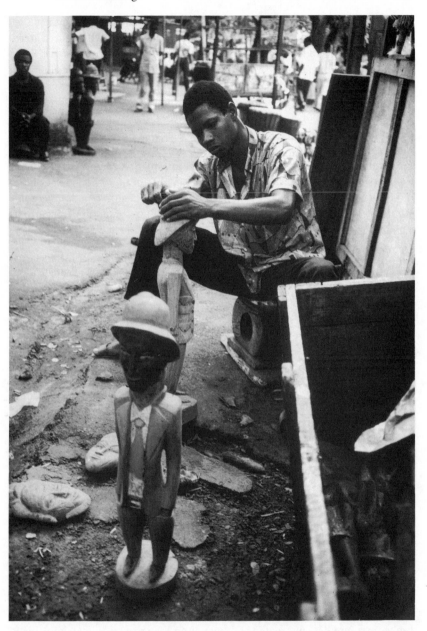

42 Dioula trader sanding down the paint from a lot of newly arrived "colonial" statues. Plateau market place, Abidjan, June 1988.

market have no idea that their works are being transformed by traders, and furthermore, I believe, they would not really understand why such a transformation would add value to the piece.[30]

The commoditization of *colon* figures has altered the discourse of their meaning. As the intended audience shifts from the African village community to the Western export trade, the message that this style of carving conveys is changed radically.[31] Originally conceived as icons signifying the incorporation of new status represented by imported materials, these seemingly similar statues now symbolize the impact of colonialism in Africa. Unlike most African art which is brought into the West and made to stand for the exotic nature of a romanticized Other, *colon* figures stand for the Other's relationship to the West. In the context of the transnational African art trade, the *colon* figure is perhaps the ultimate "postmodern" creation – as defined recently by literary critic Terry Eagleton:

There is, perhaps, a degree of consensus that the typical postmodernist artefact is playful, self-ironizing and even schizoid . . . Its stance towards cultural tradition is one of irreverent pastiche, and its contrived depthlessness undermines all metaphysical solemnities, sometimes by a brutal aesthetics of squalor and shock. (Quoted in Harvey 1989: 7–8)

Rather than achieve their value or authenticity by an emphatic denial of foreign contact, *colon* figures are interpreted by their buyers as a celebration of modern Western expansionism. Like the "vintage imperialism" or "safari-look" created by fashion designers at Banana Republic and Ralph Lauren (Brown 1990), the art traders in Côte d'Ivoire are constructing a marketable fantasy of the colonial experience. In its new context, the *colon* statue is *still* a symbol of social status not, however, because it represents the appropriation of the West by Africa, but rather because its very ownership by a Westerner signifies the reappropriation of Africa and is thus prized as an image which pays homage to the conquest of the continent.

Trade and the mediation of knowledge

The concept of "cultural brokerage" found its way into anthropological discourse sometime in the late 1950s. The term has principally been applied to the realm of politics, where culture brokers are described as middlemen bridging a socio-cultural distance in patron–client political relations. Building on the work of Fredrik Barth, Robert Paine (1971) describes the cultural broker as a middleman capable of attracting followers who believe him able to influence the person who controls the political authority (the patron or, from the Spanish, *patrón*). Paine draws a useful contrast between a *broker* and a *go-between*. The go-between, he says, is someone who faithfully relates

instructions or messages between two separate parties. The broker is someone who manipulates, mediates, or "processes" the information which is being transmitted between the two groups (1971: 6). The go-between is thus understood as a direct liaison or relay in a complex system of network communications. The broker is one who interprets, modifies, or comments on the knowledge which is being communicated. "[W]hile purveying values that are not his own," writes Paine, "[the cultural broker] is also purposively making changes of emphasis and/or content" (1971: 21). Hence, rather than simply facilitate the relationship between two different groups separated by social, economic, or political distance, the broker actually constitutes, molds, and redefines the very nature of that relationship. In the literature on cultural brokerage, the brokers who mediate between two different cultural groups are described as being "bi-cultural" in their knowledge of the two cultures, in their ability to communicate with both cultures, in their living style and physical appearance, and in their capacity to value certain elements from each culture (Briggs 1971: 61–2; Nash 1977: 40–1). The broker is perceived as someone who has "vested interests that are separate from yet dependent upon those groups to which he is intermediate" (Paine 1971: 99). Although he must understand the phenomenology of the worlds which he bridges, the broker "must now allow himself to be caught in the web of his clients' symbols, even when he undertakes to interpret these symbols to third parties" (Paine 1976: 80).

African art traders fit very nicely the model of the "cultural broker." Like the political mediator described by Paine and others, the African art trader is a cultural mediator between two groups brought in contact through common economic pursuits. Like the political mediator, the art trader is (in the language of Victor Turner) betwixt and between the groups he "brings together."[32] As links in a long chain of distribution, art traders control neither the supply nor the demand which they mediate. They can neither create a stock of objects necessary to satisfy the market, nor can they create a market for the objects they have in stock. The two principal components of a market system (supply and demand) are controlled by forces external to the trader's world.[33] Supply is dependent on the availability of objects from village sources and on the production potential of contemporary artists. Demand is largely set by Western publications, museum exhibitions, auction records, and the tourist industry. Like the *bricolage* of Lévi-Strauss's famous myth-maker, the art trader constructs a product from raw materials and conceptual tools which are limited and pre-determined by elements outside his immediate control. The best the trader can do is manipulate the perception of the objects he has at hand in order to meet what he believes are the tastes and demands of the Western buyer. Although I respect and espouse E. P. Thompson's (1966) assertion (*contra* Althusser) that historical subjects are as much determining as determined

in shaping the(ir) world through lived experience, I also believe that the intentionality of historical life is not without limitations – i.e., culture offers not only a range of possibilities, but must also be understood as something which presents a limit on the possible (cf. Ulin 1984: 148–53). Thus, although traders fashion and market images of Africa and African art, these images are constrained by the buyer's *a priori* assumptions about what is being bought – the images are constructed to *satisfy* demand rather than to *create* demand.[34]

Separated by oceans of geographic distance and worlds of cultural differences, African traders and Western collectors are brought together in a fleeting moment of economic exchange. From their brief encounter, the Western buyer departs with an object of art which s/he will integrate into a world of meaning comprehensible only through Western eyes. The African trader walks away with yet another impression of Western taste which will become part of his repertoire of understanding how Westerners perceive African art.

Conclusion: African art and the discourses of value

The African in general has no desire to produce more than he needs for subsistence level. That is the experience, I think, of all of us who have lived here long enough, and I think we realize that putting silver in his pocket is not the African's first aim and object . . . [Indeed] one of the biggest problems is the high leisure preference of the African.

<div align="right">Legislative Assembly of Southern Rhodesia, 1960
(quoted in Montague Yudelman, Africans on the Land, 1964)</div>

The art [of Africa] has degenerated [in the last few years] and veritable studios have opened to meet the demand of tourists. All that was good in African sculpture has disappeared in these examples conceived solely for sale . . . Contemporary works are far from having the same value as the older ones which were made at leisure, without any consideration for monetary profit.

<div align="right">Denise Paulme, African Sculpture (1962)</div>

It was long held in the West that "economic man" was not to be found among the indigenous populations of sub-Saharan Africa. During the colonial period, scores of documents and testimonials were written by administrators and other Western observers which reported on the putative lack of interest among Africans for matters of money, market, and work. In general, it was believed among the colonizers that Africans were unable to appreciate either the value of free enterprise or the economic potential of wage labor. In 1911, for example, the French colonial governor of Côte d'Ivoire complained to his compatriots back in the metropole, that "the indigenous populations are excessively lazy and will never devote themselves to regular work" (Angoulvant 1911: 167). In short, it was thought, by the foreign powers ruling overseas, that *homo antiquus*, not *oeconomicus*, was the chief inhabitant of the African colonies (cf. Miracle and Fetter 1970; Perinbam 1977).

During the same period of time – when colonial capitalist ventures were being stifled by an alleged unresponsiveness of Africans to economic incentives – the collectors and connoisseurs of African art in Europe and America were already beginning to complain that the traditional spirit of African art was being lured away by the seductive spirit of capitalism. They lamented the loss of artistic traditions, and declared that the quality and

aesthetic merits of art objects in Africa were suffering an abrupt decline as a result of the hedonistic calculus of the African artist and his no better accomplice the African trader – both of whom were reproached for their excessive eagerness to reap the financial benefits of the Western market economy.

On the one hand, then, if they were unwilling to participate fully in the wage labor of a colonial mode of production, Africans were criticized by Westerners and viewed as traditional, non-market oriented, and blind to the wondrous possibilities of a mercantile capitalist economy. Yet, on the other hand, if they were engaged in the production or distribution of art for economic gain, Africans were *equally* criticized by Westerners, and viewed as commercial, debased, or even worse, "greedy." While those in the West who bought, sold, and collected African art cherished the "pre-capitalist" principles of so-called traditional African society, those involved in the production and export of cash crops, and other colonial commodities, found these same principles to be wholly incompatible with their own expansionist goals.

Although these two Western attitudes toward African productivity are indicative of a whole range of contradictions in the colonial (and indeed post-colonial) relationship between Africa and the West, for the purposes of this discussion I wish to single out one point in particular, namely that these differences stem, at least in part, from a collective misconception of the nature of value in the Western art world – that is, a total disavowal of the economic structures that underlie both the production and consumption of art or, what may more generally be called, cultural capital. "[W]e all go to great pains," Mark Sagoff has noted, "to distinguish the value of art as art from the value of art as an investment" (1981: 320). In other words, the aesthetic value of art is always seen as separate from, or rather above, its economic value.

In his book *Rubbish Theory*, a seminal study on the creation and destruction of value in the world of material goods, Michael Thompson draws attention to those who stand guard at the carefully monitored boundaries between these two discursive domains – what he calls an "art aesthetic," on the one hand, and a "commercial aesthetic," on the other. "Those persons who are particularly concerned with the manning of the controls on the transfers between categories," writes Thompson, "operate almost entirely in terms of aesthetic values, refusing to countenance the vulgarities of economics, and directing all their energies towards the paramount duty of maintaining purity by identifying rubbish and preventing it from getting anywhere it does not belong" (1979: 115).

According to Thompson's theory of value as applied to the art market, both collectors and producers of art have a vested interest in denouncing the gallery system and its seemingly vulgar economic attribution of value. For the art

collectors, it is necessary to obscure the relationship between the art aesthetic and the commercial aesthetic in order to certify their capacity to recognize an object's "pure" artistic value untainted, as it were, by the inelegance of economic speculation. Although the two systems of value are obviously linked via the art object itself, the collectors must treat them as *separate* categories in order to legitimate their claim. As for the producers of art, Thompson goes on to argue, they too must deny the connection between the art aesthetic and the commercial aesthetic. If an artist's work is rejected by the established gallery system, then the artist can capitalize on the art-commercial distinction by creating anti-establishment objects – e.g., conceptual, auto-destructive, or unpossessable objects that achieve value through their repudiation of a commercial aesthetic. However, if the artist's work is accepted into the gallery system, then the artist just "adopts the gallery owner's line that the two aesthetics . . . are simply different aspects of some whole and that the best art works, judged by the art aesthetic, will inevitably command the highest prices" (Thompson 1979: 122).

No one has analyzed this conceptual negation of the economic value of art with greater insight and understanding than sociologist Pierre Bourdieu. In a general statement on the subject, Bourdieu says, "The challenge which economies based on disavowal [*dénégation*] of the 'economic' present to all forms of economism lies precisely in the fact that they function, and can function, in practice . . . only by virtue of a constant, collective repression of narrowly 'economic' interest and of the real nature of the practices revealed by 'economic' analysis" (1980: 261). Writing specifically about the European art market, Bourdieu goes on to say that the "art business, a trade in things that have no price, belongs to the class of practices in which the logic of the pre-capitalist economy lives on" (1980: 261). Adopting a Durkheimian language, he further suggests that the "world of art stands in opposition to the world of daily life, like the sacred to the profane" (Bourdieu and Derbel 1990: 165; see also Bourdieu 1968: 610–11).[1]

Drawing both on Thompson's deconstruction of the axiology of aesthetics, and on Bourdieu's analysis of the "misrecognition" (*méconnaissance*) of cultural capital, I will demonstrate below how the Western (e)valuation of African art builds itself in direct opposition to both use value and exchange value. In the first instance, I will argue that Western discourse on African art denies the instrumentality – material, metaphysical, or spiritual – of an African object once it has reached the Western context. In its new setting, the art has no "function" other than to attest to its "non-functional" role. In the second instance, I will argue, that the discourse denigrates economic benefit as a basis of, or motivation for, African art connoisseurship and collecting. In other words, cultural capital can only be maximized if economic capital is disavowed. The discussion will then conclude by locating the place of the

African art trade between these two systems of value or, what might be called, these two enchanted worlds – the spirit world from which the objects are artfully removed and the art world into which the objects are spirited.[2]

The disavowal of use value

African art objects when displayed in the West are elevated to the category of art by denying them their former utility or use value[3] – baskets and calabashes are displayed on pedestals not balanced on the head, face masks are suspended without motion from mounts on the wall not danced in the open space of a village square, and statues are intended for disinterested contemplation not religious veneration.[4] Indeed, it could be argued that an object's aesthetic merit in the art world is heightened, or perhaps even made possible, by the very fact that its value transcends any practical function thereby shedding its former utility.

Writing in the late nineteenth century, Georg Simmel touched upon this idea briefly in *The Philosophy of Money*. Though phrased in evolutionary terms, his observations nonetheless translate remarkably well to the process of valuation that occurs in the African art market today – a process which operates through transformations in space rather than in time. Simmel wrote:

The beautiful would be for us what once proved useful for the species, and its contemplation would give us pleasure without our having any practical interest in the object as individuals . . . [W]hereas formerly the object was valuable as a means for our practical and eudaemonistic ends, it has now become an object of contemplation from which we derive pleasure by confronting it with reserve and remoteness, without touching it. (1978, ed.: 73–74)

Raising a similar point in order, however, to make a quite different argument, Bourdieu, more recently, has remarked that:

[art] objects are not there to fulfil a technical or even aesthetic function, but quite simply to symbolize that function and solemnize it by their age, to which their patina bears witness. Being defined as the instruments of a ritual, they are never questioned as to their function or convenience. They are part of the "taken for granted" necessity to which their users must adapt themselves. (1984: 313)

Finally, following a parallel train of thought, for the purpose of making yet a different argument, literary critic James Bunn has suggested that, "Because objects may be given different turns as determined by their contexts, they are either useful or wasteful; in waiting they are potential . . . Removed from the context of use, tools become objects of art that display themselves as failed metaphors, as 'utensils' warped from one category of means to another of forestalled ends" (1980: 313).[5] Whether one constructs this general argument with the aim of demonstrating the necessity of "distance" in the creation of

value (Simmel), revealing the class structure that underlies the consumption and appreciation of art (Bourdieu), or elucidating the transformative sequence of tropes through which "use" and "beauty" unfold (Bunn), the essential point remains constant: i.e., that the disavowal of use value is a prerequisite for admitting what has the potential of being utilitarian into the realm of aesthetics.

One may conclude from this discussion that in the West, at least, use and beauty are not threads in a single fabric of meaning but are viewed, more commonly, as separate elements of value competing toward radically different ends.[6] In Oliver Goldsmith's novel *The Citizen of the World*, a fictional memoir written in the last century, the central character, a Mandarin philosopher traveling in England, recounts the following visit to the home of a British collector of *chinoiserie*. The passage illustrates clearly not only the contempt for utility in the Western world of "art," but interestingly it also places the Western negation of use value within the framework of a self/other or civilized/primitive dichotomy.

"I have got twenty things from China," [said the lady], "that are of no use in the world. Look at those jars, they are of the right pea-green: these are the furniture." Dear madam, said I, these though they may appear fine in your eyes, are but paltry to a Chinese; but, as they are useful utensils, it is proper they should have a place in every apartment. "Useful! Sir," replied the lady, "sure you mistake, they are of no use in the world." What! are they not filled with an infusion of tea as in China? replied I. "Quite empty and useless upon my honour, Sir." Then they are the most cumbrous and clumsy furniture in the world, as nothing is truly elegant but what unites use with beauty. "I protest," says the lady, "I shall begin to suspect thee of being an actual barbarian." (1891: 51, cited in Bunn 1980: 313)

Like Chinese jars housed in a British parlor, African art objects in the West are divorced from their proper function and original meaning. When taken out of context, African art is no longer valued "instrumentally" or "as a means to some end," but rather it is valued "for its own sake" or "as an end in itself" (cf. B. Smith 1988: 126).[7] When collectors or tourists ask a trader in the market place what function an object has (or had) in its indigenous setting, they are not asking the question in order to replicate its use in their own environment, but rather they are seeking to uncover the function of the object in its prior "life,"[8] thereby allowing the obsolescence of its past to testify, and indeed to celebrate, a loss of utility and functional value.

Because most of the traders in the art market are Muslim, and do not there-fore believe in the sacredness or ritual efficacy of the objects they sell (see Chapter 4), they are generally not distressed by the desacrilization of African art in the West. That is to say, they accept the notion of aesthetic contextual-ization as a natural result of the commodifying process. In one instance, however, which I recorded in the Plateau market place, a group of Muslim

traders became noticeably disturbed by a purchase which had been made by a French art dealer. One of the market-place traders had sold the dealer an Islamic "protective" belt (*guru*) – a narrow thong from which are suspended about a half dozen small leather pouches containing Qur'anic scriptures and verses (*laya*).

After witnessing the purchase of the belt, one of the Muslim traders, who had gathered around the dealer, asked him why he had bought this sash of Qur'anic charms. The dealer simply said that he had bought it because he "liked the way it looked." Then Ali Bagari, another Muslim trader who had joined the congregated crowd, added, in an acrimonious tone, "But you didn't have the belt commissioned for yourself, so you don't know what the charms are used for. They might be for hunting. They might be for travel. What good will it do you, if you don't know what the charms are for?" (6/7/88). A moment of tension was broken by group laughter – Bagari shook his head, silently voicing his bewilderment and disapproval. Because the belt – unlike most other things that are sold in the art market – represented to the Muslim traders something which had a meaningful religious use value, and therefore more than either a simple economic exchange value or an aesthetic value, the boundary that normally separates these different systems of value was suddenly brought into question – the process of commoditization having been momentarily jarred.

The disavowal of exchange value

Bourdieu's remarks about the negation of the economy in the collection of works of art, are plainly confirmed by an analysis of the African art market in the West – not only in the attitude of its participants toward the production of art for sale (i.e., tourist or export art), but also in the way they judge those who sell or collect art purely for financial gain and investment. Writing in 1979, for example, art dealer/collector Irwin Hersey pointed to what he perceived as a disturbing trend in the African art market which was moving toward the collection of art for unabashed monetary gain. "For the first time," he writes, "the field [of African art collecting] is being *invaded* by investors who are more interested in appreciation of the value of the objects than in appreciation of its beauty" (Hersey 1979: 1; emphasis added). Evoking similar concerns, another African art dealer remarked:

I'm getting a little tired of people coming in and saying, "What's the best investment piece you've got here?" I've always enjoyed selling beautiful things to people who appreciate them. Now, however, it's a whole other ballgame. These people couldn't care less about whether an object is a great work of art or not. All they're interested in is how much money they can make on it. It's really terribly discouraging. (Quoted in Hersey 1979: 1–2)

Both of these statements underscore without question Bourdieu's contention that "too obvious a success in the market or what is worse too obvious a desire for such success leads to cultural delegitimization because of the overall struggle between cultural and economic capital" (Garnham and Williams 1980: 220–21).

Following a general pattern of inflation in the international art market, ownership of African art today has become linked closely to economic investment. Once considered a thrifty substitute for the ownership of modern art,[9] African art (when purchased from a "reputable" auction house or gallery) now constitutes a major financial venture with high monetary stakes. Yet, on the whole, as Bourdieu predicts, collectors emphatically deny that they collect for economic gain. Like the functional context (use value) of African art which is said to interfere with the collector's pure aesthetic response to the *objet d'art*, the economic dimension of art (its exchange value) is also said to compete with a true sense of artistic enjoyment.[10] "Allow yourself to experience the object itself," gallery owner Ladislas Segy once advised his customers, "If you know what an object costs, you experience it differently" (quoted in Anon. 1988: [2]).

The commoditization of African art objects in the twentieth century would, I imagine, have fascinated and perhaps even astonished Karl Marx. Objects that were once the subjects of "fetishism" in a world putatively dominated by an organic unity between persons and their products, now become the subject of a new form of fetishism – commodity fetishism – which results from the calculated alienation of production from consumption and the overestimation of transcendent worth in the pseudo-sacral space of the international art market.[11] The mystification of value that Marx analyzed so brilliantly in the context of late-modern industrial capitalism, has in its post-modern manifestation become nearly a parody of itself.

Consider, for example, the words of one American collector as he explains his personal desire for anonymously produced African objects:

It doesn't bother me . . . looking at a piece [of African art] that I don't know the name of the artist. I mean I like the object itself enough, that I don't need that kind of information. Part of my desire to collect magical, strange objects would be destroyed if I knew it was carved by Mr. X in such and such a village and [that] he spent so much time carving it. If I knew the whole process so exactly, it would take away some of the magic and mystery. (8/10/91)[12]

The collector's remarks underscore with crystalline clarity the general assertion that the trade in African art conceals or, as it were, mystifies the relationship between human labor (both production and exchange) and its products. The *work* of African art thus becomes socially repressed by a complicity of consumers who destroy in their imagery of the African art object

all traces of production, and, in the end, celebrate the decontextualized results of dehumanized labor – the mysterious sparkle of the commodity cult.

Between two enchanted worlds

It has long been said that African art is produced in an enchanted world – a world in which a community of believers endow their ritual objects with spiritual values which are seemingly incommensurate with their physical properties. Oceans away, in a geographically separate and culturally distant corner of the globe, African art is being consumed today in a totally different, yet, I would argue, equally enchanted world – a world in which a community of believers endow objects of art with economic values that are seemingly incommensurate with their cost of production. And, at the same time, through a mystifying sleight of hand, these same devotees deny completely that their cultural capital is consecrated by, and indeed deeply embedded in, the wider economy. African art objects are moved, therefore, from a world that defies the logic of ontology to one which denies the logic of capital.

Somewhere between these two enchanted worlds is wedged, rather awkwardly, a lively commerce in African art objects – a commerce which moves in the hands of professional African traders objects of art and material culture from their context of creation to their point of consumption. Confronting directly the objects they sell, with no motives of sacralization or pretensions of economic disavowal, African art traders unveil a naked truth in the logic of art valuation – a truth which sometimes exposes itself rather unpleasantly to those who dwell in either of the enchanted realms.

Through a complex process of cultural and economic exchange, the African art trade reveals, while it also constitutes, the linkages and connections that make the world a system. Rather than view the process of commoditization as an impersonal force which arrives full-sail like a ship to shore, the study of the African art trade challenges us to view the penetration of capitalism in Africa as a series of personal linkages, forged one at a time by different individuals each with their own motives, ambitions, and set of goals. At all levels of the trade, individuals are linked to one another by their vested interest in the commoditization and circulation of an object in the international economy. Yet, ironically, the very object which brings them together does not hold the same value or meaning for all participants in the trade.

Notes

INTRODUCTION: THE ANTHROPOLOGY OF AFRICAN ART IN A
TRANSNATIONAL MARKET

1 Eric Wolf has also noted the similarity between early diffusionist anthropology and
recent studies of world systems and global political economy. "[The diffusionists]
were not much concerned with people," he writes, "but they did have a sense of
global interconnections. They did not believe in the concept of 'primitive isolates'"
(1982: 13).

2 In order to respect the decree of 14 October 1985 by President Félix Houphouët-
Boigny, the country name "Côte d'Ivoire" will not be translated into English. The
original remarks made by the President on this subject were transmitted by the
Foreign Broadcast Information Service. My thanks to Amelia Broderick of the
United States Information Service in Abidjan for making available this document.

3 Dioula is a Mande language spoken in different forms by people throughout the
western Sudan. Although the term "Dioula" refers to a specific ethnic group in
northern Côte d'Ivoire, the Dioula language is more commonly a reference to a
Dioula-related lingua franca – a language that is used as a medium of communi-
cation among people who have no other language in common (see Lewis 1971;
Launay 1982).

4 The presence of a tape recorder caused such a flurry of activity whenever it was
brought out – people either objecting to its presence or wanting to buy it – that I
decided against the use of a recording device. Notes were either written at the time
of interview and observation, or transcribed from memory at the end of the day.
Some of the direct interview quotations that appear in the book, were collected
during the filming of *In and Out of Africa* – a documentary video project on the
African art trade that I collaborated on in 1991.

5 It is ironic to note that while admiring African art for its supposedly "communi-
tarian," "antiauthoritarian," and "egalitarian" qualities, the modern primitivist
artists and intellectuals had inadvertently brought these very objects into a
competitive and hierarchical capitalist market economy.

6 The technical development of the long-distance steamship, which took place at
about the same time, also helped of course to provide improved access for
Europeans to the region (Baillet 1957).

7 For details on the life of Paul Guillaume, see Revel (1966) and Bouret (1970).

8 A second example of African objects being moved through industrial-commercial
channels comes from Bohemia (modern day Czechoslovakia), where a German

manufacturer of glass beads, Albert Sachs, was acquiring African art as early as the 1980s through his company representatives in West Africa (Paudrat 1984: 147).

9 From a conversation with Pierre Verité, Paris, August 23, 1986.

10 For some recent views on the history of the study of African art, see Adams 1989; Ben-Amos 1989; Blier 1990; Drewal 1990; Gerbrands 1990.

11 The justification for the study of African art within the narrow parameters of a single village community suspended artificially in time and space is similar to the motivation for so-called "salvage ethnography" and "salvage archaeology" which were characteristic approaches to the anthropological study of Native Americans at the turn of the century in the United States.

12 Journalist Nicholas Lemann encountered this problem when he conducted an investigative report for an article in *The Atlantic* on African art traders in New York City. "Because I found that it was impossible to gain access to the runners as a reporter," he says, "I began buying art from them earlier this year" (1987: 28).

13 As in many art/antique markets, the "discovery" element plays a crucial role both in the assessment of value by consumers and in their perception of authenticity. If a collector believes that s/he is the first to whom a trader has shown a particular object, then there is a greater chance that s/he will be interested in buying the item. The more often an object is shown among a particular circuit of buyers, the less it is worth in the eyes of the local collectors. In this sense, although art objects are not perishable in the same way as fruits or vegetables, art traders share some of the risks of a perishable commodity market.

14 I take my lead here from Pierre Bourdieu who once remarked that the "world of art [which is] a sacred island systematically and ostentatiously opposed to the profane, everyday world of production, [offers] a sanctuary for gratuitous, disinterested activity in a universe given over to money and self-interest" (1977: 197). Like theology in a past epoch, he concludes, the art world provides "an imaginary anthropology obtained by denial of all the negations really brought about by the economy" (*ibid.*: 197). This densely stated point raises a theme which Bourdieu takes as the subject of his later book *Distinction: A Social Critique of the Judgment of Taste* (1984).

15 In *Primitive Art in Civilized Places* (1989), Sally Price offers a phenomenology of the Western collector's idyllic image of "primitive" cultures frozen in time. Many collectors of African art share in the vision of this empowered gaze which strives to suspend artificially the history of Africa and its art. In *The Art of Collecting African Art*, Susan Vogel describes one collector's views which support emphatically Price's observations: "This first experience with African art reveals a touch of the romantic nature that [this collector of African art] feels goes hand in hand with his collecting. Further evidence of this can be heard in the reasons he gives for feeling that going to Africa is not necessary to his collecting. He views his objects, he says, as being conceived in the pre-colonial aesthetic that he admires. He adds that 'if Addidas [sic] sneakers and Sony Walkmen were absent from the Ivory Coast, I might reconsider my position, but, at present, my romantic vision of pre-colonial Ivory Coast is too fragile to tamper with'" (S. Vogel, ed. 1988: 58).

16 In a supposedly objective report about the African art trade in the United States, one journalist could not stop himself from putting a patronizing, negative spin on a trader's explanation about his understanding of the aesthetics of African art.

"Smoking cigarettes continuously and dropping ashes haphazardly to the floor of his one-room dwelling in New York," writes the reporter, "Zango spoke most emphatically between telephone reservations for plane flights to Chicago and Los Angeles that contrary to what many white scholars and anthropologists have written, he is one African who does indeed possess an aesthetic appreciation of art separate from art as an adjunct of ritual. 'I know art long time,' he emphasized" (Griggs 1974: 21).

17 Although the study of the African art trade has received little systematic attention in either anthropological or art historical research, a few exceptions include a number of short descriptive essays which have been written about art markets in various parts of Africa, see Elkan (1958), Crowley (1970, 1974, 1979), Blumenthal (1974), Himmelheber (1975), Robinson (1975), and Ravenhill (1980a). For an excellent bibliographic overview of different aspects of the African art market, see Stanley (1987).

1 COMMODITY OUTLETS AND THE CLASSIFICATION OF GOODS

1 The term "market place" is used here to describe the physical site where market transactions occur. It refers to an official, enclosed area where seller access is restricted and stall fees are collected. The term "market" is used to denote the social institution of the market itself – i.e., any domain of economic interactions where prices exist which are responsive to the supply and demand of the items exchanged (cf. Plattner 1985: viii). For another distinction between "market" as physical site and economic process, see Agnew 1986: 17–27.

2 Sundays are considered to be very slow market days; only one quarter to a half of the traders show up at the market place on that day.

3 Compare Cohen (1965: 14, fn. 3) on the use of similar protective charms by Hausa cattle merchants in Nigeria. The *malam* (pl. *malamai*) is an educated person trained in the teachings of Islam.

4 Abidjan was formerly the political capital of Côte d'Ivoire. However, as part of a major effort toward decentralization, the official capital was moved in 1983 to Yamoussoukro, the natal village of President Félix Houphouët-Boigny. Foreign embassies and political consulates, however, have been permitted to stay in Abidjan – which remains the focal point of the Ivoirian economy (Mundt 1987: 16).

5 In other major urban centers in Côte d'Ivoire (i.e., Bouaké, Korhogo, and Man), one finds a similar diversity of sale outlets but on a much smaller scale.

6 Because Bouaké is located in the center of Côte d'Ivoire, it has one of the largest market places in the region. People from all over the country travel to Bouaké to buy their supplies.

7 Construction in the city of Abidjan began during the years 1899–1903, when an epidemic of yellow fever threatened to wipe out the European population in the coastal city of Grand Bassam, which was the official colonial capital of Côte d'Ivoire until 1934. Abidjan grew from a village of 1,400 inhabitants in 1912, to 17,000 in 1934. The 1985 census recorded a population of over 2 million in Abidjan. In its original layout, sketched in 1925 by a corps of French military and civilian engineers brought to Côte d'Ivoire to design the new capital, the city of Abidjan was divided into three distinct neighborhoods separated by the different

waterways of the Ebrié lagoon. The Plateau Quarter, which was located on the mainland and was the most elevated section of the city – thereby providing the most temperate and healthful climate for expatriates – was reserved for European housing, a military camp, the future site of the Abidjan railroad station, and the colonial administrative offices. A second section of the city, near the banks of the lagoon, was to be used as the port and the chief commercial district of Abidjan. And a third area to the east of the Plateau on the island of Petit Bassam was designated as the *cité indigène*, where African workers and their families were to be housed. Although Côte d'Ivoire gained its independence from France in 1960, the division of Abidjan has retained much of its original segregation. The Plateau has become the business district and the center of political administration, and the *cité indigène*, which is now in a section of Abidjan called Treichville Quarter, has remained a residential neighborhood for working-class Africans. Among the several new districts which have grown around the urban core of Abidjan is the Cocody Quarter which was planned in 1960 to accommodate European, Lebanese, and high-income African residents (Le Pape 1985; Mundt 1987: 15–16).

8 Every day, the women travel to the market place with baskets full of fresh produce. After setting out rows of careful displays (fruits and vegetables meticulously stacked in small pyramidal piles), they store their empty baskets on the tin roofs of the wooden stalls. Looking down from the second floor of the market building one sees only a vast sea of upside-down woven baskets.

9 Of the two largest indoor market places which cater to an African clientele, Treichville and Adjamé, only the market place in Treichville is visited regularly by tourists. The market place in Adjamé has gained a reputation for being a dangerous place – where criminals and pickpockets prey on foreign visitors. Although Treichville is by no means free of urban crime, it is considered to be more safe than Adjamé, and thus it attracts more tourists and expatriate collectors alike.

10 As an American Embassy brochure put it, "Even without a purchase, the interplay of business at the African market and the warmth and friendliness of the African people is worth seeing first-hand" (Anon. n.d.b: 13).

11 This feature of the Cocody market place qualifies the business space as a purpose-designed marketing arena rather than the more general-purpose premises which are characteristic of Treichville and Plateau.

12 The public garden or park was built to separate the Plateau into two discrete neighborhoods: the government area in the northern part of the Plateau, and the commercial district to the south (Mundt 1987: 16). About half the garden is occupied by the art market place. The rest of the park is used as public leisure space – for sitting, sleeping, and walking; it serves as an area for Muslim prayer, and as a gathering spot for street performers. The park contains two Lebanese-operated snackbars and a public urinal.

13 The construction and expansion of the Hotel Ivoire on the other side of the Ebrié lagoon, which was begun in 1957, drew too much business away from the once prestigious Hotel du Parc. The building remains standing in Plateau, but its doors are sealed with plywood and it is uninhabited. Business in the Plateau market place has suffered a major decline since the closing of the Hotel du Parc.

14 It is with sadness that I report the closing of this market place in the beginning of 1990. Not long after I left Côte d'Ivoire (1988), the city government began

systematically to close down and fence in all large, public areas within the city of Abidjan. Gardens and monuments in the center of traffic circles (*rond points*), open-air lots with food concessions and public tables and benches, and the Plateau's *jardin public* which housed the art market were all sites targeted for closure and eventually barricaded with concrete walls and wire fencing. Because the period beginning in early 1990 was a time of political unrest – students protesting openly on the campus of the national university as well as on the city streets – I believe the Ivoirian administration was trying to eliminate all large public areas where students could potentially congregate and protest. All this was happening, after all, in the shadow of the widely reported Chinese student uprising in Tien-am men Square.

To compensate the traders who were displaced by the market's closure, the Abidjan City Hall allocated 52 million CFA ($170,000) toward the construction of a new market place, called "Centre Artisanale de la Ville d'Abidjan," in an industrial suburb known as Zone Trois. The new market place, which was completed in spring 1991, houses twenty concrete structures which are each divided into four stalls (*magasins*). Each trader was asked to pay a deposit fee of 45,000 CFA ($150) followed by a monthly rental of 15,000 CFA ($50). Although most of the traders were able to pay the deposit, none have been able to keep up with the monthly fee. The traders say that because the new market place is located so far outside of the central part of town, the few remaining tourists that were not scared off by the recent student uprisings are not even able to find their way to the new market place. One trader who maintained a prosperous business in the Plateau earned only 5,000 CFA ($17) from the time he moved into the new market until fall 1992. Were it not for his recent, moderately successful ventures in the New York art market, this particular trader would obviously have been forced out of the art trade.

15 According to Falilou Diallo, a Wolof trader in the Plateau market place, the reason the Wolof were able to dominate the market for so many years is because of the preferential treatment they received from the French. "Since Dakar was the capital of A.O.F. [Afrique Occidental Française] during the colonial period, the Senegalese could move wherever they wanted. When my father began selling in this market place in 1950, the Malians and Ivoirians used to run around and do chores for the Senegalese. When they realized that there was money to be made in art, then they started selling it on their own" (10/26/87). Another Wolof trader told me that Ivoirians were not able to sell art because they were too involved in the religions which sanctify the arts. It took the Senegalese – outsiders who did not believe in the sacredness of the arts – to show the Ivoirians that "what they had was actually worth money" (12/1/87).

16 The government policy of "Ivoirianization" was developed in the 1970s largely in reaction to French, Syrian, and Lebanese control of the export-import economy. The policy was aimed specifically to replace foreign control of capital and industry with control by Ivoirian citizens. Profits made in agriculture were used to create jobs for skilled Ivoirians, mainly by buying modern industries and technologies abroad (Den Tuinder 1978: 7–8; Monson and Pursell 1979). Although the art market was not specifically targeted as an area of state controlled Ivoirianization, the creation of the syndicate and the pressure placed on Wolof traders must be understood within the broader framework of strategic national economic policy. Barbara Lewis signals a similar pattern of Ivoirianization in the fruit and vegetable market in Treichville.

"[T]he non-Ivoirians who dominated market activity during the colonial period," she writes, "are still an important presence in the marketplace, though political pressures have reduced their dominance" (1976: 138).

17 Each major market town in Côte d'Ivoire (Bouaké, Man, and Korhogo) has its own sub-unit of the syndicate, with local representatives and elected officials. The role of syndicates or unions has a long history in Côte d'Ivoire. The Syndicat Agricole Africain, which was established in 1944 by Félix Houphouët-Boigny and was later replaced by the national political party (PDCI), was largely responsible for the independence of Côte d'Ivoire and a break with the European-planter-dominated economy which existed during French rule. Other prominent trade unions which were also instrumental in national independence include, the Syndicat des Agents du Reseau Abidjan-Niger, the Syndicat des Cheminots Africains, the Syndicat des Commerçants et Transporteurs Africains, the Syndicat des Fonctionnaires Indigènes de la Côte d'Ivoire, and the Syndicat du Personnel Enseignant Africains (Mundt 1987: 124–25).

18 An elderly Hausa trader who sells art in the Plateau market place was in the process of buying old colonial currency from an itinerant supplier, when a group of youths wandering through the market place spotted the exchange and (thinking the old bills were valuable) demanded that the traders give them some of the money. When they refused to comply, the youths stopped two policemen who were walking by, and told them that the traders were dealing in counterfeit currency (an issue which had been widely publicized in the recent press). The police arrested the two traders and incarcerated them in the Plateau police station jail. The next day, members of the syndicate stepped in to explain that the two men were only trading in antique colonial currencies. The case was pleaded before the precinct chief, who eventually dropped the charges and set free the two Hausa merchants.

19 In theory, the annual membership fees are invested to finance syndicate costs. However, during the period of field research, the syndicate had no funds. The past president of the syndicate was asked to temporarily step down, while he was being investigated for embezzlement. When a trader died, the acting-president of the syndicate went around the market place asking members to donate whatever they could toward the funeral expenses of their deceased colleague.

20 The separation of artists from Western consumers is also underscored by the artists themselves. In her book *Statues colons*, Werewere-Liking quotes one workshop artist from Bouaké saying, "We could carve better: create interesting forms with a high quality finish . . . But the traders want things which are easier to make and [therefore] less expensive . . . Unfortunately, we have no contact with the people who could better reward our work by paying us what they are paying the traders" (1987: 19, my translation from the French).

21 The traders were divided on their opinion as to whether or not the perimeter of the market place was a more profitable location than the market place center. Some argued that by being on the outer edge, they were able to gain access to tourists before any of the traders on the inside of the market place. Others, however, felt that tourists often used the traders on the perimeter to gauge the price of objects, and then moved toward the inside of the market place to make their actual purchases.

22 The rental fee for a stall varies depending on its size and structure. There is a significant initial purchase price for a stall – an entire covered stall may cost up to

400,000 CFA ($1,300). The monthly fee can range from 800 CFA ($2.50) to 6,000 CFA ($20) depending on the quality of the stall. The high price of stalls discourages traders from getting started in the market-place business. This was made clear by the abandonment of a stall in the Plateau market place, which has remained unoccupied since the death of its owner in 1985. Since the onset of the *crise économique*, traders say that nobody has been able to afford the cost of this stall.

23 Because the city never took a census of the makeshift wooden stalls that were erected in the 1970s after the division of the market place among ethnic coalitions, there is no schedule of stall fees which applies to these newly constructed structures. Traders report that the *contrôleurs* exploit this ambiguity in the system by negotiating a fee with the individual stallholder and then pocketing this "unofficial" stall right.

24 While the Wolofs tend to control the Plateau market place, the Hausa have historically controlled the Treichville storehouses.

25 Although this situation is in some ways parallel to the landlord–broker relationships described by Abner Cohen (1969) for Hausa kola and cattle trade in Nigeria, it nonetheless differs considerably. Rather than rely on the host's network of buyers, the visiting traders have their own circuits of distribution within Abidjan. Also, unlike the kola and cattle diaspora, the art traders are not housed by the storehouse owners; they often stay in inexpensive hotels near the storehouses.

26 The Hotel Ivoire first opened in 1963 with the construction of a twelve-floor building; an additional thirty-floor tower was built in 1969; an extension to the original building was added in 1972. The hotel now has a total of 750 rooms (Nedelec 1974: 76–78).

27 The couple who originally ran the Rose d'Ivoire died in the late 1970s. According to several sources, the couple had been poisoned by villagers who accused them of selling a mask which had been stolen from their village (Susan Vogel, personal communication).

28 Since it is not advertised anywhere, access to this area of the gallery is available only to those who are serious enough about collecting African art to inquire with one of the salesmen or with the gallery owner.

29 The gallery is actually run by the owner's wife. He says he opened the room at her request in order to give her "something to do."

30 It is interesting to note the variation in the pattern of price disclosure. The mid-level of the market is the only place where prices are fixed and visibly marked. At neither the low level of the trade (in the open-air market places) nor at the highest level of the trade (the up-scale gallery) are prices visible. Recently, the Department of Consumer Affairs invoked New York City's so-called Truth-in-Pricing law, ordering art galleries to post their selling prices. Gallery owners protested that this intrusion of monetary tags went against the desired atmosphere of an art gallery (Gast 1988).

31 For a discussion of Anoh Acou's work see Jules-Rosette 1990.

32 For different perspectives on the classification of Ivoirian arts, see Anquetil 1977; Etienne-Nugue and Laget 1985.

33 Sometimes objects are brought to the city with specific economic targets in mind. One day, for instance, I saw a young man bring to the market an ivory trumpet which

he said was given to him by his father in order to buy his mother a wax-print outfit. See Hopkins (1973: 60) on the concept of "target marketeers" and the role of seasonal economic cycles.

34 Although one would think that students would research the value of the objects they sell, market information is so tightly restricted that it is impossible to gauge the value of an object in the abstract. Prices are not posted in the market place, and they are not revealed until serious verbal bargaining begins. Traders will never offer an initial purchase price. They wait for uninformed sellers to state how much they want for particular objects (see Chapter 2).

35 *Nyama-nyama* is a Dioula-derived term meaning literally something that is petty or trite. The word, however, has been appropriated by traders speaking many different languages, and is used to refer to any sort of insignificant and inexpensive souvenir or export craft.

36 One particular type of object which has appeared on the market in the past several years should be classified as a sort of transitional piece between commercial fine art and souvenir. These are Baule face masks and Asante fertility figures which are inlaid with small multicolored glass beads. The beads are arranged in such a way as to form a geometric pattern on the surface of the figure. They are made by Senegalese traders, who say the style was originated in Dakar. Traders refer to these objects as "Kenya" (*masques Kenya* and *poupées Kenya*). The name, according to traders, refers to the pan-African qualities which the objects represent. They are not generally marketed as representations of Baule or Asante art – they are simply marketed as "things from Africa."

37 A few itinerant traders have "instamatic" cameras with which they can photograph objects in the villages, and then circulate the pictures among urban traders in order to find prospective buyers – before even purchasing the object(s) from the village owner.

38 In an article on the art market in Liberia, Blake Robinson notes a similar pattern among itinerant merchants. "Since they are strangers," he writes, "the merchants hire guides and interpreters from among the local population. These tend more often than not to be youngsters who have rather a diminished sense of awe for traditional objects, whether cult or not, and who have a ready appreciation for things the money economy has brought such as lanterns, cutlasses, and clothes" (1975: 75). A Dioula trader told me about the time he spent collecting objects in Mali. While he was walking through a village, two young boys came up to him and asked him if he was interested in buying "two fetish statues covered with blood and stuff." The boys asked for money, but he only agreed to pay them after they had taken him to the place where the statues were located. They brought him to an abandoned shrine. "The pieces were good," he said, "so I paid them 2000 [CFA] a piece, which in the village is like a million francs." The boys told him that if he wanted more, they knew where their father had stored other objects. "No," the trader recounts having told them, "your father needs those other things, I'll just take these" (10/25/87).

39 In some cases, a camera is used to photograph the object so that the carver can sell the original and still have a model from which to create a copy.

40 Often called *courtiers* in francophone countries (Staatz 1979: 102).

41 Cohen does note the difference, however, between cattle which are transported by foot and those transported by train. When the cattle which travel by foot arrive at the

market in Ibadan, they are thin and weak from their exposure to the disease-carrying tse-tse fly in the forest belt. The life expectancy of cattle transported by foot is only two weeks after their arrival in the city; those transported by train can live for up to two and a half months. Since the "train cattle" are much healthier than the "foot cattle," they are more valued by city butchers and they are therefore sold for a higher market price (1965: 9).

2 THE DIVISION OF LABOR AND THE MANAGEMENT OF CAPITAL

1 The hierarchy of market personnel is no different in structure than that for many other commodity markets in West Africa. In her description of the marketwomen of Bobo-Dioulasso, Ellie Bosch notes that most fruits and vegetables in the market go through the hands of three to five different traders before they reach the consumer. Each trader in the network occupies a different socio-economic position in the produce economy – ranging from wholesalers who might buy forty to a hundred baskets of tomatoes at a time, to retailers who would only buy ten baskets from the wholesaler, to the young girls who sell the tomatoes from metal trays which are balanced on the top of their head (1985: 71).

2 Before her involvement in the African art trade, Bembe Aminata was a receptionist at the Air Ivoire ticket office in Man. After losing her job, she became involved in the art trade through a cousin who knew one of the artists in the doll *atelier*.

3 At the time that I was conducting research in Côte d'Ivoire, none of these dolls were being sold in the Treichville market place.

4 For a discussion and history of the Kumase workshop, see Ross and Reichert (1983).

5 When men transport art objects they must pay fairly large amounts of money in custom bribes. Since the value of artworks are so hard to specify, the duty on works of art are always unclear. Following a widely publicized auction in Paris, where a Baule mask sold for 125 million FF (Anon. 1987c: 33), traders say that the price of bribes went way up. "Now everybody thinks that whatever you transport is worth a million francs [CFA]" (10/20/87). Traders are sometimes thrown in jail until they agree to pay a sufficient fee. More often, their merchandise is held (*bloquer*) until they come up with the required sum of money. Traders must often travel to Abidjan, from wherever their goods are being held, in order to solicit money from regular clients and/or prospective buyers.

6 In the past few years, the market for African art in the United States, like the market for other arts, has suffered as a result of the American economic recession.

7 Because the women are not professional art traders, they do not have their own network of American clients. As a result, they must sell to the African art traders (many of whom stay in the same hotel in Manhattan's upper East Side).

8 In the United States, an atmosphere of neglect and confusion is often created on purpose by auctioneers. "The best setting for a liquidation auction," writes Charles Smith, "is one that conveys a sense of disorder, fostering the hope and belief that there may be treasures here that no one has yet discovered" (1989: 113).

9 Objects which are piled up in art storehouses are sometimes referred to by traders as *gool-gool* (a Wolof-derived term referring to something insignificant or to a hodgepodge).

10 In the West, for instance, it is reported that dealers keep paintings for years, even decades, waiting for a propitious time to put them on the market (Bates 1979: 167). Objects are either kept in closed storage facilities, in the dealer's private collection, or they are placed in the gallery, but with a price so high that it is unlikely to sell (however, if the object did sell, the profit would be equal to the dealer's most favorable anticipated long-term gain).

11 In his ethnography of Hausa traders in the region of Tibiri, Niger, Gerd Spittler reports that most traders are unable to store goods in order to wait for possible price increases. The only exception, which he notes as being rather unusual, is a wealthy sugar trader who is able to store his merchandise long enough to anticipate seasonal price fluctuations. "Alhaji K. always puts many tons of sugar into storage until the month of Ramadan," writes Spittler, "when he sells at higher prices. Most traders, however, lack the capital reserves required to pursue this strategy. Traders usually sell their goods during their weekly cycles, using the proceeds to buy new supplies" (1977: 374).

12 This second service, of course, is more necessary in the food and produce sections of the market than it is in the sections where art is sold.

13 As Lewis described the marketwomen of Treichville: "Thus the market's pre-dominant tone is one of intense competitiveness: each woman has struggled, maneuvered, and even bribed her way onto 'her' space, and her keenest desire is to maximize returns for the money and energy she has expended" (1976: 139).

14 Cf. the economy of Chinese wholesale merchants in Indonesia and the operation of their warehouse-style stores as described by Geertz (1963: 52).

15 Some members of the American expatriate community in Abidjan refer to these traders collectively as the "mask men."

16 Time has very little value to many of the art traders. Because they have such a limited network of distribution, it is almost always to their advantage to wait for as long as it takes to see a client. Time can also be used as a status-signaling device by the more prosperous traders in the market. One might hear, for instance, a trader telling another trader whom he considers to be his social inferior, "Hurry up! I'm in a rush."

17 Since the objects travel through the hands of different traders it is conceivable that an object which had been in the possession of trader X would eventually end up with trader Y. If the collector was shown an object by trader X, turned it down, but then bought the very same object, on another occasion, from trader Y, then trader X would probably feel a certain resentment either toward the collector or toward the other trader. By not showing his collection to African traders, the collector avoids such conflicts or potential confrontations.

18 The reason he would probably not buy the objects from the stock of a European collector relates to the "discovery" element in the art trade which is explored in Chapter 6.

19 The term is probably derived from the Wolof verb *porah*, meaning to enter quickly and exit through the side, as in the action of a thief passing quickly through a house (Kobé and Abiven 1923).

20 At various points in the fieldwork, I observed different numbers of internal market peddlers, ranging from one to five at any given time.

21 The role of the internal market peddler is in some ways reminiscent of the

ambulant auctioneers (*dellala*) described by Geertz for the Moroccan bazaar (1979: 186).

22 The question of status is an important feature which helps to distinguish different levels in the trading hierarchy. Traders can often be sensitive to the sort of treatment they receive by Europeans. Outtara Youssouf, for example, refused to sell art to a certain American collector whom he said treated him with disrespect and with no concern for his proper status. "I am not a little boy selling trinkets [*nyama-nyama*] on the street," he said. Although he was still willing to conduct business with the collector, he would not go there himself. "I sometimes sit in the truck outside, and send the young people in to deal with him" (1/10/88). In her study of woodcarvers in Benin City, Paula Ben-Amos also notes the relationship between status and marketing. "The manner in which a carver sells his work has important social implications. Hawking is of very low status, particularly in comparison to working on commission . . . [and] to whom a carver sells [Hausa trader versus European customer] is also important and reflects on his status" (1971: 171–72).

23 Pronounced "täp", but derived from such English language expressions as "top quality," "top grade," "top of the line," or "top drawer."

24 Robinson also notes the presence of truckers, cattle merchants, and other wayfaring workers who transport art from rural areas to urban centers (1975: 76). However, he does not discuss any cases in which this practice of transporting art objects becomes a kind of "second" career.

25 Ibrahim was so familiar with such a large corpus of Lobi art, that when he showed his collection to prospective buyers he would group pieces according to the different artists which he could identify as having carved various pieces.

26 See Chapter 3 for Muslim attitudes toward selling African art.

27 Whether Tijjani had indeed made an error in his first major purchase is not entirely clear. Surely, it is not difficult to imagine that his uncle would have wanted to hinder his nephew's prospects at commercial independence, in order to keep him as an apprentice or hired hand.

28 On the sociology of trust see, for example, Bailey, ed. (1971) and Gambetta, ed. (1988). For a specific African case-study of trust among urban migrants, see Hart (1988).

29 The word *lèk* is derived from the Wolof verb "to eat" (*lèka*). Thus, the phrase, *donne moi mon lèk*, literally means "give me the wherewithal to eat" (cf. Kobé and Abiven 1923). Although it is a Wolof expression, the term *lèk* has been incorporated into the lingua franca vocabulary of all African art traders – i.e., regardless of their ethnic or linguistic background. Even when speaking French, the traders insert the word *lèk* into their conversation (cf. Turcotte 1981). Although the Hausa have their own word to describe a commission on sales, *la'ada*, in the market place Hausa art traders always use the Wolof word *lèk* (cf. Hill 1966: 365).

30 For the anthropologist trying to study the organization of the market, however, the system is at first more confusing than anything else. It seems almost impossible to figure out who owns what.

31 The word *ràngu* is a Wolof term which literally means to "carry something slung over the shoulder." When a trader takes an object on credit from another trader in order to try to sell it to a prospective buyer in the market place or to one of his clients (see below), he says that he is taking the object on *ràngu* (*je prends la pièce en*

ràngu). The metaphor of carrying something in a sling is thus transposed to the market context where objects are taken or transported from one trader's network of clients to another's. The *ràngu* system parallels what Geertz identifies in the Moroccan market economy as the *qirad* or what is called, in the Western tradition, the *commenda* – both of which refer to short-term credit on merchandise (1979: 133–36).

32 The problem of establishing client relationships is made even more difficult by the fact that many of the collectors and expatriates are only in Côte d'Ivoire for a limited period of time.

33 This last reason is the most commonly discussed problem with the *ràngu* system. Traders say that if they lend an object to a particular individual who is known for his lack of creditworthiness, he will sell the item and then *boufer l'argent* (literally, "eat the money"). He may avoid coming back to the market place, or he may return and say that he took a price below the one which was set for *ràngu*. In such cases, the object-owner's only recourse is to spread a bad reputation so that others will avoid dealing with this particular reseller. If the person does not have his own stock but relies for his livelihood on the profits from *ràngu* credit, such a bad reputation could indeed ruin his trading career. For the most part, then, the *ràngu* system is kept in balance by corporate liability among market-place traders (cf. Moore 1978: 111–26). Noteworthy parallels exist here with the organization of credit in the Jewish diamond and pearl trades.

34 It is interesting to note, however, that among Hausa merchants themselves there *is* an unwritten code which allows for the possibility that goods be returned if they are found to be of inferior quality. Reporting on Hausa trade in Kano, Hugh Clapperton wrote in 1823: "The market is regulated with the greatest fairness and the regulations are strictly and impartially enforced. If a *tobe* or *turkadee* [man's robe], purchased here, is carried to Bornou or any other distant place, without being opened, and is there discovered to be of inferior quality, it is immediately sent back as a matter of course . . . [and] by the laws of Kano, [the seller] is forthwith obliged to refund the purchase money" (quoted in Colvin 1971: 108).

3 AN ECONOMY OF WORDS: BARGAINING AND THE SOCIAL PRODUCTION OF VALUE

1 In addition, the bargaining process shares features with the purchasing of art in the West. As Constance Bates notes for the pricing of art in US galleries: "Usually the asking price is higher than the gallery owner expects to receive and bargaining is expected in order to reach a more agreeable price. Prices may be different for different customers, depending on whether the owner thinks the customer can bring in additional business" (Bates 1979: 16).

2 The term "extractive bargaining" is intended to signal the contrast between a mode of extraction and a mode of production (see Bunker 1985: 22–31).

3 In English, the wholesale/retail contrast has two meanings: (1) gross vs. retail selling and (2) intra-trade sale vs. sale to the general public. In this context, the terms wholesale bargaining and retail bargaining refer to the second usage of the wholesale/retail contrast.

4 Anne Chapman (1980) has argued that in most contexts the notion of barter ought

to include the exchange of both money and goods – i.e., that the "two types of exchange fade into one another."

5 In its original context, an African art object has no true monetary worth. Although it may have been commissioned in exchange for cash or goods, its intrinsic value is determined largely by such factors as ritual efficacy and social prestige. In the market place, however, the object becomes a true commodity. Its value is determined directly through the rational calculation of its potential resale price.

6 It is reported, for instance, that vast quantities of art have been placed on the international market during the most intense periods of Sahelian drought. People either migrate with art objects which they sell along the way, or itinerant merchants travel to their communities buying from those who need to make up lost revenues from a failed agricultural harvest (cf. Forde and Amin 1978). The surfacing of objects in Côte d'Ivoire also seems to coincide with state-sponsored urban renewal projects. During the razing of Korhogo (when many traditional forms of architecture were replaced with concrete buildings), for instance, vast quantities of Senufo masks were appearing on the Abidjan market (Susan Vogel, personal communication).

7 It is interesting to note that the justification used by the trader is an extension of the reasoning used by Western collectors and academics. As Price summarizes, "The most commonly cited justification for field collecting, even at some ethical cost, is that the documentation and preservation of Primitive Art constitutes a contribution to human knowledge. In this view, Westerners have a moral obligation to protect the artifacts of Primitive cultures regardless of the original owners' assessment of the scientific importance of the rescue operation" (1989: 75).

8 It should be pointed out that at this level of the trade *both* sellers and buyers have little sense of what an object is worth in the international market. Although urban traders (i.e., market-place stallholders and storehouse owners) have some idea of the price range of African objects in the West, they purposely keep their suppliers uninformed of these values.

9 Some of the urban middlemen may have traveled to Europe or America on selling trips. A few traders of my acquaintance held active subscriptions to the sale catalogues of the Guy Loudmer and Hôtel Drouot auction houses in Paris (cf. Himmelheber 1966: 192).

10 This point parallels Charles Smith's distinction between, what he calls "wholesale auctions" and all other auctions. "In [wholesale] situations," he writes, "auctions are more a means of allocating than of pricing goods. The issue is who will be 'allowed' to purchase the item, or, as may also be the case, who is expected to absorb the item. Uncertainty in these cases bears on the respective rights and responsibilities of the players more than on the value of the items" (1989: 42).

11 In some instances, I have witnessed traders trying to outbid one another for the purchase of a lot of commissioned goods. A carver brought to the market place a group of objects which a stallholder had ordered. Rather than hold to the agreed "contract," however, the trader tried to get more money by offering the objects to other stallholders. The objects were ultimately purchased by the stallholder who had initially ordered the objects, however, because of competition from other buyers he was forced to pay more than he had originally agreed or anticipated.

12 As Ravenhill noted in 1980, "In the past two or three years . . . untold thousands of pieces of Lobi art – wooden statues and bronze amulets and pendants – have

appeared on the market and while, currently, the supply is drying up, the price of Lobi art has increased five to ten-fold over two years. There is even talk, in informed circles, that the Lobi are the 'next Dogon' for the international African art scene" (1980a: 19).

13 Professional art dealers have told me that when buying from African middlemen they purposely try to show no emotion in their demeanor – lest the seller perceive that they are keenly interested in obtaining a certain object.

14 Since both the supply of spoons and the market for spoons are *limited*, the trader cannot seek higher profits by increasing the number of transactions. Rather he can only increase his earnings by augmenting the profit margin of each individual transaction (cf. Fanselow 1990: 257).

15 In a slightly more understated tone, Sol Tax made the same point in his study of the Guatemalan market economy. "The general market custom," he wrote, "is for the seller to name a price higher than he expects to receive, and to reduce it if necessary after an interval of haggling. A travel-book notion that his method is pursued because the people enjoy it is exaggerated" (1953: 137).

16 In an essay on bargaining in the Middle East, Fuad Khuri notes the same sort of interaction between seller and buyer: "The seller uses . . . key associations to link the commodity to the buyer's background, in an effort to show him that other people of his status do consume the same goods" (1968: 701).

17 It is ironic that in satisfying the foreign buyer's quest for an "authentic" cultural experience in the African market place, the traders have devised what is in fact the most *inauthentic* form of bargaining (see Chapter 4 on the permutations of authenticity).

18 Some tourists will try to augment their market knowledge by first pricing objects in the hotel giftshop or gallery, where prices are affixed to individual items. Then, they will go to the market place and try to buy what they want for anything *less* than the price posted in the stores.

19 In his study of the "bazaar economy" in Morocco, Geertz divided the bargaining process into three distinct phases: (1) initial bidding; (2) movement toward a settlement region, and, if that region is in fact entered; (3) settlement itself (1979: 227). The tempo or inner rhythm of bargaining is as indicative of the outcome as the monetary figures which are exchanged. Rapid movement between seller's initial price and buyer's initial bid indicates greater likelihood of sale. A slow or hesitant pace, on the other hand, usually indicates greater distance between buyer and seller and thus there is an increased likelihood of not striking a deal.

20 Expatriates who regularly visit the market place say that they are even afraid to look at particular objects for fear that the trader will pick it up and try to sell it to them. They walk through the market place, they say, without looking directly at anyone.

21 If an initial asking price is much too high, a Hausa trader buying from a member of his own ethnic group says in Hausa àlbàrkà (which, in this context, is a sarcastic rendering of the phrase "thank you very much"), after which he would either wait for a lower asking price or walk away in disgust.

22 By which it is understood that the trader probably means either another member of his ethnic group or simply a friend.

23 Some traders would insist that the "disclosure" of purchase price by other traders is *invariably* untrue, except in rare instances where a trader has a reputation for always

speaking the truth. One of the only traders that I knew who possessed such a reputation was Yusufu Bakano, a Hausa trader at the Treichville market place. Without exception, traders told me that if Bakano quoted the price which he had paid he would be telling the truth.

24 This technique finds its parallel in auctions where prices can sometimes be inflated artificially by inventing bids, a practice referred to as "taking bids off the wall" (C. Smith 1989: 150).

25 The technique draws upon one of the fundamental principles of buyer self-legitimation which is found among participants at an auction sale. "If one buys through an auction," writes Smith, "one can always rationalize a high price by observing that others were willing to pay almost as much" (1989: 90). Although in this bargaining strategy the implication is that someone was willing to pay even *more*, the pattern of manipulation of buyer consciousness is roughly the same in both cases.

26 Since buyer and seller are often equally aware that these price fixing mechanisms are purely invented, it is difficult to locate specifically the level at which this dialogue is effective. I would argue, however, that the language of bargaining is not simply an empty or meaningless mechanism for structuring an economic transaction but is in fact a very powerful device for persuading the buyer to purchase an object. Karl Polanyi hinted at this aspect of bargaining when he wrote, "[B]arter is the behavior of persons who exchange goods on the assumption that each makes the most of it. Higgling and haggling are the essence here, *since there is no other way each person can make sure he is gaining as much as possible from the bargain*" (1977: 42, emphasis added).

27 According to Rees, there are two types of market information sought by those who sell. He labels one type of information as "intensive" and the other as "extensive." He writes: "The search for information in any market has both an extensive and an intensive margin. A buyer can search at the extensive margin by getting a quotation from one more seller. He can search at the intensive margin by getting additional information concerning an offer already received. Where the goods and services sold are highly standardized, the extensive margin is the more important; when there is great variation in quality, the intensive margin moves to the forefront" (Rees 1971: 110). The two categories of market information searches identified by Rees parallel the distinction between the two market situations found in the Côte d'Ivoire art trade: (1) the contemporary fine art and souvenir trades, and (2) the traditional/antique art market. Since the former consists of the sale of similar type objects, an extensive market search would yield the greatest amount of market information and the best possible market price. And, since the latter consists of the sale of more-or-less unique items, "comparison shopping" or extensive searching would not be possible. In this type of market situation, one would need to get as much information about the particular object being sold – i.e., the greatest amount of intensive market information. In her ethnography of Jamaican middlemen (higglers), Margaret Katzin describes the search for information which is carried out by rural producers who attempt to assess urban resale prices before selling to itinerant middlemen: "Farmers congregate at the truck stops on Fridays and Saturdays where the principal topic of conversation is the prices of locally grown goods in town markets. Also, some country people always go to the market every week and return with

information about prices. Thus, the growers often know the prices received by the higglers for their goods before the higglers return" (Katzin 1960: 309–10).

28 When referring to the "faking" process, traders usually use the French verb *trafiquer* which implies the conduct of a dishonest activity.

29 Some people might have a better instinct about whether or not a car is good, but inevitably problems will only arise after the car has been purchased and driven for a certain amount of time.

4 THE POLITICAL ECONOMY OF ETHNICITY IN A PLURAL MARKET

1 The neighborhood is similar to the Hausa quarter in Ibadan described by Abner Cohen (1969). It is sometimes also referred to by the Hausa term *zango* (or *zongo*), meaning a camp or quarter which has been settled by diaspora Muslim traders (see Schildkrout 1978: 67).

2 The Wolof presence in Korhogo is far smaller than that of the Hausa. Unlike Abidjan, where the Wolofs dominated the art trade for many years, in Korhogo the Hausa have controlled the art market from very early on.

3 The Kulebele carvers were the subject of an excellent ethnographic study undertaken during the early 1970s by anthropologist Dolores Richter (1980).

4 The practice of trading in several classes of objects represents a diversification aimed at spreading economic risk. If errors are made in the marketing of one type of good, losses can be recouped in other areas. If there is a sudden drop in the demand for a certain type of goods, profits can still be made in other sectors.

5 Most traders who sell *antiquités* also sell contemporary trade pieces. Although the margin of profit in the tourist market is much smaller than it is in the antique/collectible market, it provides a more regular form of income which can be reinvested in *antiquités* and other higher value objects.

6 The honorific Alhadji (or, in Arabic, El Hadj) is accorded to Muslims who have made the pilgrimage to Mecca. Because the pilgrimage is so costly, the title Alhadji is as much a symbol of economic success as it is of Islamic piety (cf. Grégoire 1992: 2). Traders who possess this title are generally referred to in conversation simply as "Alhadji." Distinctions are understood by the context of the conversation, or individuals are specified by "nicknames" (*lakàbi*) which draw on a person's idiosyncratic qualities: e.g., "*grand* Alhadji" refers to Alhadji Inusa who is very tall, "Alhadji Peugeot" refers to Alhadji Haruna who drives a Peugeot pickup truck, etc. Since many of the traders in Aoussabougou bear the honorific title of Alhadji, it would be too confusing to follow this practice in my writing. For the sake of brevity and clarity, therefore, I refer to Alhadji Usuman simply by his family name.

7 Hausa traders avoid direct reference to commerce when they first arrive in a trade context or when they first meet another trader. According to them, it is considered extremely impolite to simply walk up to a person and directly state your business. An exchange of extensive greetings and non-trade-oriented conversation are expected to precede all discussions of a commercial nature. The length of this dialogue will vary depending on the relationship between the two traders. The most striking instance of this etiquette practice was observed when a trader of my acquaintance, Ahmed Arachi, gave a number of art objects on credit to a trader who

was traveling to France. After spending a month in France, the trader returned to Abidjan. He had been in the market place for over a week but had not yet told Arachi whether or not he had in fact been able to sell the pieces. Arachi was anxious to know the outcome of the sale, but was unable to learn anything. When I asked him how his creditor had made out with the goods he had taken to France, he told me that he had not yet been informed, and that it would be totally unacceptable and improper for him to ask.

8 Richter notes that in order to purchase the best quality objects from the Kulebele carvers, Hausa traders compete among themselves to curry the favor of master carvers in Koko quarter. She writes: "Dealers encourage, present gifts to and make social calls on the carvers they deal with, as well as extend invitations to them to share food. One dealer begins his rounds every morning at six, calling on all carvers who carve for him, as well as those he hopes will find time to carve for him in the future . . . By creating a multiplex bond with his carvers, he can expect rapid completion of his orders and favored treatment from those he commissions. 'I'll finish Aladijen's work first; he's always very nice to me and gives me lots of presents,' was the comment made by a master carver who was being pressured by Aladijen and another trader to complete each one's work first" (1980: 70–71).

9 Again, I would postulate that my presence may have altered the interaction between the traders and the Senufo carver. Coulibaly asked several times if I was an art dealer, and whether the masks were being purchased on my behalf. The traders were insistent that I was just an observer (writing a book on African art), and that the objects were strictly of interest to Madu. Their insistence on this point was not merely an issue of role clarification. If Coulibaly had indeed thought that I was a dealer buying the masks through two Hausa agents, the asking price would surely have been much higher.

10 Just as my presence may have been instrumental in initiating the contact between Tanko and Madu, it also became a factor in settling the dispute between the Senufo carvers and the Hausa traders. Because of my forced involvement in the situation as an invented American dealer, the Senufo men grew nervous at the prospect of calling in the police.

11 Grappling with the controversy surrounding the relationship between segmentation and unilineal descent is beyond the scope of this book (see Karp and Maynard 1983; Herzfeld 1987: 156–85), however, it might be useful to point out that among art traders in Côte d'Ivoire those living and working in the region of Korhogo expressed a far more explicit sense of ethnic cohesiveness than those working in the sprawling urban landscape of Abidjan. That is to say, in the more rural sectors of the country, ethnic affiliation and notions of segmentation were more important to group cohesiveness and commercial viability than they were in Abidjan, where the bond of friendship was often stronger than the ties of blood (cf. Hart 1988).

12 Some of these migrant ethnic groups are thought to possess a certain skill and shrewdness in business which is attributable to a putative psychological "genius" for trade. Cohen points out, however, that inherent personality has little to do with the success of these commercial ethnic groups. "[M]uch of this 'genius'," writes Cohen, "turns out to be associated, not with a basic personality trait, but with a highly developed economic-political organization which has been evolved over a long period of time" (1969: 9).

13 Although these ethnic groups are currently involved in the art trade, their original migration to the regions of West Africa in which they now work dates to a much earlier time and to previous commercial pursuits. The Hausa, for example, are reported to have spread south from their homeland into areas populated by non-Hausa-speaking peoples as a result of the ivory trade which began in the sixteenth century (M. G. Smith 1962; Johnson 1978; Hiskett 1984: 78). The Dioula are thought to have begun their southward migration into the Upper Niger region and, eventually, the Akan territories as a result of their participation in the gold trade which began during the late fourteenth and early fifteenth centuries (Perinbam 1980: 458). The Wolof spread east from Senegambia during the fifteenth and sixteenth centuries as a result of their involvement in the gum and salt markets, as well as in the Atlantic slave trade (Curtin 1975).

14 The negative attitude of Muslim Africans toward non-Muslim Africans was clearly expressed by Marcel Griaule when he wrote in *Conversations with Ogotemmêli*, "The Dogon, in short, were thought to present one of the best examples of primitive savagery, and this view has been shared by some Muslim Africans, who are no better equipped intellectually than Europeans to understand those of their brothers who cling to the traditions of their ancestors" (1948: 1). This attitude is felt not only in certain aspects of the Muslim relationship with non-Muslim communities, but applies also to the relationship between those who associated themselves with the colonial regime and those who resisted it. Myron Echenberg's description of the attitude of the *tirailleurs sénégalais* toward other Africans is apposite in this context: "The Wolof soldier was spoiled by his long association with France and had become 'a terrible snob' toward other Africans whom he regarded as 'savages'" (1991: 14).

15 The hadith is a collection of thoughts and sayings ascribed directly to Muhammad which was amassed and compiled by Muslim scholars after his death.

16 In his 1975 essay on the art dealers of Man in western Côte d'Ivoire, Himmelheber makes a very curious assertion for which I find no evidence in support. He writes: "The Hausa and Senegalese people are still Muslims who display no figural art even though they could perhaps earn more money from this" (1975: 19, translated from the German). In my experience, the Muslim Hausa and Wolof sell as much figural art as anyone else in the market.

17 Although the claim to Baule ethnicity is most prominent in the tourist market, some Wolof merchants falsify their ethnic identity in the *antiquités* market as well. A prominent Abidjan-based European collector of African art refused to deal with the Senegalese, claiming that they were generally dishonest and that their prices were too high. On any given afternoon, however, one could see scores of Wolof merchants lined up in front of the collector's home, waiting to show him their latest shipment of goods. They simply told him they were Dioula, Mossi, or whatever ethnic group they could think of. "We tell him whatever we want," said Barane Diop, "he doesn't know any different" (3/29/88).

18 A parallel to this practice can be found in the "authentication" of certain types of auctions in the United States. "The cowboy hat and boots affected not only by cattle auctioneers but many Midwestern and Western general auctioneers," writes Smith, "serves to authenticate their auctions by introducing a historical and traditional element" (1989: 115).

19 The social link between clothing and cultural identity was first made explicit during the 1930s in the writings of Petr Bogatyrev (1937). The semiotic link was best spelled out by Roland Barthes (1967).

20 The Dan are located in southwestern Côte d'Ivoire and northeastern Liberia; the Lobi are in northeastern Côte d'Ivoire, southeastern Burkina Faso, and northwestern Ghana.

21 For the arts of Côte d'Ivoire in particular, I am thinking here of the publications by Bohumil Holas (e.g., 1960; 1966).

22 Côte d'Ivoire has had only modest success in its promotion of tourism: 109,000 tourists visited Côte d'Ivoire in 1975, 220,000 in 1979, and 210,000 in 1980. Tourism accounted for only 2.4 percent of export receipts in 1976, yet it was still ranked as the fifth most important "product" of Côte d'Ivoire, after coffee, cocoa, wood, and refined petroleum. The Ministry of Tourism was created in 1975 (Mundt 1987: 129). In the late 1980s, tourism dropped as a result of growing economic trouble. The decline accelerated during the Gulf War, and reached stagnation when the international media began to report on the student manifestations at the Université Nationale in Abidjan.

23 The process is also reflected in the use of "traditional" symbols on West African bank notes (Francs CFA) used jointly by nations of former Afrique Occidentale Française (see S. Vogel, ed. 1991: 233).

24 It is interesting to compare Houphouët-Boigny's argument against the power of myth and the invention of a "traditional" African past with one of Marx's assertions in *The Eighteenth Brumaire of Louis Bonaparte*: "The social revolution of the nineteenth century cannot draw its poetry from the past but only from the future. It must strip off all superstition in regard to the past, else the tradition of all the dead generations weighs like a nightmare on the brain of the living" (quoted in Harvey 1989: 109).

25 The link between an African festival and the Carnival in Rio was first made by the government of Senegal in 1974 when they tried (without success) to launch a series of "ethnic" dances which "would become as famous as the Carnival of Rio or of Nice" (Copans 1978: 119).

26 In addition to the masked dancers, the new festival of masks also featured the election of "Miss Festimask," who was to be elected in a contest called "Awoulaba" according to standards of beauty set by the First Lady of Côte d'Ivoire, Thérèse Houphouët-Boigny (Lakpé 1987). Out of a group of twenty female contestants, the judges selected the most slender and light-colored woman. Strong local criticism was levelled against the contest for having selected someone with the most Western traits. The Miss Festimask contest may have been inspired by the Miss Sénégal contest which has been held from time to time in Dakar since 1974. As in Côte d'Ivoire, the Miss Sénégal competition received some harsh criticism from the local press. An article in the Dakar newspaper *Le Soleil* declared: "We have reached the epitome of the ridiculous when Senegal, confronted with the innumerable problems of a major drought . . . finds nothing better to do than to organize a national election of Miss Sénégal" (quoted in Copans 1978: 119, my translation from the French).

27 The town of Yamoussoukro, which is located about 250 kilometers north of Abidjan, is the birthplace of Félix Houphouët-Boigny and since 1983 the official

political and administrative capital of Côte d'Ivoire. Yamoussoukro houses the massive "Maison du Parti" (the administrative home of the central government or PDCI-RDA). It is also the site of the Houphouët-Boigny Foundation, the President's residence/retreat which is surrounded by a moat of sacred crocodiles, the Hôtel Président (which is the most luxurious hotel in Côte d'Ivoire), and the controversial and highly publicized basilica which Houphouët-Boigny is constructing at the cost of over $100 million (Bentsi-Enchill 1988: 1428).

28 Côte d'Ivoire is often held up by economists as one of Africa's few post-colonial success stories. From independence in 1960 through the late 1970s, Côte d'Ivoire enjoyed tremendous export earnings from coffee, cocoa, and lumber. This rapid growth of the agricultural sector, which resulted in a quadrupling of the gross national product from 1960 to 1978, is sometimes glossed as the Ivoirian "miracle" (see Shepard 1978).

29 Nelson Graburn has clearly pointed out the extent to which ethnicity can be manipulated by the state, especially in various parts of the developing world. "As countries industrialize and modernize their physical structures," he writes, "they become, at least to tourist eyes, more and more similar, yet the tourists demand that they be significantly different from the homeland, for without any differences why would one bother to travel . . . [As a result of this sort of pressure] the vast majority of modern nations emphasize their 'specialness' by playing up their distinctive ethnic minorities and their material production" (1984: 413; cf. Wood 1984).

5 THE QUEST FOR AUTHENTICITY AND THE INVENTION OF AFRICAN ART

1 Perhaps it is not surprising that the small amount which has been published on the subject of authenticity has largely been written by dealers, collectors, and others who have a direct stake in the definition of authenticity because of their economic involvement in the African art trade (see, for example, Baker 1973; Kamer 1974; Allison, *et al.* 1976; Silberman 1976; Provost 1980).

2 In some instances, the Western desire for age in African art has been communicated beyond the world of traders to the art producers themselves. Walter Van Beek reports that among the Dogon of Mali the demands of the Western art trade have triggered a series of quick and specific responses. "The Dogon are very much aware of the value that outsiders attach to . . . old things, so [when selling to outsiders] they identify their *dege* [statues] as ancestors, or they give them the look of age . . . Whereas the production of statues for traditional use has declined, that of statues for sale has become a thriving industry. The Dogon smear these new carvings with kitchen soot, bury them for a few weeks near a termite mound, soak them in millet gruel, and dry them in hot ashes, all to give them the highly valued patina of long ritual use" (1988: 64).

3 Although these objects still circulate among Westerners, they are out of *his* commercial realm. The fact that something becomes authentic because it is unattainable finds parallels in the way signs of authenticity and aesthetic merit are conveyed through subtle cues in the structuring and arrangement of space in Western art museums (see Greenblatt 1990).

4 The creation of authenticity through temporalization could fruitfully be compared

to Johannes Fabian's (1983) notion of allochronism – the creation of anthropology's epistemological domain through the distancing of subjects in time.

5 It is arguable that this view of authenticity has parallels to a religious doctrine which grounds its authority in an earlier period of revelation (cf. Tambiah 1985: 25–29).

6 An interesting parallel can also be found in the rapid rise in demand for art by the insane. Because of more responsive medical treatments for mental disorders, the production of art by the insane, which once was a thriving branch of psychoanalytic industry, has been suffering a steady decline. Limited by the efficacy of powerful psychiatric drugs, the supply of art by the insane now constitutes a finite resource whose monetary value is swiftly increasing (Kuspit 1990).

7 The techniques of object alteration are explored further in Chapter 6.

8 The idea that there exists a direct relationship between ethnic identity and aesthetic style grows out of a Durkheimian assumption that African art is the creation of a collective mind instead of an individual artist. This assumption was carried to its logical conclusion by William Fagg (1965) who was one of the first to develop systematically a "one tribe, one style" model for the classification and analysis of African art. The model assumes that every ethnic group constitutes a closed system, and that the art of one ethnic group is incomprehensible to the members of another. For an insightful critique of the "one tribe, one style" paradigm in the study of African art, see Kasfir 1984.

9 In the language of economics, one would say that the category authentic African art constitutes a "depleting non-self-renewing resource."

10 Wooden slingshots are used by young Baule boys to shoot birds and bats. Some of the slingshots are decorated with carvings of animals, humans, or masks. Many, however, are crudely hewn as they are usually created in haste by the boys themselves.

11 Slingshots were, however, known to some collectors before the publication of *Potomo Waka*. Two examples were published from the collection of André Blandin in Anonymous (1977) and one from the collection of William Kohler in Cole and Ross (1977). Slingshots were purchased from local market places in Côte d'Ivoire during the 1970s by anthropologists and art historians working in the region (Philip Ravenhill, personal communication).

12 This passage from *Potomo Waka* is strikingly similar to a point which Bourdieu and Derbel raise in *The Love of Art*: "The same people who will no doubt be amazed that so much trouble has been taken to express a few obvious truths will be annoyed at not recognizing in these truisms the flavour, at once obvious and inexpressible, of their experience of works of art. What is the point, they will say, of knowing where and when Van Gogh was born, of knowing the ups and downs of his life and the periods of his work? When all is said and done, what counts for true art lovers is the pleasure they feel in seeing a Van Gogh painting" (1990: 108).

13 In a sample of about 500 slingshots seen over the course of one year in the stock of several traders, over half were painted with bright enamel colors.

14 Potassium permanganate is used extensively by traders both to stain wood and darken brass. It is purchased in pharmacies in the form of a dark-purple crystalline compound which is then mixed with water and applied with a toothbrush. The stain imitates the effect of natural indigenous dyes used by African carvers. It is interesting to note that potassium permanganate is also widely used by European

and American antique dealers to finish and restore antique furniture. "The most reliable method of toning down the colour of wood is to use potassium permanganate, which becomes wedded to the fibres by a process of chemical decomposition" (Arnau 1961: 188).

15 Objects are often damaged or broken during their transportation along the trade routes which move objects from rural to urban areas. Traders are often skilled at repairing cracks and fractures with scraps of wood and a mixture of sawdust and commercial white glue. In the Plateau market place in Abidjan, two carvers made their living by repairing broken objects for art traders. Because the quality of their work was vastly superior to anything a trader could produce, a trader would employ their services if he needed to repair something major on an important piece – e.g., a broken carved horn on the side of a mask; a broken leg on a chair; a damaged foot on a statue, etc.

16 Although there are now at least four African art framing galleries in Abidjan, Césaréo's gallery is the only one to have developed out of a conventional African art gallery. The others started out as poster and print framing galleries and expanded their operation to include the framing of three-dimensional African art objects. While Césaréo relies entirely on the proceeds from framing African art, the other galleries continue to earn revenues from traditional picture framing.

17 The French term *cadre* is suggestive of both a frame and a context.

18 The re-circulation of beads spans a broad trajectory through the entire economic world system. It has been reported, for instance, that beads from the African trade which once flooded the US market in the 1970s are now being resold to accommodate demand in Asia, the Philippines, Mexico, and Guatemala (Liu 1975: 1). In the American Southwest, Northwest Coast, and Alaska beads from the African trade are being marketed to tourists as authentic beads from the Native American trade (*ibid.*: 1).

19 In an essay on bargaining in the Middle East, Fuad Khuri describes a similar pattern of marketing among carpet dealers in Lebanon. "The seller uses . . . key associations to link the commodity to the buyer's background, in an effort to show him that other people of his status do consume the same goods by citing specific incidents – a carpet trader told an American customer who wanted to buy a Bukhara carpet: 'I deal mostly with Americans and with the people of the American University of Beirut. They like my carpets and my prices. See the post cards they send me, all are pleased with my dealings'" (1968: 701).

6 CULTURAL BROKERAGE AND THE MEDIATION OF KNOWLEDGE

1 In his introduction to *The Social Life of Things*, Arjun Appadurai signals the distance between producers and consumers as a primary device which sustains the power and livelihood of the middleman. "[T]he translation of external demands to local producers," he writes, "is the province of the trader and his agents, who provide logistical and price bridges between worlds of knowledge that may have minimal direct contact" (1986: 42). In an essay on the social organization of the Maine lobster market in the US, James Acheson provides a specific example of the distancing mechanism – noting a similar institutional barrier such as the one

which exists between suppliers and consumers in the African art trade. "From the point of view of the fisherman," writes Acheson, "the whole marketing process is shrouded in fog, mystery and rumor. He has very little idea where his lobsters actually go, or how many hands they pass through on their way to the consumer" (1985: 105).

2 Like Hermes – who inhabited both Olympus and the underworld – traders in ancient Greece were referred to as "professional boundary crossers," who, because of their profession, "bridged the abyss between different social worlds" (Agnew 1986: 24).

3 There is an assumption which grows at least in part out of Barth's *Models of Social Organization* (1966) that entrepreneurs or brokers function as integrators of culture. In his critique of Barth's essay, *Second Thoughts About Barth's Models*, Robert Paine points out the paradox of the broker's role (1974: 24–28).

4 Because village-level traders have little contact with the ultimate consumers of African art, they tend to buy anything that they feel may be resold. And, indeed, some of the items they bring back from villages are not African at all. Among the more unusual items which I have seen brought to the market have been European military helmets and gas masks, European-made furniture hardware (some of which may have been used as goldweights, see Garrard 1983), a pair of brass factory-made Buddha figures, and an Oriental wooden statue of a Chinese peasant which was completely encrusted with sacrificial blood and feathers (collected by a Hausa trader among the Lobi in southern Burkina Faso).

5 For definitions and concepts of authenticity and fakery see Chapter 5.

6 There is a long tradition in travel writing involving an author's difficult search for authentic cultural objects. Compare, for example, the language of Lehuard's description of art collecting in West Africa in the 1970s to Sir Martin Conway's account of his exploits in North Africa at the turn of the century. "I had spent two or three evenings in the *dark* native houses of Luxor," wrote Conway, "finding nothing but the ordinary poor rubbish that came to the surface everywhere in Egypt. At last I was taken . . . into an *inner* room within the courtyard of a *specially secluded* house, and there, to my astonishment, they showed me a few quite extraordinary treasures . . . Women, *veiling their faces*, brought things in from the background, one by one" (1914: 77; emphasis added). For a self-critical deconstruction of this genre of art-travel-discovery literature, see Greenwald 1990.

7 In a recent sociological study of auctions in the United States, Charles Smith points out that certain auction sales are carefully staged to foster the impression that the sellers do not know what it is they are selling. "The best setting for a liquidation auction," he says, "is one that conveys a sense of disorder, fostering the hope and belief that there may be treasures here that no one has yet discovered" (1989: 113). And further on, he also notes that the mix of front- and backstage areas (in Goffman's sense of the term) makes it more likely that "a given participant may believe that he sees something that no one else does, which, in turn may induce him to act on his own judgment" (*ibid.*: 115).

8 On the psychology of discovery, Desmond Coke notes the following in his book entitled *Confessions of an Incurable Collector*: "The mania for 'finds', which I have already condemned, leads to a kind of Hope that almost seeks to be deceived. Indeed its victim does actually deceive himself. 'It wouldn't be worth their while to fake *this*', he exclaims hopefully at one pole: and at the other, 'They couldn't possibly

fake *that*'. He forgets, in his fool's paradise, that even a hair-pin would be worth faking if one sold enough . . . He forgets everything. He merely wants to have a 'find'. He scarcely ever fails" (1928: 164).

9 Field observations confirm the view that art buyers attempt to misguide dealers in order to get a better buy. On this subject, Desmond Coke's observations are illuminating: "I know that, according to tradition, there is an eternal enmity between buyer and dealer: where, otherwise, that find, that bargain? The more simple-minded of collectors go, indeed, to every sort of artifice as help in this long-standing warfare. They solemnly believe in disparaging an object before buying it. Perhaps, even, they will put it down and take up another. They will certainly not enter, bluntly, and ask how much the silhouette is: they will register ignorance, astonishment, disappointment, doubt, conviction, in their proper order" (1928: 91).

10 Although inexperience among traders is often genuine (rather than staged), this practice of "situational ignorance" has often led people to believe that *all* traders are naive about the objects they sell. In his essay on the art market in Man, Côte d'Ivoire, Hans Himmelheber wrote, "[Traders] have no clue as to artistic quality or as to the merit of the workmanship of a piece. The meaning of a form within the culture of its origin is unknown to the dealers and they are not interested in it if one wants to explain it to them, which almost none of the European or American art dealers do anyway. Even their lack of knowledge as entrepreneurs is astonishing. They set out the same objects fifty-fold, one next to another, so that the customer sees at once that everything is mass-produced" (1975: 20).

11 This aspect of presentation is a characteristic feature of any competitive market place. In her analysis of the international art market in the West, Bates remarks that the "intensity of competition is affected by the ability (or lack of ability) among the various sellers in an industry to engage in product differentiation. Whether or not the physical products are actually different, the sellers will try to establish in consumers' minds that they are" (1979: 134).

12 One African art collector underscores the value of collected information when she writes, "To collect in the field . . . is not just to accumulate objects. To collect, more significantly, offers an important opportunity to record specific data about an artist and the context in which the arts are used. To collect in this manner is to observe firsthand: *from the boisterous encounters in the market place to the private court-yard of an African dealer*" (Werner 1982: 12, emphasis added).

13 A striking parallel to the phenomenon of "pedigree" in the art market can be found in the context of pharmaceuticals: "Typically a drug is valued not just because it works, but because it comes from a certain source . . . It is part of the meaning of medicine that it was recommended by an authoritative doctor, or manufactured in Switzerland, that it was expensive or that it was advertised and packaged in a particular way" (Whyte and Van der Geest 1988: 4).

14 As in many art/antique markets, the "discovery" element plays a crucial role both in the assessment of value by consumers and in their perception of authenticity. If a collector believes that s/he is the first to whom a trader has shown a particular object, then there is a greater chance that s/he will be interested in buying the item. The more often an object is shown among a particular circuit of buyers, the less it is worth in the eyes of the local collectors. In this sense, one could argue that although

art objects are not "perishable" in the same way as are fruits or vegetables, art traders share some of the risks of a perishable-commodity market. They must be careful to whom they show their stock, and they must cautiously control the number of merchants who take their goods around on credit (see Chapter 2). Traditional/ antique objects have only a limited "life" within the parameters of a local art economy.

15 When traders sell art door-to-door (see Chapter 2), they will sometimes say that there is an old man from the village who is sitting outside; that the object really belongs to him, but that he is too shy or embarrassed to come inside. If the buyer agrees to purchase the object, the trader says, he will give the old man the money afterwards. Whether or not the statement is true (sometimes it is and other times it is not), the message which is being communicated to the buyer is that the art is "fresh" from its "native context" and that it has not yet been "spoiled" by its circulation through market networks and the defiling touch of commoditizing hands.

16 The tourist's intense quest for cultural knowledge relating to the objects which they purchase for their private collection, agrees with Susan Stewart's hypothesis that taxonomy and knowledge are what differentiate collection from fetishism – a proper relation with objects versus a "savage" or deviant relation (idolatry or erotic fixation). In her study *On Longing*, Stewart writes: "The boundary between collection and fetishism is mediated by classification and display in tension with accumulation and secrecy" (1984: 163). This point is also picked up by Clifford who goes on to say, "If the passion is for Egyptian figurines, the collector will be expected to label them, to know their dynasty (it is not enough that they simply exude power or mystery), *to tell 'interesting' things about them*, to distinguish copies from originals' (1988: 219, emphasis added).

17 The trade in market lore can be traced as far back as the trade in Near Eastern artifacts in pre-Carolingian times. Arnau reports that: "[the traders] contented themselves with simple deception, forcing up the market price of works of art by 'treating' them slightly *and surrounding them with some mythical tale regarding their origin*. It was not enough for a chalice to exhibit good workmanship; what was more important was that it should be wrapped in a cloak of legend. The cup must either have been used by Jesus Christ at the wedding of Cana or by Pontius Pilate at some banquet – whichever story filled the bill" (1961: 26, emphasis added).

18 The explanations are meant to confirm the buyer's stereotype of Africa and African art. As one writer put it: "The sculptures and masks are thrilling to look at and exciting to touch. *The stories behind the pieces of tribal rituals can inflame the imagination*" (Bordogna 1981: 36, emphasis added).

19 Susan Vogel reports that in the 1970s many traders described Akan brass boxes (*kuduo*) as spittoons (*crachoirs*) for the king – enticing the buyer with mixed metaphors of pollution and royalty (personal communication 1987). In point of fact, these vessels are actually used to store valuables (such as gold dust), and are often buried with the deceased (R. Silverman 1983: 21).

20 Definitions of "fakery" have focussed on the physical aspect of object alteration. Although this is the most obvious aspect of the post-production manipulation, I would argue that it is only one aspect of a larger process which also includes object placement and verbal elaboration. For some widely held views on African art

fakery see "Fakes, Fakers, and Fakery: Authenticity in African Art." Special issue of *African Arts* 9 (3), 1976.

21 Traders often face a double-edged problem with regard to the mounting of unbalanced objects. On the one hand, for the reasons elucidated above, traders cannot sell objects with wooden mounts. On the other hand, however, buyers are sometimes reluctant to purchase objects which do not stand up on their own. More often than not this reluctance is actually a manipulation of the bargaining process, i.e., if the buyer feels that the price of the object is too high s/he will complain that the figure does not even stand up, and, therefore, it ought to be sold for less money. Traders have responded to this pattern in bargaining strategies, by repairing the breakages and erosions at a figure's feet or base. If a buyer questions the ability of a figure to stand on its own, the trader will place the figure on the ground and demonstrate that it does indeed stand upright (*pas de problème, sa tiens*). Many collectors tell traders that they ought not alter the natural erosion of an object – i.e., that their repairs mask the true age of a figure by covering up the eroded wood. At the same time, however, many of these same collectors complain to the traders, during the bargaining process, if a figure does not stand up on its own.

22 The sea bean (*Entada phaseoloides*) is found in coastal West Africa and is used traditionally for medicinal purposes. When rubbed, the bean exudes a greasy fluid which, if applied to wood, imitates quickly the effects of prolonged human contact. My thanks to Robert Gustafson for his help in identifying the botanical name of the bean.

23 Summarizing a point by Bakhtin on inter-textual utterances (and, in particular, relating to a homology which Bakhtin draws between a parody and a forgery), Gary Morson writes: "[S]uccessful forgers do not imitate an original as *they* perceive it, but rather the way such an original is likely to appear *to their intended victims*, perhaps subtly exaggerating what the latter are likely to regard as the original's most characteristic features and hence as the marks of its authenticity" (1989: 66, original emphasis).

24 The nakedness of the statue also draws on the collector's emphasis on the sexual nature of "primitive" art. For a discussion of this particular facet of Western taste, see Price 1989: 47.

25 Traders are faced with a double standard which prevails among many collectors/ dealers. On the one hand, traders know that Western buyers are concerned with the age of an object and its overt signs of indigenous wear. On the other hand, however, traders know that when bargaining for individual items, many Western buyers will try to lower the asking price by pointing out that a figure is eroded, that it does not stand up on its own anymore, or simply that it is "ugly" because it is missing a limb or some other feature. Traders are faced with the decision of either not repairing objects (and capitalizing on their outward signs of use) or repairing objects so as to avoid potential losses in the bargaining process (cf. Wilsmore 1986). For the most part, traders have responded by repairing breaks and missing parts. Two artists in the Plateau market place earned their livelihood by restoring objects for art traders.

26 I once showed a group of traders a photograph from a Sotheby's auction catalogue (New York, May 20, 1987). The image is of an eroded Dogon face mask, described in the catalogue as "Highly weathered, the left side of the face and lower section

eroded away" (1987: 38). The mask was estimated in the catalogue at $5,000–7,000. One of the traders in the market place, a Mossi from Burkina Faso, said: "White people are too clever [*malin*]. If we tried to sell this [mask] in the market place, they would say that it was worthless, that it was ruined, that it was too ugly. So they would try to buy it for as little money as possible. Then they put it in this book here and they say, 'now see how nice it is; you must pay us a lot of money'. No, it's too much" (5/19/88).

27 Shifting demand, diminishing supply, and the associated transformation of "gift" into "commodity" is, of course, not unique to the African art market. Commenting on the vicissitudes of commercial fishing in New England, for instance, a Boston fisherman clearly echoes the remarks made by the Wolof trader from Bouaké. "Who can say what fish is worth. It's not like we have any control over what we bring in. I've had trips when everything went right. All we had to do was drop the nets and the nicest-looking fish you ever saw jumped in. Other times we go out, work our butts off, and still come back with *stuff we used to give away*" (quoted in C. Smith 1989: 26, emphasis added).

28 I do not believe that it is merely a coincidence that the market for African colonial figures should be expanding at the same moment as the market for American folk art (see C. Vogel 1988). Many colonial figures and folk sculptures, I would argue, bear a number of formal aesthetic similarities (rigid posture, elaborate detail of garments, sharply angled pant legs, etc.). Furthermore, both have comparable surface wear and paint erosion, and both are often carved on their own stands (see examples of American folk art in Miele 1988).

29 In 1974, Daniel Crowley reported on similar "treatment" of painted Guro masks. "[Although] the enameled masks have actually been used in Guro rituals, and hence are 'traditional art', [this] does little to improve their popularity with foreigners, so the wise traders often cover the shiny polychrome with dull paint before putting them on the market" (1974: 57).

30 In many instances those who use or produce African art objects have far less understanding of Western taste than the traders who sell directly to European and American buyers. While the traders busily *add* dirt to new objects to satisfy the Western demand for old, "authentic" African art, I have been told about several instances in which villagers have been known to *remove* dirt from old pieces in order to make them more "presentable" for sale to outsiders. One American collector in Abidjan gives the following example: "Years ago I had the experience of buying a mask [directly] from the dancer. Although I knew it wasn't terribly old, I knew for sure that it was used; I knew that it was authentic in that sense, and it was a beautiful piece. It had a couple of places on it that showed its wear and use – it was broken in one place and worn down in another, but for a collector that's appealing. In any case, they told me to come back and pick it up in a few hours. When I went back to get it, I found they had shoe-polished it and had repaired the place where it was broken on the chin. Of course I almost broke out in tears and asked why did you do that? They said 'we couldn't possibly have given you that old dirty mask'" (6/19/91).

In short, while one participant in the trade paints objects in brilliant colors, those closer to the Western market remove the freshly applied paint; and while one participant adds dirt and fake sacrificial materials to new objects, those further from

the Western buyers remove the real layers of encrustation that testify to an object's authenticity.

31 Because there is no sharp distinction between the marketing of old and new objects (i.e. both types of objects are sold in the same places and often by the same merchants), one must combine under the same analytic canopy the market for antique colonial statues and the one for contemporary figures manufactured for external trade.

32 For a perceptive discussion of the mediating role of the art trader in the West, see Hauser 1982: 506–17.

33 Lack of control over the forces of production is characteristic of the cross-cultural diaspora in many other commodities. Writing about the Hausa in Nigeria, Cohen points out that the Hausa have no control over production of cattle or kola, yet they dominate the trade in both (1969: 21). This lack of direct control over the forces of consumption and, in particular, the capacity for "taste-making" stands in sharp contrast to the function and role of art dealers in the West, where *they* are expected to "discover" new artists, set trends, and create interest and demand (see Taylor and Brooke 1969; Gee 1981; De Coppet and Jones 1984; Moulin 1987; Montias 1988).

34 This point deviates slightly from Cohen and Comaroff's assertion that in certain cases the broker can actually create a demand for the relationship between patron and client. "Thus we suggest," write Cohen and Comaroff, "that the broker role is not called into being simply by the desire of two parties to transact valued items: rather, it creates or may create the demand for those values in the 'transacting' parties" (1976: 89). In other markets, Hausa traders have a long history of being able to develop local tastes for their goods. When they entered new trading territories, for instance, Hausa merchants would offer gifts (e.g. cloth, spices, etc.) to local chiefs. These gifts not only gained the support of the local authorities, but it also created a demand for the goods among other members of the local population. "Even things like *kwalli* (antimony)," writes Adamu, "which appears to have captured the northern markets from the second half of the eighteenth century, was advertised by the wives of resident Hausa traders using it skillfully in their make-up" (1978: 83).

CONCLUSION: AFRICAN ART AND THE DISCOURSES OF VALUE

1 For a neo-classical economic critique of this perspective, see Grampp (1989).

2 Although it is true that a large portion of objects exchanged in the international African art trade today are expressly manufactured for the tourist and export markets – and therefore not immediately part of the spiritual world to which I refer – the general argument that I propose is still valid in so far as almost all the objects in the trade are either modelled by the African producers on objects associated with indigenous categories of meaning and beliefs, or assumed (often incorrectly) by the Western consumers to have once belonged to a religious or ritual world. A similar situation is analyzed by Stanley Tambiah for the "vulgar materialization" of Thai amulets (1984: 335–47).

3 I would follow Baudrillard's broad definition of use value as "the expression of a whole metaphysic: that of utility. It registers itself as a kind of *moral law* at the heart

of the object – and it is inscribed there as the finality of the 'need' of the subject" (1988: 67).

4 To say that African art objects in the West have lost their utility or use value, is not to say that collectors ignore the spiritual aspects of the art. Indeed, it is often these "magical" elements that draw the Western collector to African art. As prominent African art collector Paul Tishman once put it: "[N]o matter in what part of Africa the material originated and no matter how diverse the tribal or regional styles, through most of it runs the same spirituality, the same invocation of magic, the same attempt to express in image-form the unknown forces with which the African had to deal in his daily life . . . Although my interest in collecting African art was at first not fully shared by my wife, it was not long before the purity and force of the material worked their spell on her" (Sieber and Rubin 1968: [i]).

5 For another perspective on the "failed metaphor," see Raymond Williams's distinction between "art" and "non-art" (1982: 124–25; see also Thompson 1979: 118–20).

6 Although it is true that the separation of the categories useful and aesthetic is rather peculiar to the West, I would caution against overgeneralizing the label "the West." Just as anthropologists have become increasingly sensitive to the multiple perspectives and nuanced differences within the specific cultural groups they study, it is important to keep in mind that the same heterogeneity exists within what we designate as the West. In its reference to a specific geographic and cultural domain, the label "the West" is thus more a term of convenience – an oversimplification for the sake of brevity – than a useful anthropological or sociological term. My thanks to Ivan Karp for insisting on the subtleties of this important issue.

7 The Victorian distinction between magic and religion is apposite to the present contrast between use value and aesthetic value. According to writers like Edward Tylor and James Frazer, "magic" assumes the possibility of private advancement through personal access to the spiritual world, while "religion," by contrast, refers to a more dispassionate and, therefore, more socially acceptable form of behavior, which works for the good of society not the individual. The putative vulgarities attributed to the realm of magic translate faithfully to the negative qualities imputed to the use value of art, while the language that is used to characterize religion finds its equivalent in the creed of immaculate aesthetics. (For a discussion of the religious qualities of the art museum, see Bourdieu 1968: 610–12.)

8 My reference to an object's "life" is derived largely from Igor Kopytoff's excellent essay on "The Cultural Biography of Things" (1986).

9 Herbert Baker, a noted African art dealer/collector once remarked, "As an 'explorer' seeking treasures in second-hand stores, attics and basements, I found that I could afford African and Oceanic 'curios' that looked like copies [sic] of a Picasso, Braque, Modigliani or Vlaminck" (1969: 4).

10 When the profit motive is introduced into a discussion of African art collecting, it is done with a "light-hearted realist's" attitude. "With an indulgent chuckle," writes Price, "adherents of [art as economic investment] hover somewhere between a gentle 'tsk tsk' and a recognition that 'boys will be boys'" (1989: 77). Many of the editorials in the front of *African Arts* magazine are "clearly designed to assuage, through humor, any malaise that subscribers might feel about approaching their shared passion with an eye toward material gain" (*ibid.*: 77).

11 Heinrich Heine's thoughts on the emergence of the commodity as the new fetish of the bourgeois world is also germane here (see Betz 1971: 30–36).

12 Similar examples of this logic are to be found in Price 1989: 100–7.

References

Anonymous n.d.(a) *Artisanat d'art de Côte d'Ivoire*. Abidjan: Office National du Tourisme.

n.d.(b) *Places of Interest In and Around Abidjan*. Abidjan: US Embassy.

1977 *African Art: A Selection from Two Private Collections*. Private printing.

1982 African Art. *Collector-Investor* (Chicago), May, pp. 14–17.

1983 Festival de masques à Man. *Fraternité Matin*, February 7, p. 11.

1984 African Influence. *The Washington Post*. August 12, p. 4.

1987a *Exploring West Africa* (travel itinerary). San Francisco: Gulliver's Travel.

1987b Communiqué from the Ministry of Information to the Ministry of Tourism. Archives of the Ministry of Tourism, Abidjan.

1987c Prix record pour un masque baoulé. *Jeune Afrique* 1384 (July 15): 33.

1988 *African Art: The Segy Gallery*. Bolton, Mass.: Skinner Auctioneers and Appraisers.

Acheson, James 1985 Social Organization of the Maine Lobster Market, pp. 105–32. In *Markets and Marketing*. Monographs in Economic Anthropology, No. 4, edited by Stuart Plattner. Lanham, Maryland: University Press of America.

Adams, Monni 1989 African Visual Arts From an Art Historical Perspective. *African Studies Review* 32 (2): 55–103.

Adamu, Mahdi 1978 *The Hausa Factor in West African History*. Zaria and Ibadan: Ahmadu Bello University Press and Oxford University Press of Nigeria.

Agnew, Jean-Christophe 1986 *Worlds Apart: The Market and the Theater in Anglo-American Thought, 1550–1750*. Cambridge: Cambridge University Press.

Akerlof, George A. 1970 The Market for "Lemons": Quality Uncertainty and the Market Mechanism. *The Quarterly Journal of Economics* 84 (3): 488–500.

Alexander, Jennifer, and Paul Alexander 1987 Striking a Bargain in Javanese Markets. *Man* 22 (1): 42–68.

Allison, Philip, *et al.* 1976 Fakes, Fakers, and Fakery: Authenticity in African Art. *African Arts* 9 (3): 21–31, 48–74, 92.

Alperton, Matty 1981 Decorating with Primitive Art. *Primitive Art Newsletter* 4 (3): 1–3.

Alsop, Joseph 1982 *The Rare Art Traditions: The History of Art Collecting and Its Linked Phenomena*. Princeton: Princeton University Press.

Amselle, Jean-Loup 1977 *Les Négociants de la savane: Histoire et organisation sociale des Kooroko (Mali)*. Paris: Éditions Anthropos.

Anderson, Benedict 1983 *Imagined Communities: Reflections on the Origin and Spread of Nationalism*. London and New York: Verso.

195

Angoulvant, Gabriel Louis 1911 *Guide du Commerce et de la Colonization à la Côte d'Ivoire*. Paris: Office Colonial.

Anquetil, Jacques 1977 *L'Artisanat créateur en Côte d'Ivoire*. Paris: Agence de Coopération Culturelle et Technique.

Appadurai, Arjun 1986 Introduction: Commodities and the Politics of Value, pp. 3–63. In *The Social Life of Things: Commodities in Cultural Perspective*, edited by Arjun Appadurai. Cambridge: Cambridge University Press.

Arnau, Frank 1961 *Three Thousand Years of Deception in Art and Antiques*. Translated by J. Maxwell Brownjohn. London: Jonathan Cape.

Babb, Florence E. 1989 *Between Field and Cooking Pot: The Political Economy of Marketwomen in Peru*. Austin: University of Texas Press.

Bailey, F. G. 1969 *Stratagems and Spoils: A Social Anthropology of Politics*. New York: Schocken Books.

Bailey, F. G. (ed.) 1971 *Gifts and Poison*. Oxford: Blackwell.

Baillet, Emile 1957 Le Rôle de la marine de commerce dans l'implantation de la France en A.O.F. *Revue Maritime* 135: 832–40.

Baker, Herbert 1969 *The Herbert Baker Collection*. New York: Museum of Primitive Art.

 1973 On Appraising African and Oceanic "Primitive" Art. *Valuation* (American Society of Appraisers) December: 1–7.

Balandier, Georges 1967 *Ambiguous Africa*. Translated by Helen Weaver. New York: Pantheon Books. First published in French in 1957.

Barth, Fredrik 1956 Ecologic Relationships of Ethnic Groups in Swat, North Pakistan. *American Anthropologist* 58: 1079–89.

 1966 *Models of Social Organization*. Royal Anthropological Institute Occasional Paper No. 23. London: Royal Anthropological Institute of Great Britain and Ireland.

Barth, Fredrik (ed.) 1969 *Ethnic Groups and Boundaries: The Social Organization of Culture Difference*. Boston: Little, Brown and Company.

Barthes, Roland 1982 *Mythologies*. Translated by Annette Lavers. New York: Hill and Wang. First published in French in 1957.

 1984 *The Fashion System*. Translated by Matthew Ward and Richard Howard. New York: Hill and Wang. First published in French in 1967.

Bascom, William 1976 Changing African Art, pp. 303–19. In *Ethnic and Tourist Arts*, edited by Nelson H. H. Graburn. Berkeley: University of California Press.

Bates, Constance 1979 An Economic Analysis of the International Art Market. Ph.D. Dissertation. Graduate School of Business, Indiana University.

Bateson, Gregory 1951 Conventions of Communication: Where Validity Depends upon Belief, pp. 212–27. In *Communication: The Social Matrix of Psychiatry*, edited by Jurgen Reusch and Gregory Bateson. New York: W. W. Norton.

Baudrillard, Jean 1972 *Pour une critique de l'économie politique du signe*. Paris: Gallimard.

 1988 *Selected Writings*. Edited and translated by Mark Poster. Stanford: Stanford University Press.

Ben-Amos, Paula 1971 Social Change in the Organization of Wood Carving in Benin City, Nigeria. Ph.D. dissertation, Department of Anthropology, Indiana University.

1976 "A la Recherche du Temps Perdu": On Being an Ebony-Carver in Benin, pp. 320-33. In *Ethnic and Tourist Arts: Cultural Expressions from the Fourth World*, edited by Nelson H. H. Graburn. Berkeley: University of California Press.

1977 Pidgin Languages and Tourist Arts. *Studies in the Anthropology of Visual Communication* 4 (2): 128–39.

1989 African Visual Arts from a Social Perspective. *African Studies Review* 32 (2): 1–54.

Benjamin, Walter 1969 The Work of Art in the Age of Mechanical Reproduction, pp. 217–51. In *Illuminations*. Translated by Harry Zohn. New York: Schocken Books. First published in German in 1955.

Bentley, G. Carter 1987 Ethnicity and Practice. *Comparative Studies in Society and History* 29 (1): 24-55.

Bentsi-Enchill, Nii K. 1988 Liberalism at a Price: An Assessment of the Troubled Ivorian Economy. *West Africa* 3704: 1428.

Berger, John 1972 *Ways of Seeing*. London: Penguin.

Betz, Albrecht 1971 *Ästhetik und Politik: Heinrich Heine's Prosa*. Munich: Carl Hanser.

Blier, Suzanne Preston 1988–89 Art Systems and Semiotics: The Question of Art, Craft, and Colonial Taxonomies in Africa. *The American Journal of Semiotics* 6 (1): 7–18.

1990 African Art Studies at the Crossroads: An American Perspective, pp. 91–110. In *African Art Studies: The State of the Discipline*. Washington, DC: National Museum of African Art.

Blumenthal, Susan 1974 The World's Best Traveled Art. *Africa Report* 19 (1): 4–10.

Bogatyrev, Petr 1937 *The Functions of Folk Costume in Moravian Slovakia*. The Hague: Mouton (1971).

Bonacich, Edna 1973 A Theory of Middleman Minorities. *American Sociological Review* 38 (5): 583–94.

Boorstin, Daniel J. 1962 *The Image: A Guide to Pseudoevents in America*. New York: Harper & Row.

Bordogna, Charles 1981 The Lure of African Art. *Collector-Investor* (Chicago), September, p. 36.

Bosch, Ellie 1985 *Les Femmes du marché de Bobo: La vie et le travail des commerçantes dans la ville de Bobo-Dioulasso au Burkina-Faso*. Leiden: Centre de Recherche et de Documentation Femmes et Développement.

Bouabré, Paul 1987a Les Petits fabricants de masques: Le commerce des "bannis". *Fraternité Matin* (Abidjan), March 12, p. 11.

1987b Festimask 1987: Le masque doit servir à la paix. *Fraternité Matin* (Abidjan), July 16, p. 8.

Boulding, K. E. 1971 The Economics of Knowledge and the Knowledge of Economics, pp. 21–36. In *Economics of Information and Knowledge*, edited by D. M. Lamberton. London: Penguin Books.

Bourdieu, Pierre 1968 Outline of a Sociological Theory of Art Perception. *International Social Science Journal* 20 (4): 589–612.

1977 *Outline of a Theory of Practice*. Translated by Richard Nice. Cambridge: Cambridge University Press. First published in French in 1972.

1980 The Production of Belief: Contribution to an Economy of Symbolic Goods. Translated by Richard Nice. *Media, Culture and Society* 2: 261–93.

1984 *Distinction: A Social Critique of the Judgement of Taste.* Translated by Richard Nice. Cambridge, Mass.: Harvard University Press. First published in French in 1979.

Bourdieu, Pierre, and Alain Derbel, with Dominique Schnapper 1990 *The Love of Art: European Art Museums and their Public.* Translated by Caroline Beattie and Nick Merriman. Stanford: Stanford University Press. First published in French in 1969.

Bouret, Jean 1970 Une amitié esthétique au début du siècle, Apollinaire et Paul Guillaume (1911–1918), d'après une correspondance inédite. *Gazette des Beaux-Arts* 76: 373–99.

Boutillier, Jean-Louis, Michèle Fiéloux, and Jean-Louis Ormières 1978 Le Tourisme en Afrique de l'ouest, pp. 5–83. In *Le Tourisme en Afrique de l'ouest,* edited by Jean-Louis Boutillier, Jean Copans, Michèle Fiéloux, Suzanne Lallemand, and Jean-Louis Ormières. Paris: François Maspero.

Braudel, Fernand 1973 *Capitalism and Material Life, 1400–1800.* Translated by Miriam Kochan. New York: Harper & Row. First published in French in 1967.

1982 *The Wheels of Commerce.* Translated by Sian Reynolds. New York: Harper.

Bravmann, René A. 1973 *Open Frontiers: The Mobility of Art in Black Africa.* Seattle: University of Washington Press.

1974 *Islam and Tribal Art in West Africa.* Cambridge: Cambridge University Press.

Briggs, Jean 1971 Strategies of Perception: The Management of Ethnic Identity, pp. 55–73. In *Patrons and Brokers in the East Arctic,* edited by Robert Paine. Newfoundland Social and Economic Papers, no. 2. St. John's: Memorial University.

Brooke, James 1988 Ivory Coast Gambles to Prop up Cocoa Prices. *The New York Times,* November 21, section D, p. 10.

Brown, Patricia Leigh 1990 Lauren's Wink at the Wild Side. *The New York Times,* February 8, section C, pp. 1, 3.

Bunker, Stephen G. 1985 *Underdeveloping the Amazon: Extraction, Unequal Exchange, and the Failure of the Modern State.* Urbana: University of Illinois Press.

Bunn, James H. 1980 The Aesthetics of British Mercantilism. *New Literary History* 11 (2): 303-21.

Carpenter, Edmund 1975 Collecting Northwest Coast Art, pp. 9–49. In *Indian Art of the Northwest Coast,* edited by Bill Holm and Bill Reid. Seattle: University of Washington Press.

Cassady, Ralph Jr. 1968 Negotiated Price-Making in Mexican Traditional Markets: A Conceptual Analysis. *America Indigena* 28 (1): 51–79.

Challenor, Herschelle Sullivan 1979 Strangers as Colonial Intermediaries: The Dahomeyans in Francophone Africa, pp. 67–103. In *Strangers in African Societies,* edited by William A. Shack and Elliott P. Skinner. Berkeley: University of California Press.

Chapman, Anne 1980 Barter as a Universal Mode of Exchange. *L'Homme* 20 (3): 33–83.

Chauvin, Françoise 1987 Les Gentils petits colons. *Paris Match*, May 8, pp. 84–85.

Clifford, James 1985 Histories of the Tribal and the Modern. *Art in America* 73 (4): 164–77, 215. Reprinted in James Clifford, *The Predicament of Culture*, pp. 189–214. Cambridge, Mass.: Harvard University Press.

1987 Of Other Peoples: Beyond the "Salvage Paradigm", pp. 121–30. In *Discussions in Contemporary Culture*, no. 1, edited by Hal Foster. Seattle: Bay Press.

1988 On Collecting Art and Culture. In *The Predicament of Culture: Twentieth-Century Ethnography, Literature, and Art*, pp. 215–51. Cambridge, Mass.: Harvard University Press.

Cohen, Abner 1965 The Social Organization of Credit in a West African Cattle Market. *Africa* 35: 8–20.

1969 *Custom and Politics in Urban Africa: A Study of Hausa Migrants in Yoruba Towns*. Berkeley: University of California Press.

1971 Cultural Strategies in the Organization of Trading Diasporas, pp. 266–84. In *The Development of Indigenous Trade and Markets in West Africa*, edited by Claude Meillassoux. Oxford: Oxford University Press.

Cohen, A. P., and J. L. Comaroff 1976 The Management of Meaning: On the Phenom-enology of Political Transactions, pp. 87–107. In *Transaction and Meaning: Directions in the Anthropology of Exchange and Symbolic Behavior*, edited by Bruce Kapferer. Philadelphia: Institute for the Study of Human Issues.

Cohen, William B. 1980 *The French Encounter with Africans: White Response to Black, 1530–1880*. Bloomington: Indiana University Press.

Coke, Desmond 1928 *Confessions of an Incurable Collector*. London: Chapman and Hall.

Cole, Herbert M. 1975 Artistic and Communicative Values of Beads in Kenya and Ghana. *The Bead Journal* 1 (3): 29–37.

Cole, Herbert M., and Doran H. Ross 1977 *The Arts of Ghana*. Los Angeles: Museum of Cultural History, University of California.

Colvin, Lucie G. 1971 The Commerce of Hausaland, 1780–1833, pp. 101–36. In *Aspects of West African Islam*, edited by Daniel F. McCall and Norman R. Bennett. Boston University Papers on Africa, no. 5. Boston: African Studies Center.

Comaroff, John L. 1987 Of Totemism and Ethnicity. *Ethos* 52 (4): 301–23.

Conway, Sir Martin 1914 *The Sport of Collecting*. London: Fisher Unwin.

Copans, Jean 1978 Idéologies et idéologues du tourisme au Sénégal: Fabrications et contenus d'une image de marque, pp. 108–40. In *Le Tourisme en Afrique de l'ouest*, edited by Jean-Louis Boutillier, Jean Copans, Michèle Fiéloux, Suzanne Lallemand, and Jean-Louis Ormières. Paris: François Maspero.

Coquery-Vidrovitch, Catherine, and Paul E. Lovejoy (eds.) 1985 *The Workers of African Trade*. Beverly Hills: Sage Publications.

Crowley, Daniel J. 1970 The Contemporary-Traditional Art Market in Africa. *African Arts* 4 (1): 43–49.

1974 The West African Art Market Revisited. *African Arts* 7 (4): 54–59.

1979 The Art Market in Cameroon and the Central African Empire. *African Arts* 12 (3): 74–75.

Culler, Jonathan 1981 Semiotics of Tourism. *American Journal of Semiotics* 1 (1–2): 127–40.

Curtin, Philip D. 1975 *Economic Change in Precolonial Africa: Senegambia in the Era of the Slave Trade*. Madison: University of Wisconsin Press.
 1984 *Cross-Cultural Trade in World History*. Cambridge: Cambridge University Press.
Danto, Arthur 1981 *Transfiguration of the Commonplace*. Cambridge, Mass.: Harvard University Press.
Dark, Philip J. C. 1967 The Study of Ethno-Aesthetics: The Visual Arts, pp. 131–48. In *Essays on the Verbal and Visual Arts: Proceedings of the 1966 Annual Spring Meeting of the American Ethnological Society*, edited by June Helm. Seattle: University of Washington Press.
Davis, Whitney 1989 Review of *Object and Intellect: Interpretations of Meaning in African Art*, special issue of *Art Journal* 47 (2), 1988, edited by Henry John Drewal. In *African Arts* 22 (4): 24–32, 85.
De Coppet, Laura, and Alan Jones 1984 *The Art Dealers*. New York: Clarkson N. Potter.
Delcourt, Jean Paul, and Giovanni Franco Scanzi 1987 *Potomo Waka*. Milan: Editions Lediberg.
Den Tuinder, Bastiaan A. 1978 *Ivory Coast: The Challenge of Success*. Baltimore: The Johns Hopkins University for the World Bank.
Djidji, Ambroise 1983 Réflexion sur le festival des masques. *Fraternité Matin*. February 22, p. 10.
Donne, J. B. 1978 African Art and Paris Studios, 1905–20, pp. 105–20. In *Art in Society*, edited by Michael Greenhalgh and Vincent Megaw. New York: St. Martin's Press.
Dozon, Jean-Pierre 1985 Les Bété: Une création coloniale, pp. 49–85. In *Au coeur de l'ethnie: Ethnies, tribalisme et état en Afrique*, edited by Jean-Loup Amselle and Elikia M'Bokolo. Paris: Editions La Decouverte.
Drewal, Henry John 1990 African Art Studies Today, pp. 29–62. In *African Art Studies: The State of the Discipline*. Washington, DC: National Museum of African Art.
Dubin, Lois Sherr 1981 *The History of Beads*. New York: Harry N. Abrams.
Durkheim, Emile 1933 *The Division of Labor in Society*. Translated by George Simpson. New York: The Free Press. First published in French in 1893.
Echenberg, Myron 1991 *Colonial Conscripts: The* Tirailleurs Sénégalais *in French West Africa, 1857–1960*. Portsmouth, NH: Heinemann Educational Books.
Elkan, Walter 1958 The East African Trade in Woodcarving. *Africa* 33 (4): 314–23.
Errington, Shelly 1989 Fragile Traditions and Contested Meanings. *Public Culture* 1 (2): 49–59.
 forthcoming Artifacts into Art. In *Collections and Culture: Museums and the Development of American Life and Thought*, edited by Michael Lacey and Sally Kohlstedt.
Etienne-Nugue, Jocelyne, and Elisabeth Laget 1985 *Artisanats traditionnels: Côte d'Ivoire*. Dakar: Institut Culturel Africain.
Evans-Pritchard, E. E. 1940 *The Nuer*. Oxford: Clarendon Press.
Fabian, Johannes 1983 *Time and the Other: How Anthropology Makes its Object*. New York: Columbia University Press.
Fagg, William B. 1965 *Tribes and Forms in African Art*. New York: Tudor.

Fanselow, Frank S. 1990 The Bazaar Economy, Or How Bizarre is the Bazaar Really? *Man* 25 (2): 250–65.

Faris, James C. 1988 "ART/artifact": On the Museum and Anthropology. *Current Anthropology* 29 (5): 775–79.

Fischer, Eberhard, and Hans Himmelheber 1984 *The Arts of the Dan in West Africa.* Translated by Anne Bundle. Zurich: Rietberg Museum. First published in German in 1976.

Forde, Daryl, and Samir Amin 1978 *Drought and Migration in the Sahel.* New York: Oxford University Press.

Foster, Brian L. 1974 Ethnicity and Commerce. *American Ethnologist* 1 (3): 437–48.

Francis, Peter Jr. 1979 *The Story of Venetian Beads.* The World of Beads Monograph Series, vol. 1. New York: Lapis Route Books.

Frank, Barbara E. 1987 Open Borders: Style and Ethnic Identity. *African Arts* 20 (4): 48–55.

Galerie des Arts 1985, vol. 227.

Gambetta, Diego, ed. 1988 *Trust: Making and Breaking Cooperative Relations.* New York and Oxford: Basil Blackwell.

Garnham, Nicholas, and Raymond Williams 1980 Pierre Bourdieu and the Sociology of Culture. *Media, Culture and Society* 2 (3): 209–23.

Garrard, Timothy F. 1983 Akan Pseudo-Weights of European Origin, pp. 70–81. In *Akan Transformations: Problems in Ghanaian Art History*, edited by Doran H. Ross and Timothy F. Garrard. Los Angeles: Museum of Cultural History.

Gast, Dwight V. 1988 Pricing New York Galleries. *Art in America* (July): 86–87.

Gaudio, Attilio, and Patrick Van Roekeghem 1984 Le Charme suranné des "sondja" ou statuette "colon", pp. 197–99. In *Étonnante Côte d'Ivoire.* Paris: Éditions Karthala.

Gee, Malcolm 1981 *Dealers, Critics, and Collectors of Modern Painting: Aspects of the Parisian Art Market Between 1910 and 1930.* New York: Garland Publishing.

Geertz, Clifford 1963 *Peddlers and Princes: Social Development and Economic Change in Two Indonesian Towns.* Chicago: University of Chicago Press.

1979 Suq: The Bazaar Economy in Sefrou, pp. 123–313. In *Meaning and Order in Moroccan Society*, edited by Clifford Geertz, Hildred Geertz, and Lawrence Rosen. Cambridge: Cambridge University Press.

Gellner, Ernest 1983 *Nations and Nationalism.* Ithaca: Cornell University Press.

Gerbrands, Adrian A. 1990 The History of African Art Studies, pp. 11-28. In *African Art Studies: The State of the Discipline.* Washington, DC: National Museum of African Art, Smithsonian Institution.

Gnangnan, Desiré 1987 Festivale de masque 1987. *Fraternité Matin*, May 4, p. 10.

Gnobo, J. Z. 1976 Le Rôle des femmes dans le commerce pré-colonial à Daloa. *Godo-Godo* (Abidjan) 2: 79–105.

Goffman, Erving 1959 *The Presentation of Self in Everyday Life.* Garden City, NY: Anchor Books.

Goldsmith, Oliver 1891 *The Citizen of the World.* London: J. M. Dent and Company.

Gorer, Geoffrey 1935 *Africa Dances.* New York: Alfred A. Knopf.

Graburn, Nelson H. H. 1976 Introduction: Arts of the Fourth World, pp. 1–32. In *Ethnic and Tourist Arts: Cultural Expressions from the Fourth World*, edited by Nelson H. H. Graburn. Berkeley: University of California Press.

1984 The Evolution of Tourist Arts. *Annals of Tourism Research* 11: 393–419.

Graburn, Nelson H. H. (ed.) 1976 *Ethnic and Tourist Arts: Cultural Expressions from the Fourth World*. Berkeley: University of California Press.

Grampp, William D. 1989 *Pricing the Priceless: Art, Artists, and Economists*. New York: Basic Books.

Greenblatt, Stephen 1990 Resonance and Wonder. *Bulletin of the American Academy of Arts and Sciences* 43 (4): 11–34.

Greenwald, Jeff 1990 *Shopping for Buddhas*. San Francisco: Harper & Row.

Grégoire, Emmanuel 1992 *The Alhazai of Maradi: Traditional Hausa Merchants in a Changing Sahelian City*. Translated by Benjamin H. Hardy. Boulder and London: Lynne Rienner Publishers. First published in French in 1986.

Griaule, Marcel 1965 *Conversations with Ogotemmêli*. London: Oxford University Press for the International African Institute. First published in French in 1948.

Griggs, Anthony 1974 Dealing in African Art. *Race Relations Reporter* 5: 17–21.

Guido (Abidjan) 1987 Ces drôles de colons. No. 231: 42–46.

1988a Mary-Laure Grange Césaréo: A la recherche d'une esthétique. No. 254: 64–67.

1988b Statues colons. No. 255: 74–75.

Guillaume, Paul, and Thomas Munro 1926 *Primitive Negro Sculpture*. New York: Harcourt, Brace & Co.

Handler, Richard 1986 Authenticity. *Anthropology Today* 2 (1): 2-4.

1988 *Nationalism and the Politics of Culture in Quebec*. Madison: University of Wisconsin Press.

Haraway, Donna 1984/85 Teddy Bear Patriarchy: Taxidermy in the Garden of Eden, New York City, 1908–1936. *Social Text* 11: 19–64. Reprinted in Donna Haraway, *Primate Vision: Gender, Race, and Nature in the World of Modern Science*, pp. 26–58. New York: Routledge, 1989.

Hart, Keith 1988 Kinship, Contract, and Trust: The Economic Organization of Migrants in an African City Slum, pp. 176–93. In *Trust: Making and Breaking Cooperative Relations*, edited by Diego Gambetta. New York and Oxford: Basil Blackwell.

Harvey, David 1989 *The Condition of Postmodernity*. Oxford: Basil Blackwell.

Hauser, Arnold 1982 *The Sociology of Art*. Translated by Kenneth J. Northcott. Chicago: University of Chicago Press. First published in German in 1974.

Hersey, Irwin 1979 The Times They Are A-Changing. *Primitive Art Newsletter* 2 (12): 1–2, 5–6.

1982 The African Art Market. Lecture delivered at the National Museum of African Art, Washington, DC, April 21. Notes compiled by Janet L. Stanley.

Herskovits, Melville J. 1930 The Culture Areas of Africa. *Africa* 3: 59–77.

Herzfeld, Michael 1987 *Anthropology Through the Looking-Glass: Critical Ethnography in the Margins of Europe*. Cambridge: Cambridge University Press.

Hill, Polly 1966 Landlords and Brokers: A West African Trading System. *Cahiers d'Etudes Africaines* 6: 349–66.

Himmelheber, Hans 1966 The Present Status of Sculptural Art Among the Tribes of the Ivory Coast, pp. 192–97. In *Essays on the Verbal and Visual Arts: Proceedings of the 1966 Annual Spring Meeting of the American Ethnological Society*, edited by June Helm. Seattle and London: University of Washington Press.

1975 Afrikanische Kunsthandler an der Elfenbeinkuste. *Zeitschrift für Ethnologie* 100 (1): 16–26.

Hiskett, Mervyn 1984 *The Development of Islam in West Africa.* London and New York: Longman.

Holas, Bohumil 1960 *Cultures Matérielles de la Côte d'Ivoire.* Paris: Presses Universitaires de France.

1966 *Arts traditionnels de la Côte d'Ivoire.* Paris: Presses Universitaires de France.

Hopkins, A. G. 1973 *An Economic History of West Africa.* New York: Columbia University Press.

Imperato, Pascal J. 1976 The Whims of Termites. *African Arts* 9 (3): 72–73.

Jahn, Jens (ed.) 1983 *Colon: Das schwarze Bild vom weiben Mann.* Munich: Rogner and Bernhard.

Jamin, Jean 1982 Objets trouvés des paradis perdues: A propos de la Mission Dakar-Djibouti, pp. 69–100. In *Collections passion*, edited by Jacques Hainard and Roland Kaehr. Neuchâtel: Musée d'Ethnographie.

1985 Les Objets ethnographiques sont-ils des choses perdues? pp. 51–74. In *Temps perdu, temps retrouvé: Voir les choses du passé au présent*, edited by Jacques Hainard and Roland Kaehr. Neuchâtel: Musée d'Ethnographie.

Johnson, Marion 1978 By Ship or By Camel: The Struggle for the Cameroons Ivory Trade in the Nineteenth Century. *Journal of African History* 19 (4): 539–49.

Jules-Rosette, Bennetta 1984 *The Messages of Tourist Art: An African Semiotic System in Comparative Perspective.* New York: Plenum Press.

1990 Simulations of Postmodernity: Images of Technology in African Tourist and Popular Art. *Visual Anthropology Review* 6 (1): 29–37.

Kaeppler, Adrienne L. 1978 *"Artificial Curiosities": An Exposition of Native Manufactures Collected on the Three Pacific Voyages of Captain James Cook, R.N.* Honolulu: Bishop Museum Press.

Kamer, Henri 1974 De l'authenticité des sculptures africaines/The Authenticity of African Sculptures. *Arts d'Afrique Noire* 12: 17–40.

Karp, Ivan, and Kent Maynard 1983 Reading *The Nuer. Current Anthropology* 24: 481–503.

Kasfir, Sidney Littlefield 1984 One Tribe, One Style: Paradigms in the Historiography of African Art. *History in Africa* 11: 163–93.

1992 African Art and Authenticity: A Text With a Shadow. *African Arts* 25 (3): 40–53, 96–97.

Katzin, Margaret Fisher 1960 The Business of Higglering in Jamaica. *Social and Economic Studies* 9 (3): 297-331.

Khuri, Fuad I. 1968 The Etiquette of Bargaining in the Middle East. *American Anthropologist* 70: 698–706.

Kobé, A., and O. Abiven 1923 *Dictionnaire Volof-Français.* Dakar: Mission Catholique.

Kopytoff, Igor 1986 The Cultural Biography of Things, pp. 64–91. In *The Social Life of Things: Commodities in Cultural Perspective*, edited by Arjun Appadurai. Cambridge: Cambridge University Press.

Kuper, Hilda 1973 Costume and Identity. *Comparative Studies in Society and History* 15 (3): 348–67.

Kuspit, Donald B. 1990 The Psychoanalyst-Collector's Relation to Art Objects. Lecture delivered at the Arthur M. Sackler Museum, Harvard University. May 24.

Lakpé, Raphael 1987 Interview avec Pierre Poulou (Commissaire Général du Festimask). *I.D.: Le Magazine de Côte d'Ivoire*, no. 857, July 12.

Laude, Jean 1971 *The Arts of Black Africa*. Translated by Jean Decock. Berkeley: University of California Press. First published in French in 1966.

Launay, Robert 1982 *Traders without Trade: Responses to Change in Two Dyula Communities*. Cambridge: Cambridge University Press.

Le Pape, Marc 1985 De l'espace et des races à Abidjan, entre 1903 et 1934. *Cahiers d'Études Africaines* 25 (3): 295–307.

Leach, Edmund R. 1954 *Political Systems of Highland Burma*. Boston: Beacon Press.

Lehuard, Raoul 1976 Sacred and Profane. *African Arts* 9 (3): 73–74.

 1977 Un Voyage en Côte d'Ivoire. *Arts d'Afrique Noire* 23: 26–33.

 1979 Un Voyage en Haute-Volta. *Arts d'Afrique Noire* 31: 11–19.

Lemann, Nicholas 1987 Fake Masks. *The Atlantic* 260 (5): 24-38.

Leuzinger, Elsy 1960 *Africa: The Art of the Negro People*. New York: McGraw-Hill.

Levine, Donald N. 1979 Simmel at a Distance: On the History and Systematics of the Sociology of the Stranger, pp. 21–36. In *Strangers in African Societies*, edited by William A. Shack and Eliott P. Skinner. Berkeley: University of California Press.

Lewis, Barbara 1971 The Dioula in the Ivory Coast, pp. 273–307. In *Papers on the Manding*, edited by Carleton T. Hodge. Bloomington: Indiana University Press.

 1976 The Limitations of Group Action Among Entrepreneurs: The Market Women of Abidjan, Ivory Coast, pp. 135–56. In *Women in Africa: Studies in Social and Economic Change*, edited by Nancy J. Hafkin and Edna G. Bay. Stanford: Stanford University Press.

Lips, Julius E. 1937 *The Savage Hits Back*. Reissued 1966. New Hyde Park, NY: University Books.

Liu, Robert K. 1975 Editorial. *The Bead Journal* 2 (2): 1.

Lovejoy, Paul E. 1980 *Caravans of Kola: The Hausa Kola Trade, 1700–1900*. Zaria and Ibadan: Ahmadu Bello University Press and Oxford University Press.

Lowenthal, David 1985 *The Past is a Foreign Country*. Cambridge: Cambridge University Press.

MacCannell, Dean 1976 *The Tourist: A New Theory of the Leisure Class*. New York: Schocken Books.

 1984 Reconstructed Ethnicity: Tourism and Cultural Identity in Third World Communities. *Annals of Tourism Research* 11: 375–91.

MacClancy, Jeremy 1988 A Natural Curiosity: The British Market in Primitive Art. *RES: Anthropology and Aesthetics* 15: 164–76.

McLeod, M. D. 1976 Limitations of the Genuine. *African Arts* 9 (3): 31, 48-51.

Mailfert, André 1968 *Au pays des antiquaires: confidences d'un "maquilleur" professionel*. Paris: Flammarion.

Malinowski, Bronislaw 1927 The Life of Culture, pp. 26–46. In *Culture: The Diffusion Controversy*, edited by Grafton Elliot Smith. New York: W. W. Norton.

Malinowski, Bronislaw and Julio de la Fuente 1985 *Malinowski in Mexico: The Economics of a Mexican Market System*. Edited by Susan Drucker-Brown. London: Routledge & Kegan Paul. First published in 1957.

Manning, Patrick 1985 Primitive Art and Modern Times. *Radical History Review* 33: 165–81.

 1988 *Francophone Sub-Saharan Africa, 1880–1985*. Cambridge: Cambridge University Press.

Marcus, George E., and Michael M. J. Fischer 1986 *Anthropology as Cultural Critique*. Chicago: University of Chicago Press.

Marx, Karl 1906 *Capital*. Translated by Ernest Untermann. New York: The Modern Library. First published in German in 1867.

Maurer, Evan 1981 Caveat Ethnos: Unmasking Frauds in Ethnographic Art. *National Arts Guide* 3 (2): 22–25.

Maybury-Lewis, David (ed.) 1984 *The Prospects for Plural Society*. 1982 Proceedings of the American Ethnological Society. Washington, DC: American Ethnological Society.

Mazrui, Ali 1970 The Robes of Rebellion: Sex, Dress and Politics in Africa. *Encounter* 34 (2): 19–30. Reprinted in *The Body Reader: Social Aspects of the Human Body*, pp. 196–217, edited by Ted Polhemus. New York: Pantheon Books, 1978.

Melikian, Souren 1987 African Sculpture From the Colonial Era. *International Herald Tribune*, October 31, p. 22.

Meyer, Piet 1981 *Kunst und Religion der Lobi*. Zürich: Museum Rietberg.

Miele, Frank J. 1988 *Source and Inspiration*. New York: Hirschl and Adler Folk.

Mintz, Sidney W. 1961 *Pratik*: Haitian Personal Economic Relationships. *Proceedings of the 1961 Annual Spring Meeting of the American Ethnological Society*, edited by Viola E. Garfield. Seattle: University of Washington Press.

 1964a The Employment of Capital by Market Women in Haiti, pp. 256–86. In *Capital, Saving and Credit in Peasant Societies*, edited by Raymond Firth and B. S. Yamey. Chicago: Aldine.

 1964b *Peasant Market Places and Economic Development in Latin America*. The Graduate Center for Latin American Studies, Vanderbilt University, Occasional Paper No. 4.

 1971 Men, Women, and Trade. *Comparative Studies in Society and History* 13 (3): 247–69.

 1985 *Sweetness and Power: The Place of Sugar in Modern History*. New York: Viking.

Miracle, Marvin P., and Bruce Fetter 1970 Backward-Sloping Labor-Supply Functions and African Economic Behavior. *Economic Development and Cultural Change* 18 (2): 240–51.

Monson, Terry D., and Garry G. Pursell 1979 The Use of DRC's to Evaluate Indigenization Programs: The Case of the Ivory Coast. *Journal of Development Economics* 6 (1): 119–39.

Montias, John Michael 1988 Art Dealers in the Seventeenth-Century Netherlands. *Simiolus* 18 (4): 244–53.

Moore, Sally Falk 1978 *Law as Process: An Anthropological Approach*. London: Routledge & Kegan Paul.

 1989 The Production of Cultural Pluralism as a Process. *Public Culture* 1 (2): 26–48.

Moore, Sally Falk, and Barbara G. Myerhoff 1977 "Introduction," pp. 3–23. In *Secular Ritual*, edited by Sally Falk Moore and Barbara G. Myerhoff. Assen, The Netherlands: Van Gorcum.

Morson, Gary Saul 1989 Parody, History, and Metaparody, pp. 63–86. In *Rethinking Bakhtin*, edited by Gary Saul Morson and Caryl Emerson. Evanston: Northwestern University Press.

Moulin, Raymonde 1987 *The French Art Market: A Sociological View*. Translated by Arthur Goldhammer. New Brunswick: Rutgers University Press. First published in French in 1967.

Mudimbe, V. Y. 1988 *The Invention of Africa*. Bloomington: Indiana University Press.

Mundt, Robert J. 1987 *Historical Dictionary of the Ivory Coast (Côte d'Ivoire)*. African Historical Dictionaries, no. 41. Metuchen, NJ and London: Scarecrow Press.

Nash, Dennison 1977 Tourism as a Form of Imperialism, pp. 33–47. In *Hosts and Guests: The Anthropology of Tourism*, edited by Valene L. Smith. Philadelphia: University of Pennsylvania Press.

Nedelec, Michel 1974 *Equipements touristiques et recreatifs dans la région d'Abidjan*. Abidjan: Centre de Recherches Architecturales et Urbaines.

Northern, Tamara 1986 *Expressions of Cameroon Art: The Franklin Collection*. Beverly Hills, CA: Rembrandt Press.

Paine, Robert 1971 A Theory of Patronage and Brokerage, pp. 3–28. *Patrons and Brokers in the East Arctic*, edited by Robert Paine. Newfoundland Social and Economic Papers, no. 2. St. John's: Memorial University.

 1974 *Second Thoughts About Barth's Models*. London: Royal Anthropological Institute of Great Britain and Ireland.

 1976 Two Modes of Exchange and Mediation, pp. 63–86. In *Transaction and Meaning: Directions in the Anthropology of Exchange and Symbolic Behavior*, edited by Bruce Kapferer. Philadelphia: Institute for the Study of Human Issues.

Paudrat, Jean-Louis 1984 The Arrival of Tribal Objects in the West from Africa, pp. 125–75. Translated by John Shepley. In *"Primitivism" in 20th-Century Art: Affinity of the Tribal and the Modern*, edited by William Rubin. New York: The Museum of Modern Art.

Paulme, Denise 1962 *African Sculpture*. Translated by Michael Ross. London: Elek Books. First published in French in 1956.

Perinbam, B. Marie 1977 *Homo Africanus: Antiquus* or *Oeconomicus*? Some Interpretations of African Economic History. *Comparative Studies in Society and History* 19 (2): 156–78.

 1980 The Julas in Western Sudanese History: Long-Distance Traders and Developers of Resources, pp. 455–75. In *West African Culture Dynamics: Archaeological and Historical Perspectives*, edited by B. K. Swartz, Jr. and Raymond E. Dumett. The Hague: Mouton Publishers.

Philmon, Thierry O. 1982 Conference du Ministre Duon Sadia. *Fraternité Matin*. December 2, pp. 13-16.

Picard, John and Ruth 1986 *Tabular Beads from the West African Trade*. Carmel: Picard African Imports.

Pitt-Rivers, A. H. 1875 Principles of Classification. *Journal of the Anthropological Institute* 4: 293–308.

Plattner, Stuart 1985 Equilibrating Market Relationships, pp. 133–52. In *Markets and Marketing*, edited by Stuart Plattner. Monographs in Economic Anthropology, no. 4. Lanham, Maryland: University Press of America.

Polanyi, Karl 1977 *The Livelihood of Man*. Edited by H. W. Pearson. New York: Academic Press.

Price, Sally 1989 *Primitive Art in Civilized Places*. Chicago: University of Chicago Press.

Provost, Carl K. 1980 The Valuation of Traditional Art: Special Problems in Connoisseurship. *Valuation* (American Society of Appraisers), November: 136–49.

Ranger, Terence 1983 The Invention of Tradition in Colonial Africa, pp. 211–62. In *The Invention of Tradition*, edited by Eric Hobsbawm and Terence Ranger. Cambridge: Cambridge University Press.

Ravenhill, Philip L. 1980a Art. Ivory Coast Supplement to the *Financial Times* (London), December 9, p. 19.

 1980b *Baule Statuary Art: Meaning and Modernization*. Working Papers in the Traditional Arts, vol. 5. Philadelphia: Institute for the Study of Human Issues.

 1988 The Passive Object and the Tribal Paradigm: Colonial Museography in French West Africa. Paper presented at the Workshop on African Material Culture in Bellagio, Italy.

Rees, A. 1971 Information Networks in Labour Markets, pp. 109–18. In *Economics of Information and Knowledge*, edited by D. M. Lamberton. London: Penguin Books.

Reif, Rita 1988 It May Look Like a Hoe, but It's Really Money. *The New York Times*, October 30, section H, p. 37.

 1990 Auctions. *The New York Times*, February 9, p. 32.

Rémy, Mylène 1976 *La Côte d'Ivoire aujourd'hui*. Paris: Éditions J.A.

Revel, Jean-François 1966 Paul Guillaume par lui-même. *L'Oeil* 135: 35–40, 70.

Rheims, Maurice 1961 *The Strange Life of Objects: Thirty Five Centuries of Art Collecting and Collectors*. Translated by David Pryce-Jones. New York: Atheneum. First published in French in 1959.

Richter, Dolores 1980 *Art, Economics and Change: The Kulebele of Northern Ivory Coast*. La Jolla: Psych/Graphic Publishers.

Robinson, Blake W. 1975 The African Art Trade in Monrovia. *Liberian Studies Journal* 6 (1): 73–79.

Ross, Doran H., and Raphael X. Reichert 1983 Modern Antiquities: A Study of a Kumase Workshop, pp. 82–91. In *Akan Transformations: Problems in Ghanaian Art History*, edited by Doran H. Ross and Timothy F. Garrard. Los Angeles: Museum of Cultural History.

Roy, Joseph 1987 Marché de l'art: Le blanc et le noir. *L'Express*, November 13, p. 57.

Rubin, William 1984 Modernist Primitivism: An Introduction, pp. 1–79. In *"Primitivism" in 20th-Century Art: Affinity of the Tribal and the Modern*, 2 vols. New York: The Museum of Modern Art.

Sagoff, Mark 1981 On the Aesthetic and Economic Value of Art. *British Journal of Aesthetics* 21 (4): 318–29.

Schildkrout, Enid 1978 *People of the Zongo: The Transformation of Ethnic Identities in Ghana*. Cambridge: Cambridge University Press.

Schoffel, Alain 1989 Notes on the Art Fakes Which Have Recently Appeared in the Northern Philippines. *Art Tribal: Bulletin of the Musée Barbier-Mueller* 1: 11–23.

Segy, Ladislas 1958 *African Sculpture*. New York: Dover Publications.

Shepard, John H. 1978 Ivory Coast and the Ivorian Miracle. *Crisis* 85: 240–42.

Shils, Edward 1981 *Tradition*. Chicago: University of Chicago Press.

Sieber, Roy 1976 Forgeries without Forgers. *African Arts* 9 (3): 22–24.

Sieber, Roy, and Arnold Rubin 1968 *Sculpture of Black Africa: The Paul Tishman Collection*. Los Angeles: Los Angeles County Museum of Art.

Silberman, James M. 1976 Preparing the Appraisal for Traditional or Primitive Art Properties. *Monographs* (American Society of Appraisers) 7 (3): 58–64.

Silver, Harry R. 1976 The Mind's Eye: Art and Aesthetics in an African Craft Community. Ph.D. dissertation, Department of Anthropology, Stanford University.

1979a Ethnoart. *Annual Review of Anthropology* 8: 267–307.

1979b Beauty and the "I" of the Beholder: Identity, Aesthetics, and Social Change Among the Ashanti. *Journal of Anthropological Research* 35 (2): 191–207.

1981a Carving Up the Profits: Apprenticeship and Structural Flexibility in a Contemporary African Craft Market. *American Ethnologist* 8: 41–52.

1981b Calculating Risks: The Socioeconomic Foundations of Aesthetic Innovation in an Ashanti Carving Community. *Ethnology* 20 (2): 101–14.

Silverman, Raymond A. 1983 Akan *Kuduo*: Form and Function, pp. 10–29. In *Akan Transformations: Problems in Ghanaian Art History*, edited by Doran H. Ross and Timothy F. Garrard. Los Angeles: Museum of Cultural History.

Silverman, Sydel 1965 Patronage and Community-Nation Relationships in Central Italy. *Ethnology* 4: 172–89.

Simmel, Georg 1950 *The Sociology of Georg Simmel*. Translated and edited by Kurt H. Wolff. New York: The Free Press.

1978 *The Philosophy of Money*. Translated and edited by Tom Bottomore and David Frisby. Boston: Routledge & Kegan Paul. First published in German in 1907.

Simpson, Donald 1975 *Dark Companions: The African Contribution to the European Exploration of East Africa*. New York: Barnes & Noble.

Skinner, Elliott P. 1975 Competition Within Ethnic Systems in Africa, pp. 131–57. In *Ethnicity and Resource Competition in Plural Societies*, edited by Leo A. Despres. The Hague: Mouton.

Smith, Barbara Herrnstein 1988 *Contingencies of Value: Alternative Perspectives for Critical Theory*. Cambridge, Mass.: Harvard University Press.

Smith, Charles W. 1989 *Auctions: The Social Construction of Value*. New York: Free Press.

Smith, M. G. 1962 Exchange and Marketing Among the Hausa, pp. 299–334. In *Markets in Africa*, edited by Paul Bohannan and George Dalton. Evanston: Northwestern University Press.

Sotheby's 1987 *Important Tribal Art*. May 20. New York: Sotheby's.

Spittler, Gerd 1977 Traders in Rural Hausaland. *Bulletin de l'I.F.A.N.*, series 2, 39 (2): 362–85.

Spooner, Brian 1986 Weavers and Dealers: The Authenticity of an Oriental Carpet, pp. 195–235. In *The Social Life of Things: Commodities in Cultural Perspective*, edited by Arjun Appadurai. Cambridge: Cambridge University Press.

Staatz, John 1979 *The Economics of Cattle and Meat Marketing in Ivory Coast*. Livestock Production and Marketing in the Entente States of West Africa, Monograph no. 2. Ann Arbor: Center for Research on Economic Development, University of Michigan.

Stanley, Janet L. 1987 The African Art Market: An Essay and Bibliography. *Africana Journal* 14 (2/3): 157–70.

Steiner, Christopher B. 1985 Another Image of Africa: Toward an Ethnohistory of European Cloth Marketed in West Africa, 1873–1960. *Ethnohistory* 32 (2): 91–110.

1986a Of Drums and Dancers: Convention and Reality in Portrayals of Non-Western Peoples in European Accounts of Discovery and Exploration. *The Harvard Review* 1 (1): 104–29.

1986b Interpreting African Masks: The Harley Collection at the Peabody Museum. *Symbols* (Fall): 6–10.

1990 Body Personal and Body Politic: Adornment and Leadership in Cross-Cultural Perspective. *Anthropos* 85 (4–6): 431–45.

Stewart, Susan 1984 *On Longing: Narratives of the Miniature, the Gigantic, the Souvenir, the Collection.* Baltimore: The Johns Hopkins University Press.

Swan, Jon 1989 Guaranteed Genuine. *Connoisseur.* April: 96–101.

Tambiah, Stanley Jeyaraja 1984 *The Buddhist Saints of the Forest and the Cult of Amulets.* Cambridge: Cambridge University Press.

1985 The Magical Power of Words, pp. 17–59. In *Culture, Thought, and Social Action: An Anthropological Perspective.* Cambridge, Mass.: Harvard University Press.

Tax, Sol 1953 *Penny Capitalism: A Guatemalan Indian Economy.* Institute of Social Anthropology Publication, no. 16. Washington, DC: Smithsonian Institution.

Taylor, John Russell, and Brian Brooke 1969 *The Art Dealers.* New York: Charles Scribner's Sons.

Thompson, E. P. 1966 *The Making of the English Working Class.* New York: Vintage Books.

Thompson, Michael 1979 *Rubbish Theory: The Creation and Destruction of Value.* Oxford: Oxford University Press.

Torgovnick, Marianna 1990 *Gone Primitive: Savage Intellects, Modern Lives.* Chicago: University of Chicago Press.

Touré, Abdou 1985 Les Femmes et le noms des pagnes, pp. 127–38. In *Les petits métiers à Abidjan.* Paris: Karthala.

Turcotte, Denis 1981 *La Politique linguistique en Afrique francophone: Une étude comparative de la Côte d'Ivoire et de Madagascar.* Québec: Presses de l'Université Lawal.

Uchendu, Victor C. 1967 Some Principles of Haggling in Peasant Markets. *Economic Development and Cultural Change* 16 (1): 37–50.

Ulin, Robert C. 1984 *Understanding Cultures: Perspectives in Anthropology and Social Theory.* Austin: University of Texas Press.

Van Beek, Walter E. A. 1988 Functions of Sculpture in Dogon Religion. *African Arts* 21 (4): 58–65, 91.

Van Binsbergen, Wim M. J. 1981 The Unit of Study and the Interpretation of Ethnicity. *Journal of Southern African Studies* 8 (1): 51–81.

Vansina, Jan 1984 *Art History in Africa: An Introduction to Method.* London: Longman.

Vasari, Giorgio 1927 *Lives of the Painters, Sculptors and Architects.* 4 vols. London: Dent. First published in Italian in 1551.

Visonà, Monica Blackmun 1987 The Limitations of Labels. *African Arts* 20 (4): 38.

210 References

Vogel, Carol 1988 Nothing Folksy About Folk Art Market. *The New York Times*, January 14, section C, p. 12.

Vogel, Susan 1981a Baule Female Figure, p. 73. In *For Spirits and Kings: African Art from the Paul and Ruth Tishman Collection*, edited by Susan Vogel. New York: The Metropolitan Museum of Art.

 1981b Collecting African Art at the Metropolitan Museum of Art. *Quaderni Poro* 3: 75–83.

Vogel, Susan (ed.) 1988 *The Art of Collecting African Art*. New York: The Center for African Art.

 1991 *Africa Explores: 20th Century African Art*. New York: The Center for African Art.

Wallerstein, Immanuel 1960 Ethnicity and National Integration in West Africa. *Cahiers d'Études Africaines* 3: 129–39.

 1974 *The Modern World-System, I: Capitalist Agriculture and the Origins of European World-Economy in the Sixteenth Century*. New York: Academic Press.

Wallis, Brian 1991 Selling Nations. *Art in America* 79 (9): 84–91.

Ward, Michael 1988 Introduction. In *Symbols of Wealth: Abstractions in African Metalwork*, text by Peter Westerdijk. New York: Michael Ward Gallery.

Werewere-Liking 1987 *Statues colons*. Paris: Les Nouvelles Editions Africaines.

Werner, Ellen C. H. 1982 Field Collecting in West Africa. *Triptych* (San Francisco), March–April: 12.

Whyte, Susan Reynolds, and Sjaak Van der Geest 1988 Medicines in Context: An Introduction, pp. 3–11. In *The Context of Medicines in Developing Countries: Studies in Pharmaceutical Anthropology*. Dordrecht: Kluwer Academic Publishers.

Willett, Frank 1971 *African Art: An Introduction*. New York: Praeger.

Williams, Raymond 1982 *The Sociology of Culture*. New York: Schocken Books.

Wilsmore, S. J. 1986 Authenticity and Restoration. *British Journal of Aesthetics* 26 (3): 228–38.

Wolf, Eric R. 1956 Aspects of Group Relations in a Complex Society: Mexico. *American Anthropologist* 58: 1065–78.

 1982 *Europe and the People Without History*. Berkeley: University of California Press.

Wolff, Norma H. 1985 Adugbologe's Children: Continuity and Change in a Yoruba Woodcarving Industry. Ph.D. dissertation, Department of Anthropology, Indiana University.

Wood, Robert E. 1984 Ethnic Tourism, the State, and Cultural Change in Southeast Asia. *Annals of Tourism Research* 11 (3): 353–74.

Yudelman, Montague 1964 *Africans on the Land*. Cambridge, Mass.: Harvard University Press.

Index

Abdurrahman Madu (pseudonym), 39, 52, 63, 65, 76, 80–86, 88, 103, 129, 181 nn. 9 and 10
Abidjan, 4, 7, 23, 32, 33, 34, 37, 45, 48, 51, 52, 71, 81, 82, 87, 97, 115, 134, 148–51
 commodity outlets in, 18–33
 expatriates in, 46, 128, 174 n. 15
 galleries in, 28–31, 103, 140
 itinerant suppliers in, 38, 55
 market, monopoly in, 69–70
 market places in, 4, 19, 26, 39, 44, 52, 60, 80, 90, 127, 133, 139, 168–69 n. 14
 storehouses in, 27–28, 44
 traders in, 114, 115
 women art suppliers in, 41–42
Abobo quarter (Abidjan), 28, 38
Accra (Ghana), 53
Adams, Monni, 105, 166 n. 10
aesthetic, -s, 5, 7, 9, 10, 30, 35, 72, 92, 93, 100, 101, 108, 110, 111, 114, 120, 122, 125, 129, 133, 145, 161, 191 n. 28
 "art" vs. "commercial," 158–59
 and national identity, 99
 merit, 100, 158, 160, 184 n. 3
 postmodern, 154
 "primitivist," 95
 pure, 163
 value, 9, 162
Africa, 5, 7
 capitalism in, 4, 164
 image of, 10, 15, 104, 108, 156
African art, 4–5, 7–14
 alteration of, 140–54
 and anthropology, 10–11
 bookseller, 116–17
 category of, 108–20
 classifications of, 107–8
 commoditization of, 9, 64–65
 description of, 135–39
 domestication of, 122–24

 increases in value, 62–63
 presentation of, 131–34
 Western scholarship's vision of, 92–93
African art collecting, 159, 162
 See also collectors
African artists, 6, 36, 37, 38, 151
Afrique Occidentale Française (AOF), 5, 6, 7, 169 n. 15, 183 n. 23
age (or aging), 8, 105, 120, 139, 140, 145, 151, 184 n. 2
Age of Discovery, 108, 124
Agni (ethnic group), 34
Air Ivoire, 82, 173 n. 2
airport art, -s, 8, 35, 105
 See also tourist art; souvenir
Akan (ethnic group), 32, 48, 69, 91, 125, 182 n. 13, 189 n. 19
 See also Asante; Baule
Akerlof, George, 78–79
akuaba (fertility doll), 32
Alexander, Jennifer and Paul, 61
Alhadji Amadou (pseudonym), 69–70
Alhadji Kabiru (pseudonym), 88
Alhadji Moussa (pseudonym), 112
Alhadji Salka (pseudonym), 28
Alhadji Usuman (pseudonym), 81–82, 85, 180 n. 6
Ali Bagari (pseudonym), 162
Allison, Philip, 106, 184 n. 1
Alsop, Joseph, 105
alteration of objects, 140–54, 189–90 n. 20
Althusser, Louis, 155
America, -n, 42, 112, 125, 133, 136
 African art market in, 7, 8, 42, 91, 173 n. 6
 art traders in, 9, 42, 54, 62, 91, 177 n. 9
 author labeled as, 85–86, 181 n. 10
 collector, -s, 44, 101, 103, 157, 163, 175 n. 22, 191–92 n. 30
 expatriates, 73, 174 n. 15
 price of African art in, 62–63

American Embassy (Abidjan), 46, 71,
 168 n. 10
American Indian, 105, 109, 111
 See also Native American
American Museum of Natural History, 109,
 122
Amselle, Jean-Loup, 40
Anderson, Benedict, 107
Angoulvant, Gabriel Louis, 157
Anoh Acou (artist), 32, 108, 171 n. 31
anthropololgy, 1–2, 10–11, 105, 108–9, 110
anti-establishment objects, 159
antiquités, 33–35, 39, 49, 54, 55, 62, 64, 65,
 66, 78, 79, 81, 84, 139, 180 n. 5,
 182 n. 17
Aoussabougou (Korhogo), 27, 80–86, 180 n. 6
Apollinaire, Guillaume, 4, 6
Appadurai, Arjun, 2, 63–64, 186–87 n. 1
apprentice, -s, 45, 46, 49, 52, 80, 92,
 175 n. 27
Arabic, 51, 74
Arnau, Frank (aka., Heinrich Schmitt), 104,
 135, 185–86 n. 14, 189 n. 17
art
 vs. artifact, 107–11, 133
 as a category, 2, 7, 10, 36, 108–11, 124,
 160
 quality of, 27
 world, 111, 158, 160
 See also African art
art history, 9, 101, 102, 105, 106, 110
artists. *See* African artists
Asan Diop (pseudonym), 38, 72, 139
Asante (ethnic group), 35, 38, 41, 136–38,
 172 n. 36
Attié (ethnic group), 34
auction, -s, 7, 68, 122, 124, 135, 136, 148,
 155, 163, 173 n. 5, 177 n. 10,
 179 nn. 24–25, 187 n. 7
authenticity, 2, 14, 20, 60, 62, 71, 76, 78–79,
 84, 90, 94, 102, 106, 112, 114, 129, 132,
 133, 134, 139, 143, 184 n. 3, 184–85 n. 4,
 188–89 n. 14, 191–92 n. 30
 and age, 101–2, 103–6
 Benjamin vs. trader on, 102–3
 of "colonial" figures, 154
 construction of, 114–15
 definitions of, 100–3, 131, 184 n. 1
 levels of in gallery, 30
 markers of, 138
 and pedigree, 124
 and tourist sites, 133–34

Babb, Florence E., 26
Bagari Tanko (pseudonym), 82–86, 181 n. 10

Baglione, Giovanni, 104
Bailey, F. G., 49, 131, 175 n. 28
Bakayoko Ibrahim (pseudonym), 52
Baker, Herbert, 101, 184 n. 1, 193 n. 9
Balandier, Georges, 13
Bamako (Mali), 41
Bamana (ethnic group), 41
Bambara (ethnic group), 92
 See also Bamana
"Bangwa Queen" (sculpture), 122–24
Barane Diop (pseudonym), 182 n. 17
Barane M'Bol (pseudonym), 46, 64
bargaining, 10, 14, 20, 31, 45, 49, 56, 62,
 65–71, 70–73, 136, 172 n. 34, 178 n. 16,
 190 nn. 21 and 25
 extractive, 62, 176 n. 2
 as performance, 62, 71–73
 retail, 62, 66–71
 stating initial price in, 68–69
 wholesale, 62, 65–66
barter, -ing, 34, 55, 62, 64, 82, 129,
 176–77 n. 4
Barth, Fredrik, 89, 154, 187 n. 3
Barthes, Roland, 93, 183 n. 19
Bascom, William, 101
base, removal of by traders, 140
baskets, 34, 111, 160
Bates, Constance, 69, 174 n. 10, 176 n. 1,
 188 n. 11
Bateson, Gregory, 136
Baudrillard, Jean, 120, 192–93 n. 3
Baule (ethnic group), 26, 34, 35, 37, 66, 88,
 90, 91, 92, 148
 artist, 32, 108
 slingshots, 112, 114, 116, 185 n. 10
 statues, nakedness of, 143–45
bazaar (Moroccan), 17, 44, 76, 175 n. 21,
 178 n. 19
beach vendors, 32–33
beads, trade, 14, 20, 100, 124–28, 172 n. 36,
 186 n. 18
Bembe Aminata (pseudonym), 41, 173 n. 2
Ben-Amos, Paula, 12, 105, 166 n. 10,
 175 n. 22
Benin, 35, 111, 175 n. 22
Benjamin, Walter, 103
Bentley, G. Carter, 89
Berger, John, 135
Bété (ethnic group), 34, 132
bétisses ("pornographic" goldweights), 36
Blier, Suzanne Preston, 107, 166 n. 10
Blue Guide, 93
Bobo-Dioulasso (Burkina Faso), 28, 173 n. 1
Bohemia, bead makers in, 124, 165–66 n. 8
Bonacich, Edna, 87

books on African art, 94, 102–3, 116–17
Boorstin, Daniel J., 71
Bouabré, Paul, 41, 95, 98
Bouaké, 4, 19, 28, 37, 148, 151, 167 nn. 5–6,
 170 nn. 17 and 20, 191 n. 27
Boulding, K. E., 76
Bouna, 65
Bourdieu, Pierre, 15, 159, 160, 161, 162, 163,
 166 n. 14, 185 n. 12, 193 n. 7
Braque, Georges, 4, 105, 193 n. 9
Braudel, Fernand, 1
Bravmann, René, 11, 89
bricolage, 155
Briggs, Jean, 155
Brooke, James, 96
Brown, Patricia Leigh, 154
Brummer, Joseph, 6
Bunn, James, 128, 160, 161
Burkina Faso, 4, 25, 26, 28, 34, 52, 65, 80,
 132, 183 n. 20, 187 n. 4, 190–91 n. 26

"cabinets of curiosity," 108
Cameroon, 34, 122
capital, 8, 14, 44, 51–54, 55, 56, 70, 157–58,
 164
capitalism, -ist, 1, 2, 4, 157–58, 163, 164,
 165 n. 5
Carpenter, Edmund, 109
Cassady, Ralph Jr., 61, 74, 76
cattle market, 38–39, 51, 55, 172–73 n. 41,
 175 n. 24, 192 n. 33
celadon figures, 143
Center for African Art, The, 110
Césaréo, Mary-Laure Grange, 120, 186 n. 16
Challenor, Herschelle Sullivan, 5
Chauvin, Françoise, 148
chinoiserie, British collector of, 161
chi wara figures, 41–42
City Hall (*mairie*), 18, 26, 44, 50,
 168–69 n. 14
classification, 33–36, 91–93, 100, 106–9
 See also taxonomy
Clifford, James, 10, 12, 93, 104, 106, 107,
 122, 189 n. 16
cloth, factory, 128
 See also textile
Cocody (Abidjan), 19, 21, 41, 127, 168 nn. 7,
 11
Cohen, Abner, 38–39, 51, 53, 87
Cohen, William B., 5
Cole, Herbert M., 125, 185 n. 11
collecting, history of, 122
collector, -s, 2, 4, 7, 9, 10, 14, 23, 26, 27, 28,
 30, 33, 35, 44, 46, 48, 50, 51, 59, 61, 62,
 63, 66, 68, 72, 77, 101, 102, 104, 106,

 108, 111, 112, 114, 116, 120, 124, 127,
 129, 132, 133, 135, 136, 140, 161,
 174 n. 17, 176 n. 32, 188 n. 12,
 191 n. 30
 American, 44, 101, 104, 163, 175 n. 22,
 191–92 n. 30
 and capitalism in Africa, 157–58; tourist
 art, 35; traders, 9–10, 175 n. 22
 bead, 128
 British, 161
 French, 30, 48, 143
 German, 124
 Italian, 113–15
 preference for naked statues, 143–45
 and profit, 162–63, 193 n. 10
 vs. tourists, 138, 140
"colonial" statues, 44, 111, 148–54
Comaroff, John, 89, 192 n. 34
comb, -s, 34, 35, 91, 140, 145
commission, -s, 14, 28, 46, 49, 54, 56–58, 60,
 175 n. 29
commoditization, 9, 10, 13, 14, 64, 99, 112,
 154, 162, 163, 164
commodity, 2, 13, 20, 62–64, 76, 91–92, 128,
 163, 164
competition, 45, 46, 50, 66, 79
context, -s, 7–8, 11, 12, 13, 65, 122, 131–32,
 138, 154, 160, 161, 164, 177 n. 5
 ethnographic, 109–10, 114
Conway, Sir Martin, 68–69, 187 n. 6
cooperation, 45, 58
copies, 35, 62, 66, 79, 120
Coquery-Vidrovitch, Catherine, 122
Côte d'Ivoire, 2, 4, 7, 18, 25, 26, 34, 36, 37,
 40, 41, 52, 53, 54, 62, 65, 79, 112,
 131–32, 139, 148, 154, 183 n. 20
 Dioula as lingua franca in, 38
 fashion, Western, in, 125
 French colonial, 148, 157
 government, 23
 market places in, 16, 19
 maska and masking in, 94
 urban centers, 27, 39
 See also Ivoirian
credit, 14, 41, 45, 46, 54, 55, 56, 58, 59–60,
 62, 70, 77, 78
 See also *ràngu*
Cubist, -s, 5
Culler, Jonathan, 138
cultural broker, -age, 10, 14, 154–56
cultural capital, 15, 158, 159
culture, 89, 104–6, 111
Curtin, Philip D., 74, 87, 182 n. 13
customers vs. suppliers, 38
Czechoslovakia, 124, 165–66 n. 8

Dadié, Bernard, 96
Dakar (Senegal), 4, 7, 109, 169 n. 15,
 172 n. 36, 183 n. 26
Dakar–Djibouti expedition, 109
Dan (ethnic group), 38, 92, 183 n. 20
 dolls, 41, 90, 173 nn. 2–3
 mask, -s, 34, 35, 58, 60, 62, 66, 91, 92, 128,
 132, 139
 statues, 34
Danané, 4, 38, 41, 62
Danto, Arthur, 111
Dark, Philip, 11
Davis, Whitney, 11
dealer, -s, 2, 4, 6, 7, 9, 10, 27, 28, 30, 33, 48,
 52, 59, 61, 62, 63, 68, 72, 74, 77, 81, 82,
 90, 92, 94, 100, 101, 102, 104, 106, 107,
 111, 112, 114, 117, 124, 127, 131, 132,
 134, 135, 136, 140, 143, 148, 162,
 174 n. 10, 178 n. 13, 181 nn. 8–10,
 182 n. 16, 184 n. 1, 192 n. 33
deble (rhythm pounder), 54
Defoe, Daniel, 128
de Grunne, Bernard, 122
de la Fuente, Julio, 49, 71
Delcourt, Jean Paul, 114
Derbel, Alain, 159, 185 n. 12
desacrilization of African art in the West, 161
description of art objects, 135–39
diamond market, 53
diaspora, 2, 4, 8, 64, 171 n. 25, 180 n. 1,
 192 n. 33
Dida (ethnic group), 26
diffusionist, 1, 11, 165 n. 1
Dimbokro, 4, 37
Dior, Christian, fake belts, 129
Dioula (ethnic group), 26, 37, 49, 54, 80, 87,
 138, 172 n. 38, 182 n. 17
 language, 4, 38, 56, 165 n. 3, 172 n. 35
Direction de la Promotion de l'Artisanat d'Art
 (DPAA), 93–94
discovery of art objects, 4, 107, 131–34
Djerma (ethnic group), 37, 38
Djidji, Ambroise, 96
Dogon (ethnic group), 34, 114, 177–78 n. 12,
 182 n. 14, 184 n. 2, 190–91 n. 26
dolls. See Dan dolls
Donne, J. B., 6
door-to-door vendors, 46–48
Dozon, Jean-Pierre, 97
DPAA. See Direction de la Promotion de
 l'Artisanat d'Art
Dramane Kabba (pseudonym), 102–3
Dubin, Lois Sherr, 125
Dupont, François (pseudonym), 48
Durkheimian, 92, 159, 185 n. 8

Eagleton, Terry, 154
ebony, 36
Echenberg, Myron, 5, 182 n. 14
"economic man," 157
Egypt, 95, 187 n. 6; Egyptian, 69, 189 n. 16
Einstein, Carl, 6
enchanted worlds, 160, 164
equestrian statues, 151
Errington, Shelly, 12, 106–7, 111
ethnic group, -s, 11–12, 14, 52, 89
ethnic identity, 89–90, 92–93, 182 n. 17,
 185 n. 8
ethnicity, 10, 14, 26, 38, 73, 89, 97
 as commodity, 92–93
 and classification of African art, 91–92
ethno-aesthetics, 11
etiquette, commercial, 58–59, 71, 180–81 n. 7
Europe, -ans, 20, 34, 36, 40, 63, 87, 88, 92,
 93, 102–4, 107, 108, 114, 115, 120, 127,
 128, 129, 133, 135, 136, 148, 151, 157,
 159, 174 n. 18, 185–86 n. 14, 187 n. 4,
 188 n. 10, 191–92 n. 30
 in Africa, 4, 5–6, 48, 72, 74, 102, 128,
 165 n. 6, 167–68 n. 7, 170 n. 19,
 182 n. 17
 African art dealers in, 6, 7, 74
 artists, 4, 106
 colonial rule, 5
 and definition of art, 111–12
 demand for African art, 4–5, 7
 margin of profit vs. African, 70–71
 tourist, -s, 72, 128, 139
 trade beads, 20, 124–28
 traders returning from, 8, 92
 traders traveling to, 9, 62–63, 92, 177 n. 9
 See also France; French
Evans-Pritchard, E. E., 86
evolutionist, -s, 11, 107
exchange value, 15, 64, 159, 162–64
 See also value
expatriate, -s, 5, 21, 23, 28, 31, 32, 35, 46, 51,
 59, 60, 73, 97, 128, 148, 151, 168 nn. 7
 and 9, 174 n. 15, 176 n. 32, 178 n. 20
Exposition Coloniale de Vincennes, 5
extraction, 6, 66

Fagg, William, 106, 185 n. 8
fake, -s, 9, 10, 36, 66, 77, 78, 79, 106, 108,
 124, 128–29, 132, 187–88 n. 8,
 189–90 n. 20, 191–92 n. 30
Fang reliquary figure, 10
Fanselow, Frank S., 46, 178 n. 14
Fante (ethnic group), 35
Faris, James, 110
fashion, 125, 154

Ferrari, Antoine, 114
Festimask, 96–99, 183 n. 26
 See also masked festival
"fetish," -es, 6, 53, 88, 101, 111, 132, 163,
 172 n. 38
Fetter, Bruce, 157
Fischer, Eberhard, 139
Fischer, Michael, 2
fishing, 52
fortune, control of, 51, 53
Foster, Brian L., 87
framing, African art, 70, 117–20, 186 n. 16
France, 5, 7, 87, 108, 134, 139, 182 n. 14
 See also French; Europe
Francis, Peter, Jr., 125
Frank, Barbara E., 11
Fraternité Matin (Abidjan), 96
French, 7, 16, 21, 28, 48, 60, 94, 95, 125, 130,
 143, 162, 167–68 n. 7, 169 n. 15,
 169–70 n. 16, 170 n. 17
 antique market, tricks of, 132–33
 colonial governor, 157
 colonial rule, 4, 5, 148
 collectors, 30, 143
 language, 4, 51, 73, 103, 175 n. 29,
 180 n. 28, 186 n. 17
 See also France; Europe
friendship, 57, 75
Fulani (ethnic group), 35
furniture, 7, 30, 32, 34, 132–33

Galerie Equateur, 120
Galerie Pokou, 30–31
gallery, -ies, 6, 19, 28–32, 33, 35, 63, 70,
 104, 111, 112, 115, 117, 120, 122, 130,
 163, 171 nn. 28–29, 174 n. 10,
 186 n. 16
 owner, -s, 55, 63, 67, 70, 111, 112, 120,
 136, 138, 140, 148, 159, 163,
 171 nn. 28–30, 176 n. 1
 prices in, 62, 68, 70, 171 n. 30, 176 n. 1,
 178 n. 18
 system, 158–59
Garnham, Nicholas, 163
Gaudio, Attilio, 148
Geertz, Clifford, 17, 44, 59, 61, 66, 76,
 174 n. 14, 175 n. 21, 176 n. 31,
 178 n. 19
Gellner, Ernest, 98
Gerbrands, Adrian A., 11, 109, 166 n. 10
Ghana, 32, 34, 38, 41, 51, 52, 53, 136,
 183 n. 20
Gnangnan, Desiré, 97
Gnobo, J. Z., 40
Gobbi, Jean-François, 130

Goffman, Erving, 133, 187 n. 7
gold, 34, 35, 36, 48, 58, 69, 91, 92, 124, 125,
 135
Goldsmith, Oliver, 161
Gorer, Geoffrey, 95
Graburn, Nelson H. H., 33, 35, 36, 93, 105,
 184 n. 29
Grand Bassam, 31, 32, 108, 167 n. 7
Greek art, Roman fondness of, 103
Grégoire, Emmanuel, 40, 180 n. 6
Griaule, Marcel, 109, 182 n. 14
Guéré (ethnic group), 26, 35
Guillaume, Paul, 6, 104–5, 165 n. 7
Guinea, -n, 4, 25, 26, 34, 42
Guro (ethnic group), 35, 148, 191 n. 29

hadith, 89, 182 n. 15
haggling. *See* bargaining
Hamadou Diawara (pseudonym), 134
Handler, Richard, 98, 104
Haraway, Donna, 122
Hausa, -s (ethnic group), 4, 26, 27, 28, 37, 38,
 40, 49, 51, 53, 54, 56, 65, 112, 132, 136,
 167 n. 3, 170 n. 18, 171 n. 24, 174 n. 11,
 175 n. 22, 176 n. 34, 178 n. 21,
 180 nn. 1–2, 180–81 n. 7, 181 nn. 8–10,
 187 n. 4, 192 nn. 33–34
Hersey, Irwin, 63, 162
Herskovits, Melville J., 89
hierarchy, 5, 14, 42–50, 79, 82, 108
Hill, Polly, 39, 175 n. 29
Himmelheber, Hans, 25, 139, 167 n. 17,
 177 n. 9, 182 n. 16, 188 n. 10
Holland, bead makers in, 124
homo antiquus, vs. *oeconomicus*, 157
Hotels, 19, 23, 28, 54, 96, 120, 132
Houphouët-Boigny, Félix, 90, 95, 97,
 165 n. 2, 167 n. 4, 170 n. 17, 183 n. 24,
 183–84 n. 27

IBM Gallery, 122
Imperato, Pascal J., 139
Inagaki (mount maker), 106
inauthentic, 93, 99, 101, 104, 111, 178 n. 17
 See also authenticity
information, 61, 66, 79, 155
 about art objects, 135–36, 163, 188 n. 12
 and bargaining, 72, 76
 exchange of, 2, 13, 14
 market, 73, 76–79, 172 n. 34, 179–80 n. 27
 See also knowledge
internal market peddlers, 50, 174 n. 20
iron wealth. *See* metal currency
Islam, -ic, 8, 74, 89, 91, 162
 See also Muslim

Ivoirian, -s, 4, 14, 16, 20, 25, 32, 59, 88, 90,
 94, 148, 167 n. 4, 168–69 n. 14,
 169 n. 16
 art, -s, 90, 93, 171 n. 32
 government, 93–99
 "miracle," 97, 184 n. 28
 and Senegalese, 64, 90, 169 n. 15
 See also Côte d'Ivoire
Ivoirianization, 23–25, 169 n. 16
ivory, 36, 58, 65, 80, 81, 105, 124, 171 n. 33
Ivory Coast. See Côte d'Ivoire

Jahn, Jens, 148
Jamin, Jean, 12, 109
jewelry, 20, 21, 35, 36, 58, 71, 80, 125, 127
Jibrim Taroare (pseudonym), 28
Johnson's paste wax, 16
Jula. See Dioula
Jules-Rosette, Bennetta, 12, 36, 105, 108, 130,
 171 n. 31

Kaeppler, Adrienne L., 108
Kahan, Leonard, 106
Kamer, Henri, 100–1, 184 n. 1
Kasfir, Sidney Littlefield, 92, 105, 185 n. 8
key rings
 as status symbols, 91
Khuri, Fuad I., 61, 178 n. 16, 186 n. 19
kinship terms, 73–74
kodjo. See loin cloths
knowledge, 38, 48, 59, 65, 68, 76, 90, 93, 98,
 109, 110, 132, 138, 186–87 n. 1
 of buyers, 35, 65, 72
 market, 76–79, 178 n. 18
 mediation of, 2, 10, 13–14, 154–56
 of traders, 9, 49, 51, 55, 90, 188 n. 10
 See also information
kola trade, 40, 80, 140, 192 n. 33
Koko quarter (Korhogo), 80, 82, 181 n. 8
Korhogo, 4, 19, 27, 36, 38, 53, 54, 80–86,
 112, 132, 167 n. 5, 170 n. 17, 177 n. 6,
 180 n. 2, 181 n. 11
Koulango (ethnic group), 34
kpélié (mask), 34, 82–86
 See also Senufo
Kulebele (ethnic group), 80, 180 n. 3, 181
 n. 8
Kumase (Ghana), 41, 173 n. 4
Kuper, Hilda, 125, 128
Kwasi Adja (pseudonym), 41
Kyauta Salihu (pseudonym), 60

ladders, 34; as art, 112
Lagos (Nigeria), 52
Laude, Jean, 5

Lauren, Ralph (designer), 154
Leach, Edmund R., 89
Lebanese, 18, 30, 48, 74, 87, 167–68 n. 7,
 169–70 n. 16
Lehuard, Raoul, 101, 108, 132
lèk. See commission
Lemann, Nicholas, 7, 9, 166 n. 12
"lemons" (bad cars), 78–79
Leuzinger, Elsy, 105
Levi jeans, counterfeit, 129
Levine, Donald N., 88
Lévi-Strauss, Claude, 155
Lewis, Barbara, 20, 46, 165 n. 3,
 169–70 n. 16, 174 n. 13
Liberia, -n, 19, 34, 53, 172 n. 38, 183 n. 20
"life" of objects, 2, 13, 61, 62, 161, 193 n. 8
Lips, Julius E., 148
Lobi (ethnic group), 34, 35, 52, 65, 66, 92,
 145, 175 n. 25, 177–78 n. 12, 183 n. 20,
 187 n. 4
loin cloths, 143–45
lore, market, 138–39
Los Angeles, 54, 167 n. 16
Lovejoy, Paul E., 40, 122
Lowenthal, David, 103

MacCannell, Dean, 90, 93, 133–34
MacClancy, Jeremy, 12, 108
McLeod, Malcolm D., 101
Madonna, pirated recordings of, 129
Mailfert, André, 132–33
mairie. See City Hall
malachite, 36, 80, 81
malam, -ai, 18, 53, 54, 167 n. 3
Malam Abubakar (pseudonym), 65
Malam Yaaro (pseudonym), 42, 53, 54, 88,
 89, 136–38
Mali, -an, 4, 25, 26, 32, 34, 36, 42, 80, 134,
 169 n. 15, 172 n. 38, 184 n. 2
Malinké (ethnic group), 26, 87
Malinowski, Bronislaw, 11, 49, 71
Mamman Yayaji (pseudonym), 85
Man, 4, 19, 27, 28, 38, 41, 62, 96, 167 n. 5,
 170 n. 17, 173 n. 2, 182 n. 16, 188 n. 10
Mande (ethnic group), 4, 88, 165 n. 3
Manhattan, East Side, 111
Manning, Patrick, 5, 12
Mano (ethnic group), 34
Man Ray, 124
marché sénégalais, 23
 See also Plateau market place
Marcory quarter (Abidjan), 30, 120
Marcus, George E., 2
marketwomen, 20
Marx, Karl, 163, 185 n. 24

mask, -s, 7, 16, 17, 18, 21, 26, 30, 34, 35, 36,
 38, 40, 77, 93, 101, 105, 106, 108, 111,
 125, 132, 134, 136, 1409, 145, 160,
 171 n. 27, 172 n. 36, 173 n. 5, 185 n. 10,
 186 n. 15, 190–91 n. 26, 191 nn. 29–30
 Baule, 90
 Dan, 58, 60, 62–63, 66, 91, 92, 128–29,
 132
 and nationalism, 93–99
 "passport," 139
 theft and return of, 87
 as trademark of Côte d'Ivoire, 95
 traders' attitude toward, 88
masked festival, 94–99
 See also Festimask
Matisse, Henri, 4, 122
Maurer, Evan, 106
Maybury-Lewis, David, 89
Mazrui, Ali, 91
Mecca, pilgrimage to, 82, 180 n. 6
Melikian, Souren, 148
memory, 51
metal currency, 111–12
Mexico, 71, 76, 95, 107, 127 n. 18
Meyer, Piet, 52
Michelangelo Buonarroti, 103–4
middleman, -men, 6, 25, 55, 58, 59, 61, 66,
 78, 79, 114, 130–31, 133, 154,
 186–87 n. 1
Minister of Cultural Affairs, 96
Minister of Tourism, 95, 96, 98
Ministry of Information, 99
Ministry of Tourism, 93, 96, 183 n. 22
Mintz, Sidney W., 2, 16, 40, 46
Miracle, Marvin P., 157
modernity, imitations of, 128–29
money, 38, 51, 75
Moore, Sally Falk, 89, 98, 176 n. 33
Moravia, bead makers in, 124
Mossi (ethnic group), 26, 182 n. 17,
 190–91 n. 26
Mudimbe, V. Y., 107
Mulinde, Robert (pseudonym), 52–53, 90
Munro, Thomas, 104–5
Musée d'ethnographie du Trocadéro, 109
museum, -s, 11, 64, 92, 102, 104, 105, 107,
 109, 120, 130, 155
Museum für Völkerkunde (Berlin), 124
Museum of Modern Art (MoMA), 106, 107,
 124
Muslim, -s, 17, 18, 91, 132, 168 n. 12,
 180 n. 1, 180 n. 6, 182 n. 15
 attitude toward African art, 53, 88–89,
 161–62, 182 n. 16
 See also Islam

Myerhoff, Barbara G., 98
Nash, Dennison, 155
national identity, 90, 94
nationalism, 98–99
National Museum of Mexico, 107
"naturalization" of imports, 128
network, -s, 6, 8, 13, 14, 37, 38, 39, 40, 45, 46,
 53, 59, 61, 62, 78, 81, 82, 87, 132, 155,
 171 n. 25, 173 nn. 1 and 7, 174 n. 16,
 189 n. 15
New Guinea Highlands, 106
New York, 9, 32, 42, 54, 62, 66, 106, 110,
 116, 122, 136–38, 166 n. 12, 167 n. 16,
 169 n. 14, 171 n. 30
Ngolo Coulibaly (pseudonym), 82–86,
 181 n. 9
Niger, 4, 25, 26, 32, 36, 54, 80, 81, 87,
 173 n. 11
Nigeria, -n, 4, 34, 38, 51, 52, 53, 87, 90,
 167 n. 3, 171 n. 25, 192 n. 33
Northern, Tamara, 124
Northwest Coast art, 109
nyama-nyama, 35–36, 62, 66, 81, 120,
 172 n. 35, 175 n. 22

"one tribe, one style" paradigm, 92, 185 n. 8
Orléans (France), 132
Ouagadougou (Burkina Faso), 52, 132

Paine, Robert, 154–55, 187 n. 3
paint, 115, 151
pan-African art objects, 90, 172 n. 36
Paris, 6, 48, 62, 87, 106, 124, 130, 132, 143,
 148, 173 n. 5, 177 n. 9
Partie Démocratique de Côte d'Ivoire (PDCI),
 97, 170 n. 17
partnerships, disadvantages of, 55–56
Pathé Diop (pseudonym), 49
patina, 7, 103, 106, 140, 160
patination, 8, 91, 140
Paudrat, Jean-Louis, 5, 6
PDCI. See Partie Deemocratique de Côte
 d'Ivoire
Peace Corps, 7
pedigree, 122–24, 136
penises, carved wooden, 32
Perinbam, B. Marie, 157, 182 n. 13
pestles, 34, 112
Philmon, Thierry O., 95
Picard, John and Ruth, 125
Picasso, Pablo, 105, 193 n. 9
Pitt-Rivers, A. H., 108–9
Plateau market place (Abidjan), 18, 38, 39, 41,
 42, 48, 49, 50, 60, 64, 69, 72, 90, 91, 116,
 128–29, 151, 161–62, 168 n. 11,

Plateau market place (*cont.*)
 169 n. 15, 170 n. 18, 171 nn. 22 and 24,
 186 n. 15, 190 n. 25
 description of, 21–26
 front and back regions in, 133–34
Plateau quarter (Abidjan), 19, 21, 168 n. 7
police, 85, 86, 87, 170 n. 18, 181 n. 10
Pollock, Jackson, 105
poroh-poroh, 50, 174 n. 19
Port Bouët (Abidjan), 31
postmodern artifact, definition of, 154
potassium permanganate, 115, 151,
 185–86 n. 14
Potomo Waka, 51, 112–17, 185 n. 11,
 185 n. 12
pre-capitalist, 158, 159
 See also capitalism
presentation of art objects, 26, 131–34
Price, Sally, 9, 12, 13, 35, 62, 107, 111, 122,
 133, 166 n. 15, 177 n. 7, 190 n. 24,
 193 n. 10, 194 n. 12
price, 7, 28, 61, 77, 110, 115, 170–71 n. 30
 initial, 68–69, 72–73, 74, 172 n. 34,
 178 n. 19
 strategies for increasing, 74–75
 tag, -s, 28, 110
"primitive" culture, 9
"Primitivism" in 20th-Century Art (exhibit),
 106
primitivist, -s, 5, 165 n. 5
profit, 44, 55, 60, 77, 193 n. 10
 African vs. European, 70–71
 margin, 57, 65, 74, 151, 178 n. 14, 180 n. 5
Provost, Carl K., 101, 184 n. 1
public garden (*jardin public*), 16, 21, 22,
 168 n. 12, 169 n. 14

quality, 39, 44, 45, 54, 55, 60, 90, 157–58
Qur'anic, education, 51, 53; charms, 162
 See also Islam, Muslim

Radcliffe-Brown, A. R., 11
Ramadan (holy month), 82, 174 n. 11
Ranger, Terence, 98
ràngu (credit), 58–60, 77, 78, 175–76 n. 31
 See also credit
Ratton, Charles, 6, 122, 124
Ravenhill, Philip L., 92, 148, 167 n. 17,
 177–78 n. 12, 185 n. 11
Reichert, Raphael X., 12, 173 n. 4
Reif, Rita, 111–12, 122
Rembrandt Harmenszoon van Rijn, 114
Rémy, Mylène, 90
replica, -s, 10, 30, 34, 35, 38, 62, 120, 129,
 139, 148

reputation, 59, 91, 176 n. 33, 178–79 n. 23
restoration of objects, 140, 145–48, 190 n. 25
Rheims, Maurice, 133, 135, 143
Richter, Dolores, 12, 33, 180 n. 3, 181 n. 8
Ringo (artist), 32
Rivet, Paul, 109
Rivière, Georges-Henri, 109
roadside stalls/stands, 18–19, 31–32, 35
Rockefeller, Nelson, 122, 136
Rose d'Ivoire, 28–31, 171 n. 27
 See also Hotels
Ross, Doran H., 12, 173 n. 4, 185 n. 11
Roy, Joseph, 148
royalty, as a stereotype of African art, 138–39
Rubin, William, 7, 104, 109
Rubinstein, Helena (Princess Gourielli), 124
"runner," 9, 10

saawa. *See* spoons
sacredness, as stereotype of African art, 138
Sadia, Duon, 95, 96, 98
"safari-look," 154
Sagoff, Marc, 158
Scanzi, Giovanni Franco, 112–16
Schildkrout, Enid, 89, 180 n. 1
Schoffel, Alain, 106
secrets, secrecy, 8, 30, 38, 50, 59, 94, 134
 levels of, and authenticity, 30, 31
 object cost as a form of, 75, 77
 source of goods as, 77–78
segmentary opposition, 86, 181 n. 11
Segy, Ladislas, 104, 163
Senegal, 4, 5, 23, 25, 38, 87, 90, 148,
 183 n. 25
Senegalese, 4, 5, 18, 23, 32, 64, 91, 172 n. 36,
 182 n. 16
 See also Wolof
Senufo (ethnic group), 30, 34, 35, 37, 54, 77,
 80, 82, 84, 85, 86, 91, 132, 177 n. 6,
 181 nn. 9–10
Sepik River art, 122
sexuality of African art, 13, 190 n. 24
Sheriff Ousman (pseudonym), 116
Shils, Edward, 103
Sierra Leone, 34
Silver, Harry R., 11, 12
Silverman, Raymond A., 131, 189 n. 19
Silverman, Sydel, 131
Simmel, Georg, 160, 161
Simpson, Donald, 122
Skinner, Elliott P., 89
slave trade, 6, 107, 125, 182 n. 13
slingshots, 14, 34, 51, 112–17, 185 nn. 10–11,
 185 n. 13
Smith, Barbara Herrnstein, 161

solidarity, national, 96; occupational, 73–74
Sotheby's
 Tribal Art Department, 122
 auction catalogue, 190–91 n. 26
souvenir, -s, 20, 21, 28, 40, 48, 62, 90, 93,
 133, 148, 172 nn. 35–36
 See also airport art; tourist art; *nyama-
 nyama*
Spooner, Brian, 138
spoons, 34, 35, 69–70, 145
stall, -s, 6, 16, 17, 18, 19, 20, 26, 28, 45, 46,
 49, 52, 54, 56, 59, 72–73, 80, 81, 88, 93,
 127, 133, 168–69 n. 14, 171 n. 23
stall fee (or right), 26, 44, 45, 46, 50, 167 n. 1,
 170–71 n. 22
stallholder, -s, 26, 27, 39, 44–46, 48, 49, 50,
 52, 55, 57, 58, 59, 60, 62, 69, 77, 92,
 177 n. 11
status, 50, 91, 125, 154, 174 n. 16, 175 n. 22
storehouse, -s, 6, 27–28, 33, 35, 40, 44, 45,
 46, 55, 59, 62, 80, 81, 82, 112,
 171 nn. 24–25, 173 n. 9
success, economic, 51, 86, 130, 163
Swan, Jon, 124
Swat Pathan, 89
Swazi, 125
*Symbols of Value: Abstractions in African
 Metalwork* (exhibit), 111
Syndicat des Antiquaires, 25–26, 40–41, 54,
 170 nn. 17–19
Systema Naturae, 108, 109

tam tam (drum), 32
taste, -s, 45, 58, 66, 68, 72, 101, 102, 128,
 131, 132, 133, 136, 156, 190 n. 24,
 191–92 n. 30
"taxonomic moment," 106
taxonomy, -ies, 106–7, 108
 See also classification
Taylor, John Russell, 9, 192 n. 33
television, -s, 42, 52, 90, 125
textile, -s, 7, 19, 20, 32, 35, 54, 129
 See also cloth
theft, 18, 87–88
Thompson, E. P., 155–56
Thompson, Michael, 158–59, 193 n. 5
tirailleurs sénégalais, 5, 182 n. 14
Togo, 34
top, 51, 84, 175 n. 23
Torgovnick, Marianna, 12
Touré, Abdou, 128
tourism, 12, 94, 95, 98–99, 183 n. 22
tourist art, -s, 8, 12, 35, 71, 98, 105, 108, 138,
 148, 162
 See also airport art; souvenir

tourist, -s, 2, 12, 26, 27, 30, 31, 32, 35, 40, 45,
 46, 48, 49–50, 51, 52, 57, 60, 61, 77, 90,
 91, 94, 105, 115, 127, 128–29, 136,
 138–39, 151, 161, 170 n. 21, 178 n. 18,
 186 n. 18
 amused by trader's story, 139
 bargaining with, 62, 71–73, 77
 vs. collectors, 135–36, 140
 and commission sellers, 56–57
 and Festimask, 96–99
 hotel, -s, 19, 23, 28, 80
 interest in ethnic attribution, 92
 market, 180 n. 5, 182 n. 17, 192 n. 2
 in market place, 19, 20, 56, 168 n. 9,
 170 n. 21
 and "sweat marks" on mask, 140–43
trade beads. *See* beads
traditionalism, 95
Treichville (Abidjan)
 art found in gutters of, 70
 market place, 19, 20, 21, 127, 168 nn. 9 and
 11, 169–70 n. 16, 173 n. 3, 174 n. 13,
 178–79 n. 23
 quarter, 19–20, 21, 27, 28, 33, 44, 70,
 168 n. 7, 171 n. 24
trunk, -s, 26, 59, 128, 133
trust, lack of among traders, 55
truth, 86, 101, 104, 109, 178–79 n. 23
Tuareg (ethnic group), 32, 33, 35
Turner, Victor, 155

Uchendu, Victor C., 61
Ulin, Robert C., 156
union. *See* Syndicat des Antiquaires
United States (US), 42, 52, 53, 78, 90,
 166 n. 11, 166–67 n. 16, 173 nn. 6 and 8,
 176 n. 1, 182 n. 18, 186 n. 18,
 186–87 n. 1, 187 n. 7
 See also America
use value, 15, 64, 159, 160–62, 192–93 n. 3,
 193 n. 4
 See also value

value, 14, 15, 39, 64, 65, 66, 72, 120, 134,
 157–64, 172 n. 34, 177 n. 5, 177 n. 8
 aesthetic vs. economic, 9–10, 158
 buying below market, 42
 capacity to judge, 54-55
 of "colonial" statues, 148
 established through bargaining, 61
 fair market, 79
 investment, 30
 of metal currencies, 112
 system of, 13, 62, 68
 testing of, 136

value (*cont.*)
 Thompson's theory of, 158–59
 See also exchange value; use value
Van Binsbergen, Wim M. J., 89
Van Gogh, Vincent, 135, 185 n. 12
Van Roekeghem, Patrick, 148
Vansina, Jan, 92
Vasari, Giorgio, 104
Venice, Venetian, 124, 125
Verité, Pierre, 6, 166 n. 9
vetting, 124
Vignier, Charles, 6
villagers, 36, 38, 65, 191 n. 30
"vintage imperialism," 154
Visonà, Monica Blackmun, 11
Vlaminck, Maurice, 136, 193 n. 9
Vogel, Susan, 106, 110, 143, 166 n. 15,
 171 n. 27, 177 n. 6, 189 n. 19

wage labor, 157, 158
Wallerstein, Immanuel, 1, 89, 97
Wallis, Brian, 107
Ward, Michael, 112
Werewere-Liking, 148, 170 n. 20
Western-derived art forms, 36

Western manufactured products, 8
Willet, Frank, 101
Williams, Raymond, 163, 193 n. 5
Wolf, Eric R., 1, 2, 130, 165 n. 1
Wolff, Norma H., 12
Wolof (ethnic group), 4, 5, 23, 25, 26, 32, 38,
 49, 50, 64, 72, 90, 94, 139, 148,
 169 n. 15, 181 n. 24, 180 n. 2, 182 n. 17,
 191 n. 27
 language, 56, 174 n. 19, 175 nn. 29 and
 31
women, 18, 40, 46, 65, 125, 128, 173 n. 7
 as couriers, 41–42
 See also marketwomen
workshop, -s, 36, 41, 62, 151
World War, First, 5
World War, Second, 106

Yamoussoukro, 4, 28, 96–99, 167 n. 4,
 183–84 n. 27
Yusufu Bankano (pseudonym), 178–79 n. 23
Yusufu Tijjani (pseudonym), 54, 175 n. 27

Zaire, 34
zango, 81, 180 n. 1